'A rollicking read . . . a tale of hedonism and opportunism, of great hope and dashed expectations' *Mail on Sunday*

'A grade *Sunday Times*

'Emi... ...able' *New ...man*

'A fascinating step back to right before the web, smartphones and streaming changed the face of culture' *Stylist*

'I tore through it, savouring every high and low point of this hazy, hard-to-define epoch' *Evening Standard*

'Remarkable' *Art Review*

'Book of the Week' *Guardian*

'The tumult, the triumph and the toilery of the 90s . . . a who's who of the decade' **Shaun Keaveny, BBC 6 Music**

'Without question, the definitive telling of what Britain was in the nineties, who Britain became and how that has come to define the times we live in now' **M.M.A**

'I absolutely devoured it' **Chris Warburton, BBC Radio 5 Live**

'We guarantee, this will change the way you think about the era you lived through' **David Hepworth**

'It's so original to read about the 90s that takes in all those different perspectives and doesn't just paint a picture of a heap of cocaine with Noel Gallagher in the middle of it' **Mark Ellen**

Birmingham-born Daniel Rachel has music running through his veins. He wrote his first song when he was sixteen, was the lead singer of the band Rachels Basement in his twenties, and subsequently released two solo albums in the early noughties. He is also a critically acclaimed author with his first book, *Isle of Noises*, being named a *Guardian* and *NME* Book of the Year. His second book, *Walls Come Tumbling Down*, won the prestigious Penderyn Music Book Prize and was selected for the BBC Radio 2 Book Club. He is also a stalwart on BBC Radio 5 Live and can be found airing all things cultural on @DanielRachel69 and www.danielrachel.com.

Also by Daniel Rachel

Isle of Noises:
Conversations with Great British Songwriters

Walls Come Tumbling Down:
The Music and Politics of Rock Against Racism, 2 Tone
and Red Wedge

DON'T LOOK BACK IN ANGER

The rise and fall of Cool Britannia, told by those who were there

Daniel Rachel

First published in Great Britain in 2020 by Trapeze,
This paperback edition published in 2021 by Trapeze
an imprint of The Orion Publishing Group Ltd
Carmelite House, 50 Victoria Embankment,
London EC4Y 0DZ

An Hachette UK company

1 3 5 7 9 10 8 6 4 2

Copyright © Daniel Rachel 2020

A CIP catalogue record for this book is
available from the British Library.

ISBN (Paperback): 978 1 4091 8072 2

Typeset by Born Group

Printed and bound in Great Britain by Clays Ltd, Elcograf S.p.A.

www.orionbooks.co.uk

For Kate . . . and the time we used to be x

Life's but a walking shadow, a poor player
That struts and frets his hour upon the stage
And then is heard no more: it is a tale
Told by an idiot, full of sound and fury,
Signifying nothing.

William Shakespeare, *Macbeth*, Act V, sc. v

I don't want to be neutral. I don't want to be a saint. I
want to be a lost cause. I want to be corrupt and futile!

John Osborne, *Look Back in Anger,* Act III, sc. ii

Please don't put your life in the hands
of a rock 'n' roll band
Who'll throw it all away

Noel Gallagher, 'Don't Look Back in Anger'

Contents

Introduction: Vanity Fair

The nineties was the decade when British culture reclaimed its position at the artistic centre of the world. Not since the Swinging Sixties had art, comedy, fashion, film, football, literature, music and politics interwoven into a blooming of national self-confidence. It was the era of lad culture, ladettes, Girl Power, hedonism, a time when the country united through a resurgence of patriotism and a celebration of all things British: Stella McCartney and Alexander McQueen in fashion; Gazza and David Beckham in football; Tracey Emin, Damien Hirst and the Young British Artists; at the cinema *Four Weddings and a Funeral* and *Trainspotting*. It was the time of Britpop, the Spice Girls, and even the three surviving Beatles recording together again. *Loaded* magazine was launched 'for men who should know better', and Chris Evans re-invented the Radio 1 *Breakfast Show* before launching *TFI Friday*, providing a hub for Cool Britannia revelry. The resurgence of artistic endeavour frequently led the national news, and the country's thirst for celebrity gossip was whetted and duly served by a ravenous media. 'Spin' was the new buzz word, and as marketing and branding entered a golden age of influence, the country bathed in an innocence oblivious to the looming digital revolution of the new millennium.

If Cool Britannia was distilled to a single image, Tony Blair shaking hands with Noel Gallagher at a Downing Street reception party, in the wake of New Labour's 1997 election victory, would undoubtedly satisfy popular mythology. On the surface, the triumphant Prime Minister ingratiating himself with one of the decade's cultural icons, both basking in one another's reflected glory, defined the spirit of the age. But as with all good stories, there are nuances, subtleties and contradictions to be told. Cool

Britannia, as a concept, had a deeper and far greater ambition than pop stars and politicians sipping champagne together and sharing a joke in the eye of the media lens.

Exasperated by the Labour Party's fourth successive general election defeat in 1992, key thinkers on the left began to re-assess the identity of the parliamentary party, and on a grander scale, the image of Britain on the world stage. The emergent story was of a nation cowering in the shadow of its former glories – empire, Shakespeare, royal dynasties – and in need of a contemporary narrative. Naturally, the Union Jack became a symbol of renewal, and, coupled with a desire to embrace post-war cultural achievement, a freshly named 'New' Labour embarked on a modernisation programme fit for the twenty-first century.

By coincidence, the Union Jack was simultaneously being adopted by a new wave of artists, noticeably across music and fashion. Kate Moss was photographed on a catwalk in a Galliano Union Jack jacket, *The Face* superimposed Damon Albarn of Blur against a backdrop of red, white and blue, and Geri Halliwell left little to the imagination performing at the BRITs in a self-styled national flag Gucci mini-dress complete with a CND logo on the reverse. The happy confluence of progressive political thinking and patriotic cultural expression led to one of the great ironies of the 1990s: Cool Britannia occurred under a Conservative government.

In 1996, as *Newsweek* declared, 'London the coolest city on the planet,' and *Vanity Fair*, 'London Swings Again!' Prime Minister John Major may well have judged the jubilant mood of the nation as a welcome fillip to the government's flagging popularity. With the general public seemingly in a continuous state of heightened rapture, be it around Euro 96 and the possibility of England winning their first major football tournament in thirty years or the fifth of the population who applied for tickets to see Oasis at Knebworth, the Labour Party faced the possibility of the national mood lifting the stature of the Conservative Party and returning it to power for a record-breaking fifth successive term.

When interviewed for this book, both Alastair Campbell and Tony Blair expressed mild shock when reminded that Cool Britannia predated Labour's return to power in May 1997. Popular apologue marries the boom with Blair. It is a misconception not entirely without foundation. Although Blair never spoke the words 'Cool Britannia', whether by default or deft chicanery, the leader of the Labour Party was indelibly linked with the branded phenomenon. The face of a new, young, dynamic leader chimed with the country's aspirations for modernity after eighteen years of Conservative rule. Blair represented hope and optimism, and symbolised a kingpin who could lead the nation in an expanding international arena. Yet, despite Blair's linguistic restraint, Alastair Campbell assimilated the vernacular of Cool Britannia, and with it aligned Labour's presentation with the cultural zeitgeist. Intriguingly, behind the media limelight, an influential third man enters the sub-plot. As a strategist and speech writer, Peter Hyman was a key member of the Labour Party's inner circle and an advocate for national identity renewal. His analysis of Cool Britannia leads to the profound judgement that had 'the project' been successful, Britain today would not be experiencing a crisis of identity in the wake of the electorate's majority vote to leave the European Union at the 2016 referendum.

Don't Look Back in Anger is intended as a sequel to my previous book *Walls Come Tumbling Down: The Music and Politics of Rock Against Racism, 2 Tone and Red Wedge*. It follows the transition of a youth movement unchained from the cage of right-wing dogma and suffocating political correctness, to the liberating playground of cultural individualism, albeit in the contradictory disguise of community. In many ways, the narrative arc of *Don't Look Back in Anger* reflects my own journey through the nineties. I was comprehensively educated through the Thatcher years and caught between the appealing prospects of accumulating personal wealth and developing a social conscience through left-wing popular culture. Ultimately, music shinned a way forward and I spent my twenties infatuated by sixties music while fronting a four-piece guitar band in the slipstream of

Britpop. I lived with a pop star – Simon Fowler of Ocean Colour Scene, and a contributor in this book – and, alongside our musical careers, we wantonly explored the mind-expanding adventures offered by alcohol, clubs and chemicals.

Birmingham in the nineties was a self-contained scene brimming with possibility and excitement, and connected to the rest of the country really only through the mediums of radio, television, and magazines. 'Swinging' London was of no more interest to most than the likelihood of winning a million on the newly launched National Lottery. But, with a girlfriend in the capital, I spent long weekends in London armed with an *A–Z* and a copy of *Time Out* in search of the promise of discovering 'contemporary art', seduced by the allure of Camden Town, or hoping to receive an invitation to mingle with the in-crowd at the filming of *TFI Friday*. London had about it a buzz where high and lowbrow culture intertwined and sat happily alongside the excitement of watching the all-conquering Manchester United on the newly launched Sky Sports, or sharing the joys in the explosive breakthrough of a new, unrepressed form of comedy – *Fantasy Football League*, *The Fast Show*, *The Day Today* – or embracing the decade-defining cinematic thrill of *Trainspotting* and the social conscience of a new Mike Leigh or Ken Loach film. But, tellingly, any ideological interest I may have had in politics, in this period, flatlined against the sobering demands of day-to-day living on social security and housing benefit.

I am aware that, for many, 'Cool Britannia' is a divisive phrase. Yet, for the purposes of this book, it provides a narrative arc that structures a story beyond an unrelenting discourse on the culture and politics of the nineties. You may imagine Cool Britannia as a wardrobe that enables clothes to hang, and while there is no inherent interest in the object itself, without it the items within would lay in a jumbled mess.

Don't Look Back in Anger presents a twelve-year period overflowing with cultural and political drama. The book begins in 1990: within months of Germany's reunification after the dismantling of the Berlin Wall; when Nelson Mandela was released after twenty-seven

years in captivity; and when Margaret Thatcher resigned from office having been 'betrayed' by her own party members. The new Prime Minister, John Major, inherited a country divided between the forward march of capitalism and the struggling soul of socialism. It is this contested area and the debate around the impact of Thatcherism that propels many of the artistic achievements in the nineties. While not quite the counter-culture slogan of the 1960s' 'turn on, tune in, drop out', a generation in the nineties went in search of hedonistic pleasure combined with a resolute determination to act in spite of adverse social and economic circumstances.

Part one of *Don't Look Back in Anger* establishes a myriad of cultural initiatives and events that shaped the early part of the decade. A period that gave rise to a pulsating injection of creativity, from comedy and the first exhibitions of the Young British Artists to the publication of the debut novels of Nick Hornby and Irvine Welsh and the roots of what would become known as Britpop.

Part two of *Don't Look Back in Anger* identifies how the era came to be labelled 'Cool Britannia', when the cross-fertilisation between the different arts radicalised the cultural landscape and led commentators to compare the energy of the period to Britain's last significant creative upsurge in the sixties. It returns to the media headlines of hyperbole and sensationalism, and the days of excess, self-indulgence and proliferate drug use that swept the country. By 1995 the renaissance of British culture had thrust alternative ideas and artists into the mainstream. It was a pivotal moment, which saw the platform of mass popularity challenge the principles of many of the key protagonists' formative ambitions.

The concluding part of *Don't Look Back in Anger* contextualises years of lustful hedonism as a foretaste of the grief and emotional outpouring expressed towards Princess Diana when her life abruptly ended on 31 August 1997. As a catalyst to a nation mourning, events like Oasis at Knebworth and the tens of thousands of people who had been attending raves across the country since the late eighties demonstrated that the nineties was a decade of communal cultural worship. Although many of the millions who

felt bereaved by Diana's death would not identify themselves as part of Cool Britannia, the preceding mood of the time provides some understanding to the unprecedented fervent reaction to her passing. The nation grieved publicly, not behind closed doors, but on the streets of the capital in a most unfamiliar British form of exhibitionism. Just as people had gathered and caroused *en masse* throughout the decade in celebration, so the country collectively cried, as it had never done before, in loss.

Following Diana's untimely death the tone of the nation shifted, and with it a wave of patriotic optimism faded. As the Cool Britannia veneer began to lose its appeal the stark reality of a nation divided by class differences and race was once again exposed. Social change throughout the nineties may have benefitted 'the many', but the sobering suggestion was that Cool Britannia served only 'the few'. Britain was like a vast balloon being pumped and stretched to its limit, the nation intoxicated by an air of success. But with egos over-inflated and an exultant national mood distended, the Cool Britannia edifice burst and came crashing down.

The end piece of *Don't Look Back in Anger* is defined by the events of 9/11. The shocking atrocity in 2001, which claimed the lives of 2,996 people, marked a new world order. The fall-out from 9/11, and indeed from the Cool Britannia period, is perhaps still to settle. We live in a world where negativity and hatred swamp feelings of positive patriotism. We have the means to communicate in a global conversation, as never before, and yet we seem to be, as a human race, never more isolated and bitter. Britain in the nineties was a home for celebration and the just reward of cultural endeavour – flawed as Cool Britannia may be, they are two qualities to applaud and honour.

Biographical notes

Lorenzo Agius Photographer
Damon Albarn Blur lead singer, songwriter
Keith Allen Actor
Waheed Alli Co-founder of television production company Planet 24 and Labour Lord
Brett Anderson Suede lead singer
Suzi Aplin Producer, *TFI Friday*
David Baddiel Comedian
Matthew Bannister Director of radio and controller of Radio 1
Alan Barnard Director of campaigns and election, Labour
Aimée Bell Senior editor, *Vanity Fair*
Tony Blair Prime Minister, Labour
Ric Blaxill Producer, *Top of the Pops*
Virginia Bottomley Secretary of State for National Heritage, Conservative
Alastair Campbell Director of communications, Labour
Fiona Cartledge Owner of clothing store Sign of the Times
Gurinder Chadha Filmmaker
Melanie Chisholm Spice Girls
Jarvis Cocker Pulp lead singer
Sadie Coles Gallery owner
Mat Collishaw Artist
Steve Coogan Comedian
Michael Craig-Martin Artist/lecturer, Goldsmiths
Fran Cutler Party organiser
Jeremy Deller Artist
Steve Double Head of media relations, Football Association
Alan Edwards Founder, Outside Organisation

Tracey Emin Artist

Simon Fowler Ocean Colour Scene lead singer

Matthew Freud Founder, Freud PR

Noel Gallagher Oasis guitarist, songwriter

Sheryl Garratt Editor, *The Face*

Jo Gollings Style influencer

Katie Grand Fashion director, *Dazed & Confused*

Pat Holley Style influencer

Johnny Hopkins Oasis PR

Nick Hornby Author

Peter Hyman Strategist and speech writer, Labour

Karen Johnson Blur PR

Darren Kalynuk Researcher, John Prescott's office

David Kamp Staff writer, *Vanity Fair*

Steve Lamacq Presenter, Radio 1

Mark Leonard Researcher, DEMOS

Jo Levin Stylist

Sarah Lucas Artist

Will Macdonald Producer, *TFI Friday*

Margaret McDonagh General Secretary, Labour

Alan McGee Founder, Creation Records

Stryker McGuire Bureau chief, *Newsweek*

Sonya Madan Echobelly lead singer

John Major Prime Minister, Conservative

Gregor Muir Art curator

Geoff Mulgan Co-founder, DEMOS/director of Strategy Unit, Labour

John Newbigin Special advisor, Labour

Carolyn Payne Intern, *The Girlie Show*

Oliver Peyton Restaurateur

Charlie Parsons Co-founder of television production company Planet 24

Carla Power Staff writer, *Newsweek*

Polly Ravenscroft Press officer, Radio 1

Norman Rosenthal Exhibitions secretary, Royal Academy of Arts

Phill Savidge Music PR

Tjinder Singh Cornershop lead singer
Chris Smith Secretary of State for Culture, Media and Sport, Labour
Tim Southwell Co-founder, *Loaded* magazine
Meera Syal Author/comedian
Irvine Welsh Author
Jo Whiley Presenter, Radio 1
Matthew Wright Staff writer, the *Mirror*
Toby Young Staff writer, *Vanity Fair*

A CRUEL CON TRICK
Cool Britannia

CHARLIE PARSONS Philip Larkin said the beginning of sexual inter-
course in 1963 came 'between the end of the Chatterley ban and
the Beatles' first LP'. Cool Britannia came between the coming of
Tony Blair and the death of Princess Diana, 1994 to 1997. It was
as short as that.

MATTHEW WRIGHT You had Take That at one end of the decade
and the Spice Girls at the other, and in between was the cool bit.

CHARLIE PARSONS If you rewind it, Britain had been looking for
its national identity. In the seventies we were 'the sick man of
Europe':[1] three-day weeks and rubbish piling up in the streets. In
the eighties austerity, cutbacks, civil unrest and a depressed youth
movement defined us. Then, suddenly, there was this burst of light
and the mood changed.

SHERYL GARRATT There was a new confidence as part of a cool
resurgence in popular culture. It felt like Britain was back. There
was a real confidence in music with Blur and Oasis and artists like
Damien Hirst and Tracey Emin. London Fashion Week revived –
Tony Baratta, Hussein Chalayan and Alexander McQueen, a working-
class cabby's son doing really interesting, creative work on his own
terms – novelists like Irvine Welsh and Nick Hornby. And this

1 Although the phrase was first used in the mid-nineteenth century to
describe the Ottoman Empire, 'the sick man of Europe' was used by foreign
journalists to describe Britain's underperforming economy.

whole new generation of young British actors: Johnny Lee Miller, Sadie Frost, Ewan McGregor.

WILL MACDONALD It was this mass cultural collision of New Labour and Britpop and Brit Art and laddism and football. It felt like a happy accident but it all came together and was connected.

TIM SOUTHWELL Cool Britannia was like a colliding of different cultures all mashing into one. There were a lot of cool and innovative things going on. Music was much more exciting and powerful. You had a lot of genuine characters coming through. It was a big back-slapping exercise for anybody who was around, whether it was particularly cool or not, I don't know. What was certainly true was that a lot of people were getting things out there. Whatever had been going on in the previous couple of years that created the climate for something as outrageous as to be called Cool Britannia . . .

TOBY YOUNG What was Cool Britannia? It was a new generation of chefs and tailors, fashion designers, great bands, filmmakers, novelists, artists. What turned it into a phenomenon is that they were expressing something authentically British. It wasn't a pale imitation of what was happening in New York or Berlin or Paris. It felt like it was spontaneously coming out of England.

MEERA SYAL It felt like Britain, and particularly London, was the centre of a cool and cultural revival, and that everybody's eyes were turned towards what was happening in culture, politics and art. You had a flourishing of lots of different types of voices being encouraged and accepted. It was a generation coming of age.

GURINDER CHADHA You felt that style and culture and multiculturalism were very much part of a wider Britishness than I had ever seen done before. Steve McQueen was making huge strides in the art world. Anish Kapoor and Chris Ofili both win the Turner Prize. Britain felt like it was inclusive.

RIC BLAXILL There were a lot of young people: Tony Blair was a young leader; the guys in Oasis; the core of the England football

team at Euro 96; the Young British Artists. There were so many different elements coming out: free thinking; proud to be British; a little bit of 'anyone can do it'. There just seemed to be a ground-swell of really creative, imaginative people all hitting the scene at the same time.

SONYA MADAN It wasn't just music. That's what made it exciting. It was a honing of awareness of what it was to be British at a particular time in history. It didn't matter what form of creativity you took. It was more of an aesthetic, an attitude, that hadn't been prominent since punk; all these different avenues – music, fashion, novelists, comedy, television, even journalism – congregating in this wonderful state of attitude.

LORENZO AGIUS We had the best bands, the best artists, the best fashion designers, and Tony Blair was the new bright hope. But we didn't feel like, 'Hey, we're in a cool time. We're in the sixties again.'

MICHAEL CRAIG-MARTIN When I came to England in 1966, although it was still in the midst of Swinging London, the most striking thing was how ill at ease the country was in the twentieth century. Modernity was seen as dubious – in the nineties that changed. How did London become the most important city in the world? It became at ease in the modern world. The British reconnected with their own time and became a truly modern place. London became this amazing powerhouse; the envy of everyone. And culture played the key role.

JOHN NEWBIGIN The phrase 'Cool Britannia' was popping up in various places: Cosmo Landesman used it in the *Sunday Times*, and then the *Guardian* in 1992, 'cool Britannia rules all the new waves'; it was the name of a Ben & Jerry's vanilla with strawberries and fudge covered-shortbread ice cream in 1995. And Virginia Bottomley used the phrase in Parliament in 1996.

VIRGINIA BOTTOMLEY The phrase 'Cool Britannia' goes back to 1967 and the Bonzo Dog Doo-Dah Band: 'Britannia you are cool/ Britons ever ever ever shall be hip.'

STEVE LAMACQ The whole wave of optimism, of new ways of thinking, new voices, came together in the nineties because there was a general feeling of 'out with the old and in with the new', whether it was politics, pop music, the stuffiness of the art world or who was happening in fashion. If Cool Britannia was about anything it was based on offering an element of optimism in that change. It's unlike the British to celebrate themselves. This was a rare occurrence, and a little bit of 'invincible' that everyone could stand-up, without fear of being shot down, and say, 'You know what? We're doing all right. Things are turning round for the better.'

ALAN EDWARDS Often periods of time are fractured, when there's not much correlation between various things, and then every now and again it all meets in the middle. It did in the sixties and it did in the nineties. Suddenly you had David Beckham and Tony Blair and Oasis, and somehow all the dots magically joined. It wasn't orchestrated but I think the media encouraged it.

NOEL GALLAGHER Cool Britannia was just a label; a journalist in an office. Somebody came up with the word 'Britpop' so someone else came up with 'Cool Britannia'. As an overall thing it was people of the same generation, Thatcher's children,[2] not Thatcherites, but people who were on the dole in the eighties and got off their arses and did something for themselves. In a broader sense, we all just happened to be British, and then somebody put a tag on it and it became global. Damien Hirst is a global artist. Kate Moss is a global face. Prince Naseem Hamed was fucking world featherweight champion. Sadly, fucking Man United were fucking world champions.

GURINDER CHADHA Young people were saying, 'Okay, now we're in control and *we're* going to express ourselves in *this* way.' But it wasn't a far-reaching political movement. I don't think, for example, it was nearly as important as Rock Against Racism, which was a proper political movement that changed people's lives.

2 People who were born or grew up during the period Margaret Thatcher served as Prime Minister, 1979–90.

TRACEY EMIN Cool Britannia was a media-marketing tool to raise Britain out of the doldrums of the eighties. New Labour was the spearhead, and Tony Blair understanding that talent and creativity was taking Britain out of those really harsh times. It was also to redefine the Union Jack, and to take it back from the far right, to unite Britain.

DAMON ALBARN It didn't really became Cool Britannia until the '97 election, with an unpleasant odour of nationalism associated with it. It was very much a construct of New Labour – before that it was much more of an underground movement – and then it was, Who are those complicit in that *coup d'état*?

GREGOR MUIR Cool Britannia gained increasing political coinage throughout the nineties. It became an irritating catch-all; a branding exercise that had no relevance to the artistic practice of the time. It's an embarrassing reality that some people come along and feel the need to encapsulate a time for convenient political messaging.

JOHNNY HOPKINS Cool Britannia was a cruel con trick: a crass marketing slogan, but one that caught a lot of people's imagination. Everyone got dragged into it and was deluded on a mass scale. 'This is England, on top of the world. Isn't it great? Aren't we successful?' And in our little bubble, yes it was. Everyone was making loads of money and having a good time. But that wasn't the lived experience of the majority of people in the country.

JARVIS COCKER It wasn't Cool Britannia, it was Cold Britannia. The whole idea makes my blood run cold. It was an attempt by the establishment to co-opt this movement and divert it to their ends and, in some ways, try to take credit for, or certainly dilute it.

IRVINE WELSH Cool Britannia came from a genuine cultural place, which was then exploited; the ideas from the sixties re-manifested in the nineties. Everything was revived: there was a mod revival, a Beatles revival, a guitar-band revival; it was all packaged to be sold to the global market. It was like a requiem for British culture. It

wasn't a celebration. It was about people fucking hating their jobs or not having jobs, and saying, 'This job's shit, let's form a band instead,' or, 'Let's go to the boxing club and fight our way out of it,' or 'Let's mob up and fucking get a diversion.' Youth culture is always generated from the ground up. When it doesn't it becomes a media construct; that's what Cool Britannia was.

ALAN McGEE It was just a fucking moment. Nobody knew it was Cool Britannia when it was fucking happening because everyone was just doing it. It was just one little thing within a decade. It's kind of like saying the Football League is defined by Bradford City or that Herman's Hermits defined the sixties.

DAVID KAMP As much as people want to think that this all happened because the media were in cahoots, and said, 'Britain's being too drab, we need to make it cool again,' it didn't happen that way. It was a confluence of many things. Danny Boyle making *Trainspotting* wasn't consulting with Damon Albarn and Tracey Emin, and saying, 'You're doing something cool that's part of a youth quake and I am too, let's pool our resources and work together.' It all happened the same way things happened in the mid-sixties: there was an environment conducive to these things happening at once. And the media were there to capitalise and observe it. It was an authentic phenomenon.

SIMON FOWLER It was also known as Great Britain plc. It was good for business. The complexities are a lot deeper, much more sinewy. It was a new Prime Minister and new bands who sounded just like the old bands from the sixties and all things coming together at the same time for disparate reasons.

MICHAEL CRAIG-MARTIN Cool Britannia was a political way of exploiting what happened. It's what politicians always do. They don't really give a shit about it, but if it can be useful to their own ends they associate with it.

JOHN NEWBIGIN It has become conventional wisdom that it was a New Labour cynical ploy, that there was a recognition that all of

this stuff was going on and government had some role in assisting it, which seems very unfair.

JOHN MAJOR Cool Britannia was never about politics. The politicians may have been a backcloth – but no more than that. Cool Britannia was the result of the individual aspirations of people. I was very proud the UK was seen as 'cool' and reflected the growing diversity in our country; of social reform and changing attitudes to immigration, to gay marriage, to tolerance. And it was the impact of sport and the arts in all its forms. Cool Britannia grew out of seeds that were always there.

ALASTAIR CAMPBELL Cool Britannia was a headline that stuck because people felt there was something going on: the change of government and Tony's persona and the sense of New Labour. It was like, 'Britain is cool again.' The whole thing about renewal felt like it meant something, but it actually became a negative for us once we moved into a different phase, where the media were much more aggressive, where people were much less willing to give us the benefit of the doubt. They liked to project the idea that we had invented this thing called 'Cool Britannia'. It was a way of saying, 'You're not cool anymore.'

TONY BLAIR Bizarrely, I more heard about Cool Britannia than instituted it or directed it. I understood it had two aspects to it: one which is quite particular around how the country was marketing itself and what the different bits of government were saying about the country; then the other part of it was more to do with the general spirit of the times. I was never quite sure of what I thought of it as a concept. In some respects, it represented the zeitgeist of the time, but it was always something that was never going to be created by government. It either had to be felt by people or not.

WAHEED ALLI It was impossible to stop a movement that was so progressive about change. It had been bottled up for so long that when it exploded you couldn't write it off. The only way that

those on the right could look at it was to say, 'It's temporary, it's cool.' 'Cool' always disappears. They built it so they could destroy it. I don't think they succeeded. Change became something that bound you and you could talk about. How could Chris Smith, the Secretary of State for Culture, be having a conversation with Noel Gallagher? How is that possible? They both were experiencing change. That ability to experience change and to have a common experience typified the period.

TOBY YOUNG There's a conceptual problem, maybe even an onto-logical problem, with defining Cool Britannia. That is, how can you demonstrate that something of historical significance is happening in a particular cultural sphere; that London in 1996 is similar to London in 1966? You realise you're trying to make this argu-ment by appealing to metaphysical categories – the zeitgeist, the *Volksgeist* – which are quite impossible to track or prove the exist-ence of or analyse in any serious detail. It's almost as if people want to believe that there is something supernatural about these cultural episodes and that they are not themselves creating it, or in any way, by documenting it, adding to its reality. They have to be persuaded that it is real in order to justify writing about it.

TONY BLAIR The whole period marked a decisive turning point in social and cultural attitudes, the country's attitude to itself, and the whole sense around all of that. And what's interesting is to say, What was it that made people feel like that, and is it some-thing that is purely related to a time in history or is it something that can be generated by a confluence of events and people and circumstance?

PART ONE

REMAKING THE
CULTURAL EMPIRE

>>>

BACK TO BASICS

Thatcherism. 1992 election.

John Major

TOBY YOUNG Before Margaret Thatcher came to power in 1979, Britain was thought of as 'the sick man of Europe', and certainly Britain's ruling class were suffering from a bout of defeatism. It very much felt as though we'd lost an empire and there was a post-colonial hangover, which had descended like a funk over Westminster. Thatcher completely dispelled that funk and gave Britain a renewed sense of purpose and national identity. Maybe that took a while before it expressed itself culturally.

VIRGINIA BOTTOMLEY Mrs Thatcher restored pride in Britain. There we were in the seventies: profit is a dirty word; massive number of strikes. She wouldn't take no for an answer. She was patriotic and, having come from Grantham, she wasn't part of a London elite in any way.

IRVINE WELSH Margaret Thatcher was a lower-middle-class bigot who hated working-class plebs who came into her dad's greengrocer's store in Grantham. It was a visceral dislike. She wanted to empower the elites and the wealthy and be one of them. She was an arsehole.

ALAN McGEE She was anti the working class, anti the miners, anti the trade unions. I was white, working class and Scottish. She fucking hated people like me; the establishment hated people like me. I was a success despite Margaret Thatcher.

JEREMY DELLER You cannot imagine how awful it had been to be under Thatcher's boot. The Conservatives were very negative and punitive. It was about punishing you for doing this or that. They took their power for granted. You had nothing in common with those people.

CHARLIE PARSONS The generation running the country were basically people who had fought in the war; a country run by grey old men.

NOEL GALLAGHER There wasn't a great deal on the TV and reality television hadn't been invented, so you knew who politicians were but you could never really relate to them. The Labour Party all seemed like pipe-smoking communists.

SHERYL GARRATT There was this sense of being downtrodden. There was always someone else to blame: it was the miners, it was the unions, it was immigrants.

MEERA SYAL There was a great sense of dismantling, of being very suppressed and blocked. What made it worse is that people went, 'It's a woman Prime Minister. That's a good thing, isn't it?'

TRACEY EMIN How did I get here today? The Enterprise Allowance: thank you, Margaret Thatcher. It was fucking brilliant. You set up your own business and got a guaranteed income for a year. You only got about four quid a week more, but you didn't have the humiliation of signing on and you were able to work. It was a question of whether it was worth working. Life on the Enterprise Allowance was so much better than life on the dole. The majority of us were really grateful for every little bit we were given from the government.

FIONA CARTLEDGE The whole era was changing. People were buying their council flats and starting businesses. I went on a 'start your own business' course funded by the government. Not everything Thatcher did was bad.

JOHN MAJOR Geoffrey Howe was the architect of the Enterprise Allowance when he was Chancellor. It was for individuals, in

order to encourage self-employment and to give people the opportunity – if they had the ability and the determination – to try to do something on their own. Success is economically good for our country: Ian McKellen's skill as an actor or Tracey Emin's as an artist, and so on. It's not only the great captains of industry or the politicians, or the big companies that build our national success. It's also the aggregate importance of individual effort that adds to the diversity, the culture of our country, and thus our national economic well-being.

ALAN McGEE I was on the Enterprise Allowance. I was twenty-two and I borrowed £1,000 off the NatWest Bank to meet the government requirement and prove I had backing, and then they gave me my £40 a week. I had a successful club night and out of that Creation Records was formed.

IRVINE WELSH One of the biggest humiliations for me, coming from the left and a socialistic tradition, was realising that rather than being one of the ones who would go down, I was one of the cunts who would thrive under Thatcherism.

TRACEY EMIN A lot of people really liked Thatcher, otherwise she wouldn't have stayed in power for so long. It was a really difficult time, but whatever Margaret Thatcher was or wasn't, she obviously did some things right. But being an artist means, actually, you're not that qualified for many things. So you have to do a menial job. There were no jobs. It wasn't 'I don't really fancy going for that job' or 'I think I deserve something better.' I'm talking as a human being trying to get any fucking job that I was reasonably qualified for; every waitress job, a million people would go for it. All of those jobs were taken. Lots of the main industries were closing down, factories closed down, shipyards closed down, pit mines. Technology was taking over. Suddenly you had hundreds of thousands of people unemployed. It was a very depressing time.

IRVINE WELSH Noel Gallagher said that the dole was basically a training ground for musicians. It was true. I started to make

my rudimentary steps towards being a writer by writing songs, which came from sitting around on the dole with guys who were like-minded. I was unemployed for a long time when Thatcher came to power. You were in a country that based its whole economic prosperity on its house prices and capital. It was a one-trick pony. The whole social and economic infrastructure suffered. If you've not got money in your pocket you've got no choice whatsoever.

CHRIS SMITH Thatcherism did huge damage to the industrial and economic welfare of many communities by decimating whole areas of the country and huge parts of the population. I hated a huge amount of what Margaret Thatcher stood for and what she did. But she made the political weather. She made a fundamental change in the political psyche of the nation, and she was a commanding figure because of that.

VIRGINIA BOTTOMLEY I think she should have stepped down after ten years. She became inflexible. All bosses do. When people have been there too long they start to believe their own propaganda. The arteries harden and they lose their flexibility and innovation. I was at the House of Commons the day she resigned. I obviously supported her as a minister in her government, but in my heart I felt her time was over. People who knew her knew she'd run out of road. I so wish she could have gone with dignity.

JOHN MAJOR I wasn't around Westminster during her resignation. Many months before events began to unfold, I had booked into hospital for wisdom-tooth treatment.

TOBY YOUNG I was sympathetic to Margaret Thatcher. She had done great things for the country. It was pretty ruthless and disloyal of the Conservative Party to unceremoniously dump her after all she had achieved. I didn't like to see her being defenestrated in that way, and as a consequence I didn't have a very high opinion of John Major.

SHERYL GARRATT It's hard to describe how grey Britain felt.

Thatcher had gone and then you had John Major. Do you remember his grey *Spitting Image* puppet with his grey wife eating their grey peas? It felt like nothing was ever going to change.

STEVE COOGAN I was at Zoe Ball's house with John Thomson on the night of the 1992 general election, and we all thought that Labour was going to win it. The results started coming in and very soon the party fizzled out. The reality of a fourth Conservative term in office was so profoundly depressing.

JOHN MAJOR We received half-a-million more votes than any other party in history. It was extraordinary. It should have given us a majority of seventy or eighty, which would have changed the history of the 1992–97 Parliament. Instead, it gave us a measly majority of twenty-one, of whom thirty were unsound on every issue.

VIRGINIA BOTTOMLEY The '92 election was wonderful, wasn't it? Thrilling. By then I was very loyal to John Major; liked him, admired him, a really decent, clever, wonderful man. Because he hadn't been to university, people underestimated the level of his intellect. He had a real feel for people who don't come from elites.

OLIVER PEYTON People didn't see John Major as a bad person. He was a legacy Prime Minister. He won an election, but he was a bridge out of the old-fashioned Conservative Party.

STEVE COOGAN Major was clearly a compromised candidate, and as so often happens, the least worse option ends up with the job; one I guess he wasn't really expecting to get. But I didn't find personally anything objectionable about him. I didn't have the contempt for him for having destroyed the fabric of Britain where people have a sense of fair play, decency and the better side of our nature.

JOHN MAJOR In my 1993 conference speech I introduced the concept of Back to Basics: 'Do you know, the truth is, much as things have changed on the surface, underneath we're still the same people. The old values – neighbourliness, decency, courtesy

– they're still alive, they're still the best of Britain. They haven't changed, and yet somehow people feel embarrassed by them . . . we shouldn't be. It is time to return to those old core values, time to get back to basics, to self-discipline and respect for the law, to consideration for others, to accepting a responsibility for yourself and your family, and not shuffling off on other people and the state.'

SHERYL GARRATT In retrospect, John Major seemed a fairly decent man. But his sense of decency felt planted in the 1950s: that kind of Back to Basics morality that he was trying to peddle. It was like, 'Really?' It was like the sixties never happened.

MEERA SYAL John Major: go figure.

THE SECOND SUMMER OF LOVE

Ecstasy. Rave

FIONA CARTLEDGE If you want to understand the spirit of the nineties you have to go back to the late-eighties financial crash. So many scenes are driven by economics. Interest rates went up and suddenly loads of people were losing their jobs and houses. People were losing everything. 'My company's just shut down . . . my company's just gone bankrupt.' People would go to an acid-house club, and think, I could do a club. It was like punk: the whole three-chord thing and form a band. Insurance clerks suddenly became DJs. It was like, 'I've got nothing to lose.' I know someone who had a mortgage and posted back the keys to their house. They were like, 'I can't do this anymore. I want to live in the acid-house world. I want to go out every night.' The Thatcherite dream was breaking down and you were meeting all these different people, and that really affected how you thought about things.

CHARLIE PARSONS Rave and Ecstasy and the Second Summer of Love all fed into the cultural change. We didn't have any relationship with our parents' generation; we saw things in sunshine rather than in gloom, and felt positive about ourselves and wanted more fun.

FIONA CARTLEDGE How did acid house influence creative culture? The number one thing: it broke down barriers between people.

BRETT ANDERSON Suddenly you had all these people in clubs hugging each other. There was a real movement, a real sense that

those tribes of people and their pursuit of unruly good times – it was exciting. It had the same note of rebellion that great pop movements have had in the past, like fifties rock 'n' roll and punk, where they're genuinely standing up to the establishment. Ecstasy culture lay the foundations for what the nineties became.

OLIVER PEYTON The demise of terrace violence in football coincides with an increase in young kids going to raves and discovering Ecstasy and hugging each other instead of beating the shit out of each other.

JEREMY DELLER It was the first mass mobilisation of people since the miners' strike, in terms of people doing something themselves. But instead of being a picket line, it was a party. Also, getting to a party was quite complicated, like it was for pickets travelling across Britain trying to find a way into a county and avoid the police. You had to find out where things were happening because no one really had mobile phones. It was word of mouth. The locations were kept secret. You'd get there and the police were waiting for you.

FIONA CARTLEDGE It was cat and mouse. Raves were being shut down all the time. The police would snatch the sound systems, but the promoters would have a replacement system hidden. They were outwitting the police with army manoeuvres.

JARVIS COCKER I always preferred the cloak and dagger parties that were out in weird places. Getting there was half the excitement. And the fact it wasn't totally legal and people making their own entertainment, which was an important part of it. They used to run buses from Soho Square to the raves. We got on this coach and started driving, and we noticed everybody started getting more friendly towards the end of the journey. Obviously some people had dropped their Es to get in the zone before they got there. We got in the queue and then took our tablets; it was one of those moments when it all synced in right and we were peaking just as we got in. Then you're in this big aircraft hangar and there's a big wheel. 'What the fuck!' It was like adult Disneyland.

JEREMY DELLER Raves were like people's ideal version of the world, everyone getting on with each other and enjoying themselves. You can't underestimate the stress of living under Conservative rule – it was eight, nine, ten years into rule by a single party, by one person. It was a virtual dictatorship and incredibly dispiriting, and seeing people on TV every day who you shared no values with whatsoever saying horrible things about people. A lot of those young people had seen their parents lose their jobs, factories closing down, the mines closing down. So this event, this mobilisation, this music just seemed absolutely like an explosive, orgasmic release after years of tension and unpleasantness.

JARVIS COCKER It was the thrill of the chase. You'd have to meet somebody at a service station and he'd give you the next stage of the journey. I used to do some part-time work in the sorting office off Oxford Street when I was at college, and I'd talk to guys there who went on the raves. One was going, 'You know what, I'd sell my best mate to get there.' People would get so excited that they'd fuck off all their friends just to find this place, yet, when you got there, there was this mass friendliness. I always thought, Well, even if it is chemically induced, if you had such a great time when you're open and there aren't any barriers then surely that's got to percolate into everyday life? That you're going to realise it would be better to live life like that, maybe just cut down on the E use.

ALAN McGEE The drug culture connected up a lot of people from a lot of different backgrounds. That was the most amazing thing about it. The whole musical landscape became muddied. I was on *Granada Tonight* and Tony Wilson[1] asked me, 'Why've you moved to Manchester, Alan?' I said, 'A better class of drugs, Tony.' E made me feel complete. It opened me up in a great way. The upside was that it made you feel part of something. The downside was that it fucked people up on a long-term basis.

JEREMY DELLER It was rough and ready and grassroots. People were,

1 Co-founder of Factory Records.

in a way, putting two fingers up because it was on the fringes of legality. It's those words around it, 'community' and 'rebellion', it gave it a political edge. It showed people there was a different way to enjoying yourself that was less controlled and corporate. Where they have someone playing really great loud music on a big sound system and you are dancing to it, and it just carries on and on and you're getting into this trance-like state. The spirit and atmosphere was one of freedom and not caring.

SHERYL GARRATT The feeling of being in a field, everybody dancing with each other, lasers going into the sky, and then the sun comes up and the DJ drops some tune that you all love, and everyone goes, 'WHOOSH!' We all had those feelings, and then we went back to our day jobs wanting to replicate those experiences.

IRVINE WELSH After punk rock there was the horrible void of commercial pop music and Thatcherism, and everybody got so bored of chasing money and trying to get by and staying in. Then acid house exploded, and everyone was going out again and having fun and going into fields and setting up club nights. It was the most energising scene. Even though in the nineties a lot of people really suffered economically, compared to the eighties it was seen as a golden decade. In *Ecstasy,* the character Heather says, 'It was like we were all together in our own world, a world far away from fear and hate.'

FIONA CARTLEDGE What had the eighties been like? It was small elite clubs where scenesters dressed up to the nines in very expensive black designer clothing. It was Yohji Yamamoto, Jean Paul Gaultier, Azzedine Alaïa, Vivienne Westwood, Comme des Garçons. It was going to Browns or Jones and spending £800 on a jacket; from a fashion point of view incredible, but not dance clothes. Everyone would be eyeing everyone up and trying to network, and as soon as someone more important came in they'd be looking over their shoulder. To be part of the inner circles you had to be super trendy or super good-looking or a model. Acid house came along and broke all that down. Suddenly the hippest thing you could

wear was a £20 baggy T-shirt. It was a fantastic release.

FRAN CUTLER You dressed down. It was anti-fashion. It was Kickers, dungarees and a fucking awful T-shirt.

FIONA CARTLEDGE I first went to Shoom[2] wearing tight jeans, a Jean Paul Gaultier cropped leather jacket and a cowboy hat. Everything just stuck to me. It was awful. The next time I went I wore baggy trousers and a baggy T-shirt. That was the only way you could survive until five in the morning in a club as hot as that. The atmosphere was like no other club. It was transformational. When you walked in you couldn't see the tips of your fingers, there was so much dry ice. You didn't know who was who. And the music was so loud. You were just plunged into this incredible dance experience and you'd lose yourself. And with the dancing the barriers came down. People just made friends with the person dancing next to them. Rave was quite Labourite in a lot of ways: black and white and gay and straight mixing. It was democratic.

NOEL GALLAGHER I was at the Haçienda from its early days and at all the big raves over the northwest, before they were called raves. It was like nothing else I've experienced. In some ways it was better than fucking being in Oasis. It gives me shivers when I think about it. That's all wrapped up in being young and not being famous and just being carefree and high on Ecstasy and dancing in a field at fucking two in the afternoon.

SIMON FOWLER The first time I took E was in a recording studio. It was fucking amazing; exactly what you think drugs are like as a kid. Incredible euphoria. The second time was at a club and I thought I was going to die. I had to be taken home and I never touched it again.

JARVIS COCKER What blew my mind when I first went to a rave

2 On 5 December 1987, Danny Rampling launched Shoom in the basement of a fitness centre in Southwark. It has since come to be recognised as the birthplace of British rave.

was the inclusivity of it. I'd always been looking for that. I'd been going to nightclubs in Sheffield since the age of sixteen or seventeen, two or three times a week. It was my main social activity. But going to raves was the first time that it really felt like how you'd maybe imagined it when you were a little kid. How great it would be to dance all night and make friends with all these people.

FIONA CARTLEDGE The famous story is three DJs – Danny Rampling, Paul Oakenfold and Nicky Holloway – all went to Ibiza, heard Alfredo DJ at the open-air club Amnesia, playing pop and rock and reggae and film scores mixed in with house, techno and acid, with people dancing wildly, and decided to recreate it. And, of course, being Britain, it didn't quite translate like it did in Ibiza, so it went into little pokey clubs in south London.

SHERYL GARRATT When you talk to people about their first clubbing or Ecstasy experience, they would say it felt like all the walls were coming down. All the barriers had gone. It was total abandon. People were going ape. Arms up in the air, hugs, sweaty, no one bothering how they looked. You'd see some girl come in with an immaculate trouser suit, and then you'd catch sight of her two hours later on the dance floor wearing somebody else's underpants. It was almost like talking to people who are born again. The thing you felt more than anything is that everybody welcomed each other. There was none of that, 'Are you staring at my girlfriend?'

IRVINE WELSH When Ecstasy came into working-class communities it changed a lot of the narratives. Beforehand, men and women didn't really mix. It was like sexual apartheid. When I grew up the girls would be in the lounge bar and the guys would be in the public bar. You'd meet in the disco. You'd sit with your mates drinking. And the girls would be with their mates dancing round handbags. The last dance, everybody would pile on. When I started taking Ecstasy, all these women I'd known for ages but not known at all because they were just the girlfriends or the wife of your mates, I suddenly realised that they were much more fucking interesting

than their partners. I got a proper relationship with women for the first time. Everything was breaking down.

FIONA CARTLEDGE When you create a scene you're creating a different way of seeing, a different way of being. In Britain there are a lot of social barriers generally, and clubs break that down. It was a cross-pollination of people from the creative world to ordinary people who look good or know how to dress well. It's a very democratic way of meeting people when they're young and still open and they've got loads of time to hang out.

BRETT ANDERSON Didn't the government bring in a law about banning people gathering in the same space? When these things are taken to the extreme, where the government feel as though they need to impose legislation to deal with youth culture, you know that they're worried.

IRVINE WELSH The Criminal Justice Bill legislated against music that was 'characterised by the emission of a succession of repetitive beats'. The struggle wasn't between the left and right tradition. It was about people and freedom. It was authoritarian versus freedom and the increasing repressiveness of the state.

JOHN MAJOR What was the thinking behind the Criminal Justice Bill? I haven't the faintest idea. You would have to ask the then Home Secretary, Michael Howard. There is a belief that every aspect of government is overseen in detail by the Prime Minister. This is not true. So, I'm sorry, I simply don't know.

IRVINE WELSH I've always believed the best revenge against the government is living well. People had a duty to go clubbing. If you're enjoying yourself and you're getting the most out of life, it doesn't matter what your economic circumstances are. As long as you're having fun and you're having a good time, it's offensive to people who have power.

FIONA CARTLEDGE Acid house started to peter out when the government introduced the Criminal Justice Bill. Clubs had to go

indoors again and the atmosphere changed. It's how everything starts: a few people who've got a certain mindset, getting together and producing stuff, then it gets bigger and bigger, and then it becomes numbers and filling stadiums. The agents moved in: 'You're getting £400. The next gig I'll get you £1,500.' The underground became corporatised.

SHERYL GARRATT There was a weird contradiction in the rave era, where you had people like Paul Staines, who was an extreme right-wing libertarian, involved with Tony Colston-Hayter. They were natural Conservatives doing these big raves and then being legislated against. Tony ended up chaining himself to Jonathan Ross on live TV, 'a protest on behalf of the Freedom to Party campaign'. They were fighting for the right to make money. It wasn't all coming from a left-wing place. It was quite funny watching these entrepreneurial people making a fortune and then seeing the Conservative government against them.

FIONA CARTLEDGE The money end of rave was quite Thatcherite. It was about starting your own business and being entrepreneurial. A lot of the DJs came from estates where their parents had been able to buy their council houses.

SHERYL GARRATT If you look at the culture of one-nighter clubs and warehouse parties that sprung up in London around that time, they were not things Thatcher would have approved of in any way, shape or form, but they were people finding ways of making a living from the stuff they loved. The acid-house boom gave people the inspiration, the permission, the contacts to suddenly set up in business themselves: setting up little records shops, clothes shops, launching fanzines, doing market stalls, club nights, making T-shirts or booking coaches to take people to the raves. There was a huge upsurge of enterprise. And a lot of it funded by selling pills at clubs; that's how a lot of people got the seed capital.

MATTHEW WRIGHT I went to a few of the big rave gatherings and they were horrible – just take your money. If rave was about love,

there wasn't much left. We'd moved from chasing around in cars from the fuzz, to small little dos, and then the bigger rip-off dos. The last big rave I went to was at Kilburn Bus Garage, New Year's Eve, about '92. At three o'clock in the morning the drugs had worn off, and I was stone-cold sober and surrounded by gibbering, gurning idiots. I just thought, I don't want to do this anymore. I want to hear some guitars. Enter Britpop!

LONDON BABES

Fashion. Sign of the Times.

Kate Moss. Stylists

SHERYL GARRATT To me, the nineties started in 1988. It was the end of the era of the Wag Club[1] and sucking lemons and looking cool. It was replaced by looking sweaty and boys growing their hair long. There was a huge aesthetic shift, which was partly inspired by rave. *The Face* had done its hundredth issue and Nick Logan had thought about closing the magazine down. I fought really hard. I was like, 'No, something's starting here and we should be doing it.' We needed a new aesthetic. We needed to shift to something that was more reflective of dancing all night in fields in dungarees.

FIONA CARTLEDGE The British fashion industry wasn't taken seriously at all at the beginning of the nineties. London Fashion Week was tiny. It had been hit by the recession. It was down to the core designers – Paul Smith, Vivienne Westwood, Margaret Howell – and run by a very old-fashioned elite. As a protest, we stormed it. We called it Fashion Terrorism and we had plastic guns. It was fantastic.

JEREMY DELLER We turned up at the Natural History Museum in a double-decker bus painted like a zebra with a leopard-print interior, and we were running around doing all these stunts.

1 Founded by Ollie O'Donnell, the Wag Club opened on Wardour Street in 1982 as a members' only club, and was soon recognised as one of the hip nightclubs of the decade.

FIONA CARTLEDGE We got all these models dressed up in our clothes and we did a fashion show in the street. I was playing the Chemical Brothers on a cassette recorder really loud. It was absolute chaos, and then Naomi Campbell arrived in a chauffeur-driven car and one of my staff jumped on the vehicle pointing a gun, going, 'Arghhh!' She freaked out and drove off. We were sent a bill for £300 for damaging the car.

JO LEVIN The industry was in a bubble and very insular: they mixed with each other, talked to each other, looked at each other's work. They didn't think outside the box. It's the same with politicians; if you're just looking at each other . . .

FIONA CARTLEDGE In December 1993, Isabella Blow and Steven Meisel did a big shoot for *Vogue*, which became known as the London Babes shoot, with Plum Sykes and Stella Tennant and one of Alexander McQueen's first dresses. Up to that point, *Vogue* was aimed at middle-aged rich woman and only hired things from big names, big houses. Isabella wanted to show how fashion was changing; she liked the juxtaposition of aristocratic women wearing £40 dresses. It was quite punk in a way. She was the first person to take the street into *Vogue*. I went to the bank to ask for a loan and I showed the manager the shoot. He said, 'So you've got clothes in *Vogue*, Miss Cartledge. So what?' This is before the money came into fashion – it was still seen as something your wife did to amuse herself. I managed to get a small loan and I opened a shop in Covent Garden.

JEREMY DELLER Fiona's a very important character. She would get people to work together and make things happen.

FIONA CARTLEDGE I had had an epiphany, of a sort, in Shoom, and then opened a shop that reflected the energy and vibrancy of what I saw out at night. It was a scene shop.

KATIE GRAND I remember Toni Tambourine and Björk at the launch of Sign of the Times, and Jeremy Deller because he used to work in the shop. They were friends of ours. Fiona would say,

'Borrow whatever you want.' That was the thing, not that we ever really asked, but we always thought everyone would say no to us.

FIONA CARTLEDGE Katie was hustling for business for *Dazed & Confused* and said, 'Would you like a photo shoot for the opening of your shop?' I said, 'Yes.' She said, 'I'll get Rankin to do it.' I think I paid £600. That was their first shoot together.

KATIE GRAND I'd take anything: in fluoro or angora or mohair or a silver skirt or feather boas. We had the same thing of, 'We're the new kids in town, so let's hang out together.'

FIONA CARTLEDGE The shop was aimed at the club crowd, but suddenly the most incredible people passed through the door: Alexander McQueen, Stella McCartney, Hussein Chalayan. Take That came in and we treated them like normal people: 'Here's a box. We need some help. Come on, carry it down the stairs.' They loved it!

SHERYL GARRATT There were always people hanging out there. It was a party shop and a little hub for our culture in the middle of expensive, designer Covent Garden. There was all this cross-pollination going on. That's what people meant by 'the barriers coming down'. Whereas before you wouldn't have got past the velvet rope, suddenly all those things were accessible to everyone: people were going to illegal warehouse parties, getting into main-stream clubs, going to high-fashion shops, fashion people dancing in grungy fields.

FIONA CARTLEDGE 'It's got to be a big label', 'You have to buy the season', 'You have to buy this many pieces' – all that was bollocks. I had an open-door policy, which is a reason why the shop got famous pretty quickly. I hadn't been to fashion college, so I was just like, 'Oh, that looks good, let's have it,' or, 'That's really ahead of the curve.' If I went out to a club and saw someone wearing a great outfit, I'd say, 'Would you make some for the shop?' It meant that people who didn't have the right background in fashion suddenly had an in.

JEREMY DELLER All that generation from St Martins came. Katy England would come in and borrow clothes for shoots. All those stylists, they were just out of college and doing little shoots for this, that and the other. There was a lot happening. I started selling a few T-shirts with phrases on the front, 'My Booze Hell' and 'My Drugs Shame'. Robbie Williams bought one.

FIONA CARTLEDGE Jeremy's T-shirts were one of the best sellers. I've got a picture of Richey Edwards from Manic Street Preachers wearing 'Your Parents Fuck You Up' in *Select* magazine. It was fashion meeting art meeting music. Here was a real energy, where people wanted to show what was happening in the clubs and put it in art or the fashion world. All of us were going to clubs, waking up in the morning, and thinking, Let's put that into my day world. In a way, that's what McQueen was doing in his shows – taking all these ideas and putting them on the catwalk. Rifat Özbek was the first person to put the acid-house look on the catwalk and to take it into the fashion world, when he did the all-white collection in 1990. He did all these big crystal necklaces and flowing white clothes. You could see it in *The Face*, who were very good at reflecting all of that.

JEREMY DELLER Sign of the Times had themed parties, which were really hedonistic. There was this feeling of abandon. People dressing up and making a real effort. It was like a fancy-dress version of rave.

SHERYL GARRATT Sign of the Times parties were great. They were one of those events that was a bridge from the fashion set to the acid-house set. There would be drag queens, fashion people, eighties people, nineties people, a really good mix of music. For people who had been sweaty T-shirt ravers, it introduced them to a dressier idea of fashion and perhaps a more creative idea of how you could dress and be. Different places had different kinds of cross-pollination. You'd go to Clink Street and see West Ham top boys sitting down on the stairs with Spurs top boys, sitting down with Arsenal top boys, all having a laugh. These were people who would have been literally killing each other two years before.

FIONA CARTLEDGE We had a fashion show at the Hanover Grand. It was a mad party. The theme of the night was *West Side Story*. The line-up was insane: Jon Cooper AKA Jon Pleased Wimmin, the Chemical Brothers, DJ Harvey, Shadow People. It was the most mixed up, messed up DJ line-up. It created a really fun atmosphere. Drag queens, straight boys, celebrities, people in bands turned up. It was an incredible mix of people. Tricky from Massive Attack. Alexander McQueen with Andrew Groves [Jimmy Jumble]. It was a complete mash-up. Alan McGee brought Liam Gallagher and the boys. I was a bit of a girl in those days, always dressing in quite fancy dresses with high heels, and Liam launched at me and gave me a quick snog. I ran off and was sick in the toilets because I'd eaten something funny beforehand.

LORENZO AGIUS I used to hang out with a lot of people because you were just on the scene doing things. You'd go to a party. 'Oh, who's that?' 'It's Liam Gallagher.' 'Who's he?' 'He's in a band called Oasis.' Six months later they were massive.

KATIE GRAND I felt like what we were doing was very incestuous. Björk was hanging out with us. Jarvis, Kylie, Elastica. We would have pop stars hanging out in the office or going to sleep in the studio. That's how I met Steve from Pulp. He turned up one day, saying, 'I left a tie with you.' I said, 'I don't think you did, but it's nice to see you.' Then he passed out on the sofa. And we were hanging out with more fashion types. Basically, all people I'd been at St Martins with: Lee McQueen, Hussein Chalayan, Antonio Berardi. That's why we worked together. Stella McCartney was in the year below me. She had all that coverage because she'd used Naomi and Kate for her college show. It was amazing. Rankin was the first person to photograph her collection.

SHERYL GARRATT There were all these new young photographers like Corinne Day and David Sims, and stylists like Melanie Ward. They didn't have any money or contacts at fashion labels. They couldn't phone up and get the latest designer labels biked over to them because nobody had ever heard of them. Model agencies

wouldn't give them the top models because these were new, untried kids. Instead, they tested out with people they met on the street or very young models who came into the agency, like Kate Moss. They were buying clothes in second-hand shops or using their own because nobody would give them the designer outfits.

KATIE GRAND We had an office on Brewer Street and Corinne Day lived upstairs. She was dating Mark Szaszy who was the first one to do the videos of Oasis. We'd always fall into knowing about happening people: it wasn't through destiny; it was chance and geography.

SHERYL GARRATT Phil [Bicker] waved a Polaroid at me, and said, 'We've got this girl.' I was like, 'Okay.' He said, 'She's quite young. I think we should use her as the face of *The Face*.' I was like, 'Great idea.' That was Kate Moss. We'd used Kate before in a shoot for Italia 90, but it wasn't our highest moment. Mark [Lebon] was only given about ten minutes and a load of football shirts. Kate was everything a supermodel shouldn't be. All credit to Sarah Doukas for spotting her. That's exactly what fashion needed at that point. Kate was the coolest girl in the world. She was representing brands and magazine covers all over the world, and epitomised everything that was great about Britain in the nineties. It opened the floodgates. You didn't have to be such a conventional beauty to have a modelling career.

KATIE GRAND Kate was the poster girl. She was incredibly infectious and charming, which is why you wanted to keep working with her. She was hilarious and didn't really have an off button. She just threw all the rules out of the window.

SHERYL GARRATT When she made a record ['Some Velvet Morning'] nobody blinked or thought it was foolish. I wrote about her once for French *Vogue*, and one of the photographers said, 'When you work with Kate you always ask her what she's listening to, what she's reading, what art she's seeing because you know six months later everybody else will be talking about it.' She's one of those

people who are a lightning rod. If you gave her ten paintings or records, she'd go, 'I like that one,' and it'll end up being really cool six months later.

JO LEVIN I did an extraordinary shoot with Kate for *GQ* that all went wrong. It was the Mad Hatter's Tea Party. We had Kate as the White Rabbit, Jade Jagger as the Cheshire Cat, Elizabeth Jagger as Alice, Philip Treacy as the Mad Hatter, Paul Simonon as the gardener and Anita Pallenberg as the Queen of Hearts. It ended up in a fight because Dan Macmillan, the writer, at some point had been dating all three girls. Cakes were being chucked everywhere; jam all over my expensive clothes.

JEREMY DELLER Kate Moss was emblematic of that time: the youth, the beauty, the hopefulness, the fresh face, the glamour, the confidence, the optimism.

IRVINE WELSH She was iconic and had the look of the whole era. It's difficult to talk about a look without getting a bit pretentious, but there was something very hopeful when you saw a picture of Kate or met her face to face. She wasn't a traditional Amazonian figure. I wasn't a traditional writer. Damien Hirst wasn't what you think of as a traditional artist. Everybody was a misfit to some extent. There was a shared energy. A shared sensibility.

SHERYL GARRATT In the summer of '88 all the acid house clubs were calling it the 'summer of love'. Then in '89, when the huge summer raves started with 25,000 people dancing in fields, everybody called it the Second Summer of Love. Then we tied up the whole Manchester, London, Stone Roses link as the 'third summer of love'. There was a thought that the Stone Roses at Spike Island was going to be our Woodstock. This was going to be some kind of peak experience, but it was such an anti-climax. It didn't feel like the thing that should be on a front cover. We tried various things but none of them felt right. Eventually, Phil Bicker put the Indian headdress shot of Kate on the cover, cut the feather out, and put it over the masthead. I was like, 'That's perfect!'

JO GOLLINGS Kate with the Indian headdress and a pair of manly sandals with her bandy legs was pinnacle. You'd never seen anything like it. It was so free and understated. She wasn't wearing any clothes. They literally wrote what perfume she had on.

KATIE GRAND That *Face* cover changed the world. That's how I felt about it. It was the idea of wearing Birkenstock for fashion when it was just such an ugly shoe. You couldn't look at those pictures of Kate on the beach and not think, This is so different.

SHERYL GARRATT The way Corinne shot her was so fresh and natural it brought out all of Kate's personality. Corinne just got a warmth into her black and white. She used to observe people. She'd talk to them and take photos for hours. She was always trying to capture the essence of the person. What came across was Kate: her mischief, her gorgeousness. It wasn't contrived.

KATIE GRAND I was working on a placement at Katharine Hamnett when the Third Summer of Love issue came out with Kate on the cover. I met Melanie Ward, who had styled the shoot, and I was like, 'Oh my God, you're a superstar.' I didn't really know what a stylist did and she explained it to me – it was a better education than St Martins – and you got paid £36 for three hours; sometimes you could do two shows in a day and get £72. It was really fun. Melanie was the first person to do a nice pinstripe trouser and put it with a Stan Smith trainer. The idea of wearing trainers as fashion in my head went as far as Melanie Griffiths in *Working Girl* on the Staten Island ferry. I went to Ibiza that summer and wore a swimming costume with Adidas trainers.

SHERYL GARRATT You can't talk about Corinne Day without mentioning Melanie Ward. Her aesthetic was so important. And David Sims, who was doing very similar things, in a different way. There was a bunch of young photographers who were reacting against what they saw as the artifice: the polish, the shoulder pads and the airbrushing. Everything moves in cycles. Everything's a reaction against something else. The eighties had been so glossy

and glamorous and perfect, so this imperfect beauty, this flawed, gawky, awkward but very natural beauty was what the new photographers were exploring.

PAT HOLLEY It was a new way of thinking: the idea of Kate Moss nude and just being this innocent, young, fresh-faced thing on the most important magazine in the country.

SHERYL GARRATT Kate was sixteen when the pictures were published, and she got teased something rotten at school for being flat-chested. I wasn't bothered about her age or her being bare-breasted. Kate could stand up for herself. There's something about the gaze in photography. Kate is looking at the camera. She looks in control. She doesn't look like, 'Come and fuck me.' It's a girl running down the beach laughing on a cold day in Camber Sands. It was about freedom and joy and celebration.

JO LEVIN It was a big change. That's what happens in fashion. You go from the beautiful to the perfect, then you want to deconstruct. It's like when skirts get really short. There's only one way they're going to come down again. The proportion changes. If there's a lot of embellishment, it's like, 'Where are you going to go next?' You have to strip it back. The Kate Moss thing was a reaction, 'Let's be dirty and grungy and thrift'.

CARLA POWER There was a British twist on grunge with the Corinne Day pictures. The pictures that she took of Kate Moss for *Vogue* with the Christmas tree lights and her looking scrappy like she'd just fallen out of bed. It was the opposite of Linda Evangelista telling *Vogue* in 1990, 'We don't wake up for less than $10,000 a day.'

SHERYL GARRATT The aesthetic was very much, 'We've been up all night at a rave.' That became a new movement in fashion. There were a lot of shots after that by this new generation of photographers, of models with their hair all over their face and standing awkwardly.

KATIE GRAND I remember Corinne's picture of a pair of bloody knickers in 1994 coming in and rolling my eyes, 'Oh, God.' There's such brilliant footage of Andy King, who was head of advertising, taking that picture to somewhere like Daz Automatic, saying, 'I think you could get really involved with the magazine. Look at these bloody knickers. This is perfect for Daz.' You have no notion of how naïve everyone was. It was like, 'Yeah, let's take a Corrine Day picture to Daz Automatic and see if we can get three grand out of them.'

CARLA POWER A lot of women were very upset at Corinne Day's infantilisation of Kate Moss, but I didn't take it too much to heart any more than Eva Herzigová's advert for Wonderbra, saying, 'Hello boys', with her tits hanging out.

KATIE GRAND The first famous model we ever worked at *Dazed* with was Helena Christensen for the third anniversary special edition. For the shoot she was just wearing leopard pants, but I was like, 'We can't have Helena Christensen topless because she'd said, "If my nipples are showing, please don't use it."' Rankin had the idea to put a grey strip across her boobs that said 'INSTANT WIN SCRATCH AND SEE'.

SHERYL GARRATT Showing topless women is about the gaze and control. I felt really comfortable putting Naomi Campbell naked on the cover of *The Face* wearing nothing but a pair of Converse All Stars because I wanted to make the point that a black model could sell copies. Secondly, it was taken by Ellen von Unwerth, a really great female photographer, and Naomi was looking right at the camera in a way that left you in no doubt whatsoever who was in control. It wasn't, 'Oh, look at me boys. Come and get me.' Don't get me wrong, Naomi looked sexy as hell. But there's something about the way you look at the camera that makes you an active participant in that or not. If you wanted me to write a set of rules why one photo is okay and why another is not, I can't tell you. But nine out of ten women would point to the same one if you asked them which one made them feel uncomfortable.

KATIE GRAND I was dealing with characters at *Dazed* who were very anti-fashion. When I first met them they didn't want fashion in the magazine. They didn't like the idea of stylists. They didn't like the idea of other photographers. Jefferson [Hack] was like, 'We don't believe in fashion. Unless you've got a concept it's not going in the magazine.' And Rankin would be, 'If I don't like the idea then I'm not shooting it and it's not going in the magazine.' Rankin lived with me and we were doing the magazine out of my kitchen. The situation made me indispensable. In the end they had to give me this fashion-director job. It was their nod to, 'All right, then. Suppose you'd better do some fashion.'

FIONA CARTLEDGE It was shocking how raw Rankin's pictures were. *Dazed & Confused* deliberately wanted things to look raw and more natural. All of us were rejecting the perfection of the eighties. Rejecting Thatcherism. Rejecting artifice. None of this pretence or 'I'm more important than you'. Bros were one of the first big bands to have a stylist. Then *Dazed & Confused* came along. Katie Grand and Katy England. They were the beginning of the superstar stylists.

KATIE GRAND I would turn up literally with what I thought we were going to shoot in a carrier bag. I'd be like, 'Rankin, shall we shoot Kate naked?' and just take a hat and a pair of boots, a suede neckerchief and bits of black velvet ribbon to make a suspender belt. When we did Kylie in LA I turned up to the shoot with stuff packed in this bag of Hussein Chalayan paper clothes. I remember Kylie looking at me like, 'Is that it?' Another stylist would arrive with twenty racks, four assistants. Rankin didn't even have an assistant. I changed the film for him. If we were shooting for a sixteen-page section I'd take sixteen outfits. There was never any discussion of 'do you like this?' It was always like, 'Put this on.' I'd never worked with a designer or on a show, so I never thought in proportion of, 'That's the hair. That's the shoe. Whatever you put in between needs to make sense.'

FIONA CARTLEDGE In a way, the nineties was breeding a whole load of new jobs that had never existed before. If you'd said to

someone in the late eighties, 'I'm going to be a stylist,' people would have laughed. 'It doesn't exist! What's a stylist? How do you make money doing that?' All of these jobs were new. Even an artist like Damien Hirst, to be an international British contemporary artist was laughable. To be an international British designer was laughable. Vivienne Westwood still wasn't being properly funded. There weren't any big global designers from Britain until they went over to Paris and took over the houses. All of this happened in the nineties. It was like there was a Brit creative takeover.

SHERYL GARRATT Even though the eighties was supposed to be the designer decade, that wasn't really until the nineties. Labels that had only had maybe one shop in London, four in New York, one in LA were opening branches all over the world. If you were a man and saw someone in a really sharp shirt, you'd say, 'Where did you get that from?' And they'd name a place in Soho.

FIONA CARTLEDGE People in London wanted to dress up again. You can only wear baggy T-shirts and look like a crazy hippy for so long. Designer clothing came back, and people started wearing John Richmond's Destroy label and Michiko Koshino.

PAT HOLLEY Suddenly something started happening, you could really sense it – people who wanted a good time and to look good. We were peacocks. Britpop was a time for men to dress up again and be effeminate. Get out of the plaid shirts and ripped jeans, get out of sweaty shirts, take care of your hair and wear some nice neckwear. It was the idea of androgyny and loucheness and sexiness; a chance to show off and put on some make-up.

STEVE LAMACQ Britpop dressing up was a reaction to grunge. Pop music is all about one scene dresses down, one scene dresses up: Teddy boys dressed up, punks dress down; if the punks dressed down then the new romantics dressed up.

FIONA CARTLEDGE There was punk influence that came in about '92 as a reaction to the hippy influence, which had been really big

in the house scene, floaty dresses and floaty everything. Fashion switches like that. Polar opposites. It's all going one way then it all goes the other way. Suddenly kids were bringing in these punky clothes to us. That's where the Union Jack influence came from. We were getting jumpers with safety pins and knitted webbed jumpers. But also there was a bit of a mod revival with Blur and Oasis. Fashion and music were cross-pollinating the whole time in that period. You'd get a band wearing moddy clothes and then the designers would start making moddy clothes. Then you put them in a shop and the clubbers start wearing mod clothes. That's how it went. Fashion wasn't just coming from St Martins. It was coming from bands.

PAT HOLLEY We would mix things up and pass styles between Blur and Pulp. There'd be a moment when we'd have a band in a tracksuit top and a tie and a jacket. It was the idea of mixing visual metaphors and messages.

SIMON FOWLER It was a vaguely sixties look, but we'd always dressed like that. If you think of how incredibly stylised the sixties fashion was. The bands in '66, the Small Faces, the Kinks, the dandy look. It was a mod thing.

JO LEVIN The connection to the sixties is always important: that slick, sharp tailoring, think of Mick Jagger, Elton John. A lot of rock guys take a military jacket and chuck it with a pair of jeans and look cool. It's just that mixing. It all comes from the military. Every guy needs a good, sharp suit. There was a moment when every musician wanted to be dressed like Paul Smith. He took that classic sixties English look but give it a twist. He would take a tattersall check shirt and dye it orange, or a chef's blue-and-white-check trousers and dye them a different colour.

ALAN McGEE I always liked Paul Smith clothes. I got the *Elle* Stylish Entrepreneur of the Year Award in 1995/96. I had about twenty of his suits. I liked the cleanness and mod cut of it. I reminded Noel of this recently. 'Do you remember when I came down to hear

Morning Glory and you said I was a mod? I went, "No, I'm a punk."
You went, "No, you're a mod." I went, "I was never a fucking mod.
I was always a punk."'

JO GOLLINGS The year zero for men's styling was Roxy Music. That
was our starting point: all glam; very satiny and tight.

PHILL SAVIDGE The Skinnys[2] were a very glamorous couple and
used to go to parties dressed as Ken and Barbie. They would style
our bands. It was shabby chic; stuff you would buy in charity shops.

JO GOLLINGS The ironic thing was we'd go into clubs dressed up,
but the styling we did was anti-style. We were called the anti-
stylists. We wanted bands to appear cool so that they're not trying.

PAT HOLLEY We were influencers. Record labels would say, 'We've
got a new band. They sound okay but visually they look shit. Will
you come in and help us?' We would come in and say, 'This is your
village. This is your castle. You're going to look at these influences
and dress like this.' Bands didn't have a clue.

KATIE GRAND More often than not you'd be in these situations
with people who just didn't want you to be there. It would be
that thing of, 'I don't want a stylist.' You'd be a bit like, 'Well,
someone booked me . . . fine . . . I'll go and sit in the corner all
afternoon . . . really, don't worry about me.'

BRETT ANDERSON I did an ill-advised *Face* shoot around the time
of 'The Wild Ones' with my top off. I was heavily made-up and
trying to look like Bryan Ferry. I don't know what the fuck I was
thinking. I was disappearing into some mental hinterland.

JO GOLLINGS Bands didn't want to be bothered with stylists. They
were making the music. They loved their £5 horrible leather jackets
with horrible collars and thought they looked amazing.

JARVIS COCKER There were places that you got old clothes: the
Laurence Corner place was an army surplus shop at the back of

2 Jo Gollings and Pat Holle.

Euston Station that used to have unworn jeans and cords with incredibly small, 24-inch waists. People would injure themselves trying to wear these clothes. It was a made-up look, but the fashion thing latched on to it.

BRETT ANDERSON I was on the dole so I couldn't afford decent clothes, and I didn't want to dress like everyone else. The only way you can do that is to go to junk shops and buy second-hand clothes. The fact that we ended up in Oxfam jackets was something that was born from poverty. When 'The Drowners' came out there was a little Suede-mania thing. I'd go into the crowd and people would rip my shirt and pull it off, and I'd emerge with a bare chest. I went on tour with one pair of socks, one pair of trousers and one top, so I had to go out to junk shops and get a new shirt for the next night. I ended up getting crappy chiffon blouses that I knew wouldn't last beyond the first couple of songs and could rip easily. The stylists came along, and they saw us dressed in shabby clothes and thought, Oh, that's a look!

PAT HOLLEY If you saw Jarvis walking down the street, it was Jarvis. If you saw Brett, he would be wearing the same clothes. This is what we instilled in the bands. Once we got you looking like this, 'You wear this all the time. DO NOT step out of character. So if people catch you in the street you will be that person. You don't suddenly go back to wearing Day-Glo T-shirts.' Our mantra was, 'You're not part of the audience.' Then, Oasis wandered up in their anoraks and looked exactly like the people they were singing down to.

SIMON FOWLER Oasis's look was on the whole off the street. They didn't really have much of a look other than what everybody else wore. They looked like their mates.

NOEL GALLAGHER Adidas was my thing and fucking shitloads of it, probably because I was getting it for free. Fuck knows where I shopped for clothes. I never cared what I looked like. It was never a big thing for me. Liam, maybe. A pair of shoes is a pair of

fucking shoes. Paul Weller thinks a pair of shoes can change the world. As long as you don't get your feet wet I truly couldn't give a fuck. I never thought I was fashionable in any fucking sense, neither musically nor sartorially. A lot of the stuff we did, it was not thought out at all. I do say this to a lot to people, particularly Oasis fans when I meet them, 'You know what the first line of "Supersonic" is? "*I need to be myself, I can't be no one else*", so what are you walking around dressed like that fucking idiot for? Be yourself. It's not about being like somebody else.' I idolised the Jam, but I've never looked like Paul Weller in my fucking life.

JO LEVIN We shot Liam and Noel for *GQ*. Liam was trying to be shocking and provocative. He said, 'It's better with just me in the picture. Noel's bound to spoil it with his Adidas trainers and Prada jacket.' Noel was quite grumpy and refused to have a stylist tamper with him. These guys pretend that they don't care but actually they do. It's the kind of guy who has a messy hairdo but takes hours to get that look.

MELANIE CHISHOLM I didn't have a clue about fashion, but being in that world you're doing photo shoots and you're introduced to hairdressers and make-up artists and fashion stylists. That's when you start to learn. Victoria always had an interest in fashion, but I just wanted to be in Adidas and Nike, a lot of sportswear like Kappa and Champion, or free stuff sent from Umbro. The big magazines would have their own stylist, but usually we had one hair, one make-up and one stylist for the five of us. It used to take us hours to get ready because we had to take it in turns. They were shopping for five completely different mixes.

KATIE GRAND We worked with the Spice Girls. It was hideous. We did all this stuff in a day and they were horrible. Record companies and management would never give you a decent brief. You'd just be like, 'Let's get some Gucci for Victoria. A cute baby doll for Emma.' You'd just play to character. We'd got maybe thirty racks of clothes and they styled themselves in the end because they didn't like anything. I had no interest. I was like, 'Wear Buffalo sneakers and

tracksuit bottoms, it's fine by me.' When I went on to be friends with Victoria, years later, she was like, 'I was a fucking bitch that day'. They hated each other. They were all moaning about being fat and then ordering toasted cheese sandwiches. They were vile to each other, vile to me, vile to hair and make-up.

COME OUT, COME OUT WHEREVER YOU ARE

Young British Artists. *Freeze*. Turner Prize. Damien Hirst. The Shop

GREGOR MUIR There are so many nuances in the YBAs story. There are so many ways in which you can drill in to it, so much you can take away from it.

MICHAEL CRAIG-MARTIN This was the most amazing thing in my lifetime: art was incredibly marginal, and then suddenly it was recognised as part of an expression of the life of our time. It went from the status of poetry, where people respect it but only tiny numbers of people are actually interested, to being at the side of mass culture with rock 'n' roll and theatre and TV. It became a giant presence in British life.

GREGOR MUIR You had this sense of British art trundling along, but then into this comes the somewhat disrupting influence of a younger generation of artists who are very aware of influence and inspiration from other areas of their lives. There's a sense of a breaking away, not just from the establishment, but from artists of an older generation.

MAT COLLISHAW There was an appetite for something more, for artists to deliver something that was more of the moment.

MICHAEL CRAIG-MARTIN The decade of the nineties really starts in the summer of 1988 with Damien Hirst's *Freeze* exhibition. And

everything that happens in the art world for the next ten years arises almost directly out of that. It's a very unusual thing to have such a singular moment that can be said to be a turning point. The exhibition was that important. All of those careers started from that show.

SARAH LUCAS Looking back on it you can say that was the beginning of the whole thing, but at the time you're just doing it, and thinking, Well, great, yeah, we'll do this, it sounds like a really good idea.

NORMAN ROSENTHAL *Freeze* was absolutely key. It put the British contemporary art world on to the international map. Suddenly, London became a major capital of art.

MICHAEL CRAIG-MARTIN Damien spotted that there were all these really good people around him at Goldsmiths,[1] and decided to put together this exhibition in a warehouse building in Docklands when it was still a ruin.

GREGOR MUIR There was this intertwining of the illegal rave culture and art culture. The British artists inherited the former industrial zones of east London, and they had access to space in a very new way.

TRACEY EMIN Imagine. All the shops were boarded up; there was no money; London was falling to pieces around us. There were no nightclubs. Pubs closed at eleven o'clock.

JARVIS COCKER It was like a post-industrial landscape. You've got all these big buildings that no longer have anything happening, so you either break in to one or rent it for a week and do something. It's like playing in the ruins.

GREGOR MUIR There was absolutely a link with the rave scene and the appropriation and recycling and reusing of the former industrial buildings. The artists were looking to initiatives in

1 Goldsmiths College, situated in south London, became part of the University of London in 1988.

other cultures rather than the existing art structure in this country, most noticeably the club world. It was repurposing the ruins. The buildings that were being emptied out, by a government obsessed with privatisation, were not just former industrial buildings, they included, hospitals, former council buildings, old cinemas. So you get Damien Hirst making medicine cabinets filled with rotting drugs, which are rescued from crumbling hospitals.

SHERYL GARRATT Big chunks of London were wasteland. You'd see a light and a couple of bouncers, and you'd know that was where the party was. Those areas had been hollowed out by the recession, and culture came in and filled those empty spaces.

MAT COLLISHAW We spent a lot of the time mooching around, breaking windows and getting access to empty buildings to see if they were any good to have an exhibition. It made sense economically. We could never afford to hire a place. When it came to *Freeze* it was obvious we had to have some formal arrangement because there was going to be a lot of work invested in it and we wanted it to have the appearance of being quite professional. We didn't want the bailiffs coming round a week after the show opened and emptying all the artworks out onto the pavements, which had happened several times before.

SARAH LUCAS Damien persuaded the Docklands Development Corporation to let us use a disused Port of London Authority building in Surrey Docks.

MICHAEL CRAIG-MARTIN It was an old handsome building full of pigeon shit, and Damien and the seventeen other people he chose to be in the exhibition cleaned it up: Steven Adamson, Angela Bulloch, Mat Collishaw, Ian Davenport, Angus Fairhurst, Anya Gallaccio, Gary Hume, Michael Landy, Abigail Lane, Sarah Lucas, Lala Meredith-Vula, Richard Patterson, Simon Patterson, Stephen Park, Fiona Rae.

SARAH LUCAS We all had to transform this derelict building into something that looked like a pristine white space. It was a big deal

to take on a space as big as that, and with quite a short space of time to do it.

MAT COLLISHAW Like any building it had many things in it which weren't appropriate for an art gallery: radiators which had to be angle-grinded out; doorways which had to be closed up; everything had to be plastered and painted; manky carpets glued to the floor had to be dug up with shovels; lighting had to be installed. It was several weeks of work; eighteen artists preparing the space while we were also making our own work and doing whatever jobs we had. You were just thinking about the end gain and how great it would be if we could actually put this thing on.

SARAH LUCAS I didn't do any angle grinding, but we did all the painting and everything else. We were just tidying it up. Making art is quite a robust thing a lot of the time, so to tackle practical things was quite logical. A lot of us were living in squats that we had to tackle in that way.

MAT COLLISHAW Damien circulated a plan: 'There is a lot of work to do in the next few weeks, and I am relying on everyone to do as much as possible to prepare the space – as specified on the attached schedule. If everyone works their allocated time (i.e. eight days each person), everything *should* get done in time.' He signed off, 'Damien Hurst IT IS GONNA BE GOOD!'[2] At the opening, we were just finishing hanging the work on the wall, or preparing tables and the wine, as people started to arrive. I'd been up for two days. I was totally exhausted. Angus Fairhurst put his hand on my shoulder, and said, 'Your piece looks like shit, mate.' I was like, 'Oh my God! He's right. What was I expecting? Fuck!' I went and sat on the dockside and drank a beer, feeling despondent. Weirdly enough, on the other side of the river there was a new development in flames, and I watched it burn down, thinking, I've totally fucked up and made an idiot of myself. It turned out Angus was joking. Maureen Paley

2 Note 'Hurst' misspelt on original schedule, typed by Damien.

found someone to buy my work, *Bullet Hole*, but in factoring in the fabrication costs, plus her 50 per cent cut, there was no profit in it and the sale fell through. The work ended up rusty and rotting outside the gallery space.

GREGOR MUIR What was different about *Freeze* was the presentation: the well-designed catalogue and invite cards; and working in a way which resembled the practices of New York commercial galleries. They were taking the trade language and adopting it to their cause.

MICHAEL CRAIG-MARTIN I happened to be with Clarissa Dalrymple, who I brought along because she was curious. Clarissa owned a gallery space in New York and was a very important person. Bringing her meant that there was somebody from outside our world saying, 'If you're in London you should go over. These are people worth seeing.' It made people listen. It didn't take long for there to be an international buzz.

MAT COLLISHAW Damien was very good at getting on the phone and talking to people, hustling with charm. And he could put on voices. It's the beauty of the telephone. You could be lying in only your underpants on the floor with a cracking hangover, but you could create the veneer of some professional curator or whoever he was pretending to be. Damien was very intuitive in understanding the way things operated and the subtleties of social navigation. He understood there were key figures: if you talk to this person then maybe you can talk to that person. People like Norman Rosenthal, the exhibitions secretary at the Royal Academy, who turned out to be a huge champion of our generation over the years.

NORMAN ROSENTHAL Damien had a little, cheap second-hand car and drove me to the last of the three *Freeze* shows. I found it quite interesting. And then I said, 'What else is there to see?' He said, very generously, 'You should go and see Rachel Whiteread,' and drove me to an exhibition in Tower Hamlets showing *Ghost*.

JARVIS COCKER It wasn't about Damien building an empire and being the emperor. He's always helped and worked with other

artists to organise shows. It was like saying, 'Let's try to move the focus.' That created the modern art scene.

MICHAEL CRAIG-MARTIN Damien did something fantastic, which was, instead of closing the shutters to focus on himself, he did the opposite and brought in young artists from colleges other than Goldsmiths. The group, instead of staying small and tight, expanded. It was a real generosity of spirit and it permeated the group. Collectors and art dealers were coming to see them at their studios from all over the world. One person said to me, 'I had the most amazing experience. It's never happened ever before. I went to Damien's studio, and he said, "Do you know the work of so and so? He's wonderful. I've got to take you." And he did.'

GREGOR MUIR It felt like there wasn't a moment to waste. We were chomping at the bit. We're going to do this.

CARLA POWER After Thatcherism all these artists were coming out. They'd all been toiling away in their workshops and studies or were on the dole. It was like in *The Wizard of Oz:* 'Come out, come out wherever you are'. There was a sense of people creeping out from behind and hearing about Damien Hirst and all these other young artists. It was this nimbus feeling around it.

GREGOR MUIR The ultimate dismissal is when people refer to these artists as 'Thatcher's children'. Nothing drives me madder than to hear that it was in the spirit of entrepreneurism. It was the absolute opposite. It was to escape that and find a way forward that made sense to us. We were coming together in an aspirational way, in an opportunistic way, but it was certainly not in a way that we felt was aligned to Tory politics; far from it. This burst of energy wasn't handed over on a silver plate. It came from a need to escape a quite depressing, tough world. That cannot be understated.

SHERYL GARRATT We were more Thatcher's children than we thought we were. I would hate to argue that Thatcherism was a good thing, but it dripped in. When all the old means of support have been cut away you have no choice but to be self-reliant or

go under. It was a lot of what was celebrated in Cool Britannia. Damien Hirst didn't wait for a gallery to come and discover him. He put on his own show.

MICHAEL CRAIG-MARTIN The YBAs were in the midst of Thatcherism, the effect happens for the next group of people. But the spirit of entrepreneurialism and to find your own way and succeed is true. They were very ambitious. The British way of thinking is to wait for something to happen. It's very polite but it usually leads to nothing. Nobody cares if you're waiting. The most striking thing about them, more than any other generation, was that they were not prepared to wait. They made things happen for themselves.

TRACEY EMIN You get told 'no, no, no' enough, you just think, Fuck this, I'll just do something myself. The big thing that I did was to ask people to invest in my 'creative potential'. They had to send me a £10 note or postal order, and for that I would send them four pieces of mail and one letter marked 'personal'. I can't tell you what was in that. The first week I did it I made eighty quid. Then I actually sold £2,000 worth of art and used it to pay off part of my debts. That's what a lot of us did. We did it ourselves. It wasn't a Thatcher ethos. It was, 'I can't cope with this. What am I going to do? Sit here and die? I'm an artist.'

NOEL GALLAGHER We were all children of Thatcher. We lived through the Thatcher years and being on the dole. She stopped free school milk when I was at primary school. I remember her name being omnipresent, with bitterness and bleak winters. She was a stone-cold woman. Then she got ousted, and this guy called Tony Blair came along and it was New Labour and it started to make sense to me.

SHERYL GARRATT Almost everyone I knew were the most oppositional people to Margaret Thatcher and her ideology you can imagine, but it permeated by osmosis and her slowly snipping the chords of every safety net that existed. If you were young and wanted to do something, you had to be entrepreneurial.

OLIVER PEYTON We were naturally left-wing people. We were natural disrupters. All the rioting that had gone on under Thatcher. People didn't feel part of society, which probably spawned our success in a way. That sort of 'we'll show you' kind of thing. There was definitely a massive sense of that about.

TOBY YOUNG There was an entrepreneurial DIY ethic, a feeling that you didn't need to go through the traditional routes to achieve recognition. You could just do it yourself. You could burst onto the scene without any official imprimatur or establishment approval. That seemed to be something that carried through into Cool Britannia.

MAT COLLISHAW It was like the punk ethos of having three chords, form a band, make a song, you can do it, there's nothing stopping you achieving that. The art world, which is a little more cerebral, benefitted from that ethic. Just do it. If someone closes the door in your face, give them hell.

TRACEY EMIN You had to really prove yourself. There wasn't any money in art. The only magazine in Britain was *Art Monthly*, which was more like listings of where to buy paint or a second-hand easel from, and the odd article. It was like a dark shadow was hanging over everything. I had two meters, for electricity and gas, with a £5 minimum, and once I'd paid off my debts from dole money I had a choice to live with one or the other.

MICHAEL CRAIG-MARTIN All I was interested in was the artists surviving. How do you not go under, the first year after art school? How do you find a studio? How can you afford it? How can you live? It wasn't about getting rich and famous. It was about, 'How do you keep being able to do what you're doing?' That was the real motivation. They were making small amounts of money, things sold for £500 to £600, but every penny they made went back into their work.

TRACEY EMIN A lot of our money was used to pay our studio rent or to buy art materials. We weren't swanning around. We didn't

have cars or expensive clothes or furniture. Nothing like that. We invented everything. We made everything. When someone moved to a new studio we would all chip in and help to do it up.

MICHAEL CRAIG-MARTIN It was constant making do. It would never had worked if they hadn't done that. This desire to make more work and to use what opportunities they had and to help each other; those bonds were formed, for many of the artists, at Goldsmiths.

MAT COLLISHAW Goldsmiths was a crucible of conceptual and contemporary art. I went when I was nineteen and met a group of similar-minded people from all over the country, all very creative and eager to make stuff. We had tutors like Michael [C-M] pushing us out into the real world, because they were all practising art themselves, and saying, 'Go and look at this exhibition; go and see what's happening at the Saatchi Gallery. Stop looking in the books. Stop looking at art history. Look at what's happening now! Engage with the world as it is.' We were all probably quite dysfunctional in a normal school/academic environment. I doubt we could have scraped ten O Levels between us. But we were generally quite bright, so for the first time there was a way of being able to apply an instinctual intelligence and to be taken seriously. We were quite irreverent and informal, but the debate about what we were doing was quite serious.

MICHAEL CRAIG-MARTIN It was a moment when there were a lot of equally exceptional people, all within the college: Damien Hirst, Sarah Lucas, Angela Bulloch, Mat Collishaw, Ian Davenport, Angus Fairhurst, Anya Gallaccio, Liam Gillick, Gary Hume, Michael Landy, Abigail Lane, Fiona Rae, Richard and Simon Patterson. They were very aware of each other and became very competitive in the best creative sense. If one of them did something really wonderful the others were jealous and wanted to up their game. My encouragement was helping people to find their individual voice.

MAT COLLISHAW Goldsmiths was very fertile, a lot of cross-pollination of ideas and media to draw on. People going, 'We could use gloss paints instead of oil paints,' or, 'We could buy our materials

from the DIY shop instead of the art shop.' 'We could use pornography.' 'We could steal books from Foyles' medical department.'

MICHAEL CRAIG-MARTIN What was really interesting was because the groups were mixed, you'd have somebody doing photography, somebody doing film, someone doing painting, somebody doing sculpture, and suddenly they're all having to listen to how the other person works. That's an amazing, rich lesson, and encouraged sympathy for what other people were doing and created an incurable bond between them.

SHERYL GARRATT The new generation of artists had this confidence. With any movement, even with athletes, you notice that people break records in groups. If there's one great runner it inspires other great runners. If there's one really smart artist making a go of it, suddenly you have a movement because everybody else is inspired. They were all pushing each other to make better work.

MICHAEL CRAIG-MARTIN I've always believed that if you want a tall pyramid you have to have a big base to support it. One of the reasons the music world in Britain has been so phenomenal is because there has always been a large base of pubs and venues to play. British theatre was built on repertoire. What happened with the art world in the nineties was that the base got bigger and bigger and bigger. It enabled people to climb.

JEREMY DELLER You had that group of one or two years; a dozen people who were in the original shows. And then the scene expanded to about twenty artists who were in a lot of group shows around Europe and America. There are concentric circles to these scenes. You have the core group and then you have these circles of people around it. It was exciting because a lot was happening.

NORMAN ROSENTHAL After *Freeze* there was a second show that they did called Building One, in a former biscuit-factory warehouse in Bermondsey. Damien organised three shows: *Modern Medicine*, which featured Mat Collishaw's *Crucifixion*; Michael Landy's huge

installation *Market*; and *Gambler*, with Damien's *A Thousand Years*. That was more spectacular than *Freeze* because it was big.

MICHAEL CRAIG-MARTIN *A Thousand Years* was one of Damien's greatest and most important pieces that he ever did. No question. It's an amazing piece about the cycle of life.

MAT COLLISHAW Damien was living with me in north London when he designed that work. He built a mock-up out of cardboard and I remember thinking, Wow! This is an absolute game changer. It was beautiful with a sense of the infinite. When I saw it at Building One it was this incredible sculpture. It was so hardcore. So brutal. So simple. It was life, birth and death all happening at once. It had elements of voyeurism looking at this filthy sickness in front of you, utterly graphic in its depiction of life and death. It raised the bar.

SARAH LUCAS After *Freeze* I got quite disappointed with the whole thing, and privately thought, I can't keep doing this. I got fed with things like having an enormous amount of bricks that I had to accommodate and that nobody actually wanted to buy. When you're at college you've got a reason to make things and everything's still contextualised by the fact that you're still in this environment. But once you leave you think, Why am I doing this, what does it mean to me? I had to answer that question.

TRACEY EMIN Me and Sarah were looking for a studio together, and one of us said, 'What about a shop?' Sarah said, 'Yeah, but not a shop as a studio.' Then we both said, 'No, a shop shop.' Sarah had just sold her work to Charles Saatchi, and she used the money from the sale to finance a space at the top of Brick Lane. She paid the rent on the condition that I was there doing my 50 per cent.

SARAH LUCAS We did The Shop because we didn't want to get a studio. We thought it'd be quite fun. We only had it for six months, so it had to become something and gather force in that time, which it did. Tracey used to make these little cards, which just said, 'Have you seen that Shop?' and we'd pass them out to

people. People came along, mostly other artists, or occasionally some gallery people, or people off the street who just happened to get interested and were passing.

JEREMY DELLER Shops are scenes. They're like your front room or bedroom. They are places to hang out with the proprietor and watch the world go by, or the world comes to you.

TRACEY EMIN We made our own environment where people could come. And people came; sometimes one person, sometimes two people, sometimes ten people.

MAT COLLISHAW The Shop was somewhere to hang out and eat and drink and meet friends and chat. It was a hub. We all used to go to openings because it was a place to get free wine, get pissed and meet people. That was fine but it only lasted for two hours, whereas The Shop was like an opening that lasted forever, quite often all night.

TRACEY EMIN Our opening hours were Tuesday till Friday, 11 a.m. to 6 p.m. We had to work really hard. We had to serve, make all the merchandise, clean and sweep, and count the money. We were shop-keepers. Then on Saturday night we would open at eleven o'clock, all night till Sunday afternoon. We'd be really tired. It would be one o'clock in the morning, freezing cold, no one had come, and we'd say, 'Oh, let's make another piece of work.' I remember going, 'Oh, I saw David Hockney the other night and I asked him for a light. He said he didn't have one. I said he had one on his cigarette. He said he didn't want to give me his cigarette to light a cigarette.' Sarah thought this was really funny, so we decided to make a piece of work about it, *Our David Where We Find Light*; all these brilliant drawings with David Hockney with a cigarette – a sort of chicken-wire altarpiece.

JEREMY DELLER They were selling bits and bobs they'd made. I was always scared to ask how much things were. They had these mobiles they'd made, little signs, ashtrays. All these knick-knacks, and you'd think, Is this £2 or £50? They'd price it according to who they were selling it to.

SARAH LUCAS Tracey had a lot of business nous from the word go. She would say, 'If we sell something for this much, next time we'll double the price.' She had a knack for it. But it wasn't that much of a business thing. It was about being more visible. Nobody hated Thatcher more than Tracey did, so it wasn't about jumping on the bandwagon of yuppyism.

TRACEY EMIN Prices started at fifty pence. We made badges. We made a fish pond, painted in the style of Ken Kiss, and all the fish were called Ken, after Ken my tutor at the Royal College of Art. There were real goldfish in it. If people didn't have enough to buy anything they could throw some money in it and make a wish. Me and Sarah would take the money out and use it to buy goldfish food or pints of Guinness in the Dolphin pub next door. Then we would have to write the fish an IOU note, and they would be stuck all around the bowl. I did a pillow, *Give Me the Head of Tracey Emin*, that was stuck in the window. We put notices in the window about things that annoyed us or things that we believed in. I did a T-shirt that said 'HAVE YOU WANKED OVER ME YET', and Sarah's T-shirt was 'I'M SO FUCKY'. We were years ahead of *Loaded* magazine and laddism and ladettes.

MICHAEL CRAIG-MARTIN There were ashtrays with pictures of Damien Hirst's face stuck to the bottom sticking his tongue out. It was fabulously trashy.

MAT COLLISHAW The artwork was constantly changing. Tracey and Sarah would be making work when you walked in; stitching together some old neighbour's tights. I bought a David Mellor badge after he'd just been caught with his Chelsea football shorts down and was in the news for toe-sucking.

MICHAEL CRAIG-MARTIN It was mad and very funny. I look back on it and wish I'd bought everything in there.

TRACEY EMIN We were women who just did what we wanted. We used to ride our bikes everywhere, and people used to say, 'Oh, it's an attitude they've got.' And we'd say, 'No, we ride bicycles.'

Sarah brought a Chopper in the shop that she made a piece of work out of.

GREGOR MUIR Sarah is a brilliant relational artist. She has always wanted to work with the public and with people. For Sarah, art is in people, and is something she brings out through dialogue. She is an expert at acknowledging that if you sit in a studio for too long on your own, you run the risk of becoming uninspired. Whereas if you take over a building at the top of Brick Lane and turn it into a shop, people will be walking in every other minute saying, 'What's this?' Sarah rather brilliantly spotted that need to go for very naturalistic forms of engagement with people.

TRACEY EMIN One minute we were all scrapping around on the dole, feeling suicidal, and wondering whether to jump off Waterloo Bridge, thinking, Fuck this. And then suddenly things started to pick up.

SADIE COLES That was a definite shift. It was exciting because up until that point contemporary art hadn't even been featured in magazines, except for in this very stuffy generational way: a feature about Picasso's studio on the front of the *Sunday Times* magazine, that kind of thing. Suddenly there was interest and people being aware.

SHERYL GARRATT In May 1994, *The Face* did a Brit Art special. We were always looking for ways of filling space without having to commission a photo. If we liked it, we put it in. We did Gavin Turk's Sid Vicious full-page. You'd just look at it and think, Yeah, that's cool. Gillian Wearing came in one day with all her photos of people with white boards, and said, 'Do you want to look at this?' 'Oh, they're brilliant!' We did a double-page spread on them.

BRETT ANDERSON I loved Gillian Wearing: *Signs that Say What You Want Them to Say and Not Signs that Say What Someone Else Wants You to Say*. And *Confess All on Video. Don't worry you will be in disguise. Intrigued? Call Gillian*, when she got people to wear costume masks so you can't see their face and then on camera they have to confess

to something they've always wanted to get off their chest. The idea that you can say things behind a mask that you can't say normally posed the whole question to me of why people develop personas in pop music, in order to be able to do things they wouldn't normally be able to do.

MICHAEL CRAIG-MARTIN The YBAs made work that was accessible, readable and pertinent to their generation. It comes from having had an audience from the word go. They never worked without an audience. Many artists work in a situation where there's very little come back. Their work was affected by the fact that there was somebody to receive it. There was a shift in the relationship between the artists and the audience.

GREGOR MUIR There was a warmth and it brought the public into direct dialogue with contemporary art. It was work made to get your attention and engage you. As in, BAM! Big. In your face. Colourful. Immediate. You didn't need to read Foucault to understand it.

LOVE'S GOT THE
WORLD IN MOTION
Football violence. World Cup 90.
New Order. *Fever Pitch*

NICK HORNBY Throughout the seventies and eighties, football and music seemed very separate things. Rod Stewart was one of the few people who recognised that these two worlds co-existed, and John Peel, funnily enough. I remember going to a festival when I was a kid and Peel reading out the football results, and people booing around me: 'BORING. SHUT UP.' You had to be really passionate to carry on watching football throughout the eighties. Arsenal's first home game of the season in 1985 had a crowd of 23,000 in a ground that held 60,000. Hooliganism and the general misery of the conditions in which you watched had driven a lot of people away. You got used to seeing hundreds of people fighting with a line of police trying to separate them. It was just part of the fabric of football.

DAVID BADDIEL Most people would have thought of football as hooligans or burly blokes going abroad to cause trouble. That wasn't true of the vast amount of football fans, but their voice had been crushed by this grotesque hooligan figure.

STEVE DOUBLE It was lads wanting to have a good time. I went to Euro 88 in Germany as an undercover news journalist and did a 'day in the life' of an English hooligan. I spent some time with a Bristol City supporter. He was actually quite a decent chap: married

with two kids. He wasn't a Neanderthal, but in a short space of time he got involved in fights, stealing booze and using prostitutes. He did everything that an English thug abroad would do.

NICK HORNBY The national team was something that was not to be proud of, on or off the field. There's a piece I wrote in *Fever Pitch* about taking a group of Asian visitors to Wembley in 1988 and it was just awful because of the racism: 'Look at all these fucking wogs in our seats.'

TJINDER SINGH That's the flag I know: the flag that creates the fucking violence on the terraces. Every time England play I don't pass the fucking Tebbit test.[1]

TIM SOUTHWELL The jingoistic side of supporting England is often difficult to deal with. It makes you feel uneasy being part of that fan brigade; some people will be singing 'No Surrender to the IRA'. Football was so derided by the majority of critics and by people who didn't have a vested interest in the game.

NICK HORNBY Then Heysel[2] happened, and people got even more pissed off with it because English fans plus crumbling infrastructure in the stadia had caused thirty-nine deaths. Things got worse and worse. And then there was Hillsborough and the tragedy of ninety-six deaths.

STEVE DOUBLE The combination of Heysel and Hillsborough were massive shots to the system. Something needed to be done. Unwittingly, Italia 90 gave the game a premium.

DAVID BADDIEL Italia 90 had a lot to do with a shift in youth culture. It was the beginning of a redefining of what maleness

1 In an interview with the *Los Angeles Times* in 1990, Conservative MP Norman Tebbit said, 'A large proportion of Britain's Asian population fail to pass the cricket test. Which side do they cheer for? It's an interesting test. Are you still harking back to where you came from or where you are?'

2 On 29 May 1985, at the European Cup Final between Juventus and Liverpool, thirty-nine fans were killed during clashes between supporters.

was: it's all right to like women; it's all right to like football; it's all right to like beer.

KEITH ALLEN That World Cup changed everything: the BBC adopting Pavarotti singing 'Nessun Dorma' as their tournament tune; the heat of that summer; Ecstasy; Gazza as a football phenomenon; and New Order recording the official World Cup song.

SHERYL GARRATT There was a real sense that there was a semi-underground scene going on with music and clubs and Ecstasy and football fanzines. It kept poking its way into the mainstream. Everyone was in on the joke: everyone understood the drug references in songs, and those songs were number one. We thought it was hilarious. Footballers went from uncool to cool in five minutes.

KEITH ALLEN Tony Wilson was approached by a guy called David Broomfield at the FA, who asked if he knew anybody who would be interested in writing the World Cup song. New Order don't know a great deal about football, so Tony asked me to write the lyrics because I knew something about football. I was running around the basement of the Haçienda trying to piss on him with my cock out. 'STOP IT, KEITH. I'VE GOT A PROPOSAL.'

JEREMY DELLER Most football songs are awful. 'World in Motion' was a great song.

KEITH ALLEN The first thing I wrote was 'E is for England/England starts with E/We'll all be smiling when we're in It-aly'. Tony said, 'Fuck off! We're not having that.' Then out of the blue, he phoned me and said, 'We're in Peter Gabriel's studio. We need you down here.' 'Fucking what!' I'd been to a club in London and I was absolutely twatted, so that morning I sat on the train to Bath listening to the backing track I still had on a Walkman and started to write the lyrics. I remember writing the rap and giggling about it being a drug and sexual double entendre: 'You've got to hold and give/ But do it at the right time'. It was just me being naughty: 'Get round the back'.

JO WHILEY I wasn't that interested in football, but I thought 'World in Motion' was hilarious because I loved New Order more than anything in the world. The fact that they'd teamed up with the England squad and were doing this football song, they were right there in the mainstream.

KEITH ALLEN About a month later I got a call from Tony: 'We're in Led Zeppelin's studio. Six of the England team are coming. We need some more words.' I turned up and that was the first time I heard the chorus, 'Love's got the world in motion'. I remember saying to Tony in the car when we went to pick up Bernard [Sumner] from his hotel, 'Is *arrivederci* an Italian word?' He said, 'Yes it is, Keith.' I said, 'I've got it: "We're singing for England/Arrivederci it's one on one."' Bernard got in the car and puked up in a Boots bag. We took him to the studio and there was Steve McMahon, Des Walker, Peter Beardsley, Chris Waddle, John Barnes and Gazza – the only six players that bothered to turn up. They were like school children. Even New Order were shocked. We tried them all to do the rap. It was fucking hilarious. Steve McMahon, *mumble, mumble*. Des Walker, the only black person I've met with no rhythm. And you couldn't understand a fucking word Gazza was saying. It was just insane. He saw the vocal shield with a pair of tights stretched across it, sniffed it and said, 'Beardo, are these your wife's knickers?' He then drank three bottles of champagne and drove back to England's training camp in a Merc.

SHERYL GARRATT Seeing the England football team singing those lyrics and clearly not having a clue of the double meaning was incredibly funny. It was like, 'They're getting away with this? I can't believe it!'

JO WHILEY I remember so clearly seeing the video for the first time – I was working at BSkyB's Power Station[3] – going, 'John Barnes! Doing a rap! What's he doing?' It was hilarious.

3 British satellite television channel dedicated to music.

NICK HORNBY It was only a few years before that England fans were booing John Barnes. I got very excited when 'World in Motion' came out; that nexus of cool music and football felt genuinely new in 1990. When you think of the previous tournament songs, which were not cool in any way whatsoever – the players would go on *Top of the Pops* standing stiffly with a rewrite of some national anthem. Then suddenly there's New Order, right at the peak of their coolness, doing this really good song that had a sort of ache in it.

STEVE DOUBLE 'World in Motion' took hold before the tournament because it was a bloody good tune. It was the best England song, and John Barnes's rap fitted in nicely. But it was never a terrace chant. It was a good hot-weather tune and captured the era pretty well.

TIM SOUTHWELL 'World in Motion' was probably the start of Cool Britannia. It put football back on the map and it made people really proud. New Order were a really cool, seminal band and they were football fans. That song legitimised my passion for football. I wore my 'World in Motion' T-shirt all year.

KEITH ALLEN A lot of people were going to raves then going home and watching Italia 90. The big shift was having women and girlfriends included in the experience because you had a club culture interweaving itself with a football culture. That had never happened before. They'd been up all night raving; there was a huge love thing; everyone was everyone's mate; it was party, party, party. World Cup 90 was an extension of a rave. It wasn't something over there in a box that sporty people watched. It permeated everything because everyone was on the same drugs.

NICK HORNBY World Cups had not made an impact in the UK, either because England weren't there or because they were embarrassing or because it was on in the middle of the night. You look back: 1974, didn't qualify; 1978, didn't qualify; 1982, qualified, peak of hooliganism, didn't do very well and some trouble; 1986, Maradona 'Hand of God', did quite well but games broadcast at eleven o'clock at night because it's South America. Then 1990. It

was primetime television with spectacular new technology. When you saw those dramatic close-ups and slow-mos of Italian faces, and the agony of the crowd and the penalty shoot-outs and faces of beautiful Italian girls in the crowd crying. This was new stuff. Plus, England go through to a semi-final, which hadn't happened since 1966. It became a drama.

STEVE DOUBLE I remember all these teenage Italian girls had to be seen with an English thug on their arm; the bizarre sight of these lovely looking girls with English tattooed brutes. It was very funny. It was a fabulous tournament, and as the team progressed it became less of a hooligan story and more of a celebration. And then, of course, there was Gazza mania.

JEREMY DELLER Paul Gascoigne was a really interesting person in British life, his vulnerability and the tragic quality to him. I saw him as someone who couldn't cope with what was going on around him. He was massively talented, but the drama of his life was played out in front of everyone, beyond his understanding, almost. Like a normal guy who was treated in a certain way and all these things happened to him.

STEVE DOUBLE After the 1–1 draw against the Republic of Ireland in the opening group match I got a call from the office saying, 'Get yourself to Rome airport in the morning. We're flying out Gascoigne's best mate.' I went to the airport and met this mad Geordie I could barely understand called Jimmy Gardner. The idea was to get Jimmy's story, but of course Gascoigne told him, 'Tell him nothing.' Jimmy and I got on quite well, but it was like trying to get blood from a stone. I remember asking him, 'What does Gazza call you?' He wouldn't answer for three days. Finally he said, 'Five Bellies.' The headline was 'Gazza and my mate Jimmy Five Bellies'. One of the craziest things I had to do was when the news desk said, 'You need to get Gazza a trout.' I said, 'Why?' They said, 'He misses trout.' I said, 'This is ridiculous. You want me to escort his best mate, who is completely off his head, and find a trout?' They said, 'Yes.' So Jimmy and I found a fishmonger, half-cooked a trout and presented it to him.

SIMON FOWLER In their second match, England had a goalless draw against Holland and then beat Egypt 1–0 to progress to the last sixteen. David Platt scored a stunning late goal against Belgium and then we beat Cameroon in the quarter-final, which put us in the semis, and the nation was gripped by the possibility of England making the final.

STEVE DOUBLE I was in Turin for the semi-final against West Germany, and one of my favourite memories was, before the game in the car park, a Korean lad doing fantastic ball skills who had a ghetto blaster playing 'World in Motion'. The German and England fans were being begrudgingly civil to each other watching this guy. I remember Lineker's equaliser in the eightieth minute, and the penalty shoot-out when Pearce and Waddle missed, but a lot of the match passed you by.

SIMON FOWLER It was a tense game and then Gascoigne picked up a yellow card, which meant he wasn't going to play in the final.

STEVE DOUBLE You didn't have the benefit of TV cameras, so I didn't see the tears. But suddenly, as far as the British tabloids were concerned, Gazza was hot property. We flew to Bari and attempted to meet up with him. It was a classic tabloid stunt. There was me, a Sunday redtop journalist, bowling up with his mate: 'Can I talk to Gazza?' 'No, you can't.'

KEITH ALLEN We followed the team down to Bari, and I've got some great pictures of me and Gazza naked on a diving board with him wearing a pair of plastic tits.

DAVID BADDIEL I don't think, Gazza cries and suddenly it's all right to like football. But it was part of it. England were knocked out, but Italia 90 certainly made an impact, and out of the ashes of the terrible things that happened at Hillsborough and Bradford[4] and Heysel, football grounds were changed. And for better or worse,

4 On 11 May 1985 a fire in the main stand at Bradford City Football Club killed fifty-six people.

the Premier League starts. That is important because it changed the economics, the advertising and the iconography around football. It offered an opening to say, 'I'm a football fan but I'm not a hooligan.'

NICK HORNBY The first season of the Premier League was 92/93. There was a notorious night at Highbury when The Shamen entertained the crowd at half-time and mimed to 'Ebeneezer Goode', accompanied by a troupe of dancing girls. It was a Sky initiative, which they thought was going to entertain people. The Shamen were roundly booed off.

SIMON FOWLER It's significant that the Premier League started after Italia 90 and football becoming so enormous in the country. Apart from internationals, *Match of the Day* only used to show highlights from three games. Football had always been huge, but suddenly it was in a different way.

ALASTAIR CAMPBELL During the eighties football became a big negative because of all the hooliganism. Added to which, Thatcher didn't have any interest in football whatsoever. I think that football and the rise of the Premier League and the elevation of some of these players, suddenly becoming like film stars, felt like part of this same story of renewal.

JOHN MAJOR An amalgam of things made the Premier League a success. After Hillsborough it was clear that we needed to look at the safety of sports grounds. Football had to be for everyone. It is a national sport, and the grounds had to be secure and safe environments. After the Taylor Report[5] I argued that it was prudent to put money into football in order to make sure that was the case.

NICK HORNBY The thing that made a huge difference was the money. We suddenly had European superstars like Dennis Bergkamp and Eric Cantona playing in England. Previously, players

5 In 1990, the Hillsborough Inquiry, overseen by Lord Justice Taylor, established the cause of the tragedy and made recommendations for the future safety of football grounds.

would go to Europe: Ian Rush to Italy; Mark Hughes and Gary Lineker went to Spain. You got used to the idea of losing stars. All of a sudden, you're watching some of the best players in the world, right in front of you.

JOHN MAJOR Thirty years earlier everyone would have seen Pele when he came to play for Brazil at Wembley – that was it. With the Premier League everyone could see the greatest players in the world, on television, or live at the grounds, every week.

DAVID BADDIEL There was a sea change in the early nineties around the identity of the football fan. There were things being written that were changing the way people talked about football, like Nick Hornby's *Fever Pitch*, and *All Played Out*, about Italia 90, by Pete Davies. What was different about those two books was that they were about the experience of football fandom. The main experience of football fandom in literature before that was hooligan literature. There hadn't been emotional, funny, intelligent writing on what it meant to be a football fan. As such, it said, 'Maybe the football fan is a more complicated person than just the skinhead,' or whatever.

SHERYL GARRATT *Fever Pitch* was like an infectious disease. Every man I knew who read it suddenly decided his future happiness depended on whether his team won on Saturday. 'My life is over. West Ham lost today.' It suddenly became fashionable to have a football team and your life hinged on the results. It's not what Nick Hornby meant. He was talking about Arsenal taking the place of a lot of emotional things he'd lost.

NICK HORNBY *Fever Pitch* came out of fanzine culture. When I saw the first few issues of *When Saturday Comes*, and it was funny and smart and clearly being read by people who were not hooligans, that encouraged me to think there was a market. The readers weren't yobs or tattooed Millwall fans. They were literate people who wanted to read something about football that wasn't gibberish pumped out by the clubs.

DAVID KAMP Nick Hornby was a warm, lovely, ordinary person. There was no flash to him. He was this humble, balding fellow, like a normal person who struck it big. He put his finger on something with *Fever Pitch*, and later *High Fidelity*, that had previously gone unarticulated: there are people who are passionately geeky about football in the same way they are about music.

NICK HORNBY *Fever Pitch* created, in small cultural circles, an environment that enabled people to talk about their love of football. And then people started to parody it: 'Oh, now Sebastian Faulks says he likes football.' Sebastian had a letter printed in *Shoot* in 1965. People didn't believe you if you said that you liked football at the end of the eighties. Plus, all these people who were kids in the sixties were commissioning articles, writing articles, writing books. It was a whole new generation in media and politics.

IRVINE WELSH There was definitely an influx of new football blood. *Fever Pitch* gave a lot of middle-class people who liked football permission to say, 'Yeah, I do actually like this.' I knew people who had never been to a football game in their life and suddenly became season-ticket holders at Arsenal or Chelsea; people who disdained football and became really interested in the nineties. It became much more of a consumerist thing: 'I want to buy a season ticket because I need my seat to be there.'

NICK HORNBY I'd love to claim credit for *Fever Pitch* bringing people to football, but it's complicated because no one's got any figures. It's all gut feelings. These observations that middle-class people were all of a sudden going to football: I remember Tony Parsons saying to me, 'Who do they think sat in those fucking big stands anyway in the 1930s?'

DAVID BADDIEL Middle-class blokes had always liked football but hadn't really had a voice within football for a long time.

STEVE DOUBLE *Fever Pitch* was exceptionally well-written, but I can't imagine anybody who wasn't a football fan read that book and then thought, Oh, jolly-ho – let's go to the game this afternoon!

I think it was more prosaic than that. All-seater stadiums made it more comfortable and family friendly. Tickets slowly got more expensive, coupled with the fact that it had to be a more planned activity. You couldn't just turn up. It was less spontaneous. There was an element of traditional working-class fans being priced out of the game.

NICK HORNBY I particularly noticed with increased admission prices the expectation of success. If you're producing mediocre results for eye-watering amounts you've got problems. In the seventies and eighties you never resented the money because you didn't think that you had some investment in their success. Prices increased with all-seater stadia, so you've got an increase in popularity of the game followed by a decrease in the capacity of the stadium. Suddenly it's a hot ticket. Also, kids and women could see. It's such a basic thing. If you stood on the terrace and were an average-sized woman there wasn't much point in going. I would say that people started coming back to football in the nineties when it became a more attractive option. I remember seeing someone at Arsenal with a National Theatre carrier bag coming through the turnstiles. I thought, Oh, this is getting different!

STEVE DOUBLE Arsenal had the most middle-class crowd I'd seen anywhere.

NICK HORNBY In *Fever Pitch* I wrote, 'Assumption: You like football? Then you also like soul music, beer, thumping people, grabbing ladies' breasts, and money . . . one can admire Muriel Spark and Bryan Robson.' The number of reviews I had where they picked out lines that had literary references and said, 'Ooh! Look at this. This bloke watches football and he's read *Pride and Prejudice*.' It used to really piss me off. I knew loads of guys like me – grammar-school boys, liked their music, liked their football, supported a team, went to watch them play – who were not represented anywhere in the media.

DAVID BADDIEL It became a cliché to say that suddenly football was more middle class and prawn sandwiches, blah, blah, blah. I don't

accept that. I come from the lower middle classes. I've always been interested in football. It was impossible to be a Jewish male in the seventies and not be. What happened was the middle classes came out of the football closet and said, 'We are interested in football.'

NICK HORNBY Football became the new cinema. It was nothing to do with class and violence anymore. In the eighties, you wouldn't cross London with a scarf. Now everybody wears a shirt and nobody's bothered. That all started to happen during the nineties. Football became a day out. That culminated in England hosting Euro 96. It was symbolic of football's transformation from an unsafe, and often dangerous social activity, to being a focal point of all that was great about being British.

A BLOODLESS REVOLUTION

Roots of Britpop. Morrissey. Union Jack. Grunge

SIMON FOWLER The rave scene awakened a generation, but it wasn't exactly music you'd listen to on a Saturday afternoon goggling over the album sleeve. It was a movement devoid of leaders and pop glamour. The Stone Roses turned that around in 1989 with 'Fools Gold', and what became known as 'indie-dance'. And they just looked so fucking cool.

PAT HOLLEY The Stone Roses and the Manchester baggy scene had been this little glimpse of what could have been a glorious reign of British music, but it burnt out very quickly. It was then taken over by house music and grunge. Fucking hell, which one do you want to stab yourself with? We were getting to our early twenties, and thinking, We're never going to have our youth movement. Then Suede appeared on the front cover of *Select* magazine in April 1993 and everything changed.

PHILL SAVIDGE Danny Kelly, to make a statement as the new editor of Q, had put Brett Anderson on the cover exposing his chest with the title 'Revealed! The band of 1993 . . . Can you stomach SUEDE?' It was one of eighteen front covers Suede would have before they released their first album. Then *Select*, with the idea to claim back some of Suede, put Brett on the front cover as the head of a movement with a Union Jack superimposed behind him, and the title 'Yanks Go Home!'.

BRETT ANDERSON I was angry because the Union Jack was very much seen as a nationalistic symbol. It was ugly and not very Suede-like. It's tasteless superimposing someone in front of any flag. It was almost like I was saying, 'Yanks go home!' I would never say something as idiotic as that.

STEVE LAMACQ What's the single absolute symbol to bring all these bands together and to give it a powerful purpose and a context? Put the Union Jack on a front cover. We had started to ignore our own maverick stars. It needed a catalyst that was something sexier and younger. And that was Suede.

PHILL SAVIDGE There was an illustrated diagram inside the *Select* feature depicting British bands invading the US, with the *Dad's Army* reference 'WHO DO YOU THINK YOU ARE KIDDING, MR COBAIN?' in reference to Kurt Cobain and Nirvana. That was my music philosophy. I had been saying for the past year, 'Why don't we just do British bands and celebrate English music?' Grunge music said a lot of things about social alienation to American teenagers but not to English teenagers. Stuart Maconie wrote the leader, 'Enough is enough! Yanks go home! And take your miserable grunge wear and your self-obsessed slacker bands with you [. . .] we want people who never say 'dude' or 'sidewalk' [. . .] we save the Union Jack from the Nazis . . .' It was more jingoistic than I wanted.

JARVIS COCKER The *Select* cover marks a point. Once you start putting a flag behind things, it turns something from being a revolutionary ferment to nailing your colours to the most traditional establishment thing you can. That's where it begins to get co-opted. You can see it right there.

BRETT ANDERSON This is what journalists like to do. They're slightly obsessed with creating scenes, finding the new punk. All you have to do is look at the grouping of the bands included – Suede, Saint Etienne, Denim, the Auteurs, Pulp – to realise that it was nonsense. They were looking to create a union of bands.

I didn't have any kinship with any of those bands. There was never a vanguard or a scene. But that might be the cusp of where the Union Jack went from being an ugly, dubious nationalistic symbol into a symbol of pride, which later Britpop bands seemed so happy to twirl around them. That's the point where the Union Jack became acceptable.

JOHNNY HOPKINS I hated the cover. It was a backward step and clumsy. It stirred up the whole Morrissey thing again, when he flaunted the Union Jack on stage at Finsbury Park in 1992 when he supported Madness.

JEREMY DELLER The flag was really troublesome because it was associated with right-wing demonstrations. So, in that context, Morrissey's use of the Union Jack was disturbing. I was at the gig: it was quite a drunken audience and felt quite territorial. Before Morrissey came on, the crowd was chanting football songs and singing patriotic renditions of 'Rule Britannia' and 'Land of Hope and Glory'. An image came down of two skinhead girls and the audience started booing. Then Morrissey came on wearing a gold lame shirt and, mid-set, he whipped out the flag. It was like, 'Oh, shit.' There were lots of boos and shouts of 'poof'. He played 'National Front Disco' and people started chucking plastic bottles, stuff was flying around. You could see people getting intimidated and thumped. Morrissey turned his back, and someone chucked something and it whacked right on his back and he walked off.

TJINDER SINGH It wasn't just the incident at Finsbury Park that we took umbrage to. It was a whole catalogue of incidents. The fact that Morrissey was vegetarian and he could persuade people to follow his need was a virtuous act, but if he was encouraging or turning a blind eye to what some might consider racism, and being Oscar Wilde about it, while people are getting kicked in in the East End, then that's not good.

JEREMY DELLER Morrissey was definitely trying to make a statement about nationalism and misjudged what he was doing. He

had form. For years there were things he'd said and songs he'd written which were ambivalent about race. It hadn't come out of nowhere.

SONYA MADAN What he was doing by singing 'England for the English' was making you think. Morrissey wrote with honesty, unapologetically. We need to wake up a little bit. All this PC banal culture of niceness and nothingness and no artistic integrity – which one do we want? People have the right to an opinion, and if you push that down and call them racist you just create a powder keg. You have to allow expression and try to understand where artists are coming from. You can never push things down and make people shut up. They don't stop thinking it. They just feel they can't say it and then violence happens. Everyone is racist but they don't realise it. It's human nature to judge each other.

BRETT ANDERSON Morrissey was covering Suede's 'My Insatiable One' at the time, so I went to Finsbury Park to hear it. He didn't do it, but you couldn't avoid the incident. The next week on the cover of the NME there was Morrissey with the Union Jack, and the headline 'Flying the flag or flirting with disaster?'

NOEL GALLAGHER That's the NME for you: as soon as they invent Britpop then the Union Jack is fucking cool. If somebody two years before – Morrissey – is actually the inventor of Britpop, he's a racist. I guess they just didn't like him. But waving a Union Jack on stage to a load of skinheads is probably not the brightest idea.

SONYA MADAN At the end of the day Morrissey was celebrating his culture, his heritage. What's the problem? They were looking for an excuse to demolish him.

TJINDER SINGH We burnt Morrissey posters on stage and then burnt one outside his record label. People were getting angry. There were a lot of marches and demonstrations against the rising tide of the right wing. Morrissey probably kept quiet about it because that's the way to get people talking.

SONYA MADAN I had a T-shirt with a Union Jack on it and the words 'ENGLAND SWINGS'. I crossed out 'SWINGS' and wrote 'MY HOME TOO'. It was for an interview in *Vox* magazine. I said, 'For an Asian girl to wear a Union Jack is obviously going to spark discussion. I like to piss people off by taking something that's sacred to them and throwing back the true meaning in their face.'

PHILL SAVIDGE Sonya was claiming the Union Jack on her own terms.

TJINDER SINGH Sonya never sang anything with regard to that situation. She was posturing and jumping on the Brit Cool bandwagon.

MEERA SYAL 'MY HOME TOO' was the nub of it. We had a lot to prove. We were the first kids born to parents who had come directly from the mother country. We were the bridging generation, the generation that got the brunt of the racism, in many ways. We really had to question where we belonged. The Union Jack didn't belong to us. When I was growing up, patriotism was synonymous with fascism.

JARVIS COCKER The nearest Pulp got to flying the flag was Russell, the guitarist, who had a pair of Union Jack socks. He used to delight in putting his foot on a box or something so you would see the sock. There was something happening in the early nineties, but it had nothing to do with nationalism. It was more to do with what I thought was the indie scene, and trying to bring alternative and maybe left-wing ideas into the mainstream. That was an exciting feeling because it seemed pop could become interesting again. 'Wouldn't that be great if these ideas weren't just something happening in a room above a pub for thirty people to watch; that you could play in a stadium and people would be interested.' It was the idea of a bloodless revolution; a revolution for fun and interest. At that point they hadn't coined the term 'Britpop'. At first, they tried to call it 'Lion Pop'. It sounded like an ice cream.

STEVE LAMACQ We didn't use the term 'Britpop' in the *Select* piece, but it was the birth of where Britpop, as a scene, started.

You had a really interesting diversity. You had Pulp, who grew up in Sheffield and had a certain drudgery chic about them and were writing about how you get by with two quid in your pocket, and Suede, who, even though they only had two quid in their pocket, were more aspirational glamour.

PHILL SAVIDGE What is the definition of Britpop? That's the most difficult question I've ever been asked. It was obviously British: there was a lyrical strain that ran through bands like Blur and Pulp and Suede; they had connections to downtrodden lives and aspirations. I claim that I invented Britpop as an anti-grunge movement, because as Savage & Best we were the only PR company that exclusively did British bands. We were representing three of the bands that were on the first Britpop cover, so it obviously emanated from our office. It was the conscious decision to do only British bands.

STEVE LAMACQ Everyone claims to have invented Britpop. Britpop wasn't really embraced until the first wave of bands had really started happening, and bands like Supergrass and Sleeper came along. One of the defining moments of the whole period was 'Common People' getting to number two. Before that, alternative music could barely get arrested in the chart. And then very rapidly, over the course of a couple of years, the music that we liked became more prevalent. Major labels suddenly realised there was an audience out there that they'd not understood or tapped into. All of a sudden, Pulp began to sell records in huge numbers; this ultimate misfit band from Sheffield, with their weird idiosyncratic view of life, became pop stars.

JO GOLLINGS How many people bought 'Common People' who would never have listened to indie music? 'Sing along with the common people', and everyone did.

MEERA SYAL We did a version of 'Common People' on *Goodness Gracious Me*: 'I want to live like Hindi people . . . I smiled and said, "Do you want a vindaloo?"' It was brilliant.

STEVE LAMACQ I don't think I've ever played a record when DJing – apart from the Stone Roses – where I've seen an audience go, 'This is the one. This is us. This is now.' I stood there and thought, This is our victory; we've come from nothing and we've won. Jarvis represented all of us. He was the guy who said, 'Anyone can do it.'

SHERYL GARRATT It felt like we were taking back control. Suddenly all these bands came up that were British and exciting and accessible to us. It was thrilling.

JARVIS COCKER In some ways, to be included in something seemed great because we'd always been considered as outsiders. And the fact that it was home-grown was good, in the way that you weren't worshipping something from afar. But I hated the term 'Britpop'. It put creative people in an awkward situation. Anything that's got 'Brit' in it, it sounds horrible. Anything that tries to play to nationalism.

NOEL GALLAGHER Britpop was the same thing as Cool Britannia, just a label some fucking bright spark put on it. From what I understand a letter was sent to all the indie record labels that the *NME* were going to focus their entire thing now on British guitar music because grunge had died. All the record labels were asked to bring an artist and Creation put forward Oasis. It wasn't with my permission. It was nonsense.

ALAN McGEE I would never be party to a music business that was rallying against grunge. That's what journalists do. Zero of it was thought out. It happened. As much as people want to think there's a wicked puppet master, it doesn't fucking exist. You can sum me up by sending Primal Scream to Memphis with Tom Dowd. For better, for worse, Oasis defined Britpop, with Blur. They didn't like the term. I didn't like the term. But that's what it was. It was a movement of bands.

JARVIS COCKER It was painted in the media as a UK versus US type of thing. I don't think it was that. It was more the idea of trying to involve an audience. The thing we felt was that you had

to reach out to the audience and include them in what you were doing. Grunge had an almost abusive attitude to the audience. If you think of the words to 'Smells Like Teen Spirit' – 'Here we are now, entertain us' – you've got this idea of the audience saying, 'Come along, entertain us.' That's quite an ambivalent attitude, whereas we, maybe because we'd spent twelve years in search of one, actually liked the idea of an audience. This idea that everybody was in it together.

KATIE GRAND I hated Nirvana's album. It was like, 'Oh, turn it off.' It used to be something that the boys put on at four in the morning, 'Oh, God, can we have some disco instead?'

BRETT ANDERSON Grunge was a red herring. There was a raw, animalistic intensity to grunge that I quite liked. I had always looked, slightly woefully, at a world full of boys in backward baseball caps pretending that they were living in New York, and thought, Why don't you celebrate your own culture? If there was anything good that came out of Britpop and Cool Britannia, it was a rejection of American cultural imperialism.

STEVE LAMACQ If you think about it, Britpop should never have happened. What is Britpop? It's some foppish art-school chancers from Essex, Blur, who have already had one go at being pop stars and essentially blown it.[1] You've got these swaggering Mancunian casuals, Oasis, and you've got this odd band from Sheffield, Pulp, who write songs about hiding in a wardrobe. How do you bring that and the Manic Street Preachers and Radiohead together and then give it a title? The reason Britpop happened was because everyone was different and everyone had their own story.

BRETT ANDERSON One of the reasons Britpop happened was because, on one hand, you had a very strong sense of underachievement in the alternative world, and then in the pop world there was just faceless charisma-less pop and anodyne dance music. There

1 'There's No Other Way' was a number eight hit for Blur in April 1991, but the group's subsequent four singles all failed to break the top twenty.

was a sense of cultural malaise that was reflected politically in John Major's Britain. It was a very depressing, grey place to live; a world of unemployment and cut-price lager and crap boy bands. It was desperate men in cheap suits and ugly logos on phone boxes.[2] Everything was painted in landlord magnolia and nothing seemed to work properly. People got excited about Suede because we were diametrically opposed to everything all those other bands stood for, and were very much reacting against that backdrop.

DAVID KAMP When Suede's first album came out and then Blur's *Modern Life Is Rubbish*, I thought, Something exciting is happening here. Blur were returning to a mid-sixties English songcraft with melody and precision and sharp lyrics about harried London commuters and people named Colin and Julian.

KAREN JOHNSON Blur did a photo shoot that showed different vignettes of life. BRITISH IMAGE 1 with a Great Dane and the band wearing Doc Martens and Fred Perrys. It was a hard street look. They did another one with 'Modern Life Is Rubbish' sprayed on a wall behind them, and another one with a living-room set-up called BRITISH IMAGE 2. The *NME* thought it was racist and called it 'fascist imagery', and accused the band of being 'nationalists'.

DAMON ALBARN *British Image 1* was a photographic book from the mid-seventies produced by the British Arts Council. We put that image out and there was quite a bad reaction, but it was part of who I am: the lad; the England supporter; the person who is moved to tears by 'Jerusalem'. I was consciously walking a tightrope between that sense of connection and disconnection to my country. Tris Penna, who was our clever guy at Parlophone, said, 'Why don't you do one where you're all dressed up as Oscar Wilde?' So two days later we put that out.

JEREMY DELLER *Modern Life Is Rubbish* was Blur trying to make an English record with a soft mod, 2 Tone look. It's like a Kinks

2 In 1991, British Telecom shortened their name to BT and introduced a new kiosk with a piper brand logo on clear glass.

record with louder guitars, and it had a great cover of the Mallard steam engine.

DAMON ALBARN We toured relentlessly around the country in Fred Perrys and DMs. At the end of it we were headlining festivals with a whole sea of people who dressed like us, singing all the words back at us. There was a sense of underground solidarity; a celebration in terms of the look, the sound and a shared heritage.

SONYA MADAN I remember early on, when we'd just got Echobelly together, and we were all hanging out together in Camden and Soho. I was in a pub off Berwick Street, and Blur turned up and we were wearing the same clothes. They looked at us and we looked at them, and it was this thing of, 'Oi! You're wearing our uniform.' It sounds trivial, but it was a sudden awareness that something was happening and jumping off-board for something bigger. Damon is very astute. He probably mapped it all out. A lot more than we did.

DAMON ALBARN My vision was my experience as a nine-year-old, moving from multicultural, working-class Leytonstone into deepest, darkest Essex and feeling quite alienated as a result of that. It's only fifty miles up the road, but culturally it was dramatically different. I had school friends who were white English, black English, Pakistani English, but Colchester was 100 per cent white, Anglo-Saxon. Those characters were my bedrock – the good yeoman of the fair county of Essex – people I watched and observed and lived among, and who then populated my songs for many years. Also, it was imagining what would happen to them with this tsunami of Americanisation I could see coming: in our media, in our eating habits, the prevalence of advertising.

JO WHILEY Britishness was absolutely key: young kids on the streets of Britain singing about their lives and claiming music for their own. Turning their back on the music from America and wanting to reflect their day-to-day living. It was very much about the issues that directly affected them: the mundane, relationships,

their heritage, how they'd grown up. That's why it translated and that's why so many young kids seized it and the scene grew.

BRETT ANDERSON I was never celebrating Britishness or Britain. That's the huge difference between Suede and the bands that came later. It wasn't an obsession with Britain; it was documenting the world that I saw around me, which was failed and cheapened, 'all the love and poison of London'. London itself is a beautiful, poisonous, ugly, wonderful city. It's almost like a microcosm of life. So celebrating it and just seeing it as a great thing seemed incredibly simplistic. Our relationship with Britpop was like the mother who finds the child stealing from her purse and would never be able to look at it in the same way again. We gave birth to Britpop, and then ultimately Britpop betrayed us.

DAMON ALBARN Why did we make a record so knowingly English at a time when guitar music was utterly in the shadow of Nirvana and grunge? We had spent quite a lot of time in America after our first album, playing small clubs. It was a brutal apprenticeship in why we were doing what we were doing, and I spent a lot of time walking around cities and seeing things that were just beginning to emerge back home that were going to be quite destructive to our sense of ourselves. I brought back this warning, this anxiety about a profound wind of change coming over the Atlantic and weaving into the society. Its brightest manifestation was when *Parklife* came out.

PHILL SAVIDGE *Melody Maker* had a cover subtitled 'Cool Britannia' with Blur, and the heading 'England's Dreamers . . . Britpop '93'.

JO GOLLINGS I remember being on a train and picking up a copy. Damon totally slagged off Nirvana and American imperialism.

KAREN JOHNSON At the time, Blur were in the mentality of wanting to be as big as Suede.

PHILL SAVIDGE Damon was jealous of Suede. The press would write about anything that Brett did, whereas it felt like Damon had to tell them what he did.

JEREMY DELLER It was probably quite calculated: 'We've got to do this. We've got to make music like this. We've got to beat Suede.'

DAMON ALBARN Alex [James] said Britpop was 100 per cent my idea. Brett wouldn't agree with that. But you know what, he can have it all. There's no ownership of any of it, for any of us, really. It's about that intangible thing that has fascinated man for ever, the spirit. I think everyone fed off each other's interpretation of that spirit.

PHILL SAVIDGE The evolution of Britpop, in many ways, centres on Justine Frischmann. She was the original guitar player in Suede and was going out with Brett. Then she started seeing Damon and formed Elastica. Damon and Justine became the Britpop couple, and many of the ideas that Brett had developed in Suede found their way into Blur.

BRETT ANDERSON Justine is the keystone in all of this in lots of ways. It's interesting the incestuousness of what was going on. She was there developing this idea of Britishness with me and then she passed it on to them. She was a conduit. It's a tricky one. This person who I knew in one sense, an ex-girlfriend, was suddenly projected into a different world.

JO WHILEY Justine said, in a *Guardian* interview in 2003, 'The whole Suede thing was very much to do with Britishness, and I carried that scene onto Damon and told him about it, and he took it a step further. But he was more playful: he put on a mask and played a part.'

KAREN JOHNSON Damon met Justine at a gig. I was sitting next to Damon and Justine just started chatting to him. That was the moment. There was obviously a spark. It got a bit dark because she was still going out with Brett.

DAMON ALBARN Brett won't say my name, nor the word 'Blur'. It's a shame there's that residue of bad feeling because at the end of the day we all live and love and are fascinated and repulsed by aspects of this country.

BRETT ANDERSON Hating people is part of the inspiration. Revenge and resentment and jealousy are motivations. Lots of people become successful because they want to try to prove a point. Justine and me splitting up was a huge thing that enabled me to find something to write about. Those early Suede songs laid the foundations of what became Britpop.

STEVE LAMACQ I don't think anyone really worked out Britpop before Britpop happened, but, inadvertently, Damon Albarn probably shaped what Britpop looked like. He was looking for things in his roots, and thinking, Where do we go next? And partly, I think, it was, I just want to be different.

DAMON ALBARN I was creating these characters, people lost on this island with an innate sense of their own heroic failure, but unable to see further; sort of myopic heroic failure. My point is that those records – *Modern Life Is Rubbish, Parklife* and, later, *The Great Escape* – were seen as this modern celebration, of what would become Cool Britannia. They were not a celebration. They were a satirical look at the erosion of an Englishness and the emergence of a new mid-Atlantic, post-European weirdness. So everything that happened after that was, in a way, a misinterpretation of what we were trying to do.

STEVE LAMACQ April 1994 is a crazy month that sees Oasis's 'Supersonic', Blur's 'Girls and Boys' and *Loaded* magazine all released within a matter of weeks of one another. I saw the first night of the *Parklife* tour: Blur came on, and I was looking around, going, 'This is happening! This is going to go! Nothing's going to stop this!'

JEREMY DELLER I saw the tour in Brighton, and the set was decorated like a sitting room with lampshades and armchairs. They played 'Girls and Boys' and it was like the catchiest record I'd ever heard. Of course, it went on to be their entrance into the pop world.

STEVE LAMACQ I thought, Not only are Blur digging around in this mod thing, now they've got something which sounds like the

Human League with a disco romp. They played Alexandra Palace and there were 10,000 people there. It was a statement, and one of their best gigs. People were really connecting. It was the most exciting thing to see them taking off.

KAREN JOHNSON Liam Gallagher came to Ally Pally. He was a massive fan. The antagonism with Damon came later. I was in the loos and his girlfriend was crying and saying, 'Liam's just finished with me.'

DAVID KAMP The release of *Parklife* signalled a change in British youth culture in that its music was inspired almost exclusively by British influences. Blur were celebrating Englishness in the same way that Ray Davies had with the Kinks.

DAMON ALBARN There was that whole idea of uber-Englishness. There hadn't been a record before like *Parklife*, in the sense of its attack on the mainstream, and then to have something that left-field become that popular, so quickly.

SHERYL GARRATT Kurt Cobain was found dead on 8 April 1994, and the next issue of *The Face* was Damon Albarn on the front cover. It was like, 'This is British. We should celebrate it. Let's put a Union Jack behind him, "Blur: Brit up your ears".' Oh, that's a great pun, a nod to Joe Orton. Damon was perfect. He looked the part. I very much felt that the Union Jack had been taken from us. It was in danger of becoming a symbol for racism and unpleasantness. I felt that this was our country too, and I was damned if they were going to have my flag.

KAREN JOHNSON I was concerned about the cover because of the Morrissey thing at Finsbury Park two years earlier. But I understood they'd done it in pop-art style rather than the traditional 'we're flying the flag'. It was a sixties throwback and it was reclaiming the flag. It was saying, 'It's for all of us.'

DAMON ALBARN I was singing out my slightly dystopian vision of the future, of the country, and everyone was going, 'This is brilliant!

It's great!' It became a nightmare. I suffered profound anxiety for years after as a result. And then Oasis came along, and went, 'Huh! We're going to go with this pure, euphoric optimism. We're going to lift the people up.' And that's exactly what happened next.

FREEDOM'S CHILDREN
Tony Blair. Clause IV.
New Labour, New Britain

CHRIS SMITH I am absolutely certain that if John Smith had lived he would have handsomely won the '97 election and ultimately been a better Prime Minister than Tony Blair. However, that was not to be. John died of a heart attack in 1994 and Blair became the leader. There was a real determination within the Labour Party by that stage. We'd lost the '79 election, the '83 election, the '87 election and the '92 election, which provided a real jolt to the party. So the huge concentration was, 'We've got to make sure we win next time. We will swallow whatever we need to do in order to make that happen.'

MATTHEW WRIGHT Relentlessly fucking miserable is how I remember politics. Everybody felt so badly we needed a purge of how things were. It really did feel like the government pushing down on the people. By the time you got to John Major, you think, Fucking grey old man.

JOHN MAJOR On the day I became Prime Minister – 9 April 1992 – the party was divided, standing on either side of a widening gap on Europe. Unemployment was rising, and went up to around three million, interest rates were 14 per cent and inflation was 10 per cent – not the best inheritance ever. It took us a long time to put that right, and doing so required some very unpleasant and unpopular decisions that hurt people badly. Understandably, they reacted negatively.

MATTHEW WRIGHT It felt like the Tories were on the back foot, but there just wasn't anything coming through to deliver the *coup de grâce*. Then, after John Smith unfortunately died, Tony Blair became the heir apparent. He was young, not grey and not Tory. I would have voted for those three qualities alone.

DARREN KALYNUK There was something Kennedyesque about Tony Blair. I was young and it felt like it was a time for the young. It was less about the politics and more about Tony representing a new beginning. He was a different generation. He spoke a different language.

SIMON FOWLER Blair was forty-three. He didn't sound like he was from the older generation. Everything seemed different. The Conservatives had done their time, and suddenly this new lot came along.

FIONA CARTLEDGE The Conservatives had been in for three decades. People had had enough. Blair was a fresh face and had a young family. They looked modern while Thatcher and Major looked like the old guard.

JOHN MAJOR I was ten years older than Tony. I was the third-youngest Prime Minister in our history, but I had already been in government for seven years beforehand, so had become a familiar figure. Tony was a fresh face, unblemished by government, and that was attractive after one party had been in power for so long. He was an attractive political bundle to the country, as a whole. And, of course, there's also the cultural point: the natural instinct of people, wired deep into DNA, that the left is cool and the right is staid, small 'c' conservative, and conventional. The Conservatives were seen as yesterday, and New Labour looked like tomorrow. It was that perception that enabled New Labour to catch the public mood so successfully.

STRYKER McGUIRE Eighteen years is such a huge period of time. Most Labour MPs had never been in government, so you had a party that was energised by the idea that they were going to take over.

VIRGINIA BOTTOMLEY The extraordinary thing was the way Tony Blair came from nowhere. I remember doing *Any Questions?* with him in '92, and I had to ask somebody who he was. When they lost the '92 election a lot of people thought Labour would never survive. But suddenly the mojo was with them. He was a new song.

POLLY RAVENSCROFT Blair came into Radio 1, when he was Shadow Home Secretary, on the Nicky Campbell afternoon show. It was pre-leadership and Nicky asked him about being in a band at Oxford: 'I heard you did the Mick Jagger routine down to a tee?' Blair winced, and said, 'Oh dear . . . it was a casual stroll around the stage with a microphone!' But the fact that he chose Radio 1 to do an interview was quite significant. He was obviously thinking about young voters. I thought, Great, Tony's going to save us from the Conservatives.

TJINDER SINGH I was a dyed-in-the-wool Labour supporter, but I didn't look at it as 'Tony Blair and New Labour'. I looked at it as 'not the Conservatives'. I saw him as an individual who could talk like no one else and convince. It was a vibrant time to be living. There was a lot of money. New ideas. New technology. The pace of things was getting quicker and more international. We looked to Europe. All the tectonic plates just fitted into place.

JEREMY DELLER Blair was like a rock 'n' roll leader. He was someone young and he spoke differently about things. He was not part of the establishment as I saw it.

ALAN EDWARDS Blair came along to a Bowie gig at Wembley Arena. He turned up early and I was given the job of looking after him. We went and sat in one of those old cheesy dressing rooms with a bottle of wine and he just wanted to hear rock 'n' roll stories. Then he watched the gig. At the time, David's show was almost three hours. Normally a politician will disappear after a couple of songs. Blair was there to the end. I was very impressed by that. I thought, You're either a real music fan or you're really smart. When he left he said goodbye to every one of the security guards

he had met when he arrived, and even remembered half of their names. I thought, Anyone that good's going to be Prime Minister.

GURINDER CHADHA Interestingly enough he came to Southall, and my mum and dad went to see him do this talk. At the end, my dad put his hand up and asked, 'If you come into power how will the Labour Party make things better for Asian pensioners like me?' Blair said, 'Well, we won't because my job is to make life better for all British pensioners whether they're Asian or not.' My dad was quite chuffed by that.

NORMAN ROSENTHAL Blair once came to the Royal Academy and gave a talk on an Italian exhibition we were showing. He was so well fucking briefed about seventeenth-century Neapolitan art that he gave a better talk without notes than the president of the RA. I couldn't believe it. He was like a great lawyer speaking.

PETER HYMAN Tony was a powerful orator. Almost uniquely, and I'm sure this came from his barrister training, Tony was obsessed with wanting to make a clear, coherent argument. You can disagree with the argument, but they were proper arguments. Most people just do either statements, making claims, or they're just covering ground: five lines on the health service and how much I support it, and then five lines on education and defence. Tony's view was that you had to persuade people almost solely by head. I used to try to persuade him that you needed head combined with heart. I said, 'You've got to tell a story.'

NOEL GALLAGHER I remember seeing a speech of his really early on and it suddenly spoke to me. To me, politics leading up to that point had been like a bit of a Punch and Judy show, and he seemed to rise above it and was trying to drag the Labour Party above it. They were very clever by rebranding it New Labour. None of us realised then that the modern world was coming, but thank God Blair and Clinton did; they adopted that thing called the Third Way. New Labour danced in between; they took a bit of, 'It's all right to take some of the Conservatives' things and some of the

left's things and make your own thing out of it, and let's call it New Labour.'

DAVID BADDIEL What is New Labour? It's really a soft-left, possibly centre-right, political party but wears the clothes of something cool and young and socially progressive. People were saying, 'We've had enough of these stuffy, old, un-hip politicians. We want someone younger in power who knows about football and pop music.'

OLIVER PEYTON I was beguiled by Blair. We all thought he was cool. He understood the worth of embracing youth culture. There was a lot of anger towards the Tories, just generally. I don't think anyone would have admitted to being a Tory at the time. There was a sense of possibility coming out of New Labour and it felt fresh. When you see a young Prime Minister in waiting, and then you see the burgeoning scene in music and art, it's an attractive package. Labour's success was partially tied up in attaching themselves to what was happening in the City and understanding very well the zeitgeist.

STRYKER McGUIRE Blair captured the changing mood of the country. John Major loved cricket; Tony Blair loved football. He was very good at adapting, like a chameleon, to the new time.

PETER HYMAN When people see decay on one side and optimism on another, they gravitate towards you. We were sending out the signals that we wanted Britain to have a more forward-looking outlook and tap into the great talent of this country. There was a buzz around the fact that you could have a different type of government and a different type of politician. For everyone – from business leaders to head teachers to National Health Service workers to people in small businesses to entrepreneurs to the creative industries – there was a sense of, 'We can do things differently; there is a different way of running the country.'

NICK HORNBY There was a really big generational shift because those people had grown up with popular culture. Thatcher hadn't.

GEOFF MULGAN I wrote a paper with Helen Wilkinson[1] called 'Freedom's Children', which was published by DEMOS in 1995. We argued, 'For this generation politics has become a dirty word. Over a third of eighteen- to twenty-four-year-olds take pride in being outside the system. But they are nevertheless concerned with many specific issues: environment, AIDS, and, above all, animals. The overwhelming story emerging from our research was of a historic political disconnection. In effect, an entire generation has opted out of politics.' By the mid-nineties no one in their right mind would join a political party. That age group was disempowered. In a way, their strongest value was autonomy, a bit Thatcherite: they were quite into individual freedom, entrepreneurism, but also with a degree of social conscience and environmentalism. So they didn't fit the traditional twentieth-century political spectrum very well. This is the age demographic wrapped up in Cool Britannia, and yet they were the disconnected. Tony Blair was pretty good at articulating a cluster of value shifts his predecessor just couldn't. It came down to personality.

KEITH ALLEN I'd read a biography of Blair and what was interesting was that his father, having been the Secretary of the Scottish Young Communist League, became a Tory. There was something about him. His language. His mannerisms. Remember, I'm an actor, I watch people quite closely. Blair had been in a band and acted in Shakespeare and failed at both. People are musicians or actors because they want to be appreciated and respected and loved and to serve their own ego. If then you go into politics to satisfy that desire . . .

DAVID BADDIEL I thought of Blair as someone who could have been an actor – he played Mark Antony in a university production of *Julius Caesar* – the sense in which it was more about the presentation than the substance.

1 In 1993, Helen Wilkinson was a founding member of the independent think tank DEMOS, alongside Martin Jacques and Geoff Mulgan.

JOHNNY HOPKINS I had an awareness that Blair was coming with a broom, or perhaps a machine gun, and taking people out and replacing them with different types of people for the good of himself. Behind the scenes they were completely changing the structure of the party; a radical rebranding of the party. Abolishing Clause IV was a shock. [2]

MARGARET McDONAGH There was the big ideological fight in the Labour Party about the constitution and Clause IV.

CHRIS SMITH The abolition of Clause IV was totemic, and a way of very publicly saying, 'The Labour Party has changed.' It probably wouldn't have happened under John Smith. He would have been very good at reassuring the electorate that Labour was now respectful, responsible and could be trusted to run the country and the economy, whereas Blair was young and untried and had to do something more disruptive.

MARGARET McDONAGH Peter Hyman wrote the phrase 'in the hands of many, not the few'. He was a really bright guy.

PETER HYMAN It was a Sunday afternoon and one of Tony's children was having a party, which we were banished from, so we were upstairs, sitting on his bed rewriting Clause IV. The phrase 'power, wealth and opportunity are in the hands of the many, not the few' replaced 'common ownership of the means of production'. 'New Labour, New Britain' was Tony and Alastair's phrase. There was an absolute pragmatic imperative to reframe the Labour Party and tell the British people loud and clear that the old Labour Party, which had been rejected for over eighteen years, was not the same as this one.

2 Clause IV formed part of the 1918 Labour Party written constitution: 'To secure for the workers by hand or by brain the full fruits of their industry and the most equitable distribution thereof that may be possible upon the basis of the common ownership of the means of production, distribution and exchange, and the best obtainable system of popular administration and control of each industry or service.'

STRYKER McGUIRE Blair spoke in Dublin of a Britain that was 'emerging from its post-empire malaise'. He was characteristically optimistic. He said he hoped the Irish saw Britain as a country that was 'modernising, becoming as confident of its future as it once was of its past'. Those were heady times for Britons. Phrases like 'New Labour' and 'new dawn' and 'New Britain' were not yet curdling on the tongue.

ALASTAIR CAMPBELL Tony always had the view that if you give the British public a choice of traditional right and traditional left, historically, in the main, they'll go for traditional right. That's why Labour had only ever had quite short bursts of government, which often felt like the Tories just needed a bit of a breather: 'Let Labour in for a bit then get them out again and off we go.'

PETER HYMAN The question is how much you gain from being seen as 'new' as in completely new, and 'new' as in building on what has gone before. Some of us said, 'How much of a clean break? Is it helpful to imply you're not even in the lineage of Atlee?' Tony's point was, in order to make things stand out you need to accentuate the new, even if underneath there are layers that say, 'Well, actually, this is partly continuity.' His argument was, if he wasn't going to accentuate the 'new' bit of New Labour, there were very few other people who would. He quite relished being the outlier and that he wasn't very traditional Labour. He thought that gave him an edge and it meant that he could cross boundaries and create a bigger tent.

TONY BLAIR The renaming of the party and the line 'New Labour, New Britain' chimed with where Cool Britannia was coming from. Absolutely. The important thing was that it was rebranding of a new product; it wasn't the same product rebranded. The concept of New Labour would never have worked if it had simply been rebranding of an existing product. The reason for doing Clause IV and then making all the policy changes was to say, 'We are rebranding because we are actually different.' The risk always in this situation is 'here's presentation' and 'here's reality'. My view was always that

the purpose of the presentation was to present better 'the reality', but if the reality was 'old' no amount of language around 'new' was going to do it. I think the same is true for the way Labour was culturally and socially, and much more in favour of gay rights and all of this, which at the time was very controversial in many quarters. It was only just a few years before that you had debates in the House of Commons where the Tories would say the most terrible things just as a matter of course; things that no one would say today. I was very keen to make sure that the product was a genuinely new product. We were offering a new way forward on the economy, a different way forward on society and one part of that was to be avowedly socially liberal.

BOLLOCKS TO THE NEW MAN

Lad culture. *Loaded*. Ladettes.
The Girlie Show. Pornography

DAVID BADDIEL Journalists tend to chart the rise of laddism with *Loaded* magazine; that's a very journalist thing to do, to look to other journalists to chart a history. Comedy was doing that stuff ages before. In the late eighties, there were a lot of us playing with 'what does it mean to be a bloke?' I remember Eddie Izzard at the Comedy Store saying, 'I went out last night, I had a jar, me and my mates, then I had another jar, then another jar, then another jar, eventually I thought, That's enough jam.' Beyond the obvious joke, it was saying, 'I'm going to pretend that I'm a bit of a lad and then I'm going to undercut it.' I did a show called Superlads, which was about being a lad, and my first ever stand-up routine began, 'I'm an intellectual and a lad. That's a problem because . . .' It was about saying, 'Actually, I do like football and naked women and beer, and I'm perfectly happy with being heterosexual – all the things which would have been considered something to be ashamed of then – but I'm able to be ironic about it, to prove I'm also not Bernard Manning.'[1]

TIM SOUTHWELL Sean O'Hagan coined the phrase 'New Lad' in a piece he wrote in *Arena* in 1993 titled 'The Re-invented Man. Is the New Lad a fitting role for the nineties?' He explained the

1 A self-confessed racist comedian who came to prominence in the 1970s.

essay in an interview with the author Jonathon Green:[2] 'The New Lad was a media invention . . . the characteristics I described are representative of a lot of blokes I [knew]: "The New Lad is fairly aware of the social issues, has grown up with the shadow of feminism behind him at every point, can no longer make sexist jokes, is fairly middle class, articulate, well-read and educated, aware of the issues, but hasn't gone as far as re-inventing himself to please women. He still enjoys boozing, football and is proud to be a man. He has the best of both worlds." I concluded the article by saying, "The New Lad is a distinct improvement over the New Man, who is a bit of a wimp and whom women don't fancy anyway because he's a doormat; and over the Old Lad, who is just a George Best look-a-like – get it in, get it out, get down the pub to tell your mates. Though maybe he's just a sensitive Old Man, just a bit more cocky, sharp, witty."'

MATTHEW BANNISTER I was first aware of the New Lad phenomenon with *Loaded* magazine. It seemed to crystallise what was going on, and say, 'It's okay to be a lad and be interested in football and girls and drinking and smoking,' with a knowing wit. It wasn't about tits or putting women down or about men being superior to women. It was about saying, 'We can enjoy ourselves.'

TIM SOUTHWELL We launched *Loaded* in 1994 as a reaction against the puritanism of the eighties. You were almost embarrassed to be a bloke. You could never do enough right. If you wanted to behave in an instinctive way and have as much fun as possible there was plenty of people that would say, 'Grow up.' The whole thing about *Loaded* was that we didn't want to grow up. We didn't want the normal route of getting married and having kids. We were much more interested in going out and having a great time, as much as was humanly possible.

IRVINE WELSH *Loaded* was a tremendously strong concept. It pushed a cultural view of white working-class maleness. It came

2 *It: Sex Since the Sixties*, Jonathon Green, Secker & Warburg, 1993.

out of the football fanzine culture: when you have guys talking about birds they fancy and getting pissed, it's interesting because there's a smallness about it, a locality and in-jokes. When you do it as a national magazine it has a whole different thrust and emphasis to it.

TIM SOUTHWELL James Brown made *Loaded* happen. He had the audacity to say that the magazine was going to be a celebration of all the things that we loved doing, like football, going out, drinking, having a party, great holidays etc. And then I filled it up with stuff people wanted to read. Certainly the language like, 'Good Work Fella!' and 'Bunch of arse' . . . The genius of James is I'd say something like, 'Drop your bacon sandwich,' and he'd say, 'Fucking hell, we've got to use that!' And it would suddenly become part of the magazine. His confidence in his own instinct was remarkable.

STEVE LAMACQ I'd known James for a long time. He had grown out of writing for the *New Musical Express* and wanted to do something else. His chaotic, zeitgeist mind suddenly settled on this very timely idea, in that he was looking around at his friends who were into football and pop music and thought, There must be something in this. He encapsulated the whole ethos of *Loaded* in his first editorial for the magazine. It read: '*Loaded* is a new magazine dedicated to life, liberty and the pursuit of sex, drink, football and less serious matters. *Loaded* is music, film, relationships, humour, travel, sport, hard news and popular culture. *Loaded* is clubbing, drinking, playing and eating. *Loaded* is for the man who believes he can do anything, if only he wasn't hungover.'

TIM SOUTHWELL James and I were in the office putting the dummy issue together with Mick Burnage and laughing about stuff, and Mick said, 'I really should know better at my age.' James latched on to it and said, 'That's the strapline. For Men Who Should Know Better.' It was a brilliant tag. It encapsulated *Loaded* and created the opportunity to do anything. We made up a dummy issue of the magazine which was used in focus groups and to show to

potential advertisers. The feedback was basically, 'If *Loaded* was going to succeed it would already exist.'

STEVE COOGAN I was on the front cover of the test issue as Paul Calf, with a cigarette hanging out of my mouth and the cover line 'Drunk's not dead!', which was a cultural reaction against the perceived PC mentality in the early nineties. It was valid but became tired very quickly, so much so that the non-PC mentality was even worse than the *bien pensé* it replaced. A load of public schoolboys swearing and doing coke . . . yawn!

NICK HORNBY I was lumped in with it all, 'It's *Loaded* magazine, it's *Fantasy Football*, it's *Fever Pitch*.' You think, Oh my God, really? Someone from the BBC came round to do a lifestyle interview piece with me before it came out and they showed me the publicity material. One of the things it said was, 'For the Nick Hornby reader.' I just felt sick. It was so not what I was into or what I felt I represented in any way whatsoever. I thought, These people are the enemy. It just seemed to be beer and shagging, which, of course, you're never going to go broke making a magazine about.

IRVINE WELSH Even though *Loaded* aspired to be working class, in some ways Nick was closer to *Loaded* culture than I was. What he did with both *Fever Pitch* and *High Fidelity* was to look at two big male obsessions, football and music, and construct a narrative around them as to why they were fundamental, which is what *Loaded* was trying to do in a magazine way.

NICK HORNBY I suppose so, but mine was agonised Woody Allen angst, which didn't seem to be very *Loaded* to me. It was their confidence that frightened me. 'This is a GREAT thing and NAKED WOMAN ARE GREAT and BEER IS GREAT.' I felt that *Fever Pitch* and *High Fidelity* had been much more doubtful than that. I was afraid of *Loaded*, but then they called up and said, 'Do you want to go to the Cup Winners Cup final and write about it?' I said, 'Yes.' They said, 'If you know a mate who's a photographer then

two of you can go.' We got two cheap flights to Copenhagen and had the best day ever. And Arsenal won. I filed the piece, and they said, 'Would you be interested in doing anything else for us like that?' I said, 'Yeah, like *that*.' They said, 'What does that mean?' I said, 'Well, if Arsenal get through to another final somewhere nice and I can't get a ticket, I would love to.'

TIM SOUTHWELL *Loaded* was credited with creating lad culture. It didn't help that on the cover of the very first magazine it said 'Super Lads'. We weren't trying to create a culture, but for a lot of people it represented something completely different: bad behaviour, objectifying women and being a lout.

JOHNNY HOPKINS The first proper issue had Gary Oldman on the cover. Paul Weller was in there. Liz Hurley had two pages. The rest of it was interviews with interesting blokes done in an interesting way. Sporting adventures. They had interesting angles on everything.

TIM SOUTHWELL The only thing you found in the magazine were things we wanted to celebrate or believed in or deserved a chance of being great. It had massive impact and it was a massive success.

JO LEVIN Urgh, *Loaded*! It was a semi-porn magazine. I was aware of lad culture but I didn't like it. It was so yicky-yuck. It's rather like reality TV, that kind of low-brow . . . I couldn't relate to it, but *Loaded* was not aimed at me.

CAROLYN PAYNE *Loaded* was sexist and making that side of things acceptable. There was a whole thing where female children's TV presenters would do *Loaded* shoots to try to appeal to an older generation.

TOBY YOUNG Today, university students might find the contents of *Loaded* quite shocking in a way that they didn't in the mid-nineties. It wasn't straightforward objectification in the way that Page Three was; there were layers of irony and knowingness in the way that women were being presented. There was certainly

something self-consciously post-modernist about the way in which women were photographed in the magazine.

TIM SOUTHWELL I had lunch with Germaine Greer and she thought *Loaded* was hilarious because it was so honest. As men, we were fed up with feeling like we weren't quite good enough. Fine. What's the point in chasing your tail when you've got a life of fun to live? We couldn't believe everyone was using all these column inches over us berks. It was hilarious. Sheryl Garratt was one of the first people to come out and say, 'You've got it wrong. You're criticising this but it's not what you think it is.'

SHERYL GARRATT Initially, I loved *Loaded* because it was funny. It was a welcome bit of irrelevance. You have to remember what men's magazines were like then: it was all about the perfect suit and should you have your brogues handmade? It was good having league tables of crisp flavours. It read like they were having a laugh. But you can overdo me being a vocal supporter. What it did under 'irony' was bring back a bunch of horrible laddish sexism that I thought we'd seen the back of. There was a sense of 'look at the jugs on that!' There was such pressure on young women to sell whatever they were doing via their bodies. I felt really upset that we'd come back to that; that a great way to get a cover was to get your tits out.

DAVID BADDIEL Rob Newman and I were on the cover of *City Limits* in 1989 with the strapline, 'Lad attitude – Bollocks to the New Man'. Rob posed as a Page Three girl, holding his shirt and pouting and sticking his arse out, and I'm just laughing at him. There was a difference between that and the sexist cover Frank and I did for *Loaded* in 1996 with a European model taking her top off – it's not a cover I would do now.

TIM SOUTHWELL Steve McManaman and Robbie Fowler did an interview talking about wanking, and Robbie said his favourite chat-up line was, 'Do you like jewellery? Well, suck my cock – it's a gem.' It got them into all sorts of trouble at Liverpool. Roy

Evans called a team meeting and had a right go at them. Those sorts of things probably defined *Loaded* way too much. The irony was that none of us on the staff were like that. We had many articles written by women. Mary Anne Hobbs was very involved in the first year. Barbara Ellen. Emma Forrest. Jenny Eclair was the guest editor when Jo Guest was on the cover. Very occasionally, if we couldn't get a shoot with somebody like Robert De Niro or Paul Weller, we resorted to route one, which was a model. One time, we had a sensational photo of Emma Noble pulling down her skirt and 'Come on Down' written on her stomach in lipstick, but James insisted Suggs from Madness went on the cover instead.

TOBY YOUNG Why was *Loaded* so successful? People bought it because it gave them permission to look at pictures of naked and semi-naked woman. It wasn't straightforward *Penthouse* or *Mayfair*, but something a little more sophisticated and more humorous. Men could buy it and not feel embarrassed about being seen with it. It was respectable sexism.

TIM SOUTHWELL The reason that *Loaded* was successful was because it wasn't trying to be cool. It wasn't *GQ* or *Esquire* where it's ten-grand suits. If we had ever had that sense about ourselves it would never have worked. It was an accidental cool. It's a bit like a football team dressing room where it's about the banter and everyone's taking the piss out of everybody else. If you talked to any of the girls who worked in the office they would dispel any notion whatsoever of any culture of objectifying women. We were scared of women. We knew they were better than us. The key for anyone working at *Loaded* was that they had to be funny and not take themselves too seriously, while at the same time aspiring to achieve amazing things as writers and photographers and everything else. If you get hold of any copy of *Loaded* it will give you an insight into exactly what was happening culturally in Britain in the mid-nineties.

JARVIS COCKER *Loaded* became a mag for blokes who didn't have the balls to reach up to the top shelf and actually buy a porno magazine.

TOBY YOUNG If I recall correctly, they had quite an elaborate defence for including pictures of scantily clad or topless models.

TIM SOUTHWELL The *Guardian* would laud *Vogue* or *Vanity Fair* for putting Kate Moss virtually naked in the magazine because that was art, but if *Loaded* did it, it was objectifying women; it was smut. To us, you couldn't have it both ways. I didn't understand the difference between Rachel Garley with her breasts out, which was considered to be okay, and Cameron Diaz in a swimming pool with her top off on the cover of *Loaded*. It was just a convenient way of boxing *Loaded* in and saying, 'That's the only reason it's successful.' We made no apologies for it. It was very much the *Spinal Tap* line, 'What's wrong with being sexy?' It was a case of, 'Is it objectifying women?' The answer was, 'Absolutely not.' Ultimately, we didn't really care what people thought one way or the other.

TOBY YOUNG They were clearly conscious of that criticism, and they fell back on the defence that it was an authentic expression of male working-class culture and anyone objecting to it was basically a snob. There wasn't anything authentically working class about *Loaded*. It was an idealised, certainly rarefied, version of what they thought of as laddish working-class male behaviour.

IRVINE WELSH It wasn't just a male gaze on tits and arse. The guys involved in *Loaded* were working class, but quite clued up and sensitive and arty and into music as well. They weren't your classic leering-cavemen sort of guys. It was a desire to play with but actually move beyond sexism, as well.

TRACEY EMIN *Loaded* was cars and semi-porn. But I'm not going to deride it completely. Men started buying magazines and reading, and within it there was the odd article that was insightful and interesting for men to read.

JO LEVIN What is true is that *Loaded* made certain guys look at men's magazines. These were guys that walked by *GQ* and *Esquire*. It made guys aware. Suddenly there were all these magazines like *Nuts* and *FHM*. There was a bit of noise.

TIM SOUTHWELL *FHM* was a gay fashion magazine, which EMAP bought after *Loaded* became successful to get in on the act. Their policy was girls only on the cover. It was just tits and lists. Their ad campaign was, '*FHM* – it's a guy thing!' It was so wanky.

IRVINE WELSH *Loaded* changed the readership of magazines. Working-class men would never read magazines like *GQ* or *For Him Magazine* – which poncey middle-class and new men tended to do. *Loaded* discovered a hitherto completely different market. But like all these things, it outstayed its welcome. It was very innovative and then it became just another magazine.

STEVE COOGAN I remember thinking, 'It's quite interesting, this *Loaded* magazine. It's a little bit irreverent.' And then ten years later, 'This is a terrible, terrible magazine, responsible for all kinds of ignorance and bigotry. I wish they'd thrown in the towel five years ago.' I did a front cover of *Loaded* in 1998 as Alan Partridge with two dolly birds on my arm. When you play with irony there's always danger.

PHILL SAVIDGE It was part of the movement of football and Oasis. It was thuggish. I didn't want any of my bands to be part of that. That celebration booze culture felt so unnecessary. It was almost like, 'I stayed up last night till midnight eating biscuits – aren't we crazy?' It felt so obvious. *Select* did a piss-take of *Loaded* with a one-page advert inside from a magazine called *Bloke*, with a bloated Brett [Anderson] holding a pint of beer. It was really funny.

JOHNNY HOPKINS. Blur bought into that whole lad culture thing with the 'Country House' video and Damien Hirst zooming in and out of Jo Guest's breasts, in an ironic way. It was ridiculous. The video was a low point. It said it all: the fakery, the shallowness, the class tourism.

DAMON ALBARN It wasn't ironic. It was a satire on the tabloid view of society. I had known Damien since Goldsmiths. It felt like mates all doing really well, 'Let's fucking make a video.' It wasn't a huge amount of thought went into it. It was a reflection of the times.

KEITH ALLEN *Loaded* and 'Country House' were woven into the same fabric: Benny Hill, dolly birds. Ironically, a lot of people had me down as a lad, but I hated lad culture. I'm far too egotistical to belong to any gang.

KAREN JOHNSON It was quite a thing to have Damien Hirst direct the 'Country House' video. It was Alex James-led. Damon did it but I don't think he loved it. The shoot was in Bow, and I took a *Guardian* journalist to cover it. As soon as I arrived I could feel an atmosphere. Graham was not a happy chap. He didn't want to be part of that *Loaded* scene with Alex and Damien and Keith Allen. They were everything that Graham wasn't – confident, loud, forceful, domineering.

KEITH ALLEN Damien's treatment for the video just said 'Benny Hill'. Blur were riding around on pigs and there were loads of dolly birds, people like Sara Stockbridge. That was part of the fabric of the piece and quite deliberate. I sensed there had been some coercion: Damon wasn't very happy with it all, and Graham hated everything about it. There was a sense of them and us.

KAREN JOHNSON The atmosphere was palpable.

ALAN McGEE It was all part of the same thing: Britpop, lads, ladettes, all that bollocks. Lad culture was just like everything that's ever mass-marketed to anybody. It's kind of wank. I had a fight with James Brown once. It was at John Peel's fiftieth birthday party. He said something snide to me and I told him I'd fucked his girlfriend. Suddenly punches were flying. It was pathetic. I was twenty-eight. To be fighting at that age is sad.

SIMON FOWLER Lad culture was what we did anyway: get drunk and take drugs. We'd done it for years.

LORENZO AGIUS Everyone was a lout. Everyone was getting into trouble. They were the times.

KAREN JOHNSON Lad culture was a term that the media could get mileage out of. Damon was associated with it because he'd go out to parties and hang out with Phil Daniels, that's as far as his

laddishness went. He got associated because he was cocky and was written about as a mockney. I think Damon's attitude was, 'I can be both. I can be an intellectual and a lad. Why is one mutually exclusive from the other?'

TIM SOUTHWELL Jon Wilde did an extraordinary interview with Damon Albarn for *Loaded*, and the record company went mental. On the Queen, Damon said: 'I have to admit that I quite fancied the young Elizabeth Regina. I'd have been happy to have given her one when she first came to the throne. [. . .] The same goes for that Princess Margaret, who seemed like a bit of a goer.' On cunnilingus: 'I think its appeal has a lot to do with how many drinks you've had and whether a woman has washed down there recently. If you've had a skinful, it doesn't matter so much that she hasn't been near the bath of late [. . .] but I'm quite a long way from mastering the art of going down.' On wanking: 'I never went at it with raw liver or a loaf of bread with the middle gouged out. The only wanking anecdote I have is that there was this buzz at our school about bottles of Vosene. They reckoned that, if you cut the bottle in half and slipped it over the end of your dick while lying in the bath, the suction power would bring you off. If you had a particularly small dick, you'd cut the bottle at the top. If you were more generously endowed, you'd slice it off in the middle where it started to widen out. Sadly, it never did much for me. Though it did leave me slightly chafed.'

DAMON ALBARN Really! I said all that?

KAREN JOHNSON Blur were showing their film at the South Bank and there was an after-show party, and Graham, as usual, got too pissed and started running round with a drinks trolley in the green room. I was like, 'Here we go!' James Brown was there and said, 'I've got *Loaded* to show you.' There was the interview with Damon where he was asked, 'How about going down on a lass when she's got the painters and decorators in?' Damon replied, 'I think it depends on how heavy the flow is. If we're talking Niagara Falls, you might want to explore other possibilities for the time being.

There are advantages, though, to that time of the month. For a start, a woman's tits are biggest when she's having a period, so you might fancy concentrating on them for a bit.' I was furious. The interview was so graphic and so unlike Damon. He was never that into groupies and stuff like that. Wily old Jon Wilde stitched Damon up, got him drunk and duped him into saying those things. I was more bothered than Damon.

DAMON ALBARN My lad credentials are emblazoned upon myself, as anybody else's. I wasn't different to anybody else. Back then I told the *Observer*, 'For eighteen months I became torn between who I really was and this persona I'd created on *Parklife* . . . Oasis let me off the hook; they can take over the mantle of laddishness.' I desperately wanted to be accepted. Moving to Essex when I was nine had stripped me of that sense of identity that I very strongly had when I was growing up in east London. It was recapturing a life I had missed out on.

STEVE LAMACQ I don't think there was a huge crossover between the lad-mag thing and the music that was happening. That comes later as the audiences become bigger. You could say Oasis were a bit laddish, but they don't dominate at first because there's lots of other bands around. They were more the voice of the terrace. Britpop was quite arch at the time. It's the difference between *Parklife* and *Definitely Maybe*. I don't have any answer for where the confusion begins over Britpop and its attachment to this laddish thing.

SONYA MADAN Britpop wasn't a thinking person's era. It was a guttural, visceral thing. It was about celebratory bigness, and fitting into a cultural expectation. There was definitely an agenda of what the era was demanding and what bands were being shoe-horned into.

PHILL SAVIDGE Brett changed the way he acted on stage and became more like a *Loaded* persona. He started pogoing and grabbing the mic rather than smacking his arse and wriggling around. He started

speaking with an estuary drawl, and shouting things like, 'Oi,' and, 'D'you like that?' He changed his demeanour thinking that's what people wanted, because effeteness wasn't working anymore and because Oasis had become hugely successful and changed the way music was going. It made Brett act more like a man.

BRETT ANDERSON It wasn't me trying to be blokier. A lot of that was ironic. I was seeing the *Carry On* thing that was happening with Britpop and I was aping that. I felt as though Suede's vision, our documentation of British life, had been turned into something quite ugly. There was one time when we did 'My Old Man's a Dustman' as a jokey comment on where we saw music going culturally. I was saying, 'Fuck that. This is boring to me now. Let's do something else.' I had the bravery to step out of that cosy little parochial *Dad's Army/Carry On*-film world and distance myself from the continuing ballooning of Britpop.

NOEL GALLAGHER It's when Britpop turned into this lad fucking thing and started objectifying women. Everybody wanted to be like Liam, the village idiot, who considered himself to be the king of the lads, ergo every other brain-dead fuckwit in England wanted to be like him. 'Mad for it' and all that.

ALAN McGEE Noel was as fucking laddy and as guilty as anybody. We were all just basically having a laugh, and we got away with it for a long time. He liked the nineties for all the reasons that everybody else did, which was drinking, drugs and chasing women, but I don't think you'd ever define him as sexist.

NOEL GALLAGHER I wrote 'Wonderwall and 'Don't Look Back in Anger'; they're not laddish anthems, or about scratching your balls and drinking lager. They're about something a little bit deeper; but only a little bit deeper. We were surrounded by women working with us, but it was always overshadowed by Liam and his fucking moronic behaviour. Every guy that ever worked for us wanted to be in the fucking band and thought that it was all right to be doing coke at nine in the morning. You can trust women a little bit more.

STEVE COOGAN I saw Oasis at Wembley Arena, and when they did 'Wonderwall' everyone got their lighters out and waved them around. Noel said, 'Put your lighters away. It's not a fucking Elton John concert.' It was interesting because that was him being irritated by his own audience. It was like, 'That's not who we are. This is not empty sentiment.' That's when you think, Do all these people get what I'm about?

TIM SOUTHWELL Every time Noel met a writer from Loaded he would tell them, 'Get a Loaded TV programme together and I'll present it from my sitting room. It'll be top.'

JOHNNY HOPKINS Loaded made total sense for Oasis: they're blokes, they're into music and football and good times, and they're intelligent and articulate and funny. They were hedonistic and not ashamed to be male in a positive way. Liam in many ways was the complete Loaded male, but where Loaded had been brilliant and refreshing and intelligent, then there was a period when it overturned a lot of the progress that was made in the eighties and had a bad influence on attitudes to women, and the whole popular-culture landscape. Things like The Girlie Show, Never Mind the Buzzcocks, TFI Friday, FHM and the way that GQ and higher-end magazines changed to capitalise on the success of Loaded and Oasis.

TIM SOUTHWELL Loaded was very much on the Oasis side of the net. Liam and Noel were working-class kids from Burnage, Irish descent; normal geezers who ended up being the most famous people in the country. They had to be on a cover of Loaded, but we were banging our head against a brick wall with Johnny Hopkins. He blocked us from getting anywhere near them. It was ludicrous. We'd see them out at a party and have a drink with them and say, 'We've got to get you in the mag.' They'd say, 'Yeah, brilliant. Too fucking right.' We were like, 'For fuck's sake!' This is how ridiculous it got. We got a private detective to find out where they were and to monitor their movements. We had all these things made up, like a tie pin with a camera in it and a microphone. We were going to pretend to deliver a pizza and then come clean.

In the end Paolo Hewitt saved the day. He recounted the story on oasis-recordinginfo.co.uk: 'I was really close with Noel and I remember *Loaded* had said to me, "Look, can you get an interview with him?" So I rang Noel up and said, "Are you up for doing an interview for *Loaded*?" And he said, "Yeah, come round – we'll do it now." I went round and we did the interview. . . we went to Regent's Park and this photographer came along, took some photos. And then I went home and wrote it. Didn't even think anything of it. Just sent it in and, of course, it was the front cover and it wasn't part of their press campaign. And suddenly all hell broke loose. I remember Johnny saying to me, "This interview could've well and truly scuppered the sales of *(What's the Story) Morning Glory?*" Eleven-million albums later . . .'

MELANIE CHISHOLM Alongside lad culture there was the whole ladette culture, about girls drinking and being really loud. We just wanted to come out. 'We can be down the pub, downing pints, calling blokes "wankers".'

TIM SOUTHWELL The whole ladette thing was really embarrassing. Let's acknowledge the fact that *Loaded* re-invented the lad; that isn't somebody burping or pouring drink down someone's back or swearing, or some girl puking up outside a nightclub and getting into a fight and being obnoxious. Those were all the things that ladette culture seemed to be. Who wants to carry on like that?

JO WHILEY It was quite strange being a girl with the whole lad/ladette thing that took off. Steve [Lamacq] and I started to do photo sessions, and I was very aware that I was getting more attention as a female. It was not a good thing. I'd always felt like one of the boys, even when I was at school; I always wore clumpy shoes, DMs. But the way the tabloids turned it round into this cartoon caricature of the ladette wasn't particularly healthy.

IRVINE WELSH It was the advent of the geezer bird; birds that could drink and swear and go further and party and have a laugh and all that.

SARAH LUCAS I got bandied up with that ladette thing because I was quite a drinker at the time. It was more of a coincidence. By nature I am quite laddish. It was tiresome.

MELANIE CHISHOLM Ladette became a derogatory term. Girls were going out and trying to drink boys under the table. Physically we can't take that much booze so people would be puking. That's been happening for ever. It just went to an extreme. Fundamentally, it was just girls who wanted to give as good as they got.

SHERYL GARRATT Calling somebody 'a wanker', why does that make you a ladette? I don't see why, if you're a girl and you like going out, that makes you a ladette? The tabloid judgement went from having a party to being really judgemental and then to shaming, very quickly. First it was, 'Oh, this is really good fun.' Then it was, 'They're really going over the top, look at them.' Judge, judge, judge. Then, 'Let's try to get a shot up their skirt as they fall out of a taxi drunk.'

POLLY RAVENSCROFT There was that picture of Zoe Ball on the morning of her wedding with a cowboy hat on, a cigarette in her mouth, and clutching a bottle of Jack Daniel's. That was a dream for the papers and how they, in a slightly sexist way, decided to portray women. They went for it with Zoe. And then Sara Cox, when she presented *The Girlie Show*.

JO WHILEY They seized on Zoe and Sara and made them into these so-called ladettes. I kind of escaped because I don't think I was particularly glamorous or attractive enough to capture the imagination, whereas Zoe and Sara were a little bit more showbizzy. I did a horrendous photo shoot with Zoe and Jayne Middlemiss. It was for a Sunday supplement, and we just looked horrendously awkward wearing very tight skirts and way too much make-up. They were portraying us as the 'nineties girls'. It was really quite tragic. I never knew whether to talk about my daughter and being a mother; it was quite hard being involved in the whole scene because no one else particularly had babies.

POLLY RAVENSCROFT We got Zoe to do a cover of *Esquire*, and she wore a black PVC dress and thigh-length boots. She could carry it off. It was done in a stylistic way. Zoe would never wear something she didn't feel comfortable in. She was her own person. And if you're an attractive woman in that spotlight then it's an easy caption. The whole thing got hard for Zoe. Just the amount of attention. Everyone underestimates that.

SUZI APLIN It was called ladette just because women were drinking, but wasn't it actually just a turning point when women were given more of a voice?

MEERA SYAL That was very depressing for me. Having grown-up with hard-line feminism at university and Reclaim the Night marches, I remember thinking, What has happened? Why do women think that the way to equality is to ape the worst excesses of men? That whole ladette culture was so depressing. And, as a woman of colour, it was like, 'Jesus! Our battles haven't even begun and you're doing this.'

SHERYL GARRATT All those things can be very liberating and then fast become a stereotype. If you're Sara Cox on *The Girlie Show*, at what point was the line crossed where it went from being, 'Wow! A bunch of women doing a show,' to 'Oh, God, this is a tedious stereotype. Actually, I don't want to drink ten pints every time I leave the house, thank you.'

MEERA SYAL It was those Channel 4 late-night programmes, *The Word* and then *The Girlie Show*. This sort of effing and blinding and chugging pints. Not that there's anything wrong with wanting to chug pints and having sexual freedom. It was the demeaning of every other woman that didn't fit into that that I found unaccep-table. The whole point of being a feminist is about the freedom to choose in all areas of your life. I don't feel I'm any less than a woman who chooses to stay at home and bring up children. That is her choice. We should not, as women, be making each other feel bad about the choices we make. Also, it was a very ageist

movement. It was totally about younger women. That's not to say they shouldn't have the freedom of expression, but that's a long way from the shout of 'it's cool to be smart'.

CAROLYN PAYNE *The Girlie Show* was awful. They were trying to do something interesting by having all female presenters, but it was hardly feminism. 'Girlie' is hardly a strong feminist statement; girlies are silly little things.

JO WHILEY *The Girlie Show* wasn't anything I could relate to. It felt like a cartoon, like a *Viz* comic. It didn't sit comfortably with me.

CAROLYN PAYNE David Stevenson, Channel 4's commissioning editor for entertainment and youth, said, 'It was to be a celebration of women in the nineties.' Series one was Sara Cox, Clare Gorham and Rachel Williams. It was Sara's first big break and she took it in her stride but seemed a little dizzy – Wanker of the Week was an item you could make up the day before.

SHERYL GARRATT Where else was Sara Cox going to get a presenter's job, for a start off? There weren't a lot of female presenters, so the fact that it was carving out a space for some women to be on the telly on their own terms . . . She was a breath of fresh air.

MELANIE CHISHOLM *The Girlie Show* just felt part of the movement and what was happening and girls being at the forefront. I liked it. It was good fun. It was important, and the first television interview the Spice Girls did.

CAROLYN PAYNE They wanted to do an item on penis plaster-casting, and I was told to ring round this list of celebrity agents to find someone who would do it. I was like, 'Really!' The assistant producer said, 'Just use your contacts. Get it done.' I was like, 'Shit.' So I embarrassingly rang up these agents, and Damien Hirst was the only person who had any interest, but in the end he was too busy.

JO GOLLINGS On the one hand, you had programmes like *The Word* and *The Girlie Show* debasing attitudes to gender, but then in

the music world you had bands like Pulp and Suede addressing sexuality in their songwriting, with a refreshing, considered eye.

BRETT ANDERSON There was an atmosphere of sexual expression in artists like myself and Jarvis and Sarah Lucas. I suppose things go in cycles. Because sexuality had been verboten to express artistically for a while, automatically it becomes an exciting thing to talk about. It's always about trying to find the fresh new thing. After years of sex being treated as an anodyne thing, I was trying to bring an element of sexuality back into music, but something that wasn't polite or cartoonish. I described myself as 'a bisexual man who's never had a homosexual experience'. I was trying to break down the sexual barriers. It felt very easy to shock people in the early nineties. I remember saying in *Melody Maker*, 'We're talking about the used condom as opposed to the beautiful bed.' It summed it up quite nicely. I was trying to talk about sex as a very real thing rather than as a fantasy, fictional thing: the grubbiness of it; the failure; the hesitancy; not quite knowing what the other person is thinking.

JARVIS COCKER It was important for me to write about sex, which I often did from the women's perspective. 'Underwear' was very much addressed to the female protagonist in a situation, but I don't know if that comes across in the song. It's not, 'Oh aye, come on here . . . shag birds all night long,' it's completely the opposite. That was part of why I wanted to be in a band. I'd loved pop music from a very early age, and yet when I'd got to adolescence and got some experience of love affairs I found it was nothing like it was portrayed in songs. I wanted to write songs that somehow included some of that awkwardness. That was always a mission statement for Pulp, songwriting to put the reality of the situation in it. Some people would say, 'Well, that's not the place to put it. Music's a form of escapism. Why are you spoiling it by bringing it down to earth?'

SONYA MADAN One time on *Top of the Pops* we all dressed in school uniforms. It was taken as such a sexual thing. I was amazed; it

wasn't like I was naked. I didn't even have my top open or anything. It was more like *Grange Hill*, an innocent, fun thing, but it says a lot about the British psyche. We're so easily titillated. It was the same with *i-D*. I went in, and Juergen Teller said, 'Would you mind unbuttoning your shirt a little bit? Go on. It's the rock 'n' roll issue. Do this now. Lean forward. Strike a pose. Look rock 'n' roll.' That's it. Gone. Next interview. The strapline was 'get your rocks off!' It was their biggest-selling cover to date. So what? I took two buttons off. It was 'the rock 'n' roll issue'; it wasn't 'the come and fuck me' issue. If I wanted to do porn I could do better than that.

SARAH LUCAS I started using newspaper cuttings in my work because they were cheap and they had content and I could have some fun with it. It struck me as odd that this kind of stuff coming through the letterbox was normal and that anyone could read it, and it wasn't censored for families or anything like that. It was like, 'It's not even pornography. This is okay.'

MAT COLLISHAW Sarah used lots of images from the *Sun* and the *Sport* and grotesque, pornographic images. Obviously she's a woman, so she's got more of a right to use images of a woman than I have. I think we both wanted some kind of debasement of sensibilities without trying to be too artistic, debasing the image by using images of pornography, using the lowest common denominator.

SARAH LUCAS The fact that presenting the *Sport* pages exactly as they were, just blown up, made people question those images in a different way just because I was a woman. It was using myself as a positive force. I thought it was interesting that it didn't have an opinion about what it was saying and that everyone looks at it in contradictory ways. So no one bats an eyelid and yet at the same time there's a hell of a lot of prudery in other ways that we're all subject to.

SADIE COLES The thing that struck me about Sarah's early work was its particularly British humour and language. Jarvis Cocker's lyrics are exactly the same. It's a very British sense of humour,

which is a bit pervy – they're both pervs! That's why John Currin liked Pulp so much. *This Is Hardcore* was his cover. It was quite mild compared to his paintings of big-busted women – in the art world you can get away with much more hardcore stuff.

JARVIS COCKER The cover of *This Is Hardcore* – a woman from the midriff up lying naked on a bed – was trying to create an image that was both attractive and repellent at the same time. The idea was that it was a troubling image and superficially attractive because it's an attractive naked woman, but there's something that's not right about it. I saw a parallel with the pornography industry, which was really starting to take off, because the Internet was just coming into being and that was becoming a way of disseminating that.

KATIE GRAND I thought the Pulp cover was great. In the full picture, Steve [Mackey] is having simulated sex with her from behind. It was cropped and we were quite relieved after.

PHILL SAVAGE Posters on the underground were defaced with graffiti, saying things Like, 'This Offends Women', 'This is Sexist', and 'This is Demeaning'.

JARVIS COCKER I understood why some women's groups were offended. In some ways the cover was intended to be a bit offensive, that from the pose you could think that the woman was dead. Are you going to get turned on by a dead person? It couldn't just be a titillating image. I hope it doesn't come across as that. There was this thing about sexuality because magazines started having pictures of women without many clothes on again. It was an attempt to comment on that, I suppose. The idea that sex sells.

MAT COLLISHAW I wanted to make works that had the relationship and impact of a poster of a horse on the wall of a fourteen-year-old girl's bedroom. With *I'm Talking Love* I took a series of slides that I had photographed on my TV while the film *The Accused* was on; the scene just before Jodie Foster's character gets raped. I projected them on a carousel slide projector, and you had snapshots of what

appeared to be a nightclub scene, with a strobe scope flashing, of a dancing woman in various different positions. The scene is quite erotic because you're just seeing these little fragments of somebody dancing in a very sexy, provocative manner. It's a question of how many points does it take before this scene goes from something that's benign and innocent to something that's much more predatory and criminal and abusive and exploitative.

TRACEY EMIN I thought, 'Wow! This is really hardcore and dark.' It was really sexy and turned me on. Mat was a devil's advocate. He'll push things to extremes where other people would never. That's the job of an artist. They should open up dialogue.

MAT COLLISHAW We'd gone from a period in the seventies of *au naturel* – women not shaving their body hair, black and white pictures, basic props – into the eighties when people were getting pretty sophisticated contriving porn: airbrushing and refined sets; a product that was more polished and therefore more pernicious. It was less about women and more about male contrivance about what women were. I thought it was time for a reappraisal of pornography, particularly as porn was getting more confected and an insidious power that I found quite troubling. It's possible my generation shared a certain dissatisfaction with political correctness and were tired of being told what we couldn't do.

DAVID BADDIEL In my first novel *Time for Bed* the main character is addicted to porn. I gave Nick Hornby the manuscript, and I said, 'Have you got any notes?' He was very nice about it, and said, 'I think the main character should be more aware that's he's not meant to watch all this porn, that there's something wrong with it.' I said, 'I don't want to do that.' I felt the argument had moved on and now what was interesting was the way he was just ridiculously open and unashamed about it.

NICK HORNBY This is pre-internet, so I was rather taken aback to read a novel in which the character was unapologetic about

pornography. I felt that if David wanted a book-reading audience they would want some kind of contextual explanation. It was just there, 'Then I got some more porn . . . then I did this.' If you went to university in the seventies you would know about it if you were trying to objectify women. They'd all read *The Female Eunuch*. The openness towards sexuality in popular culture in the nineties is where I had to part company with things like *Loaded*, and why I was troubled with bits of David's book.

MAT COLLISHAW To make images of naked women using pornography isn't that different to the way Titian might have done it. The human form can't change in four-hundred years. You're dealing with this absolute abhorrence, in terms of its status as art: porn is the opposite of art because it's prurient. Why shouldn't that stuff be in a gallery? In *Crucifixion*, for example, I inverted an S&M picture into an image that resembled Christ and the two thieves on the cross. Which itself is an image of prurience, of a man suffering and being tortured; an image that has been cherished by millions of people for two-thousand years. We are very visual in the way that we relate to the world. Porn has an allure for a lot of men. We're genetically hardwired to be attracted to women's bodies. To be an honest artist, I think it was something necessary to deal with. Men's relationship to women is a fundamental part of life.

SONYA MADAN There was an attempt in Britpop to bring women up in balance with men, perhaps that's why the ladette culture grew. It was almost like 'we can do anything you can do'. What I found really sad was that there was very little camaraderie between the women in the various female-fronted bands. There was distrust and dislike, and perhaps a natural level of competition as well. If we'd all sat down together and had a drink we'd have probably got on really well. But there was no love and the press went out of their way to try to get us to bitch about each other. And when you're young you kind of go with the flow. It was all about headlines. It was a vicious time.

THE MAN FROM U.N.C.L.E.

Oasis. Britpop. War Child.

Labour Youth Vote

STEVE LAMACQ Kurt Cobain's death on 8th April, 1994 came two days after Oasis played live for the first time on Radio 1, and the tectonic plates of pop music started to shift. That's it. In twenty-four hours Britpop had arrived and grunge was dead.

JOHNNY HOPKINS Grunge was so fucking negative and depressing. Oasis was a band that was upbeat and confident, funny, ambitious and making really celebratory music. The contrast was stark; chalk and cheese. *The Face* called up and said, 'We're doing this big feature on new British groups. We'll give you a page.' I was like, 'No. Oasis deserve a page on their own. They're going to be bigger than all the other groups.' Six months later Liam was on the front cover, 'SUPERSONIC! OASIS: THE NEXT BEATLES, THE NEXT PISTOLS OR JUST THE NEXT BIG THING?'

NOEL GALLAGHER As grunge ended the world wasn't crying out for a fucking band from Manchester ripping off Slade riffs with Beatles melodies. Manchester was dead. There was nothing happening of any great significance in the music business. The only band that had been like us was the Sex Pistols. They had the tunes, put it out there and then imploded.

JOHNNY HOPKINS The whole of Oasis's success is extraordinary: they spoke brutally honestly, got in to trouble for it and achieved

mainstream success. The Sex Pistols achieved a lot of notoriety but not the record sales. They never did a Knebworth.

ALAN McGEE I was in my own bubble and I collided with mainstream. It wasn't premeditated. It just fucking happened. I hit the zeitgeist and went up in the lift. I saw a band, I fucking liked it, I backed it and fucking got thrown into the fucking stratosphere forever more with this fucking thing that was called Oasis.

DAVID KAMP Alan McGee made a great assessment of Oasis's audience in *Vanity Fair*: ''94 was a pretty pivotal year. Blur sold a million records, then we came out and sold one and a half million records. The timing was absolutely right. Post-acid house, a lot of people were fed up with going to clubs and hearing techno and wanted to go back to guitars. The British music renaissance, if you might call it that, started in the mid-eighties with bands like the Smiths and the Jesus and Mary Chain [. . .] bands that said, "Fuck you, we've got attitude." It was maybe 100,000 or 200,000 kids that bought those records, and by the time you get to the Stone Roses in '89 that audience had grown to about half a million. Oasis comes in and that audience isn't just half a million, it's fuckin' mainstream!'

ALAN McGEE If I hadn't done it myself I would think discovering Oasis in King Tut's was a set-up. I go to the gig and I don't even know they're playing. I was definitely not looking for a band that night. I showed up at half-eight, a little bit early, and saw this band who were moody as fuck. I didn't think too much about them. Then I saw Liam and he looked amazing. He had a Paul Weller haircut and looked like a rock star; I thought he was probably the drug dealer and Bonehead was the singer. They did their set, came off stage and I said to Noel, 'Do you want a deal?' He said, 'Who with?' I said, 'Creation.' He said, 'Yes. Do you want a tape?' I went, 'No, it's all right. I just want to sign you.'

JOHNNY HOPKINS My first knowledge of Oasis was getting a phone call just after midnight from Alan: 'Hey Johnny, I've just seen this band. They're amazing. They threatened to trash the venue. They've

got great songs. They look amazing.' 'Okay, Alan, that's great.' I'd only been working at Creation for six months and he'd already spun this kind of line a million times. He said, 'I want you to do their press.' I said, 'Okay, that's great. Let's talk tomorrow.' Half an hour later he phoned up again: 'Johnny, they're going to be the greatest band in the world. I can't get over it.' He phoned back every hour, all through the night. By the end of it I was going, 'This is something different. This isn't the normal McGee spiel.'

ALAN McGEE I always thought, It's a good story, Johnny. Then Susan, my sister, went, 'Alan, after the gig we went to the Sub Club and took Ecstasy.' She was right. I was phoning everybody, going, 'Oasis, blah, blah, blah.'

JOHNNY HOPKINS Alan arrived back from Glasgow, called me down to his office and handed me a cassette. It had a Union Jack on the cover going down the plughole in a disorientating, psychedelic way. I went, 'Wow! This is interesting.' At the same time, Alan was playing some of the tracks – 'Columbia', 'Rock 'n' Roll Star'. I was going, 'Fucking hell!'

NOEL GALLAGHER A friend of ours had a computer and we needed a cover for the cassette. He was training to be a graphic artist and said, 'I'll do one,' and used the Union Jack with a little twist in it. We all went, 'Fucking hell.' Of course, when we see McGee, he goes, 'Is that a Union Jack going down the toilet?' We were like, 'Yes, it is – that's a great idea!'

ALAN McGEE Before I'd ever met Oasis I'd been to the Boardwalk in Manchester[1] to see my friend Debbie, and she'd said, 'Do you want to come downstairs and smoke a joint?' I was looking around and I saw this Union Jack painted on the wall. I said, 'Who's this?' Debbie said, 'Oh, it's fucking some band Oasis we share the room with.' I was like, 'Oh, right. Are they fascist?' Debbie's a fucking little rat sometimes, and went, 'Yeah!'

1 Oasis made their live debut at the Boardwalk on 18 August 1991.

NOEL GALLAGHER McGee did that student thing and freaked out and thought the Union Jack was National Front. We were all looking at each other going, 'What's he fucking going on about?' To us the Union Jack was the Jam and the Who. It was the pop art, mod thing. We were Irish. We weren't flying the flag for Britain or making any political statements. We didn't give a fuck about any of that shit. We were trying to get out of the situation we were in.

GURINDER CHADHA Oasis weren't talking about 'England for the English'. That was the difference. They felt part of a new British consciousness that was part of multicultural Britain, represented by Tony Blair.

STEVE COOGAN Oasis were a breath of fresh air. It was like, 'Oh good, something real and authentic.' I went to see them when they were first blowing up. People were jumping up and down, and I was thinking, 'Fucking hell! This is a phenomenon.' *Definitely Maybe* was out and every track was like a singalong hit. No one had done that since the Beatles.

JOHNNY HOPKINS Noel being older and being incredibly sensible and focused knew it was there for the taking. He'd seen the Roses flounder, and thought, if no one else is going to do it then I'm going to. He worked and worked and worked and drilled the band. I'd never seen that work ethic combined with musical talent combined with humour and insight. It was unbelievable, that determination to succeed. People have that impression of Oasis just being party animals, and they were, but they worked and earned the right to enjoy themselves.

NOEL GALLAGHER When I learnt to play the guitar and started to write songs and joined Oasis, I remember thinking, I've got one chance. It wasn't about Britpop, or like Jarvis says, 'We've been rounded up. This is it.' I thought, I have one chance to make some fucking money; just not to be fucking poor, and to see the world. That was it. I come from a family of grafters. You don't get anything by not working. I did it all the time, every day.

ALAN McGEE Oasis connected because they were an absolutely fucking awesome band. I got them on the upswing. If you can get on the upswing you can go through the roof. I made the connection that the Stone Roses' second album hadn't come out and this band could fill the gap. I thought we could maybe go gold. That was about as far as my ambition went.

JO WHILEY When Noel and Liam came in and did the first Oasis session they were so unlike anyone I'd interviewed before. The music was electric, but it was their attitude. They just stood out a mile. Noel was incredibly quick-witted and the swagger of Liam was palpable. Star quality emanated from him. They were very much a band the audience really loved.

SONYA MADAN Liam is one of the nicest people I've ever met. There's a front that he plays as his official personality, but in my experience they are the sweetest people, and completely opposite to what people who don't know him seem to think.

SIMON FOWLER How would you describe Liam? He isn't like anyone else; more front than Brighton. He was just really funny. The two of them when they were getting on were brilliant and hilarious in a way only brothers can be; somewhere between telepathy and empathy. The first time I met Liam was at the Jug of Ale in Birmingham. I was sitting talking to him when a hand came round the door and threw a wrap of cocaine, and Liam caught it in one hand. I remember thinking, I want to be like you; I've never met anyone like you in my life. So we became friends. And then we introduced Noel to Paul [Weller] and they became friends. Liam, I used to think, was a little jealous and used to refer to Noel as 'Wellerfeller', because suddenly instead of wearing trainers Noel was wearing Paul shoes: loafers. The irony is that Liam opened the clothes shop Pretty Green, named after a Jam song.

FRAN CUTLER Noel and Liam were all about fun and laughing. They took it really seriously but they knew they had it, so they didn't

have to worry about anything. Oasis were the be all and end all of everything. It started and it finished with them.

LORENZO AGIUS Liam would be coming out of a club, doing that walk. 'Fuck off.' He'd push a pap down and there'd be trouble. He was very much, 'If you're going to be a rock 'n' roll star be a rock 'n' roll star. None of these clean fucking pop stars.' Everyone was protecting their image, but Liam and Noel didn't care and the press loved them for it.

JOHNNY HOPKINS Liam singing 'tonight I'm a rock 'n' roll star' – yes, you are!

STEVE COOGAN I was in County Mayo and I got off the plane at the same time as Liam, and we ended up in a hotel with a woman playing a harp and somebody playing the piano to American tourists. They introduced Liam from 'The Oasis' and said, 'Would you come and sing a song?' He wouldn't so I got up and sang 'Wind Beneath My Wings'. I was crooning it and he was laughing his head off, and all these American tourists were telling him to shut up because he was ruining my performance. We left the hotel and went in to the village. Liam said, 'Watch this', and burst into the local pub, spun round and went down on one knee and did the V sign. Everyone turned round and went, 'Oh my God!' Within about half an hour the pub was rammed. We got drunk and at the end of the night we fell fast asleep on my bed – not under the covers, I hasten to add.

JOHNNY HOPKINS Liam and Noel almost came to blows in an interview for *NME*, after getting thrown off a ferry on a disastrous trip to Amsterdam. Noel was saying, 'Getting deported is summat that I'm not proud about.' Liam said, 'Well, I am.' Noel said, 'Well, if you're proud about getting thrown off ferries then why don't you go and support West Ham and get the fuck out of my band and go and be a football hooligan cause we're musicians, right? We're not football hooligans.' Liam said, 'You're only gutted cause you was in bed fuckin' reading your fuckin' books.' It just went on with

loads of 'shut the fuck up's and, 'No, you shut the fuck up . . .'
The interview got released and made number fifty-two in the chart.

SIMON FOWLER I did an interview with *Melody Maker* and said, 'Oasis
seem to say things to people that nothing else around, certainly socially
and politically, seems to say to anyone. It's amazing, isn't it, that all the
adults think that they're role models or wankers, and all the kids think
that they're just wicked. It's so good that there is a band like Oasis who
have got something to say that is really up, like "Live Forever". They say
more about life to me than six months of electioneering will ever do.'

DAVID BADDIEL 'Live Forever' was the quintessential Britpop song.
It's a self-aggrandising song about how you want to be different
from everyone else, 'did you ever fed the pain in the morning rain/
As it soaks you to the bone'. It's a beautiful song about hoping for
some kind of triumph, but it's vulnerable at the same time.

NOEL GALLAGHER People liked us because the fucking songs were
great. I would say that as the songwriter. Liam would say it was
all about him. The songs have stood the test of time.

JOHNNY HOPKINS 'Live Forever' was an absolute work of genius.
The upbeat lyrics that Noel tended to write were very similar in
positivity to the feelings in the lyrics of acid-house records; that
reaching for the promised land. The club connection was crucial. I
remember phoning the editor at *Mixmag* and saying, 'You're prob-
ably going to say, "Stop talking now," but I've got this rock 'n' roll
band that I think is perfect for the magazine.'

IRVINE WELSH Every guitar band had a dance remix and every
dance outfit had a rockier sound. There was a fusion going on.

ALAN McGEE There was all these great big soul house anthems
happening, like Frankie Knuckles's 'Tears', and then by the time
Oasis came the music became quite techno, less *ugh, ugh, ugh* and
more *ee-eee-eee*, just electronic bleeps. Oasis dressed as if they were
from the clubs with big fucking rock tunes and it connected. They
got the Ecstasy audience three or four years later.

SHERYL GARRATT Bands started creating these big events where people would come from all over. There would be that sense of, 'Are you here for the Oasis gig?' 'Yeah, yeah.' It happened in every aspect of popular culture; the idea of being with a huge group of people sharing something. That's what we got from Ecstasy. If the eighties were about Margaret Thatcher saying, 'There's no such thing as society,' the nineties were about trying to rebuild some sense of community through culture. Ecstasy was a huge catalyst. You had bands that grew up with this euphoric music, going to the Haçienda in '88, '89, and wanted to get that sense of joy. The way a lot of Oasis songs were structured, it was that huge swell, which a lot of rave music did. It was all about recreating that feeling of, 'We're in this together. We can do anything if we do it together.'

NOEL GALLAGHER 'Some Might Say', if you think about it, is lyrics for a cheesy dance track. It's almost like a Martin Luther King thing set to a fucking Slade riff: 'One day we will find a brighter day'. It's like a prayer.

IRVINE WELSH I wrote an 'appreciation of Oasis' for *Loaded* and said Noel was the most successful songwriter in Britain today because he had the two most essential qualities any true artist needs: empathy and courage. Oasis were the rock 'n' roll band ravers loved. An Oasis gig was like going to a big community party. They had that sense of excitement that made you feel part of this whole thing; the uplifting songs, like fist-in-the-air anthems. Oasis and Blur and Pulp all had singalong songs. It had been seen as quite cheesy to do that, but it was a revival of that belief in British culture, like an old British music hall tradition was being revived. The idea of just going, 'Whoa! Party!'

BRETT ANDERSON I can see why you might interpret the whole Oasis thing as coming out of Ecstasy culture. I can see the parallels. Being at those clubs in the late eighties and having that sense of euphoria and oneness definitely made me want to write anthemic music for Suede. Oasis were creating a more mainstream unity.

STEVE LAMACQ If you look at the way lyricists had been pre-E, it was quite nihilistic; a lot of inward, bleak, nihilistic songwriters. Drugs feed off who you are. If you're susceptible to feeling like you want to embrace people then E works very well and Noel Gallagher will write a massive anthem. If you're susceptible to being cynical then coke will make Damon Albarn write an acerbic song like 'Charmless Man'.

JARVIS COCKER The rave scene released an energy. Bands traditionally had been this insular thing. There was always rivalry between bands. 'We're not going to be friendly with them because we've got to be more famous than them.' Then when rock bands saw what was happening in this basically electronic-music-based thing, they realised that this was so much more interesting than the insular little indie thing that they were doing. It certainly had a massive effect on Pulp and opened your mind up to another possibility, another way of doing it.

NOEL GALLAGHER There was a connection between young people's emotions being freed up by drugs and how it made you see the world, and how people reacted to Oasis. It's why we were bigger than anybody else. Jarvis was talking about supermarkets and fucking washing-up powder and Brillo Pads and Brussels sprouts and whatever else these little fucking gritty northern soap operas that he wrote were about. Damon was on about the dirty old man next door and whatever he was experiencing wherever he grew up. My outlook on life was global. I was writing songs for everyone and about everyone.

SIMON FOWLER Remember the pastiche of 'Wonderwall' by the Mike Flowers Pops? Chris Evans made it Radio 1 Single of the Week and told listeners it was the original, and it went to number two.

NOEL GALLAGHER I was away on tour and somebody called me and said, 'Is "Wonderwall" a cover?' I was like, 'Is it fuck. What are you talking about?' They were like, 'They've just played the original on Radio 1.' I was like, 'I'd like to hear that.' I heard

the record and it was obviously a fucking guy taking the piss. I thought it was great.

SIMON FOWLER It was a tongue-in-cheek tribute to the power of Oasis. It was certainly better than the Wurzels' version of 'Don't Look Back In Anger', which was from an album rather brilliantly entitled *Ciderdelica*. It's exactly as you'd imagine, 'Don't look back in anger, I heard thee say.'

JARVIS COCKER 'Don't Look Back in Anger' was when I realised Oasis were the ones who had made that journey from being alternative to being a part of everyday life. Every single bar seemed to be playing it. They'd done that thing that everybody had been trying to do of making that connection with the mass public. 'Wonderwall' had been a massive hit, but 'Don't Look Back in Anger' was like a done deal. It has a tune that instantly sets it apart. A great song is indestructible. It can survive anything you throw at it – even the terrible video didn't kill it.

NOEL GALLAGHER The title 'Don't Look Back in Anger' fell out of the sky. No idea. I wrote it in Paris on a rainy night. We'd been to a strip club. People have said to me, 'Maybe it's about a stripper?' Could be. The song itself is about a person looking back on their life and toasting it, having no regrets. The first time I played it was in Sheffield on an acoustic guitar to an arena – preposterous, ludicrous! Verve pulled out and Pulp and Ocean Colour Scene supported us.

JOHNNY HOPKINS It was a perfect live song, a lighter-in-the-air kind of moment. It's one of those songs that brings everyone together.

LORENZO AGIUS I went to the Ministry of Sound, and at the end of the evening they played 'Don't Look Back in Anger' and everyone, that's probably a couple of thousand people, was singing along. I was like, 'Wow! This band have got amazing followers.'

NOEL GALLAGHER It struck a chord with everyone. We still don't know what that song is. It's still growing after twenty years. It's

because there's some kind of universal truth in it, where if you listen to 'Common People' it could only be of its time. I guess what I'm trying to say is, I've never thought that any of my thoughts or what I wanted to say was that special, but I was channelling something.

SONYA MADAN Oasis represented something that was missing in culture; about being northern, being male. They meant a hell of a lot to young men around the country – the level of passion they managed to get from the fans . . . It's a fascinating story because you couldn't make it up. It was a celebration of Britishness.

NOEL GALLAGHER I didn't feel part of a new British idea at all. If you were in Sleeper, Elastica, Blur or Pulp, and around that boozer in Camden, play the guitar, could stand upright and wore Doc Martens, you were Britpop. We only got dragged into it probably because of the Union Jack and the New Labour thing. We were nothing to do with it. We had to be involved in it because it fucking sold it. You couldn't have a thing called Britpop and not have Oasis in it. We were bigger than Britpop. We were about to become the biggest thing since the fucking Beatles.

STEVE LAMACQ There is a point when Britpop became bigger than the music press and part of the broader media. By the time Blur and Oasis are written about regularly in the tabloids and there are think pieces in the broadsheets, it was a mainstream phenomenon.

MATTHEW WRIGHT The press, when it comes to cool things, is invariably way behind what's going on. I interviewed Blur after their first album and you couldn't give it away. The explosion of interest in Oasis blew a door ajar.

JO WHILEY It invites tabloid awareness because of the outspoken nature of Noel and Liam, and Jarvis, and their amazing quick wit; also, Justine and Damon's relationship. There were just so many sound bites and stories. It had absolutely every ingredient you could possibly want to write about, and then for the public to digest and feed off and invest in.

STEVE LAMACQ Everyone started seeing influences in the groups that they'd grown up with, things that hadn't come to the fore in pop music for a very long time. There were a lot of journalists and bands who suddenly thought, This is an underrated part of British pop music history and here are some people updating it and doing it in a different way. It's not like the bands were aping what the bands in the sixties and the early glam seventies had done; they were using some of these influences but bringing a viewpoint of the here and now.

KAREN JOHNSON People say, 'It was a watered-down sixties,' but actually, isn't everything reinvented in pop music? It was a youth culture. It wasn't just the stuff that the big record companies were pushing out. People in the media had to take notice of it.

JARVIS COCKER Once it got called 'Britpop' that was a fatal error; it turned from a forward-looking movement to a backward-looking movement. It became too enthralled to this thing of, 'Ooh, let's make the sixties happen again.' Once you get a thing that is just trying to make another period of time happen again it's just impossible.

DAVID KAMP The term Britpop was agitatingly vague, as Elvis Costello observed, 'Flattering the worst people and insulting the best.' But as I wrote in *Vanity Fair*, 'It remains helpful in describing the clutch of mid-nineties guitar groups whose music displays a fealty to mid-sixties ideals of catchiness and concision.' Cast sounded uncannily like the early Who. Damon Albarn was unabashed in his admiration for Ray Davies. Ocean Colour Scene made virtue of their loyalty to the Small Faces. And Noel Gallagher's penchant for referencing the Beatles was legend.

SIMON FOWLER There were two ground zeroes – either the Beatles or the Pistols – and the writers of those papers saw it as the Pistols. The strangest thing is that when Oasis came along they were doing retro music. Before Oasis you had to apologise for liking the Beatles, 'I love the Beatles but . . .' Suddenly the Beatles were the greatest

thing since sliced bread, again. Oasis legitimised liking the Beatles, which sounds absurd but it's true.

ALAN McGEE You were suddenly allowed to like the Beatles. People liked them but you couldn't admit to it. Then it became hip to namecheck them.

DAVID BADDIEL I think of Ocean Colour Scene as the most sixties of those bands. Not negatively. I really liked *Moseley Shoals*. It was a problem with the music press. There were certain bands like them who, because they wrote good songs that weren't particularly experimental and sounded a bit like other great songs from the sixties, were reviled by the music papers. You think, Well, no, it's not actually that easy to write songs like 'The Circle' or 'The Day We Caught the Train'.

SIMON FOWLER Maybe it's an age thing. Everyone suddenly realised how exciting the sixties were. What would their relationship be with the sixties? Their parents' record collections. Suddenly bands like us could play the music we'd always played and be accepted. I remember Liam and Noel did an acoustic support slot for us when we played the Electric Ballroom, and for the encore we all did 'Day Tripper' together.

NOEL GALLAGHER I was too pissed to play. I switched the guitar off and blagged it. From punk onwards every generation of artists spent their entire time trashing the monuments of the sixties. They didn't want anything to do with it. What my generation did was rebuild the monuments of the sixties because the eighties didn't mean a great deal to us. We reinvented the Beatles.

SIMON FOWLER On 4 September 1995 we recorded 'Come Together' as the Smokin' Mojo Filters for the War Child charity LP *Help*. There was something like twenty bands involved in making the record – Blur, Radiohead, Suede, Neneh Cherry, the Charlatans. You had to start at midday and finish by midnight. We went to Abbey Road and it was Paul Weller, Paul McCartney, Noel Gallagher and us. Johnny Depp came with Kate Moss. Kate was lovely. I was off my

face on coke and there's me explaining to Johnny all about the nature of stardom. He must have thought, Who's this dickhead? Johnny had a beanie hat on and looked like he was off the street. I looked down and noticed that he had cigarette stubs in his turn-ups, which he showed to Kate. Johnny had a band called P and one of their tracks was a cover of a Daniel Johnston song, 'I save cigarette butts for a poor girl across town'. I thought, That's why he's got them!

NOEL GALLAGHER I wasn't even supposed to play on that record. I was just going down to hang out because I lived round the corner and the night before I had recorded an acoustic version of 'Fade Away'. Nobody was quite sure if McCartney was going to show. Then he turned up and he went through the stories of 'Come Together'. He was claiming he wrote it that day: 'Y'know, when John came it was like a little rock-a-billy tune. I said, "John, you've got to swamp it out a little bit."' We were like, 'Oh, right. Bloody hell!' Then Weller handed me a guitar and said, 'Do you want to put a bit on?' As the tape started it suddenly dawned on me that I'd never played 'Come Together' before. I looked at Steve Cradock,[2] and said, 'What key's it in?' He went, 'It's in C.' I was fucking winging it.

SIMON FOWLER Macca did the guitar solo in the control room on an Epiphone Casino in one take! Then he said, 'I've got a new song.' All I remember was it was in A minor. He was teaching everybody it, but they ran out of time. At the end, Macca shook my hand and said, 'Look after yourself.' I called him 'Sir'. He wasn't at that point but he was to me.

NOEL GALLAGHER It was a great day, but it didn't mean a great deal at the time, to be honest. The whole thing with Oasis and Britpop, you only realise it in hindsight. They were just like normal Tuesdays and Wednesdays. I had fucking days like that five days a week. If it wasn't hanging out with Paul McCartney it was being at a bonfire

2 Guitar player with both Ocean Colour Scene and Paul Weller's band.

with George Harrison. If it happened now, it'd be like, 'Whoa, fucking hell!' I guess 'cause you're young and slightly sozzled half the time, and a bit like, 'Yeah, whatever, let's go and fucking do it.'

JOHNNY HOPKINS It all gets a bit silly when people like McCartney are in the picture. It was a mark of Oasis's success. Everybody wanted a part of it. It was a great media story.

ALASTAIR CAMPBELL We went to the Q Awards that year to present War Child the award for the best compilation. Tony posed for some photographs with Bob Geldof, Ronnie Wood and Eric Clapton. And then Mark Ellen, who was in Ugly Rumour with Tony at Oxford, introduced his former bandmate. Tony said, 'I'm just trying to remember the last time we were on stage together . . . I'm trying to forget it very quickly [. . .] *Help* was a remarkable feat. It was recorded in one day . . . mixed then pressed the next, and it was actually in the record shops that weekend and was the fastest-selling number-one album of all time.' It was the beginning of Tony aligning himself with music and youth culture.

MARK LEONARD The Labour Party was going through a profound generational change. There was a thirst for new ideas and new ways of looking at things. A lot of the people who were involved in the party were sceptical about New Labour, and therefore there was space for people who were younger, who were less experienced but who felt more in tune with the political project and could have their voices heard.

DARREN KALYNUK In the early nineties there was a thing called Arts for Labour, but it was very luvvie and not very current. I organised a charity auction, and numerous celebrities like Julie Walters, Victoria Wood and Ben Elton sent stuff in. It was that generation and I thought the party were missing a trick and could do something bigger. So I organised a Labour Party event at the Mermaid Theatre. Neil Kinnock co-hosted and Mo Mowlam[3] spoke. Then Harry Hill and Steve Coogan did some impressions. It was

3 Shadow minister for Northern Ireland.

brilliant. That's how I started dipping my toe into the link between popular culture and the endorsement of the Labour Party. There was a whole new generation of opinion formers who were anti-Tory, but whether they were pro-Labour at that point was more difficult to conclude.

ALAN EDWARDS I did a report on youth media for New Labour. It was about the culture of *The Face* and *NME*, and what young people thought about politics. It said, 'People think politicians are boring but maybe if you did this it could help.' I don't know if anyone read it.

DARREN KALYNUK Off the back of the Mermaid Theatre, Tom Watson[4] said, 'I want to do this again. We'll give you more support.' So we did something at the Clapham Grand and Tony came to speak. Alan Rickman introduced him, Alison Moyet did a couple of acoustic songs and Ben Elton was the headline. We sold it out. I had a call from Anji Hunter, from Tony's office, saying, 'Tony's raving about Saturday night. Why don't you get a job at Labour Party headquarters?' I went in to meet John Prescott and he was up for trying something out. He spoke to Tony, who said, 'Let's try it.' John's view was that we didn't want to leave any stone unturned. He always used to say, 'I don't want to think the day after the election, I wish we had done *x*, which could have pushed us over the line.'

PHILL SAVIDGE Darren Kalynuk called me out of the blue to get a list of people in the music business who Peter Mandelson wanted to meet, to get them behind New Labour. The first conversation we had was, 'Are you a Tory or are you Labour? Do you want to help? Can you get your bands to endorse the Labour Party?'

DARREN KALYNUK Mo Mowlam was out talking to the City, and I wanted to build connections into a new generation of opinion formers like Oasis and Blur, who meant something to young people. Often the party would think, Why don't we approach *x* to do *y*?

4 National Youth officer, later Deputy Leader of the Labour Party.

And they hadn't established a relationship. Elections rolled around and they wanted to get support and input from celebrities and they felt used: 'You only ever talk to me once every four years.' Jarvis was on the hit list. He was a tough cookie to get hold of so I got Mo to drop him a note through his manager, saying, 'It would be great if we could have a chat?'

JARVIS COCKER We'd been through this long period of Tory rule, so the prospect of a Labour government was exciting. It was a weird situation: we were being courted quite intensely to go to events and to nail our colours to the Labour mast, but there was something about the way they went about it that made me feel quite uncomfortable. It was like when Tony Blair made a big thing about playing guitar in a band, trying to get down with the kids. Part of me just thought, Okay! But we don't really need another person who can play bad guitar. We've got a lot of people who can do that already. Can't you just concentrate on politics rather than trying to ingratiate yourself with young people?

DARREN KALYNUK Damon Albarn said in a *Mirror* interview that Tony should 'give up politics and join Blur' and he would 'definitely' be voting Labour at the next election. Then I got a call from John Prescott's son, David, who said to me, 'Blur are going to be on *Top of the Pops* this week. Why don't you just go down and meet them?' So I got in contact with their press office at Parlophone, Karen Johnson. At that point, I knew 'Girls and Boys' but not much otherwise, so I spoke to Ann Rossiter, who was the sister of Martin Rossiter from Gene[5] and worked for a Labour MP. I said, 'Tell me about Blur.' She faxed me a list of the band with descriptions of the four of them. It was like, 'Dave, drummer: the clever one . . .'

KAREN JOHNSON Damon was curious and wanted to find out what it was about.

5 Following the top ten success of their debut album *Olympian*, Gene's highest-charting single, 'For the Dead', peaked at number fourteen a year later, in January 1996.

DARREN KALYNUK I went down to Elstree and met Blur's manager. 'Ah, yes, Damon's expecting you,' and they ushered me into a room. It was surreal. PJ & Duncan were there in their baggy shell suits. After a while I began to think it wasn't going to happen. Eventually, I saw Damon walking past. I shouted out, 'Damon, I'm Darren from John Prescott's office.' He said, 'Oh, right. Yeah, yeah, yeah. I've been expecting you.' We had a chat, and I said, 'I've just started putting together groups of supportive people in music and comedy and entertainment, and I read what you said about Tony.' He said, 'Yeah, I'm a fan.' I said, 'Would you like to come and meet him?' He said, 'Yeah, yeah, I'd love to.' He gave me his number, and then said, 'It's not going to be Red Wedge, is it?'[6] I said, 'Absolutely not.' He invited me to the bar and Justine Frischmann was there. I'd said to Damon before, 'Obviously keep this confidential,' so he introduced me as 'The Man from U.N.C.L.E.'

KAREN JOHNSON Damon was invited to the House of Commons to meet Alastair Campbell and Tony Blair in John Prescott's office. Tony Blair was quite young and had a music background so he could connect. How many politicians have ever had that? It wasn't John Major's 'warm beer and cricket.' Damon was seduced by it.

DARREN KALYNUK Beforehand, there was a meeting where I was asked to talk about what I was doing, and I mentioned that I'd been in touch with Damon and he was coming in to meet Tony. Peter Mandelson got up and left the room. Peter had this thing about 'Tony Blur', that it might become an issue. They were hypersensitive. Then I had a call from Tony's office, 'Can John meet Damon on his own?' I said, 'Not really, he's expecting to meet John and Tony together.' So it was agreed to hold the meeting in John's office, so if anyone caught wind of it we'd be able to deny that Tony had met Damon in his office. It was all a bit Machiavellian.

6 Formed in July 1985, Red Wedge was a collective of predominantly musicians who were 'for' but not 'of' the Labour Party. With 'hands-off' backing from the Labour leadership, local and national tours were organised to encourage young people to vote.

DAMON ALBARN My secret meeting with Tony Blair and Alastair Campbell plotting the future. I was fascinated, as a kind of commentator, observer. It was too tempting not to go, like a lot of things in those days. It was the night after Oasis's 'Some Might Say' celebration party, so I had a terrible hangover. That twenty-four hours was very pivotal and quite beautifully reveals and becomes the centre of this Cool Britannia narrative.

DARREN KALYNUK Damon arrived dressed in a tracksuit top and trainers. John told one of his crude Les Dawson jokes and then he picked up this Russian doll he had on his mantelpiece, with John Smith on the outside. He unscrewed the doll and inside it was Margaret Beckett, the Deputy Leader. Then John unscrewed the Margaret doll and inside was a small John Prescott. He said, 'That's the only time I'll ever be inside Margaret Beckett.' Then Tony and Alastair walked in with their jackets and ties off and shirtsleeves rolled up. Tony stretched out his hand and said, 'Hi, love *Parklife*. So what's the scene like out there?'

DAMON ALBARN Tony asked, 'What do you think people of your age want?' I was surprised how little I knew when actually posed the question, and how clearly I was not a spokesperson for my generation, let alone knowing why I was there. My hangover was really kicking in by then and I was having mid-afternoon sweats, so I couldn't really answer their questions. For them, there was a job to be done, this wasn't just a social meeting. They were genuinely interested, and they probably learnt as much from what I didn't say, and the way I behaved, than they did from what I did say.

ALASTAIR CAMPBELL Damon said he thought his role should only be one of 'identification', and the minute that celebrities became too political they were a menace. I said, 'What if you turned around and called Tony a wanker?'

DARREN KALYNUK John said, 'If he called Tony a wanker we'd just tell 'em to fuck off.' Damon said, 'No, no, absolutely not. We've all got our heads on. We'd never do that.'

DAMON ALBARN Alastair was standing behind me for a lot of the time, gesturing and making sure Tony stayed on point and didn't digress.

ALASTAIR CAMPBELL John thought I was being a bit aggressive and barked at me, 'Stop yelling at him like he's a private and you're the sergeant major.' I said, 'I'm just trying to find out why he's doing this.' When you bring people in you're giving them the opportunity to go out and do damage. You had to be a little bit careful that they weren't trying to use us because Tony was cool.

TONY BLAIR It was nice meeting Damon but I know what Alastair meant. The trouble with the artistic community is that they can turn on you as swiftly as they come to you. I had a very clear view that, when you met successful people in the space of art and culture, they can't necessarily tell you how to run the country, but they can tell you a lot about what the spirit of the times is like, because they've managed to capture it. Art reflects what's happening in society, so if you want to analyse the zeitgeist, which I was very keen on doing, people like Damon, and Noel, were very good people to talk to.

DAMON ALBARN Tony said, 'If you're doing as well come the election then we can do some business together.' I was like a rabbit in the headlights. Then John said, 'Come and have a drink.' We ended up getting really drunk together. At one point, he turned round and said, 'None of this matters anyway, because the shit's going to hit the fan in a few years' time.' He didn't qualify what he meant. It was a very strange chord to leave that particular reel of life.

ALASTAIR CAMPBELL I liked Damon and I think he was genuinely motivated. I wrote in my diary that he 'was clever and articulate, if a bit spaced out'.

DARREN KALYNUK I saw Damon out, and said, 'If you want to support the Labour Party, brilliant, but if you have an issue just think, These are high stakes. Please be careful about what you say and who you say it to. We're trying to get the Labour Party elected.' What I didn't want was the replication of Red Wedge, where you've got Paul Weller spouting off about party policy.

DAMON ALBARN I was terrified after that meeting. My relationship with New Labour didn't really progress. It was a mad twenty-four hours, within a mad week, within a mad month, within a mad year.

DARREN KALYNUK In broad terms, Alastair was probably agnostic about what I was doing. He wanted footballers and soap stars, not pop stars. But I was thinking about who young people were connecting with. I wasn't doing this in an academic way. John Prescott was constantly asking me, 'So what is it that young people see in me and Tony?' I didn't want to break it to him that it wasn't really him, it was Tony they were keen on.

KAREN JOHNSON I had my doubts and was suspicious. I would talk with Damon and say, 'If they get into government they're going to be the establishment tomorrow. They'll drop you or they won't listen to you anymore. It could come back to haunt you.'

MARGARET McDONAGH We were not cynical. Nobody sat there and said, 'This person is doing this and this person is doing this. There's two hundred there and two hundred there, and if we bring them together we've got four hundred.'

DARREN KALYNUK There was a dose of scepticism among various bands, but my entire focus was on the election. I was trying to say, 'Look at these extraordinary talents, people who you listen to and watch and enjoy, they're all supporting the Labour Party. Why don't you think about it? If they're supporting Labour there must be something there.' It was just the fact that Damon Albarn came in to meet Tony or that Alex James came in for a drink with Mo Mowlam or Eddie Izzard was a supporter. And then, in the course of their daily lives, if they were asked about or talked about their interest in politics or their support for the Labour Party, then that was good enough for me.

PHILL SAVIDGE I went to the House of Commons to meet Peter Mandelson but he wasn't there, so I got absolutely hammered with his secretary instead. At the end, she said, 'Take me away from this. Politics is so boring. I want to work in the music industry.' It was the most ridiculous day I'd ever had.

THE PHYSICAL IMPOSSIBILITY OF DEATH IN THE MIND OF SOMEONE LIVING

YBAs. Low Expectations. Pulp

TRACEY EMIN In the eighties, there was nowhere for contemporary art to go beyond three or four galleries. There was no way I could ever have got in one to show my work. Art galleries were down Cork Street with Hessian fucking wallpaper and little glasses of disgustingly acidic white wine. It wasn't like it is now with Tate Modern. Contemporary art in Britain was stuck in the dark ages. When there is nothing there is room for something.

GREGOR MUIR The absolute ground zero of YBA was seeing Jeff Koons's *One Ball Total Equilibrium Tank*, the famous piece with one, two or three basketballs suspended in water-filled tanks, and his stainless-steel cast of an inflatable rabbit, at the Saatchi Gallery. Seeing that, we all felt the need to act; that this world wasn't closed save to a certain type of weary aristocracy. There was a generation of artists that Charles Saatchi was showing that had a similar conceptual pop-art sensibility. Within a matter of months you have *Freeze*. It is very clear, the connection between the two.

NORMAN ROSENTHAL Charles Saatchi was the king of collectors. The king of mediators. His gallery was key. Going to openings, there would be hundreds and hundreds of young people from all the art schools.

MICHAEL CRAIG-MARTIN I had been taking students to the Saatchi Gallery since it opened in 1985. You can't exaggerate how fantastic it was. There's never been a better place to show art. He collected the absolute best artists being shown perfectly. This had never happened in Britain before. It was the greatest collection in the world at that time. The level of ambition of the YBAs came from the fact that they were going to Boundary Road and seeing the highest level of achievement. Their aim became 'I want to be a part of this'.

GREGOR MUIR We all went to those openings, least of all for the free Prosecco. The Saatchi Gallery became the most influential exhibition space of its time. It was the most beautiful gallery in a former paint factory. You would see incredible presentations of works by Bruce Nauman, Richard Artschwager and Donald Judd, and, in a way more importantly, the younger generation of artists coming from New York, such as Ashley Bickerton and Jeff Koons.

MICHAEL CRAIG-MARTIN Charles's greatest influence was showing young British artists what was being accomplished and what could be done, and he gave them a different perspective of what they might aspire to. When *Freeze* happened Charles wasn't particularly interested. It's only some years later that he starts to really get interested and goes to every exhibition. Charles has probably looked at more art than any person on earth. Every week he would travel round to every gallery to see every show. Nobody did that. Charles did that for years.

NORMAN ROSENTHAL Charles Saatchi picked up on it for a reason. He was this big advertising agent, Saatchi & Saatchi. They had this huge headquarters on the south side of Barclay Square, but after the Black Monday crash of October 1987 the move backfired. Suddenly his business went pear-shaped, and he discovered that his art was more valuable than his business: he sold everything.

MAT COLLISHAW Saatchi helped Thatcher on the '79 election campaign: 'Labour's not working'. Labour wasn't working: there

had been the three-day week, rubbish on the streets. I'm not validating Saatchi. It's spin. It's manipulating the public to believe a certain thing. That's the job artists are in. How is an audience manipulated by art? The size of font. The colour of a poster. All the psychology that goes with manipulation is part of an artist's toolkit.

MICHAEL CRAIG-MARTIN Artists have always been in the position of needing patronage. In the Renaissance it was the Popes and the Medici. Without the Vatican and the Florentines pouring money into these artists there would not have been the Renaissance. The history of the arts is this ambivalence between needing financial support to survive and prosper and the quite different needs of the people who sponsor it. There are always contradictions. In the music industry, when you buy a record it's as close to the original work as is possible. An artwork bears no relation. There's only one. That changes the relationship because it needs somebody with a million pounds to do it. Britain, on one hand, is a philistine place, and at the other extreme the people who are interested in the arts enable it to flourish.

GREGOR MUIR There is a move to integrate the language of advertising and the language of art. It's so apt that the chief collector is the head of the UK's biggest ad agency. And the artist who is prepared to work with him the most is pretty keen on getting press, and makes work which can play into the hands of the media.

MICHAEL CRAIG-MARTIN Damien Hirst had had the idea of the shark suspended in formaldehyde for a long time, but suddenly there's someone who's actually willing to buy a shark and finance his dream. It wasn't easy for Charles, to find somebody with such a fully fledged dream. It was very fortunate for both of them.

NORMAN ROSENTHAL Without Charles it wouldn't have happened. He made it possible. It was extraordinary amounts of money . . . but for a king. It was an amazing collaboration: Damien had the imagination, and Charles financed it.

MAT COLLISHAW The English public are an unpretentious bunch, so they're not that impressed by artists taking the piss out of them by putting things that they can't understand in a gallery space. They can get their heads around a painting of a hay wain in an English landscape, but they feel that someone's trying to mock them if they see a pile of bricks or a urinal or a four-foot shark in formaldehyde solution in a gallery.

TRACEY EMIN The shark in a tank was like something out of a fairground. Like a spectacle, not a piece of art to go and see. When I first saw it I was disappointed because it was so small. I was thinking more of a whale than a shark. But it was a breakthrough idea: that's what Damien was there for.

NORMAN ROSENTHAL Art was a tiny, elitist world. Through the world of Damien Hirst it suddenly broadened enormously. There's no question: Damien's a genius.

KEITH ALLEN Much in the same way that comedy had never been on people's horizon in the early eighties, art had never been on people's horizon until the early nineties. I'd never considered it until I saw the shark. I met Damien in the Groucho and I said to him, 'Anyone can think of pickling a shark and putting it in a vitrine, the difference is you did it.' He went, 'Oh, wow!' I said, 'I really admire you.' He said, 'I admire you too.' We became best mates.

NORMAN ROSENTHAL Damien comes from a very poor Leeds family; a working-class, north-of-England boy. He had an amazing sense of enterprise and an incredible business mind. You mustn't underestimate the intelligence and the culture of these people. That's why we could connect.

STEVE COOGAN I knew Marcus Harvey's brother Miles and knew he shared a space with Damien. I used to say, 'Bring that Damien bloke over, he's really funny.' I knew nothing of his work but he used to make me laugh a lot. He had weird photographs and used to show me stuff, but I didn't really pay any attention to

it. He once pressed his thumb into the tweeters of my speakers and damaged them. I remember thinking some time later, I wish I'd kept that.

IRVINE WELSH It's a clichéd thing to say because he's had so many accolades, but there's a genius about Damien Hirst. You can't deny it. I saw the shark piece at the White Cube and it hit me on a really emotional level. I saw the title *The Physical Impossibility of Death in the Mind of Someone Living*, and you wrestle with that. It was the interface of what it was called and what it was saying and how you perceive this thing. It was the same when I saw Tracey's *Bed*; it made all the difference from just seeing a picture of it.

CAROLYN PAYNE The art world became trendy. You became a pop star if you were a leading artist in a way you hadn't before then. That was Charles Saatchi.

TOBY YOUNG My view was that Brit Art was essentially a racket and that people like Charles Saatchi and Jay Jopling were part of this great charade. It was all highfalutin bullshit. They were just making this shit up as they went along. They used their force of personality and their various social connections to advance their careers. It seemed to be they were all just flimflam artists of various kinds just managing to dupe people into thinking they were fantastic. In so far as they had a talent, it was for bamboozling and dazzling people and persuading them that they were talented. With a conceptual artist you expect them to be a bit of a con artist at the same time. Damien Hirst did not seduce me.

JEREMY DELLER YBA work was incredibly visceral and tough and violent. It was very different from what conceptual art had been before, which is a lot more about politics or ideas and theory. It looked very good in photographs. It was quite easy to understand. It was arresting and had energy and attitude. It was going to grab people's attention. Its popularity was about surprise. It was also quite traditional; it's sculpture and it's painting. It wasn't a departure in terms of form or a revolutionary moment like Duchamp.

They weren't inventing a genre. But the content and the way they went about it, the attitude and the marketing, clearly was very important.

MICHAEL CRAIG-MARTIN It's more revolutionary than Jeremy is acknowledging because something really significant does change that makes the audience feel like they're being addressed. They don't feel excluded anymore; that it's a con; that they're been taken the piss out of; or it's a club in which they're not a member. Suddenly there's a substantial audience that isn't sceptical. That's a very significant change.

TRACEY EMIN There was the whole thing about the YBAs being known as the shock generation. Actually, if you look at everybody's work, that's not true. There's nothing shocking about Gary Hume. There's nothing shocking about Damien Hirst. There's nothing shocking about loads of people.

GREGOR MUIR What was helping the move was not just a shock-and-awe tactic; it was the fact that the work was very good and very engaging. It didn't speak to the navel. It spoke outwardly to people. It had a sense of public fascia.

MAT COLLISHAW Nothing that we were doing was any more radical than Duchamp's urinal. But as Matthew Collings wrote, Sarah Lucas went one better by plumbing her urinal in and likened it to the *Spinal Tap* moment when the volume knob goes up to eleven. As far as the press were concerned, there was nothing Sarah could desecrate a gallery with more.

GREGOR MUIR Needless to say, a fully functioning toilet in an art gallery caused a real ruckus in the press.

SARAH LUCAS Not just the content, but making things out of anything. I see it as a social statement. You can make things out of anything, anybody can. It's only about putting things together and that's actually a liberating thing. You don't have to toe some existing line on what materials are, and what art is, what anything is.

MICHAEL CRAIG-MARTIN Sarah has this wonderful vulgarity. It's partly the vulgarity of the double entendre and the seaside postcard. It's the *Sun* . . . It's sexy, very British and rang true with a lot of people.

MAT COLLISHAW The urinal was great and irreverent, and where Damien was raising the bar, Sarah was lowering it, which is a brilliant thing to do. You don't have to spend ten grand making a work. You can do it with stuff that you've got in your kitchen or on your table, which she did with *Au Natural*. If your intent is incisive and potent you have an artwork that has strength and currency; people can consider it something worth meditating on, which you generally wouldn't with an old mattress, a bucket and a couple of melons.

SARAH LUCAS I made *Au Natural* on the hop for a group exhibition at Portikus, in Frankfurt. I didn't take anything with me, so I went looking round some second-hand furniture place. I thought, I like that mattress. I was just looking to make something on the spot out of whatever grabbed my fancy. Then I thought, Well, how can I put this together? What could they be? Fruit and veg was a bit of a last resort, in a way, because they're very graphic and easily available.

MAT COLLISHAW She developed a language about art. It became the language of Sarah Lucas. It was art as a means of reflecting on life. Although the work that we made might have seemed a little bit pop, unserious, it was attempting to be part of this serious debate about what art was and could be.

SADIE COLES Sarah's work questions hierarchies and power. And how women are treated in art. It's the female body presented in a completely different way. There's a levelling of the traditional hierarchy and sometimes a complete flipping of it, in terms of the male body. That was evident in these very early works.

TRACEY EMIN Sarah was using a language that was already there but using it in a British context and using everyday objects. From a woman's point of view, that seemed to me a lot more accessible

than having to compete with the whole history of painting. It was irreverent and fresh and political. Sarah was making a stand. She was making feminist statements. *Penis Nailed to a Board*, for example. Sarah had an opinion and made a work about it.

SADIE COLES Sarah was like a one-person revolution. The language was strong and fully formed and uncompromising. It was dealing with big issues in a really tough way. I was just like, 'Wow!' A lot of that Goldsmiths generation, the work was very cool and clean and intellectually heavy, and *Penis Nailed to a Board* was like a punch to the stomach and surprising that it was made by a woman. For me, that was very important.

MAT COLLISHAW People like Sarah and Tracey, Rachel Whiteread, Angela Bulloch, Fiona Rae were all very strong women. They were all very outspoken, independent, good artists and perfectly capable of fighting their corner on whatever grounds. There was never a question of any imbalance between the power of the men and the power of the women.

TRACEY EMIN It was a lot more difficult for women to succeed in all fields. Galleries were a lot more interested in showing men than women. Sadie Coles worked for Anthony d'Offay and she learnt lots through working with him, enough to open her own gallery. Sadie was an exception and excelled in a man's world.

SADIE COLES There were just fewer women artists having success and having opportunities to show; fewer women gallerists, fewer women curators. It was tougher.

SARAH LUCAS A lot of the time the bigger picture has to be ready for something. You can't really define what that is and it's way too complicated to get your head around to know what made that happen. It's always a lot of things. There has to be a readiness or things don't go anywhere. It takes a lot of people.

GREGOR MUIR Even though you had the Saatchi exhibitions – *Young British Artists I* and *II* in 1992 and 1993 respectively – YBA

was a term that became more prevalent around the mid-nineties because there was a need to interpret the initiatives being undertaken around the world by the British Council.

SADIE COLES The grouping of the YBAs was journalists just latching onto something.

GREGOR MUIR Certainly some of the key artists were very good at self-publicising and very focused on gaining attention for themselves and their work.

TRACEY EMIN I didn't accept the term 'YBA'. Everyone thought we were really young but we weren't. In general, people weren't eighteen or nineteen, they were thirty, twenty-nine, thirty-six, or whatever.

JEREMY DELLER The media colluded: support of British art. There was a patriotic pride in it. Even though elements of the press were anti- at first, it soon became clear that it was something we were good at and there was an exciting scene around – it was going to grab a journalist's attention. It's a similar way that journalists got wrapped up in Oasis and hung out with the band and drank and did drugs with them.

MAT COLLISHAW Phrases like 'Cool Britannia' and 'YBA' were totally irrelevant and uninteresting to the group of people that I grew up and matured with. Obviously the media has got to cover what's happening so they're looking for a snappy little caption that they can use as an umbrella term. But being 'cool' was not something we aspired to. People were listening to Rod Stewart. It was the antithesis of the way we were thinking.

GREGOR MUIR All that institutional speak boiled and reduced everything down to the term 'YBA' and then later 'Cool Britannia'. It was enough to make you wince. It was the beginning of the end. They were using the increasing international proliferation of young British art across the world to help their cause. It was a way of summarising a spectrum of artists, both in terms of who

they might be and who other people thought they might be. For instance, if we were talking to an institution overseas it might become clear that they wanted 'a YBA show'.

SARAH LUCAS It is other people who are bothered by all those terms, but it did get on my tits getting called YBAs because all artists define themselves against other people. You're not trying to be the same as anybody else. You can't really complain about it because it worked for us. It was hilarious being on the road. There was a great, big scrawny bunch of us doing all these group shows in different places – Berlin, Cologne, New York – all staying in the same hotel and getting absolutely pissed. Before that time there hadn't been such a communal thing in the art world; group shows were a new phenomenon.

MICHAEL CRAIG-MARTIN *Brilliant! New Art from Britain* opened in October 1995 at the Walker Art Center in Minneapolis. It was one of many shows, quite rightly, trying to capture the energy coming out of the UK. There was a wonderful selection of twenty-two British artists exhibited, including Dinos and Jake Chapman, Adam Chodzko, Mat Collishaw, Tracey Emin, Angus Fairhurst, Anya Gallaccio, Liam Gillick, Damien Hirst, Gary Hume, Michael Landy, Abigail Lane, Sarah Lucas, Chris Ofili, Georgina Starr, Sam Taylor-Wood, Gillian Wearing and Rachel Whiteread.

GREGOR MUIR Richard Flood, the curator, tried to make it political by making the cover of the catalogue a photograph of London blown up by the IRA, which Mat Collishaw had taken, as though it was part of the revolution. It was absolutely nonsensical.

TRACEY EMIN We got asked to send in images that were significant about Britain. Mat sent a photograph and they used it on the fucking front cover underneath the title 'BRILLIANT!' It was demented. Mat wasn't saying that the IRA bombing was brilliant. I rode a children's bike, standing up, everywhere, which I got for five quid. I cycled every morning past Liverpool Street station at around ten-thirty, except Saturdays. That's when the Bishopsgate

bomb happened. A photographer was killed and forty-four people were injured. If I'd been cycling past I would have been killed. There's no doubt about it.

MAT COLLISHAW I had a lot of archive clippings, from squirrels and flowers to dead pole cats that had been trapped and killed to the IRA bombing in Bishopsgate. They were all part of the spectrum of the material that I sent, and they chose to use the IRA image. A bomb's a terrible thing. It wasn't cool. It was unsavoury and exploitative.

TRACEY EMIN Most of us were pretty shocked that it was used, it cheapened the integrity of Mat's work, but we only saw it when we got to New York. We were then asked what we needed for our work, and I said that my *Tent*[1] had to have some quietness so people could contemplate when they were inside. They put me in the middle of a thoroughfare next to three film installations. I said my work couldn't be seen like that. They said, 'It has to. You have no choice.' I said, 'Yeah, I have.' So I just picked *The Tent* up and dragged it out. It had plastic posts so it could bend, and as I took it down the escalator it went, BOING! Richard Flood went, 'Where are you going? You can't take it.' I said, 'Yeah, I can.' He said, 'Where are you going to put it?' I said, 'In my hotel room.'

SHERYL GARRATT I loved *The Tent*. It was small and dome-shaped and Tracey had sown into the inner lining the names of 102 people she had slept with. It created a couple of problems for friends of mine who were named, one in particular. His girlfriend of the time was not happy.

TRACEY EMIN *The Tent* was kind of like a little church. It was much more spiritual inside than you'd imagine. With all the colours it was like stained glass because the light came in. It was really pretty. You just sat in it and read all the names. It wasn't all about sex. It was about many different things. It wasn't at all what people think.

1 *Everyone I Have Ever Slept With 1963–1995.*

MAT COLLISHAW It was more of a poetic recollection of people she'd slept with, like her mother, rather than people she'd had sex with. It was Tracey finding her language using common everyday objects and sowing on names, generating an intimacy with the viewer by talking about her intimate moments.

JARVIS COCKER Art was aspiring to the popularity of music. Since then the art world has grown and grown and music's dwindled. Art has eclipsed music. If you're a young guy now and you want to live what used to be called 'the rock 'n' roll dream' – of making lots of money and meeting lots of glamorous women and travelling the world – you'd be better off trying to becoming an artist than trying to play guitar in a band.

MAT COLLISHAW The music that we were into was extremely important, definitely as equally important as art as an influence. A century ago artists had poets like Rimbaud and Verlaine; our generation had Johnny Rotten and Paul Weller and Joe Strummer. There is no shortage of examples of musicians with art-school backgrounds. They created their own worlds that you could dive into, strong visual identities on the album covers and inner sleeves. It was a physical thing. You would be looking at the cover of a record as you were listening to the music, and you'd be totally absorbed inside this world that they'd created. That was very important for a lot of us, that you could create your own world and image.

JEREMY DELLER I would be invited to these mayors' parlours in small towns, where they have presentation cases with gifts from visitors. I thought it would be nice to present a record rather than a cup with a picture of the Queen on it. I remember handing over *I Should Coco* by Supergrass to a French mayor. It served as a great indication of where you came from, geographically and spiritually.

GREGOR MUIR We all went through the same phases, liking certain bands. Elastica were really big with the YBAs. And there was always an enthusiasm for Pulp.

JARVIS COCKER We were setup to be part of that scene, studying at St Martins and Steve at the Royal College doing film. It was very novel for an artist to work with music, and to make art out of music or for music to inhabit a gallery. For a long time, pop music was just a commercial thing that people were into, so the artistic aspect of it was ignored or wasn't considered to be artistic.

GREGOR MUIR If we were looking to America and people like Sonic Youth and their relationship to the art world, at what point could we acknowledge Pulp and their output as art?

JARVIS COCKER When we signed to Island we were offered quite a big budget to make a video for 'Do You Remember the First Time?', and we thought, Instead of just doing 'Rio', why don't we split the budget; we'll make a video, but we'll also make a small film to go with the song. We were doing *His 'n' Hers* at Britannia Row recording studio, and the room that normally you'd play table-tennis in, we converted into a makeshift film studio and we pieced together this film about people's first sexual experiences, people we'd met or we thought, They're all right: Jo Brand, Justine Frischmann, Terry Hall, Pam Hogg, John Peel, Alison Steadman, Vic and Bob. We premiered the documentary at the Institute for Contemporary Art and discovered later that someone had actually lost their virginity that very night, a few hours after the screening.

MAT COLLISHAW Pulp had a strong visual identity: we were all drawing on the same kind of upbringing. All the influences that we had absorbed in the seventies were part of the fabric of what we were dealing with and making into our own work.

JARVIS COCKER Angus Fairhurst was a really good friend of Damien Hirst's, and one night he mentioned that he had a band and gave me a CD. Sampling wasn't that advanced then, and he basically took the intros to famous songs and looped them. You got this anticipation but it never paid off, so it was called Low Expectations. I thought that was an interesting idea.

MAT COLLISHAW There were several different collections of songs: the first collection was called Low Expectations; the next one Lower Expectations; and the final one Lowest Expectations. The context was 'Going Nowhere'. It was a changing band line-up. I was a guitarist but we were all miming. Angus was on vocals. Philip Bradshaw and Gary Hume played guitars. Adam McEwen was on drums. And Pauline Daly danced, swishing her hair. It was songs like 'Babies' by Pulp and 'Alright' by Supergrass. It would be four bars and then that would be repeated and fade into another song. Then another loop would come in and after those four bars another loop would come, so you would have three loops playing on top of each other. You would keep adding loops on top of loops, and end after ten minutes when you had about thirty different songs playing, all at the same time. It was a cacophony.

GREGOR MUIR It was so loud! One of their best gigs was in a tiny studio space in Clerkenwell. It was about two-hundred people in a shoe box. They were posing heavily and dancing and swinging around. You'd hear the opening guitar of 'Smells Like Teen Spirit' over and over. It was part of Angus's Sisyphean interest, inspired by James Joyce and artists like Bruce Nauman. The idea of hearing the familiar without a beginning or an end, and the sense that sampling was another form of architectural salvage. That sense of building something out of the detritus of contemporary culture rather than the pretence of thinking that you can just start again; that we could appropriate music culture in the same way that there had been an appropriation of former industrial spaces, and all the junk and debris around it.

JARVIS COCKER Pulp were playing some big shows in Brixton, and we said, 'Have you ever played it live?' So they supported us. The point for Pulp to get famous wasn't just for the ego trip. I'd always hated the idea that when you get success you pull the drawbridge up after yourself, and say, 'Bye, bye. See ya.' There was a certain thing of thinking, You have to use the opportunity to try to open things up for everybody. Instead of having a bog-standard support

band, let's put on something that will make people think or isn't what you expect. Just shake things up a bit.

MAT COLLISHAW I had to collect some supplies for the band in Tottenham on the day of the Brixton gig, and I got a message from Angus saying, 'We're going on in twenty minutes. Where the fuck are you?' Tottenham to Brixton was a long journey, and by the time I got there Pulp were on. Jarvis said the audience were pretty confused because we'd been billed as a support act and not an art band.

JARVIS COCKER Gary Hume borrowed one of my shirts and Pauline Daly added a bit of much-needed glamour. It was pretty funny but the audience were quite bemused by it all. Around that time we made some music for Damien Hirst for an installation called *Inferno Paradiso* for the Florence Biennale. There were all these animals there, a goat and a few rabbits. People could wander through and stroke the animals, and then the idea was the animals would make noises. We put microphones in the pens going through echo and delay systems, and that would mix into the music, so the animals were making the music. But in the end none of the animals wanted to make a noise and the rabbits gnawed through the cable of the microphone.

BRITISH HEAVYWEIGHT CHAMPIONSHIP
Blur vs Oasis

STEVE LAMACQ When you look back to that week in August 1995 when Blur and Oasis released new records on the same day and fought it out for the number one slot, if you put it into context: the late-eighties and early nineties had seen the breakthrough of alternative music into the chart; then we had quite a period of being colonised by American rock music and feeling like the alternative bands that we liked were being somehow overlooked in favour of things we didn't really understand. Then all of a sudden there was a celebration of Britain, a celebration of culture all coming together at the same time – pop music, a change in politics. It felt like we had a voice again.

ALAN McGEE There was a situation with a girl. That created the Britpop war. Damon shagged somebody close to Liam. That was how it all started. It was one of these many women Damon was friendly with. Then he got off with her for a one-night stand and that created the rub. They were all goading each other after that. It created the Blur–Oasis wars. It was Liam and Damon. It was all for a woman.

NOEL GALLAGHER Liam and Damon were shagging the same bird; and there was a lot of cocaine involved. That's where the germ of it grew from.

DAMON ALBARN Is it that simple? It wasn't the reason for antagonism from my point of view. But I suspected it was something

to do with that. It always seemed slightly ridiculous considering the context of the quite bohemian atmosphere of the time. It's a very old-fashioned view of things, really, and might I say a little bit hypocritical considering Liam was probably doing exactly the same thing to other people. We were just young and enjoying life and going out, and inevitably part of that was sharing partners. But I didn't go with Liam's girl intentionally. I didn't go, 'Right, I'm going to start this massive beef between us.' Not at all.

IRVINE WELSH I was inexplicably thrilled that 'Some Might Say' got to number one in May 1995. It felt like a victory for the working class, like our time had come. There was that sense with Oasis, this northern working-class council-estate band, that our boys had done it.

KAREN JOHNSON 'Some Might Say' went to number one and Oasis had a party at the Mars Bar[1] to celebrate. That was the turning point.

NOEL GALLAGHER Someone said, 'Blur are outside.' It was like, 'Let them in.' Then Liam started acting like a dick and got in Damon's face. It went from there.

KAREN JOHNSON Alan McGee was from the school of Malcolm McLaren and Andrew Loog Oldham. That was his template. He helped to create this whole Rolling Stones, the bad boys, versus the Beatles vibe. It created a rivalry and was the classic plan to get his band noticed. Blur were the obvious target. It made sense.

ALAN McGEE I invited Damon down because I was friends with him. Oasis were a bit put out that I'd put them on the guest list. I didn't know it would rile them. I didn't do things to deliberately wind people up – well, sometimes I did, but not with them. But equally I was like, 'It's my party. I'm buying the drinks.' I never had a problem with Blur. Damon would say, 'Come down to the studio,' before Chelsea matches because it was round the corner. We were good friends.

1 Situated on Endell Street, Covent Garden, Alex James owned a flat on the same street.

KAREN JOHNSON 'FUCKING NUMBER ONE!' There was a lot of that between Liam and Damon.

NOEL GALLAGHER There was an *NME* Awards where we fucking won everything and then we were photographed with Blur, and Liam said, like, 'Fuck you, cunts . . . blah, blah, blah.' It just escalated from there. They're both singers and singers are fucking idiots. They're wired the wrong way round. Once they've looked at themselves in the mirror for four hours, what else are they going to do?

JOHNNY HOPKINS The bands hated each other. Oasis hated Damon because he was a cock. And Damon hated Oasis because they were a threat to him. Damon is incredibly competitive. Noel is as well, but he's more laid-back about it. But Damon's competitive in a horrible way, and it showed in a lot of ways.

NOEL GALLAGHER It's like gangland wars start over ridiculous things and then it's very hard to put them to bed. It was kind of like that.

JOHNNY HOPKINS Oasis went in the Good Mixer[2] to mark Blur's card. It was like, 'Oasis are here. Watch your backs.' This was in '94. We went out drinking with a couple of people from the *NME* and at some point the idea came out, 'Why don't we go to the Good Mixer and see if Blur are there?' We walked in and it was like a cowboy film where the gang rides into town. Push open the saloon doors and you hear them whack against the walls and flap. There's silence and everybody in the room turns towards these figures standing in the doorway. They've got their hands on their guns; cigarette hanging from the corner of the mouth. Noel said to Damon, 'Get the drinks in, you're rich.' Damon got funny, saying they were just like shit northerners, poncing off him. It was like, 'Watch out.'

2 Located in Camden, the Good Mixer became a popular pub for musicians in the nineties.

NOEL GALLAGHER I don't recall Damon being there. As I remember it, we walked in and were like, 'Oh, look, that's Graham Coxon.' He'd seen us play and was like, 'Oh, you're the guys from Oasis. I really like "Supersonic".' We were kind of taking the piss a bit, but it was quite friendly. I always got on with Graham, even at the height of the mudslinging. I'd always see him in the same second-hand shops: 'Oh, all right. How's it going?'

KAREN JOHNSON We weren't all living in our social bubbles then. I would see Alan McGee and Johnny Hopkins out and about and chat. I saw Noel at the BRITs in '95 and said, 'I just wanted to say hello, I'm Blur's press officer.' He went, 'You're doing a good job.' Blur won four awards that night, and after receiving Best Group, Damon, being generous, said, 'This should have been shared with Oasis.' And Graham added, 'Much love and respect for them.'

NOEL GALLAGHER Did they say that? And we were dancing when they performed 'Girls and Boys'? I have no recollection of those nights at the BRITs. We were just fucking wasted all the time, 'Just give us that award, aarrrgh!'

DAMON ALBARN I felt like a right pillock the next day. I mean, fucking hell, it was just ridiculous winning all those awards. It was like, 'What is going on here?' I was embarrassed. I said, 'Oasis are fucking brilliant as well. Why aren't they getting anything?' It came from a genuine place, but I was probably naïve to think that it was that easy. Noel and Liam came from very different backgrounds from me.

KAREN JOHNSON Liam came up to our table afterwards and said, 'Look me in the eye and tell me you deserve this award.' I was like, 'Get the fuck away.'

JOHNNY HOPKINS Liam wound up Damon's girlfriend, which he relayed in NME, 'I was double rude to Justine the other night, going, "Go and get your tits out." It's her boyfriend, innit, 'cos I love getting at him 'cos he's a dick. If anyone said that to my bird I'd chin the cunt. But I fancy her big time! I'm having her, man.

In the next six months it'll be all over the press – I'll have been with her. Don't say that, though, 'cos I'm mad for her and that'd fuck it right up . . .' It was a provocation that wasn't going to go down well, and evidence of the huge rift between Blur and Oasis. Liam continued with it in *Smash Hits*: 'I wouldn't kick that Justine out of bed.' Justine responded, 'What a sad cunt. I mean, I'd think he was being ironic if he wasn't so fucking thick!'

RIC BLAXILL Damon agreed to present *Top of the Pops* and we were going over the running order, and he sees Oasis are down to do 'Whatever' and looked at me. I said, 'But it's a great song!'

KAREN JOHNSON Take That were on the show, and Damon said, 'Next week we have a Christmas Special with those pretty boys from Manchester, and here are another five pretty boys from Manchester. It's an exclusive. They're Oasis and they're wonderful.'

RIC BLAXILL Damon was positioned in front of Oasis, and throughout the whole introduction Liam and Noel were behind him, in among all these sunflowers set up on the stage, flicking Vs. The number of times we had to say, 'Will you calm it down.'

JO WHILEY The rivalry was comical. It felt like we were all acting out some kind of weird soap opera. It became this hideous battle for chart supremacy and this war of words. It felt like it had run away with itself. It wasn't part of a music scene anymore. It was tawdry and cheap and nasty.

NOEL GALLAGHER The whole chart battle thing with Blur was pretty fucking unnecessary. What annoyed us more was that everyone said it was us that started it, that we moved the singles around. It was like, 'Fucking hell! That's not what we do.'

DAMON ALBARN Did I move our single date release to clash with Oasis? I honestly can't remember. Knowing Noel, I tend to believe his story, but I'm not sure.

NOEL GALLAGHER A journalist at the *NME*, who was a friend of theirs, came up with the idea and said, 'Why don't you put

your record out on the same day as Oasis?' Blur ran with it. We were making *Morning Glory* and McGee came to the studio and said, 'Blur are going to put "Country House" out the same day as "Roll with It"?' I was like, 'What the hell for? Fuck it, we'll move ours back. Let them go first.' Then they put theirs back. We were like, 'Oh, okay.' I think we moved it once more and then right at the death they moved theirs again, so we knew what was going on. In the end, we said, 'Fuck it, if they want to be like that I hope they know what they're getting themselves into. Bring it on.'

ALAN McGEE Damon made that moment. He moved the single so Oasis had to go up against him.

KAREN JOHNSON Oasis were obviously looking for a fight, and Damon said, 'Let's just go with it.' I think it was six of one and half-a-dozen of the other, a bit of fun; tongue-in-cheek.

NOEL GALLAGHER I didn't even like 'Roll with It'. Some other fucking idiot decided it was going to be a single. Then all their camp blamed us, 'Oasis have manipulated this.' That really annoyed me. I don't give a fuck what anybody says about me, but two things I'm not is a hypocrite and a liar.

DAMON ALBARN If I did move the single, Oasis didn't do badly out of it, did they? I was doing them a favour, while shooting myself in the foot. These are things you learn in life. At the end of the day it was a bit of fun really. I wouldn't take it that seriously. But at the time it wasn't fun at all. It was like a nightmare.

KAREN JOHNSON McGee ramped it up as a class warfare, north versus south. I'm not saying it all came from him but it polarised people. You couldn't like both. It was ridiculous. My big gripe was if Oasis were so bloody northern why didn't they stay in Manchester? It was difficult enough being from the north. It was divisive.

DAMON ALBARN The weird thing was the casting of myself, and us as a band, as these public schoolboys. Noel identified a very

unprotected part in the armour and very effectively stuck his sword in there. I went, 'Ow, that really hurt.'

IRVINE WELSH The cultural wars in Britain have always been class divided. Oasis were from a council scheme, working class, northern. Blur were more middle class, southern, art school. It was also two musical traditions. The Stones and the Beatles. There was that element to it as well. Two fabulous bands that came up at the same time and were pitted against each other. They matched up perfectly.

JOHNNY HOPKINS I always fucking hated Blur. I didn't want them mentioned in the same breath as Oasis. Noel was writing fucking amazing songs. Liam was an amazing singer. Oasis needed their own space.

STEVE LAMACQ Why it worked was because of the differences between them. I don't mean because of north and south, and working- and middle-class. It wasn't that. It was about how they wrote songs. Noel wrote about *we* and *you* and *I* and *us* – a collection of people, of which Noel is one, writing to the heart of the people in a way they will associate and identify with him, and think, We're all part of this group. Noel's use of vocabulary is very much 'I'm one of the people', whereas Damon's vocabulary is more withdrawn; it's about *him* and *her* and *them* and *those* people. It's a voyeuristic view of the world.

DAMON ALBARN My songwriting always has two things going in parallel: I have quite a strong sense of satire and observation, and then I have an emotional truth which allows me to be able to sing the two things in balance. 'Blow, blow me out, I am so sad, I don't know why' in 'Country House' is an example of that.

NOEL GALLAGHER I'm not suggesting for one minute that Damon is a snob, but I'm certainly not a snob and my lyrics are not snobbish. Sometimes they're a little bit shit, and sometimes they're just a tool to get you from one part of the song to the other. They're honest and they're from the heart. I'm not pretending

to be something that I'm not. I never went to college. I had no qualifications. I've never had a music lesson in my fucking life. I just spoke from the heart. I'm not saying that Damon or Jarvis or Justine or any of that fucking mob didn't do the same. I'm just saying I'm not a fucking snob.

STEVE COOGAN I've got be brutally honest, Oasis had fantastic melodies but please don't anyone try to deconstruct their lyrics. It's just stuff to sing along to.

STEVE LAMACQ The media had to find an angle. The first angle is grouping bands together. Then, as it becomes more popular, it's creating a conflict. I don't think either camp shied away from playing, 'That's going to create some more copy.' The actual competition was probably between the record labels more than it was the bands.

ALAN McGEE I wrote a letter to *NME*, in which I said, 'What people are not acknowledging is the David vs Goliath situation between the companies. On paper we [Creation] shouldn't stand a chance . . . it's the equivalent of Brentford vs Manchester United.' It was true, but I was pulling on the heartstrings of people. We were probably just as big. Oasis were legally signed to Sony. I didn't really care. I still put the records out. I still found them.

SONYA MADAN Ultimately, it was about stories making the news and people wanting to hone in on the whole concept of Britpop. It was about sensationalism and laddishness and competition and just celebration in who's going to win. It raised everyone's status and awareness.

KAREN JOHNSON Then *NME* came out: 'BRITISH HEAVYWEIGHT CHAMPIONSHIP: BLUR VS OASIS' with the boxing-match style cover. That was when it just went absolutely nuclear.

RIC BLAXILL It was incredibly exciting to see the story being on the front page of newspapers. It was *the* moment for Britpop.

KAREN JOHNSON It was August so parliament was in recess, which meant the BBC and all the news channels picked up on it. They

thought it was a great silly season story. It was a nightmare because they all rang me: press, radio, TV. We didn't have a filter system at Parlophone, so they got straight through. I had tabloids calling every day: 'My editor says we've got to have a Blur story.' It was getting to a different level. You had to give some sort of comment, so I ended up as the spokesperson for Blur.

MATTHEW WRIGHT It felt like nobody wanted more of a chart rivalry than the *Mirror*. Piers[3] would be saying, 'It's just like East 17 and Take That,' but it was actually more like the Beatles and the Stones; good boys versus bad boys. You have to play one off the other, and here was that moment in an artificial race to number one. It was the peak of Britpop.

MATTHEW BANNISTER It felt like, Which camp did you fall into? Were you with the art school guys or the working-class heroes from Manchester?

KAREN JOHNSON I remember going to somewhere like Solihull to see a friend. It was a warm night and every bar we went past was playing either Blur or Oasis. Everyone was talking about it. It was just incredible. This wasn't Soho. It was a phenomenon.

IRVINE WELSH Damon came up to see me for the *Trainspotting* premiere and we were out on the piss, and every pub we went in they put on 'Roll with It' and everybody was singing it in his ear. He took it well and eventually started singing it as well.

DAMON ALBARN That was a brilliant day. It was in Leith, pub trawling on an afternoon in the middle of the week, meeting all the characters that he wrote *Trainspotting* about.

SIMON FOWLER It was a great opportunity to sell papers. Oasis saw Blur as 'soft southerners' and were very hostile towards them. Remember what Noel said, 'I hate that Alex and Damon. I hope they catch AIDS and die.' Not one of Noel's finest moments.

3 Piers Morgan was editor of the *Mirror* from 1995 to 2004.

KAREN JOHNSON That's when it got nasty. Miranda Sawyer showed me the piece she'd written and I was absolutely shocked. Noel had gone too far. It was wrong and left a sour taste.

DAMON ALBARN I didn't take that seriously! Noel was probably off his tits. I refuse to be indignant about trivia like that. There are more important things.

NOEL GALLAGHER That fucking ugly bitch who wrote that piece who looks like a fucking pickled duck knew what she was doing. I was too stupid to realise what was going on. I was racking out lines with her and then the whole thing gets fucking blown out of proportion. When I did interviews I'd just forget I was being recorded. I'd just be in a conversation with someone and then the next thing it'd be in the paper; 'Fucking hell, I've really got to get my shit together.' It was such a fucking ridiculous thing to say, it's school kids. I don't particularly have a great deal of time for Alex James. I don't dislike him but who gives a shit about a bass player?

JOHNNY HOPKINS It was a massive shitstorm. I was gobsmacked. Inevitably people got the wrong end of the stick and interpreted it as a homophobic remark. Noel thought he was talking off the record in a dressing room where everyone was taking drugs. He issued a formal apology: 'The off-the-cuff remark was made last month at the height of a war of words between both bands, and it must have been the fiftieth time during that interview that I was pressed to give an opinion of Blur. As soon as I had said it I realised that it was an insensitive thing to say, as AIDS is no joking matter, and immediately retracted the comment but was horrified to pick up the *Observer* and find the journalist concerned chose to run with it. Although not being a fan of their music I wish both Damon and Alex a long and healthy life.'

KAREN JOHNSON Then you had all the think pieces, like the *Spectator*; they hadn't a clue about the music or the bands and were making political currency out of it. It sat uncomfortably with the artists. They didn't want to be part of tabloid-fodder kiss and tells.

I'd be polite and helpful on different things, but I had to protect the band from this intrusion. That's what the job is: it's not just getting press; it's keeping them out of the press.

DARREN KALYNUK There was talk of getting a photo op with Tony, Damon and Noel together, saying, 'The only thing they hate more than each other is the Tories.' It sounds like an Alastair idea, but Damon was dead set against it and I don't think it got as far as Noel.

PHILL SAVIDGE There was a BBC2 live special called *Britpop Now*, which featured the first TV performance of 'Country House', with Damon dressed up in plus-fours. Pulp did 'Common People' and there was also Supergrass, Elastica, Sleeper, Gene, Boo Radleys, PJ Harvey, Menswear, Marion, Powder and Echobelly. Damon presented it, and his caveat was, 'I'll do it if Suede aren't on it.'

JOHNNY HOPKINS Oasis turned it down.

RIC BLAXILL Oasis did 'Roll with It' as an exclusive on *Top of the Pops*. Robbie Williams was presenting, and said, 'It's an honour and a pleasure to introduce the next band. They are the band of the people. They are Oasis . . .' It cut to the band, and Noel and Liam had swapped places. So Noel was singing lead vocals and Liam was pretending to play a guitar and doing backing vocals.

SHERYL GARRATT Robbie told me he slipped up and said, 'The band of the people – Blur!' The BBC did a retake, perhaps not realising how funny it would have been to let the mistake stand.

KAREN JOHNSON Damon went on the Chris Evans *Breakfast Show* and sang 'Rockin' All Over the World' over the top of 'Roll with It'. It just became so incredibly tense.

POLLY RAVENSCROFT That was funny: two bands having a row. It played out quite well for us.

MATTHEW BANNISTER It was grist to the mill that they were having this rivalry and slagging each other off. Everybody seemed to benefit. Blur vs Oasis became mainstream.

STEVE LAMACQ It became pretty clear by the Thursday that Blur were probably going to win because they put out two different CDs rather than Oasis's 7-inch and a cassette. I think that's what tipped it in their favour, regardless of which song was better than the other.

NOEL GALLAGHER I was on holiday in Sorrento in Italy, and some guy came to the pool and said, 'There's a phone call for you.' I was like, 'Fuck!' It was someone from Creation. They said, 'There's been a problem. Some of the barcodes are not registering in Woolworths on the 7-inch' – or some shit like that – 'so it's looking like you're not going to be number one.' I remember thinking, The biggest day in British pop history for thirty years and you're telling me that there's some fucking cocksucker in a shed somewhere can't get it right . . . fuck off!'

DAMON ALBARN I avoided the whole of that week. My dad, as a teacher, had gone to set up an art school in Mauritius, so I went to see him with my mum. I only got back into London on the Sunday.

KEITH ALLEN I was with Alex at Damien Hirst's country place, a shithole derelict farm that just happened to have electricity. We used to go down there and fuck about. I'd got an audition for *Evita*, which Alan Parker was directing, with Madonna, and Alex had bought an Abba songbook, and we spent the day in a field on a motorbike with a guitar, him trying to teach me how to sing 'I Have a Dream'. It was hilarious. We drove back to London listening to the chart show on Radio 1, and it got down to number two . . .

KAREN JOHNSON Mark Goodier announced it, 'They'll be celebrating in London . . .'

KEITH ALLEN Alex went mental and we cracked open the champagne.

STEVE LAMACQ That night, Blur had a muted celebration at Soho House. Graham wasn't enjoying it. Everyone was quite drunk and he made a dash for the window.

KAREN JOHNSON He tried to jump out of a second-storey window

and we grabbed his legs. He was not a happy bunny; about the song and everything that had built up.

DAMON ALBARN That was a little frustrating because when we recorded 'Country House' I was like, 'Are we all absolutely sure we want to put this out as a single?' Alex: 'Yeaaah!' Dave: go along with the flow. 'Graham, I've seen signs over the last couple of years that you're uncomfortable with the populism of this band at the moment. Are you comfortable with this?' He was absolutely adamant that we should put it out. Then for him to react so badly to it was just a bit like, 'Ugh.'

MATTHEW WRIGHT It felt like a very hollow campaign. Blur certainly didn't seem to give a fuck, but Oasis did. And consequentially Blur winning would have wound Oasis up.

KAREN JOHNSON We were all really pleased Blur got the number one. But I liked both records, to be honest. The following week, Alex wore an Oasis T-shirt on *Top of the Pops* and did his stupid gormless grin that he did with his bass guitar.

RIC BLAXILL It was crazy. You came out of whatever programme was on before, and the next thing it's Blur on a milk float beeping the horn, and Alex saying, 'Hello, we're Blur and we're number one and we're going to be camping it up later on *Top of the Pops*.' Jarvis was presenting that week, and while Damon was trying to yank off his jacket, he said, 'It's the taking part, not the winning.'

SIMON FOWLER Blur won the battle but I'm never quite sure who won the war.

ALAN McGEE The reason we lost that singles race was that Blur were bigger than Oasis at that point, but they made us big overnight by dragging us into the ring. We were the ultimate winner.

IRVINE WELSH Everybody said Blur had won, but after there was this incredible dynamic charge to Oasis. They'd lost that battle but decisively won the war because of the power of *Morning Glory*.

Blur crafted an uplifting, powerful album with catchy pop tunes, but it couldn't match Oasis over the long haul.

NOEL GALLAGHER Nobody had heard 'Don't Look Back in Anger' by this point, or 'Wonderwall'. *Morning Glory* was about to change the world. I knew what was coming. It was like, 'Why are we fucking around with this?' But if you're very publicly in a chart battle you don't want to finish second. If I could sum it up in a word, unnecessary. It was just so fucking unnecessary. What did it prove? Nothing. I know Damon well now, but we've never spoken about it. One night, a few years later, we just happened to be in the same bar at the same time.

DAMON ALBARN A mutual friend re-introduced us, and said, 'Just have a fucking drink together.'

NOEL GALLAGHER We both went, 'Argh, fucking hell!' I can't remember exactly how the conversation went, but the gist of it was us both saying, 'That was a bit fucking mad, wasn't it?' Then it quickly got into, 'but wasn't it great, though?'

DAMON ALBARN It was called growing up!

HANGING ON IN QUIET DESPERATION

British film. *Trainspotting*

BRETT ANDERSON Mike Leigh was a huge influence on what we were doing – his little vignettes of weird English life were quite beautiful. All of those films like *Nuts in May* and *Grown-Ups* and *Meantime*, set in Hackney in the early eighties. We used to watch them obsessively. These suffocated English lives 'hanging on in quiet desperation', as Pink Floyd said, living on the edge of some sort of personal invisible cliff.

JARVIS COCKER It was that idea of trying to write about how things really are. If you take *Abigail's Party* as an example, it's become almost a byword for seventies kitsch, but it's really uncomfortable to watch and it's tragic. Maybe that's just a thing, that people remember what they want to remember, not necessarily what the person who made the thing would want them to remember. It's a similar thing to people in bands who had this dream of creating something extravagant or experimental, but in the collective unconsciousness it's just Geri Halliwell in a Union Jack dress; that's the thing that stuck, not the highfalutin artistic vision.

JOHN NEWBIGIN The state of British film, with a few exceptions, was not all that great. There was this constant 'we're about to break through in the US' but it never quite happened.

JARVIS COCKER I liked the idea that everyday life can be entertaining. It gave one hope. When I was at college I was really

fascinated by that early sixties period when you got all these kitchen-sink dramas like *This Sporting Life* and *Up the Junction*, where it's a realistic thing, and then almost as quickly as it happens it disappears and then there's this long twenty years when seemingly nobody wants to make films about that.

DAVID KAMP David Aukin[1] said, 'The film that really changed things was *Shallow Grave*. It hit a nerve. You sensed a new generation coming to the fore. There was a real division, a real generation gap – people under forty loved it, people over forty hated it . . . it emboldened us to say, "Danny Boyle go further."' It was like how *Modern Life Is Rubbish* was perceived as potentially too British, but was well received, so it emboldened Blur to make *Parklife*.

IRVINE WELSH David Aukin was involved in just about every major British film in the nineties. He was a massively influential figure. He was that kind of powerhouse guy. There are many people like that who are the engine room of the whole thing. They just get on and do, and have that sensibility, 'This is our time. You should be doing this,' and they push it through.

GURINDER CHADHA David commissioned *Bhaji on the Beach*. It was an exciting period for British film: Mike Leigh's *Secrets & Lies*; and Ken Loach came back in a big way with *Raining Stones*, *Ladybird Ladybird* and *Riff-Raff*. British cinema tried to crystallise what Britain, as a nation, had become from those Merchant Ivory films. Suddenly they were gritty and working class and trying to explore the very nature of Britishness.

MEERA SYAL I wrote *Bhaji on the Beach*. The film was very significant and fed into the whole Cool Britannia thing. Channel 4 Film's remit was to showcase the unheard voices in society. I wanted to do something about the daytrips I used to go on to Blackpool. It was twenty-five Asians in a Datsun Sunny: you took your pickles and your roti silver foil, and be embarrassed to walk with your elders because they'd want to paddle in the sea. I went in to see Karin Bamborough with this pitch and they basically went, 'That sounds great. Here's a

1 Head of Channel 4 Film, 1990–98.

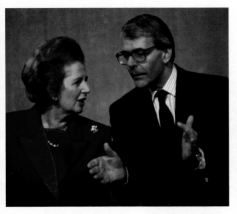

Above: Margaret Thatcher with John Major at his first party conference as Leader of the Conservative Party, 1991.

Above: John Major and Virginia Bottomley depicted as puppets for the satirical television series *Spitting Image*, 1992.

VIRGINIA BOTTOMLEY *I was very loyal to John Major, but because he hadn't been to university people underestimated the level of his intellect.*

Below: Police stand guard over decks after busting an illegal warehouse party.

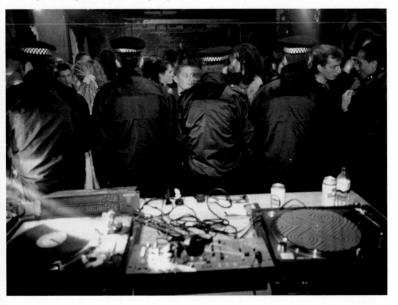

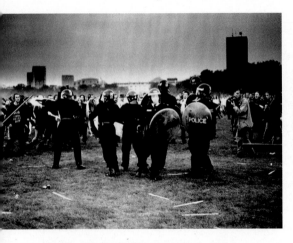

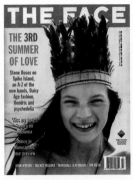

Kate Moss front cover of *The Face*, July 1990.

Criminal Justice Bill protest, Hyde Park, London, 1994.

IRVINE WELSH *The Criminal Justice Bill legislated against music that was 'characterised by the emission of a succession of repetitive beats'. It was about people and freedom.*

SHERYL GARRATT *Kate was everything a supermodel shouldn't be. She was the coolest girl in the world, and epitomised everything that was great about Britain in the nineties.*

Young British Artists (l-r) Michael Landy, Steve Adamson, Damien Hirst, Angela Bullock, Sarah Lucas and Mat Collishaw (dismantling a radiator) preparing for their first exhibition, *Freeze*, 1988.

Morrissey performing at Madstock, Finsbury Park, London, 8 August 1992.

BRETT ANDERSON *The next week on the cover of the NME was the headline 'Flying the flag or flirting with disaster?'*

Cornershop, with Tjinder Singh holding a burning poster of Morrissey, outside EMI Records, London, September 1992.

TJINDER SINGH *People were getting angry. There were a lot of marches and demonstrations against the rising tide of the right wing.*

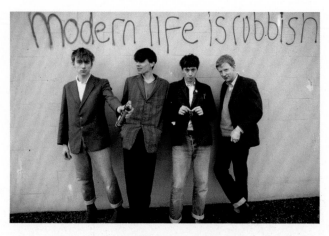

Above: Blur (l-r) Damon Albarn, Alex James, Graham Coxon and Dave Rowntree, 1 March 1993.

DAMON ALBARN *It was part of who I am: the lad; the England supporter; the person who is moved to tears by 'Jerusalem'.*

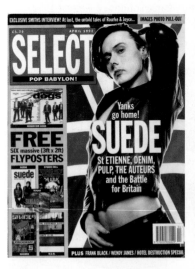

Brett Anderson on the front cover of *Select*, April 1993.

BRETT ANDERSON *That might be the cusp of where the Union Jack went from being an ugly, dubious nationalistic symbol into a symbol of pride.*

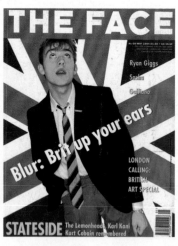

Damon Albarn on the front cover of *The Face*, May 1994.

SHERYL GARRATT *The Union Jack was in danger of becoming a symbol for racism and unpleasantness. This was our country too and I was damned if they were going to have my flag.*

Steve Lamacq and Jo Whiley, hosts of the Evening Session on Radio 1, 1994.

JO WHILEY *We didn't feel like radio DJs at all. We felt like imposters.*

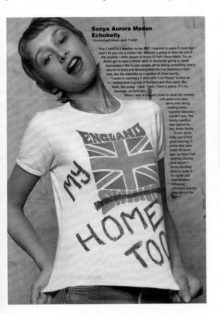

PP Arnold and Simon Fowler (Ocean Colour Scene) at the author's flat, Moseley, Birmingham 1997.

SIMON FOWLER *Pat came round and sang 'The First Cup is the Deepest'. It was like a religious experience for two non-believers.*

Sonya Madan wearing 'MY HOME TOO' T-shirt. *Vox* magazine, September 1994.

SONYA MADAN *I like to piss people off by taking something that's sacred to them and throwing back the true meaning in their face.*

Left: Hugh Grant and Andy MacDowell during the filming of *Four Weddings and a Funeral*, 1994.

DAVID KAMP *Four Weddings was so English, in a public-school way. It showed how acute Englishness could sell beyond London.*

Below: (l-r) Justine Frischmann, Damon Albarn, Eve and Ewan McGregor, Irvine Welsh and Ewen Bremner at the *Trainspotting* premiere, Cannes Film Festival, May 1996.

IRVINE WELSH *It was a celebration of false intimacy and smarm, with the air-kiss and phoney handshake almost obligatory.*

Trainspotting studio shots (l-r) Johnny Lee Miller, Ewan McGregor and Robert Carlyle.

LORENZO AGIUS *They were all so amped up, maybe coked up, I said, 'Let's shoot each actor in character'.*

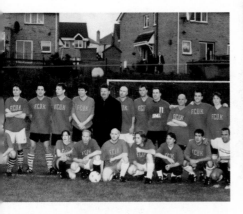

Trainspotting football XI (l-r standing, inc.) Danny Boyle, Robbie Coltrane, Irvine Welsh, Nick Hornby and Johnny Lee Miller; (kneeling) Peter Mullan, Ewan McGregor, and Robert Carlyle.

NICK HORNBY *Ewan McGregor scored and everyone did a mock chasing him round the pitch and jumped on top of him.*

Liam Gallagher and Damon Albarn at a music industry Soccer Six Tournament, Mile End Stadium, East London, 12 May 1996.

ALAN MCGEE *There was a situation with a girl. That created the Britpop war.*

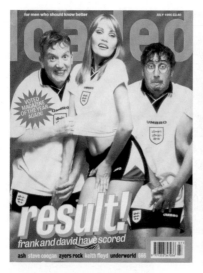

Frank Skinner, Kaja, and David Baddiel on the front cover of *Loaded*, June 1996.

DAVID BADDIEL *Frank and I did it for Euro 96 with a European model taking her top off. It was sexist.*

Stuart Pearce and Paul Gascoigne on the front page of the *Daily Mirror* the week of the Euro 96 semi-final between England and Germany, 24 June 1996.

STEVE DOUBLE *It was despair. Blatant xenophobia.*

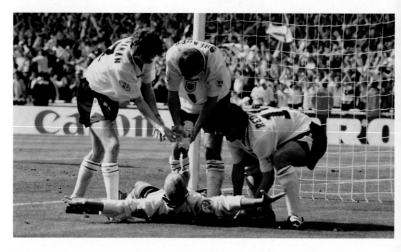

(l-r) Steve McManaman, Alan Shearer and Jamie Rednapp celebrate Paul Gascoigne's goal against Scotland, Wembley Stadium, 15 June 1996.

commission.' She had the money and the sensibility and probably knew very smartly that the time was right for this. It's still the only film in Britain written and directed by British Asian women about British Asian women, and pretty much wholly a British Asian female cast.

CARLA POWER There was a lot of interconnectivity. I think of it as an electromagnetic field where you had these different particles buzzing off each other. Tony Blair was cool. Then suddenly Noel Gallagher is shouting about him at the BRITs. Then suddenly Richard Curtis is directing Hugh Grant in a film with Andie MacDowell. It's a small enough island that everybody can feel one another's energy when they all come out of their studios.

DAVID KAMP Richard Curtis was such a commercially minded person. There was no art-house aspect to *Four Weddings and a Funeral*, but its sense of humour was so English in a public-school way. It emboldened British filmmakers because it showed how acute Englishness could sell beyond London.

JO LEVIN Michael VerMeulen, the editor in chief at *GQ*, said, 'There's this funny little film called *Four Weddings and a Funeral*. I hear it's going to be huge. I'm going to take a risk, Jo. I want to photograph Hugh Grant for the front cover.' At the point, nobody really knew who Hugh Grant was, apart from *Maurice*. Hugh turned up at the studio and he had that floppy-hair gesture. I had to say, 'Will you stop flicking your hair – do you want a kirby grip or an Alice band?' He burst out laughing. He said, 'I'm really nervous, I hate having my picture taken.' I said, 'You'll be fine. I'll look after you.' He said, 'May I have a Coca-Cola?' I said, 'Sure.' I had a plate of Kit Kats, and he said, 'And may I have a Kit Kat?' I said, 'Of course! May I have half?' He said, 'Sure.' Anything to get a good picture! He walked onto the set wearing a Paul Smith blue-and-white gingham shirt and he was holding a can of coke, which became the front cover. Later, we got sued because there was an issue with the Coca-Cola can.

STRYKER McGUIRE It's safe to say that, globally, more people were

familiar with *Four Weddings* than *Trainspotting*. It was the firm opposite. It painted a very depressive picture.

MATTHEW WRIGHT *Trainspotting* was a brilliantly executed film but it wasn't like *Four Weddings*. That was instantly massive, you couldn't give the editors enough. *Trainspotting* was about Scottish smackheads. It definitely held the tabloid press back a little.

IRVINE WELSH *Trainspotting* was a cultural success for two main reasons. One is the characters are universal: everybody knows the psycho intellectual, the fanny rat, the psychopath and the lovable loser. To a greater or lesser extent, we've all met people like that in our lives. Also, it's the existential idea of 'what are human beings for?' There are people who are struggling to come to terms with life, without paid work, and drugs are filling the gap. It happened to the industrial working classes, it's happened to everybody, students, professionals. They're facing that existential crisis: what is the point of us, we're being replaced by machines. To me, *Trainspotting* wasn't about drugs. It was about youth culture and that long transition into a world without work.

NICK HORNBY Irvine was a phenomenon. He was a voice and a writer with an energy who touched a chord with many people who, as far as I could see, did not read much contemporary fiction. That's where I think we were quite close together. We spoke in voices that people could understand and wrote about things that reflected their own interests and lives. We wrote about things that people didn't expect to see on the shelves of a bookshop.

IRVINE WELSH *Trainspotting* started off as my daft little book and a few friends got some copies sent to London. When I sold ten-thousand copies I was a hero back home. Then next year it was like a hundred-thousand, and everybody was going, 'Wanker.' The book hadn't changed. A few years later it was a million. Then it was this little underground stage play. Then it was Danny Boyle. Then it was Richard Branson's train advert. When the film went global that was a more concerning part of the process. At the outset

there was no money. You've got to remember, *Trainspotting* was a £1 million film – the cocaine budget on most studio blockbusters is bigger than that – and a £2 million budget to promote it.

LORENZO AGIUS Danny Boyle was genius and put an amazing soundtrack together. Whenever 'Lust for Life' comes on I see Ewan McGregor running down the street.

IRVINE WELSH We phoned up artists and invited them at various stages to a screening, and then said, 'Can you give us a track?' Danny brought in Leftfield, and I knew Iggy and Primal Scream and Pulp and Damon and Underworld. It was amazing how it worked out because it was basically desperation, 'Who the fuck can we get?'

JARVIS COCKER We were in Townhouse Studios trying to finish off *Different Class*, and then we got a message, 'We would like a piece of music for this film. Do you want to come and have a look at a bit of it?' We went down to a cutting room in Soho and they showed us the scene where Ewan McGregor disappears down the toilet. We thought, This looks really good. As luck would have it, 'Mile End' didn't really fit in the sequencing of *Different Class* so we said, 'Maybe you could have that song.' Then it turned out there was a bit in the film where Ewan's character, Renton, moves to London and lives in a shitty squat. It was almost like we'd written it for the film because we were living in a squat just by Mile End in 1990.

DAMON ALBARN I saw an edit up to the point where the baby was left to die. I said to Danny, 'What the fuck are you doing? It's disgusting.' It was a very strong image and I was worried about the effect it would have on people. But I ended up being really into the whole thing and writing 'Closet Romantic' for the soundtrack.

PAT HOLLEY If you deconstructed *Trainspotting*, you'd go, 'It's a night at Smashing.'[2] It's the playlist: Bowie, Iggy Pop, Lou Reed,

2 Together with two other West End nightclubs, Blow-Up and Syndrome, Smashing (located on Regent Street) played a key role in the nascent Brit-pop scene. The video to Pulp's hit 'Disco 2000' visually tells the story of the influential club.

Blur, Elastica, Pulp, Primal Scream – the way it looked, the way it was colourised, and certainly the styling of it. And the poster.

LORENZO AGIUS There was a Calvin Klein campaign running in the States and it was all gritty black and white of young people cast off the streets. It was very cool. I said, 'Why don't we do that for the poster?' They'd hired a young art director, Mark Blamire from Stylorouge, who were famous for doing cool record sleeves for Blur, and he suggested a teaser campaign with a numbered poster of each character – #1 BEGBIE, #2 DIANE, #3 SICK BOY, #4 SPUD, #5 RENTON – and they went with the idea. On the day of the shoot, the actors all turned up and it was one of those crazy London 95-degree days. No air conditioning. Everyone smelt and was sweating and burnt out from doing loads of night shoots. They were all so amped up, maybe coked up, I said, 'Let's shoot each actor in character.' So Ewan was soaking wet because he'd gone down the toilet. Sick Boy [Jonny Lee Miller] was Bond and Begbie [Robert Carlyle] was this violent, aggressive hoodlum. He was terrifying and had bottles of beer and was spraying them all over the camera. I was screaming at him, 'GO FOR IT!' He was going, 'YOU FUCKIN CUNT. I'LL FUCKIN' HAVE YOU!' There was all this shouting and swearing, and people in the other studios were like, 'What the hell's going on?' Robert stuck his fingers up in a V-sign and that was the shot. I was walking round London going, 'Fuck, my posters are everywhere.'

GURINDER CHADHA *Trainspotting* gave a version of cool British cinema around the world. Danny Boyle was a groundbreaking director. It was the cinematic form and the way he was pushing, on so many levels, how to tell stories. It was extremely dynamic.

JO LEVIN It was disturbing; brutal and very cold. I'd never seen a film like it.

CARLA POWER It didn't make me want to touch heroin with a barge pole after seeing the withdrawal scene, but that whole heroin-chic thing and the frantic energy of *Trainspotting* and its soundtrack and

the relentless, speedy coked-up world view was very much of the time. It scoured a real British glorification of self-deprecation and a celebration of elaborate failure, but with style. And which to an American seemed both punchy and really glamorous. It inverted the glamour with these anti-charismatic anti-heroes.

VIRGINIA BOTTOMLEY I remember going to see *Trainspotting* at the premiere in Cannes. I think people said I didn't approve but I don't think that's true. Remember, I spent the first ten years of my life in Brixton and Peckham and Bethnal Green, so I probably had more experience of inner city and the underclass than a huge number of other people in the House of Commons. The film was challenging and raw, but it was communicating a culture, a community, an exempted group who definitely needed to be understood and recognised.

IRVINE WELSH The Cannes Film Festival was a celebration of false intimacy and smarm, with the air-kiss and phoney handshake almost obligatory.

MATTHEW WRIGHT The party afterwards was fucking amazing. It was a crazy warm night and there was a huge ship sponsored by a porn magazine filled with porn stars and fun seekers. Noel [Gallagher] went off to it in one small tender and I went in another. I was out of my face but I do remember laughing about it with him the next day.

NOEL GALLAGHER There wasn't sex going on, it was more like being in a strip club. But I wasn't on the boat with Matthew Wright. I wouldn't go on a boat with that cunt.

DAMON ALBARN I don't think I went on the porn boat. I would have loved to.

LORENZO AGIUS Leftfield played in this massive stadium in Cannes. It was madness, like a rave, three-thousand people. Everyone talks about it even now. We were all young guys who couldn't believe our luck. Ewen Bremner had never been in a film before. Robert

Carlyle had only done a couple of little things. Liam and Noel had their drug dealer fly over from London. There were tons of everything. It was wild. Liam had this carefree, 'give a fook' attitude, and all the *Trainspotting* guys just gravitated towards him because he was such a cool guy.

NOEL GALLAGHER That party was insane. Everyone who was anyone had gone there. It got proper out of hand. Everybody went back to Mickie Most's[3] gaff, a huge fucking villa. I was in the toilets with Harvey Keitel and I'd done so much drugs I couldn't even speak. Robert Downey, Jr was there, at the height of his fucking madness,[4] Johnny Depp, Kate Moss, Iggy Pop. It was wild. Great music, loads of people, fucking loads of drugs, loads of birds, loads of nonsense talked, then you wake up the next day and you can't remember any of it.

IRVINE WELSH Noel and Damon avoided each other and stood at opposite ends of the room. There was no warmth or social connection between them. I thought, Fucking hell. These guys really do hate each other. Good on them.

NOEL GALLAGHER Irvine thought the rivalry between me and Damon was a fabrication and to see it, he said, 'restored his faith in mankind'. He said, 'It's amazing. I can't believe it's fucking real.' Irvine said something quite profound to me that night: 'Do you know what I love about you? If you were a footballer you would go in for the tackle two-footed, whole heartedly.' I was like, 'Yeah, I know what you mean, like all or nothing?' I spent the night with him and we ended up in my room at the Hotel du Cap. My room had these big glass double doors opening onto the balcony that were so beautiful and shiny that they looked like there was no glass in them. Irvine walked straight into them and

3 Hugely successful English record producer with hits in the sixties and seventies.

4 In April 1996, Downey, Jr was arrested for possession of cocaine, heroin and a .357 Magnum handgun.

knocked himself out. Me and Nellee Hooper were sat on the bed, going, 'What do we do? We can't call an ambulance because we've got shitloads of drugs everywhere.' We were kind of booting him. 'Irvine? Irvine?' We had to wait till he came round.

ALAN McGEE What connected Oasis, Creation and *Trainspotting* was drugs. It was working class, creative music and hedonistic. All these different ingredients were Creation were Oasis were Irvine.

LORENZO AGIUS Amazing book. Amazing director. Amazing actors. Amazing time. There was a cartoon in the *Financial Times* that a famous satirist drew of the *Trainspotting* poster but the characters were Tony Blair and his government. It was a great honour.

NICK HORNBY I played in a *Trainspotting* XI charity match against prisoners recovering from drug addiction in Edinburgh. When we arrived on the coach from London there were all these teenage girls hammering on the window. Ewan McGregor said, 'I think I'd better get off at the back, lads.' Irvine said, 'Fuck off, you cunt. You get off at the front. They're not here for us.' The match was in front of one of the biggest crowds I'd ever played in front of in my life. Robbie Coltrane was the manager and the team included Jonny Lee Miller, Danny Boyle and Robert Carlyle. I played number ten, wide on the right. The first ball came out to me and went right under my foot, and two-thousand people jeered. The opposition had the Cowdenbeath goalkeeper playing for them, and I hit this shot that in every game I had ever played before would have gone straight into the top corner, and this hand came out of nowhere and flicked it over the crossbar. Then Ewan scored and everyone did a mock chasing him round the pitch and jumped on top of him.

SUZI APLIN We did a *Trainspotting* special on *TFI Friday* and Ewan came on expecting to be asked about heroin.

WILL MACDONALD Chris said, 'Doesn't it worry you slightly, a little bit, that young kids may be tempted to get into . . . acting?' Ewan creased up.

PART TWO

BACKING BRITAIN

> > >

FOOTBALL'S COMING HOME

Comedy. *Fantasy Football League*.
'Three Lions'. Euro 96

DAVID BADDIEL Alternative comedy in the eighties started as a reaction against mainstream British comedy in the seventies. As a result, it was very political and aggressively anti-sexist and anti-racist, deliberately unglamorous and a tad downbeat; and everyone wearing donkey jackets and being very serious. Me and Rob Newman and people like Sean Hughes and Jack Dee were doing material about what it was like just being young and around. It was very open. I would talk about pornography, for example, but it wasn't a big statement. It was just, 'Well, I think it's funny to talk about something that most people don't talk about, in a confessional way.'

STEVE COOGAN The comedy circuit in the eighties was everyone who became part of the establishment in the nineties. Jack Dee, Eddie Izzard, Lee Evans, David Baddiel, Frank Skinner. I toured with Frank in 1990, and I remember thinking, He'll never make it in this business because he's too politically incorrect. He didn't change but the landscape shifted.

MEERA SYAL I admired Steve Coogan. I loved that very precise character comedy that he did, like Paul and Pauline Calf. It was very laddish. It wasn't specifically about my world, but it was opening doors for a new kind of sensibility that we would all benefit from.

STEVE COOGAN 'You can't joke about that. You can only joke about this,' which is what happens with political correctness; and then people rail against strictures and control and these unyielding rules or attempts to govern our behaviour.

DAVID BADDIEL Part of the whole thing was a reaction against the political correctness of the eighties. John Thomson did a character called Bernard Righton. He spoke like Bernard Manning but did jokes like, 'A black man, a Pakistani and a Jew are in a pub having a drink. What a wonderful example of an integrated community.' You couldn't have had a joke like that in the eighties, but in the nineties you could take the piss out of political correctness. In a way, it's what the Labour Party would say was the Third Way. It was the Third Way in comedy.

MEERA SYAL Alternative comedy kicked a lot of the old dinosaurs out and the old ways of seeing the world. We embraced a new liberalism. There was a flowering. Suddenly, there was a whole young generation coming up that wanted to have a different kind of expression. An Asian generation that I was part of, that had been born and brought up here, felt that we belonged. And we staked our sense of belonging through our creative expression. We'd been here, this whole sub-culture, doing comedy characters in our little community centres for years, never thinking we'd have an audience for them; suddenly, it felt like the population really wanted to hear what we wanted to say. Alternative comedy opened those doors: Ben Elton, David Baddiel, *The Comic Strip* and a lot of the female comedians, people like Jo Brand and French & Saunders to some extent. You suddenly couldn't make the Paki and the mother-in-law jokes anymore.

STEVE COOGAN I thought what I was doing was the cutting edge and different and I was on to something. I used to think, The only kind of comedy I want to watch is the stuff I'm doing. The trouble was there were no venues for people like me and Caroline Aherne and John Thomson. If you wanted to do alternative comedy you had to gatecrash an indie-band gig and go on before them.

DAVID BADDIEL The atmosphere at Newman and Baddiel gigs was genuinely rock 'n' roll. Our first gig after we'd been on telly was at the Venue in New Cross, and there were queues round the block. We came on and people were going mental. This was people wanting us to do 'the hits', like History Today, and characters and catchphrases that people loved. By the time we were doing Hammersmith Odeon ten times in a row it felt like being-in-a-band atmosphere, rather than being in a comedy theatre. Then, of course, we did Wembley Arena and, like a band, we fell apart viciously and unpleasantly. Rob and I really hated each other at that point and weren't speaking on stage. It was like being in Sam & Dave.[1]

STEVE COOGAN Newman and Baddiel were the first phenomenon of the new comedy and crossed over from being alternative to being populist. They were young and sexy when a lot of comedy was middle-aged men.

DAVID BADDIEL Vic Reeves was on the cover of NME in May 1990, six months before us, and the caption read, 'Not many people know this yet, but Vic Reeves is Britain's funniest man.' That was a sea change. It was the NME saying our readership is not just interested in music anymore.

BRETT ANDERSON Newman and Baddiel did a sketch about me being gay and Matt Lucas did an impression of me on Vic Reeves and Bob Mortimer's Shooting Stars. It was hilarious. Suddenly, music had become mainstream and we were being parodied. Then it was, 'Fucking hell! Suede are on Spitting Image.' Previously they'd only satirised bands like the Rolling Stones and the Beatles. It was quite an achievement.

NOEL GALLAGHER Comedy was at its peak then. There was something about our generation. We were very talented, creative people who made it. It's extraordinary. The Fast Show was fucking

1 Sam Moore and Dave Prater were a hugely successful American soul duo in the sixties, but famously did not speak to one another off-stage for more than a decade.

unbelievable: Jazz Club was a favourite, the trumpet player who came on, 'We're joined by the legendary Horn Finger – nice!' And then 'Half the World Away' ended up on *The Royle Family*! They made the song what it is. I'd known Craig Cash because he had his own radio show in Manchester, 'I'm writing this thing with my mate called Caroline.' 'Oh, yeah!'

STEVE LAMACQ There was a lot of mutual appreciation between music and comedy and football. People used to go to each other's gigs and hang out together at after-show parties.

KAREN JOHNSON The whole scene was becoming more mainstream, and the tabloids and TV were well on board by then. It was whipping into a storm. A lot of people jumped on board when Blur played Mile End Stadium on 17 June 1995 in front of 27,000 people. That was the first major Britpop event. The band invited the comedian John Shuttleworth to compère and play his Bontempi organ. And they also had Matt Lucas as George Dawes. It was another example of how music and comedy were coming together.

DAMON ALBARN Matt Lucas came on tour with us as the opening act when we were doing *The Great Escape*. We made a weird psychedelic film about travelling round English piers with Matt as George Dawes. There's a scene with him trying to get us up in the morning but we're all really fucked.

KAREN JOHNSON Matt told *Vox* magazine, 'I've just been in Blur's dressing room and I must tell you that Damon Albarn has got the most enormous cock. Alex James, he's got quite a large cock. Dave Rowntree has got a small cock. But Graham Coxon, oh dear, he's got nothing at all. Not a thing, bless him. Lovely bloke, though.'

STEVE LAMACQ Blur at Mile End was ridiculous. I'd never been to a gig before where I'd seen anyone who was a 'celebrity' outside of the music world. That's where you can see the idea of Cool Britannia in reality. David Baddiel was there. A couple of the *Fast Show*. I was thinking, This is obviously a hot ticket.

KAREN JOHNSON There were a lot of cultural connections. It was quite a small, London-centric world. Damon used to play football every Sunday in Regent's Park with Steve Lamacq, and the Soccer Six developed out of that. There was quite a fractious match once with Robbie Williams and Liam Gallagher.

DAMON ALBARN I made a link between football and music. I remember going to see the Happy Mondays and seeing the undulation of the crowd moving to the music. It was like, 'This is the most magical thing I've ever seen. I identify with this. This is powerful to me.' It was a visceral, direct thing. Football had the same sense of the crowd, it was like the music of a match. I was trying to earn my place among that.

DAVID BADDIEL I used to regularly meet Damon and Phil Daniels before Chelsea games at their studio in Fulham and hang out. Damon was always a bit out of it. This was around the time me and Frank did the *Fantasy Football League* show on BBC2. It had a certain Englishness and was a hip show, so you could get people like Damon, Noel, Patsy Kensit, Roddy Doyle, Nick Hornby, Paula Yates or Caroline Aherne. It was a barometer of popular culture in Britain at the time. The primary thing was we wanted people on who were funny, interesting and football fans. I was sharing a flat with Frank and the set was a version of what our actual flat was like, with mates coming round and the feel of blokes watching and talking about football.

NICK HORNBY Originally *Fantasy Football League* was a radio show, and when they said, 'We're going to do it on TV,' I thought, Oh, that's brilliant.

DAVID BADDIEL It was a huge hit. It was a show for football fans, but interestingly enough it had quite a high female viewing; something like 40 per cent. One woman said to me, 'I just like watching two men who clearly love each other.' It was like a window on a very benign version of blokeishness. Remember, we're still in a time when quite a lot of men are apologising for being men.

Part of what modern comedy was trying to do was have its cake and eat it. We were straightforwardly saying, 'We are going to do jokes about football and about being heterosexual and about pornography. We're going to make it clear that we know we are self-aware, that this stuff has been considered to be shameful in the past; we are not culturally ignorant. But we are still going to do the jokes.' Famously, I blacked up as Jason Lee in a regular running sketch that we had, and it also involved wearing a pineapple on my head. Lee was a Nottingham Forest player who was missing a lot of goals. We weren't making fun of him because he was black. We were making fun of him because he was a shit player.

NICK HORNBY My main association with *Fantasy Football* was walking through some kind of glass wall where I was being invited on with people that I admired. I'd never been on television before, so I was petrified. David and Frank were on their sofa interviewing you and here I was, sitting next to Elvis Costello. I was thinking, How come I'm here? It led to one of my great experiences of the nineties. Elvis and I were both in HMV in Dublin, and he was walking in front of me chucking CDs over his shoulder, saying, 'Have you got this? Have you got this?' I had a wire basket trying to catch everything, thinking, I'm going to buy all of these because Elvis Costello has told me to get them.

RIC BLAXILL It just seemed like a seismic time for the country: there was a great music and comedy scene happening, politics seemed more approachable and defined, and rather bizarrely we were doing well with our football team. It was all linking together.

STEVE DOUBLE There was nothing particularly pro-football in the preceding decade. Under Thatcher football had been seen as a force of evil. Thatcher hated football. The Minister for Sport, Colin Moynihan, was a football basher. You had David Evans, the Tory MP and chairman of Luton Town, who banned away fans. John Major was a cricket fan and you didn't have a sense that he was particularly interested. Blair and Campbell understood the power of football more than any politicians previously. You felt

they were just a bit more on it. Remember the photo shoot with Kevin Keegan?

ALASTAIR CAMPBELL That was the week of Tony's first conference. I really felt sport was a big thing that we should be doing. I was banging on about it all the time. We always felt that the previous government was paying lip service to sport and policy. We were trying to do something different.

TONY BLAIR Your speech at the party conference is one of the big moments as a party leader. I used to spend a week, ten days, working on that speech. It was an agonising process. There would be drafts, redrafts; it would be an incredibly difficult, time-consuming, anxious period. Usually two days before, or sometimes even the day before, you'd just lose the thread of what you really wanted to say and come to the conclusion that the whole thing was hopeless and had to be started again. And that's what happened that year. I thought, I've got no speech to give tomorrow. The whole thing's absolutely hopeless. So we went off to do this event with Kevin Keegan at a school in Brighton.

ALASTAIR CAMPBELL Keegan was down there doing something, and we thought, That'll be good. Do something with him. There was a huge media turnout.

TONY BLAIR We got kicking the ball around and Kevin said to me, 'Why don't we do some headers?' Alastair sort of froze, because obviously the likelihood is that your footballing skills will be exposed. But by then I just didn't care. I thought, The speech is crap, heaven knows what's going to happen tomorrow, why not? So I just did it.

ALASTAIR CAMPBELL Most of the people in our team were horrified, 'This is mad! He won't be able to do it.' I said to them, 'Listen, if I threw a ball to you now, could you head it.' They said, 'Yeah.' I said, 'Right, well, Kevin Keegan heading a ball is like me throwing it. It's not going to be a problem.' And, of course, it wasn't. Twenty-eight consecutive headers!

TONY BLAIR That was not easy. Actually, the truth of the matter is Kevin was so good that he was able to just keep planting the ball back on my head, more or less. The look of shock and surprise on my press posses' faces was quite something to behold. I did feel in a much better mood to go off and rewrite the speech, which I then did that night.

IRVINE WELSH Blair had no interest in football, whatsoever. For example, his classic lie about standing in the Leazes End at Newcastle. Apparently, when he was a public-school boy in Edinburgh he was a Hearts supporter.

JOHN MAJOR Politicians pretending they're football fans, when they don't know which team they support, is a bad idea. I first went to Chelsea in 1954 when they beat Wolves 1–0 and Peter Sillett scored from a penalty.

NICK HORNBY I think it's incredibly simplistic to say, 'Tony Blair got in and suddenly decided he liked football, or even Oasis, because it was cool.' Tony Blair was in a band. The idea that any Prime Minister before that point would have been in a band was preposterous. There was a generational shift.

MARGARET McDONAGH We did huge amounts of work with football clubs. Why wouldn't you use football as a force of good for education to engage hard-to-reach kids? It was all aspirational. It was using culture and icons to bring about improvement, and there was an awful lot of football influence among Labour supporters: Peter Coates at Stoke, Alex Ferguson at Manchester United, Bob Murray, the chairman of Sunderland. When we introduced the New Deal, kids could get free tickets at Sunderland. We were into football and music. You could go round and Tony would often have his guitar. It wasn't put on. It was us. Our communication was holistic. My expression of politics is in words, it's in song, it's in design and it's in expression. I see it as a circle. It's about a soundtrack to your beliefs.

ALAN EDWARDS John Major was pretty boring. Then this bloke

came along who wore denim shirts and came to David Bowie gigs and kicked a football around with Kevin Keegan. It was a breath of fresh air. 'Blimey! He's sort of one of us. I could have a drink with him' – in fact, I have had a drink with him and talked about UB40 – it was a game changer for the whole country.

GEOFF MULGAN Football was very much a successful, globalised British cultural industry rooted in youth, and not in the traditional upper class. That's why football worked as part of this story because it was much more genuinely classless than, say, athletics or cricket. Alex Ferguson is an important figure on that cusp.

ALASTAIR CAMPBELL I first spoke to Alex Ferguson when I wrote an interview with him for *New Labour New Britain*. It was one of the first pieces where he talked about what motivated his politics. He said, 'I was born a Labour man and I'll always be a Labour man [. . .] Tony Blair has done a brilliant job. He has built the bridge between what the trade unions have wanted from Labour, and what the general public have wanted. The result is that the Labour Party is actually speaking for the people again.' It was a front-cover piece, and as a result of that he started to do a couple of events and over time we became friends.

TONY BLAIR Alex was someone I admired enormously. He had tremendous leadership skills. My theory of leadership is that it's the same whatever you're doing, whether you're running a corporation, a community centre, a football team or a country. When we'd meet, or talk by phone, he would always be a source of good instinct and advice. We'd often talk about things like how you manage people, because politics and managing a big football club are the same essentially: managing the egos, when you're cuddling them or whacking them, how you man manage, how you think about strategy, how you deal with the media.

JOHNNY HOPKINS Football is part of the celebrity picture because players come in to the party. I remember when Oasis played Manchester Arena: Ryan Giggs and Gary and Phil Neville came; Man City players, Liverpool players; soap actors; even George Michael

drove up with a car full of friends. It was madness. All of those people were coming into the picture. The link between Oasis and football was made very early on. It was an important part of who they were.

NOEL GALLAGHER Oasis was that much of a thing in British culture that everything that we did, wore, said, everywhere we went – people became famous because they were our friends – so if we went to the football everybody started going to fucking football.

SIMON FOWLER Oasis always used to bang on about football. Football and beer has always gone together. Maine Road was one of Oasis's finest moments. Noel and Liam were big Man City people and suddenly they're playing their team's stadium. They'd only been making records for two years, if that.

ALAN McGEE It was fucking amazing to play a football stadium to 40,000 people. It was Maine Road. It was their team. For them, it probably doesn't get any bigger than this now. It was wild and brilliant.

SIMON FOWLER We were supporting, and Noel's chocolate-brown vintage Rolls-Royce was there, which Alan McGee had given him as a Christmas present. Noel said, 'Liam's got a Rolex. I got a Rolls-Royce, which is brilliant, cos I can't drive and Liam can't tell the time.'

RIC BLAXILL Noel came on stage with a Union Jack guitar that he'd used on *Top of the Pops* for 'Don't Look Back in Anger'. They were seizing the moment.

JOHNNY HOPKINS It was an iconic moment, but I was like, 'A Union Jack guitar, why?' That's being polite. The big question is what did the flag mean by '95? The Union Jack had nearly three-hundred years of history: of Empire and conquest, and death and chaos. Can you just wipe that out with a pop-art symbol painted on a guitar?

NOEL GALLAGHER There's a photograph of the Who asleep under the Union Jack and half the Stars and Stripes – we did a similar picture for a cover of *Melody Maker* – that's what it meant to me. It's a fantastic fucking piece of graphic art and a brilliant fucking flag. I didn't see that representing anything in me and I didn't see me representing anything in that. Oasis were the biggest band in the country, soon to become the biggest band in the world, and playing Maine Road was the biggest thing of that particular moment. Meg [Mathews], my then wife, had just got me that Union Jack guitar for my birthday. I wasn't thinking, This is going to be a great image. I just thought it would look good on the fucking screens. We never thought anything out. Never. That's why it became so big, because you can't fake what we had. You can't own who you are. It's just who are you. That's it.

SIMON FOWLER If Oasis reconnected youth culture with the Union Jack, the alliance between music, comedy, football and patriotism was secured when Baddiel and Skinner recorded 'Three Lions' for Euro 96.

DAVID BADDIEL There's some confusion about this. Simply Red were asked to write the 'official' Euro 96 tournament song, and recorded 'We're in This Together', which was godawful. At the same time, Ian Broudie was asked by the FA to write the 'official England song'. He wrote the music and then phoned us up and said, 'I think you and Frank represent football fans in this country. I want you to write the lyrics.' There hadn't really been an England song that was properly about football. 'World in Motion' had John Barnes's rap, but 'love's got the world in motion' was not about football. The other thing was, and this was really key, Frank and I decided to write a song about what it was really like to be an England fan. So – rather than 'this time more than any other time' – about how we were probably not going to win, how everything normally goes wrong but you end up hoping against your own reason that it's going to be good. 'Three Lions' was a vulnerable song about how being an England supporter is essentially a position of doubt and uncertainty and probable loss.

STEVE DOUBLE 'Thirty years of hurt' summed up nicely where we were: 'There's no point getting carried away. This ain't going to be easy. Let's see what we can do this time.' That's why it worked so well. There's this siege mentality among England fans, and it played to that. Originally, there was a line that effectively said 'we'll fight for England'. I said, 'Sorry, guys, that's got to come out; it could be misinterpreted and encourage people to be violent.' Baddiel and Skinner's management team was apoplectic: 'Over our dead bodies. No way. You're compromising their artistic talents.'

DAVID BADDIEL It wasn't an aggressive act on our part. We were just looking for rhymes. We wanted to conjure up famous moments that would speak to England fans. 'I still see that tackle by Moore' was his famous tackle on Jairzinho against Brazil in 1970; 'when Lineker scored' was his goal against West Germany in 1990; and we replaced 'Butcher's ready for war', which was from the World Cup qualifying match against Sweden in 1989 when Terry Butcher got his head bloodied and carried on playing, with 'Bobby belting the ball, and Nobby dancing', which was Charlton's goal and Nobby Stiles's Celebration in 1966.

KEITH ALLEN Interestingly, 'three lions' was a line Craig Johnston wrote in 'World in Motion': 'Three lions on my chest I know I can't go wrong'.

DAVID BADDIEL Frank and I took the song to Bisham Abbey to play to the England team, and the whole squad were sitting around in their tracksuits, eating in this massive sterile dining room. We played the song through this little beatbox, and Terry Venables was tapping his car keys and said, 'It's a real key tapper'. I was like, 'Is that a thing?'

STEVE DOUBLE Footballers, as a group, are pretty cynical. I've seen comedians of the day trying to get a laugh out of them and failing miserably. They're a tough audience. Skinner and Baddiel warmed them up and then played the song.

DAVID BADDIEL No one paid any attention.

STEVE DOUBLE There was a bit of indifference. 'Oh yeah, it's all right.'

DAVID BADDIEL A few of the players were selected to be in the video. Most of them were like, 'I don't want to do this.'

STEVE DOUBLE They recreated Bobby Charlton's '66 World Cup goal with Teddy Sheringham and Lineker's World Cup 90 with Robbie Fowler. The players ended up quite enjoying it.

DAVID KAMP I spoke to Damon Albarn and he said he found the 'Three Lions' video a bit scary, a moment of things going too far. We talked about how there was an almost feral nature to the way Frank Skinner sang and tugged at his football jersey when he was singing 'three lions on a shirt'.

DAVID BADDIEL Pedro Romhanyi was the top video director and had done 'Common People' and 'Parklife'. Pedro was very keen that the video should feel homely; that's why it starts off with me and Frank watching telly and making tea. Then we go to the pub and Geoff Hurst is at the bar and we are transported to playing football with the England team.

STEVE DOUBLE It was the thirtieth anniversary of the '66 World Cup, so there was a natural synergy with Euro 96 and the video captured that nicely. 'Three Lions' was issued as part of *The Beautiful Game* compilation, which featured some of the cream of British music – Supergrass, Blur, the Boo Radleys, Massive Attack, the Wannadies, Pulp, Teenage Fanclub – along with Black Grape and Keith Allen's alternative anthem 'England's Ire'.

KEITH ALLEN I wrote the words for 'England's Ire' at Peter Gabriel's studio, and had what I thought was my best ever line, 'My wife's lactating and I'm spectating'. In the studio, Shaun [Ryder] said, 'What the fook is this?' The producer, Danny Saber, said, 'It's *lactating*, Shaun.' 'You fookin' what?' He couldn't get his head round it at all. Danny called a break and the band all went to watch Frank Bruno fighting Mike Tyson for the WBC heavyweight championship. I stayed in the studio and said to Danny, 'Why don't

you put the track up and I'll do it in the style of Shaun, and you can play it back to him as a guide vocal.' Danny said, 'Great.' But they left it on. So it's me on the track, not Shaun Ryder.

ALAN McGEE We put out Irvine Welsh and Primal Scream's song 'Big Man and Scream Team Meet the Barmy Army' for Scotland.

IRVINE WELSH We thought, Let's just have a laugh and do something that's not really about football and about people making a drunken exhibition of themselves, just get all the fucked-up Scottish neurosis in there. Adrian Sherwood had this riff, Duffy had the chant 'who are you, who are you?' and I just ranted some stream-of-consciousness lyrics about a time I went to Wembley in '79, when I'd been drinking all morning and I was trying to find a toilet to do a shit and then I followed through. I found a toilet and it was smashed to pieces. It was like a paddling pool of urine. I had to take off my shoes and socks and trousers and wade through to find a cubical. It was ten times worse than the *Trainspotting* toilet. I managed to shit out all these dregs and then I had to use my Y-fronts to wipe my arse. I was stripped from the waist down trying to get changed, with everybody just walking past not giving a fuck. I didn't get into the ground. Anyway, we did the song in a day and the FA hated it and tried to ban it, but it still got to number seventeen in the charts.

DAVID BADDIEL I was on holiday and I got a telegram from my manager, saying, '"Three Lions" has sold 80,000 units. Gina G is no longer number one.' It was number one for one week and then got knocked off by the Fugees' 'Killing Me Softly'. I thought the song was over, but then a month later it went back up to number one. 'Three Lions' was representative of a coming together: of pop music, football and comedy. I would say it was the high watermark of Cool Britannia.

JOHNNY HOPKINS The nineties were so bad 'Three Lions' was the high point. It was a terrible record. It was everything that was wrong. It was 'Parklife' or 'Country House' times a million. I hate jingoism. I hate patriotism. I hate anything that smacks of

Little England. If you put it out there and a majority of people are singing it, it becomes dangerous.

DAVID BADDIEL We claimed Britishness for a little while. It was a version of Englishness that was inclusive and hopeful. I'm the son of a refugee from Nazism, so I was really proud of the fact that we were part of what appeared to be a way of celebrating our country without being horrible about it. I think that's what makes those shots of thousands of people during Euro 96 waving the Cross of St George not feel aggressive and nationalistic. The song became a rallying cry.

STEVE DOUBLE Gazza used to play it on his beatbox to the England team on the coach on the way to Wembley from the hotel to gee them up. It made a huge difference.

TIM SOUTHWELL The whole nation was singing 'Three Lions'. It put hairs on the back of my neck.

NOEL GALLAGHER Football only took off in this country in 1996. Before Euro 96 – nothing. If you were discussing football in the press, people would be like, 'Musicians and football: what the fuck's all that about?' I'd been going to Maine Road since I was seven years old. To me it's not a thing. It's just who I am. The only time I connected football and music was watching a documentary of the Beatles and the Kop were singing 'She Loves You'; and then after Euro 96 'Wonderwall' became the song of the summer. It became a big fucking thing to sing at football grounds; you'd hear it everywhere.

ALASTAIR CAMPBELL The mood around Euro 96 was extraordinary. That was the point I first started to notice the overwhelming nature of marketing and advertising that was surrounding football as an event: every second advert was about something to do with the Euros; the Baddiel and Skinner song.

STEVE DOUBLE The Euros in '92 had been a non-event and England didn't make the World Cup in '94 – but there was a tipping point where suddenly wives and girlfriends, who wouldn't normally go

to matches, wanted to watch the game, and TV audiences suddenly go from nine to eighteen million.

NICK HORNBY I wrote in *Fever Pitch*, 'When England won the World Cup in '66 and George Best became the fifth Beatle, the game threw off a lot of its old class connotations and loving it became as uncomplicated as loving pop music.' You could switch the names and say the same about Euro 96 – apart from the bit about winning.

RIC BLAXILL Euro 96 was a transformational tournament for supporting England. Suddenly it wasn't about hooligans abroad; it was 'Three Lions' and Gascoigne, who was like a character in a band. It just seemed to land straight in the middle of everything and marry up. It was a euphoric time.

VIRGINIA BOTTOMLEY Euro 96 was thrilling. I don't pretend to be a football expert at all, but I can tell you I became the most popular aunt/mother/godmother because I could take a nephew or niece with me to the games. It was wonderfully organised. It was Britain at its best because it was all so professional and the crowds behaved so well. It was about congregation. People find meaning in their lives by gathering and coming together with a common purpose. Whether it's the Last Night of the Proms or a pop concert or Euro 96, it's unifying and energising: the arts and sport bring people together and they promote creativity.

STEVE DOUBLE Everyone got so hyped up about the first game against Switzerland after all the baggage from the pre-tournament trip to the Far East that had ignited the tabloids: England played against a Hong Kong select eleven and, following a formal dinner, one of the coaching staff asked a senior member of the FA management team if it was okay for the boys to go out. A wad of notes was handed over and the players went out and got absolutely hammered, making it an FA-funded piss-up. And then on a 747 Cathay Pacific flight back from China somebody in the management team had to tell one of the players to quieten down a bit; nothing

out of the ordinary. That was it. No problem: went home, went to bed. Got up in the afternoon, all hell broke loose: damage on the flight, and pictures of Gascoigne and Sheringham in the 'dentist's chair', having Drambuie and tequila poured down their throats, splashed on the front pages.

SIMON FOWLER It was footballers behaving like rock stars: a tabloid dream. That's what happens when you get a bunch of lads together on tour. It's just like an extension of school really.

NICK HORNBY The tournament began terribly for England: a draw against Switzerland. You thought, Oh, I forgot. They're terrible.

ALASTAIR CAMPBELL Switzerland equalised and I was about to jump up and celebrate. It was partly because I'm Scottish, but also I didn't want, as I wrote in my diary, 'a great nationalist football fervour creating a feel-good sense that could let the Tories win back a bit of a list. I have no idea whether sport can do that, but there has to be a chance that it can.'

DAVID BADDIEL Second game: Scotland.

ALASTAIR CAMPBELL It was the same day as the IRA bomb attack in Manchester and yet there was no sense of fear. When they played the national anthems it was incredibly loud. We weren't in the main Scottish bit but there were fans everywhere. Rod Stewart was sitting by us.

DAVID BADDIEL The first half wasn't very good. Second half, Terry Venables put on Jamie Redknapp, who made a massive difference in midfield.

TIM SOUTHWELL England were one–nil up, and Scotland got a penalty with thirteen minutes to go after Adams brought down Durie in the box. I was right behind the goal and the Scots around me were going mental. We were thinking, Oh, fuck.

IRVINE WELSH My friend woke me up and said, 'Scotland have got a penalty.'

TIM SOUTHWELL Gary McAllister ran up and, just as he was about to hit the ball, it slightly moved, and Seaman saved it with his left elbow. We went mental. After the match Uri Geller claimed he made the ball move, which was a load of toss.

IRVINE WELSH I went back to sleep again.

TIM SOUTHWELL From the goal kick, Sheringham touched it on to Anderton, who whipped it down the line. It looked like Colin Hendry had Gascoigne covered and was showing him the outside.

STEVE DOUBLE. I remember thinking, There's only one thing he can do here and that's put it over Hendry's head. He can't do that.

TIM SOUTHWELL At that point everything went into slow motion: Gazza knocked the ball over Hendry's head, and the next thing you know he's volleyed it right into the bottom corner. It was one of the best goals ever and we all went insanely berserk.

DAVID BADDIEL Gazza was a god because of how he played football. Retrospectively, off the pitch there are contradictions that play into the atmosphere of lad culture and Gascoigne's treatment of his wife, but you can dissociate that from the fact that the team got incredibly pilloried for the 'dentist's chair' and then played brilliantly in Euro 96 and were ironic about it for the celebration. They were able to take the piss out of themselves.

STEVE DOUBLE The 'dentist's chair' celebration was a release of tension. It was very clever: Gazza lying on his back and Sheringham squirting water from a bottle into his wide-open mouth, replicating their antics in the Far East. Brilliant!

DAVID BADDIEL It was an incredible goal. England win. The sun comes out and the DJ plays 'Three Lions' – who has since told me was against the wishes of the FA because it was too partisan. It was the most extraordinary moment of my life because 78,000 people started waving their flags and singing instantaneously, 'It's coming home, it's coming home, football's coming home.'

KEITH ALLEN They'd played 'Three Lions' before the game. No reaction. I was really quite pleased because I didn't think David Baddiel was very funny. I was being a twat, going, 'This is shit.' But after the final whistle the stadium didn't empty. It was the first time the crowd had got behind it.

STEVE DOUBLE 'Football's coming home' became part of the feel-good factor. You can't ask for anything more than the crowd taking it to their hearts.

WILL MACDONALD Hearing 'Three Lions' was amazing. It all joined up: here's the song by the band and comedians that have just played on *TFI Friday* and we're at Wembley and our friend Gazza has scored the winning goal.

STEVE DOUBLE Gazza's goal changed the news agenda entirely and took the genie out of the bottle. Then it was all about the next game. It was about football.

SIMON FOWLER 4–1 against Holland; the best England performance I'd ever seen.

NICK HORNBY England looked like world-beaters. It was huge in terms of turning people round.

KEITH ALLEN Shearer's penalty after Ince was tripped. Sheringham's header. Gazza's lay off to Sheringham and then to Shearer who blasted it in. Then Sheringham again after the goalkeeper had only parried Anderton's shot. Everybody was going, 'This is fucking unbelievable.'

DAVID BADDIEL The crowd were singing 'Three Lions' full on, and my manager turned to me and said, 'This is incredible, if you win an Oscar it won't be better than this.' It was a totally grassroots phenomenon; just people taking it to their hearts. The *NME* gave the singing the 'Musical Moment of the Year'.

TIM SOUTHWELL It felt like you couldn't have anything more perfect. It was a balmy summer night, and after we went to a

music industry party and every single person there was laughing and smiling. There was such a buzz.

NICK HORNBY Next match: Spain . . .

STEVE DOUBLE The Friday afternoon before Spain, Gazza was downing a bottle of red wine and organising his wedding, trying to find a Scottish pipe band. You were thinking, Relax . . . and stop drinking that wine.

NICK HORNBY A dodgy win.

SIMON FOWLER We won on penalties, and Pearce scored having missed in the World Cup in 1990. That's where he got the name Psycho from because his celebration was like an insane roar to the camera.

KEITH ALLEN I was in Dublin with Black Grape, supporting Blur at the RDS Showgrounds, and we'd gone to a pub to watch the match. I remember, when Pearce scored in the penalty shoot-out, jumping up, and as I came down there was a puddle of Guinness on the floor and my left leg went out sideways and I heard my tendon snap. It was fucking agony. Shaun Ryder came with me to the hospital, and while the doctor was injecting me with cortisone Shaun had his hand in his bag taking out handfuls of whatever was in there.

STEVE DOUBLE That weekend the Sex Pistols were playing a reunion gig in Finsbury Park and I had to accompany Stuart Pearce, and Gareth Southgate who he'd asked to come along. We had backstage passes, and I remember Patsy Kensit was there staring goggle-eyed at Stuart and Gareth. We watched the gig from the side of the stage and afterwards somebody said, 'Do you want to come and meet the boys?' There seemed to be about fifty people in the caravan – jagged scars everywhere – but it was mutual fan worship between Stuart and Johnny Rotten.

SIMON FOWLER Suddenly, we were in the semi-final: England vs Germany.

STEVE DOUBLE I had to drive through Trafalgar Square. I was gobsmacked by the taxis and Union Jack flags and the whole thing. Even though I was in the middle of it all with the team, I didn't understand until then how much the tournament had captured the nation. The *Mirror* headline on the Monday morning was 'ACHTUNG! SURRENDER For you Fritz, ze Euro 96 Championship is over' with a photograph of Gazza and Stuart Pearce wearing military tin hats. Alongside that was a leader by the editor, '*Mirror* declares war on Germany.' It was despair. Blatant xenophobia.

DAVID BADDIEL Me and Frank were on the front cover of the *Sun* the day before the semi-final. We had the Cross of St George on our cheeks and we were wearing the England strip, and they had the lyrics of 'Three Lions' printed underneath us. It said, 'Here's what every English fan must sing tonight.' Here was a dark-skinned Jew with a Catholic and a manky lion. The newspapers had been criticised for doing Hitler, jingoistic stuff, but this wasn't aggressive or screaming, 'Beat the Bosh.' It was a brief window when you could be patriotic and proud to be English without it being hideous.

STEVE DOUBLE During the tournament we had some bonkers requests from the tabloids; they were throwing money at the players. The *Sun* were very clever, and would phone up and say, 'Can we have Tony Adams wearing a Union Jack bowler hat, it's five grand to him? Can you put it to him, please?' You can't not. It was a lot of money then, a week's wages for a lot of players. So there'd be a silly picture of Tony wearing a Union Jack bowler hat on the front page of the *Sun* the day before a game. Stuart Pearce holding a Union Jack, another five grand. I can remember Boris Johnson ringing up from the *Telegraph* and asking inane questions. I was like, 'Who is this idiot?' He clearly knew nothing about football.

NICK HORNBY When you look back at the media coverage of England winning the World Cup in '66 it wasn't as big a deal as Euro 96. If you look at the front pages after the final there was a photo of Bobby Moore, but the main headline was about politics or whatever. I've seen interviews with some of the players, who

said, 'It was a nice thing . . .' If England had won in '96 life would have stopped. It would be on the front page of every paper for probably five days afterwards.

ALASTAIR CAMPBELL What's incredible about the '66 World Cup is all the flags in the crowd were Union Jacks. At Euro 96 it became very much the English flag. Didn't the *Sun* give away hats with the St George flag on? It was English nationalism upping itself.

NICK HORNBY I'm not very interested in the national team. I distrust everything that surrounds it. But that was the only time, pretty much since the sixties, that I can remember an England team being a pleasure to watch. The difference was that the far-right tinge of England supporters were drowned out by the enthusiasm for the tournament as a whole.

MATTHEW BANNISTER It felt like we were all connected to something wonderful and exciting that was going on. The semi-final was an extraordinary night. The excitement was palpable.

NOEL GALLAGHER I went with Johnny Marr. They played 'Wonderwall' before the teams came out and the whole stadium was singing it. I would have been the last person to recognise it. 'Listen.' 'What . . . Oh, yeah. Nice one.'

VIRGINIA BOTTOMLEY My anxiety watching the Britain–German match, apart from the football, was that the crowd didn't start making deplorable gestures.

JOHN MAJOR Helmut Kohl, I remember, wound a German scarf around his neck.

ALASTAIR CAMPBELL Major was sitting on the front row – we were the opposition, so we were a couple of rows behind. I was sitting next to one of his bodyguards having to pretend I was supporting England – I could feel his tension. Pele was at the game, and I thought, That'll be all right – get Pele and Tony Blair. Virginia Bottomley was in the front row and when I went over to Pele and said, 'What do you think of the idea of . . .' she said, 'You are absolutely incorrigible!'

NICK HORNBY The semi-final was one of the best games I've ever seen. Being a goal up after two minutes seemed vaguely surreal. You thought, Could England be going to a final?

ALASTAIR CAMPBELL It was an amazing game of football. I mean really heart-stopping stuff.

NICK HORNBY Gazza being an inch away from putting the cross in. Paul Ince's passion and the way he drove the team forward throughout the game. But after extra time it was 1–1.

SIMON FOWLER Paul Ince, the 'Guv'nor', was sitting the other way in the centre circle during the penalty shoot-out. And what the hell was Gareth Southgate taking a penalty for? I don't think he'd ever taken one in his life.

MATTHEW BANNISTER It was a golden summer. And then we crashed out.

WILL MACDONALD Andreas Möller scored the winning penalty and puffed his chest out about twenty feet from where we were sitting.

ALASTAIR CAMPBELL Major looked absolutely gutted. It wasn't that winning the Euros, necessarily, would have saved him, but going from the semi-final into the final and then England winning it would have been a phenomenal mood changer. I doubt enough to keep the Tories in power, but we don't know. The thing about it is, even if there isn't a political dividend, the fact that a lot of people think there might be affects the mood. I certainly think it takes a lot of the space out of the debate. At that time, we were very much setting the agenda and full on in terms of battering the Tories. If the country's obsessed with a football tournament you lose that space.

JOHN MAJOR The feel-good factor was complete codswallop. When it comes down to the decision of which political party you're going to vote for, I think it has the tiniest of marginal impacts. Harold Wilson capitalised on it when he joked, 'We only win World Cups under Labour governments.' He had a dry sense of humour.

ALASTAIR CAMPBELL After the match, we got back to the car and I said, 'Yesss!' and shook my fist. Tony said, 'Can you save your celebrations till you get home.' I said, 'Don't pretend you feel any different.' We dropped him off, and I said, '*Gute Nacht, mein Kapitän. Jetzt sind die Tories gefuckt.*'

STEVE DOUBLE After the game, Gareth Southgate was going up a back set of stairs at Wembley as John Major was coming down. He stopped and said. 'Hard luck, Gary.' You can't imagine Tony Blair getting his name wrong. It summed up the difference. Labour, generally, were much more football friendly.

SIMON FOWLER Liam Gallagher snuck in to the players' lounge after, and said to Southgate, 'Don't fucking worry about it, at least you had the balls to go up and take a penalty.'

DAVID BADDIEL Germany's fans started singing 'Three Lions', and in a very German way decided, 'We won the tournament so it's our song now.' 'Three Lions' went to number seventeen in the German chart, and Frank and I were invited to do it at their sports review of the year show. We thought it would be a laugh and wore replica England 1966 shirts, and they tried to stop us. They couldn't understand the irony. Then, a couple of months later, I was watching the Labour Party Conference at my flat in Belsize Park, and Tony Blair said, 'Seventeen years of hurt never stopped us dreaming. Labour's coming home!' It was perfect. 'Three Lions' was a successful attempt to create a type of patriotism that was vulnerable and not racist and triumphalist. It fitted with New Labour's Cool Britannia identity.

TONY BLAIR The idea probably came from Alastair. It was the obvious thing to do at the time. Whereas I think a lot of things we did weren't opportunistic, I think that can go in the 'reasonably opportunistic' category.

THE £1 MILLION CUP OF TEA

Radio 1. Chris Evans. *Top of the Pops. TFI Friday*

STEVE LAMACQ Radio 1 had a revolutionary rebirth sweeping out the old DJs and bringing in a new generation of music fans. It radicalised the station and crucially positioned Radio 1 centre stage just as the Britpop wave hit – the timing was perfect.

MATTHEW BANNISTER At the turn of the decade Radio 1 had nineteen-million listeners every week, but it was effectively a middle-of-the-road station. My predecessor had been quoted as saying Nirvana's 'Smells Like Teen Spirit' was 'too noisy' for daytime play. In 1992, when Radio 1 had its twenty-fifth anniversary concert in Birmingham, Status Quo were the headline. It did a poll of its listeners to ask them what their most popular song was, and 'Bohemian Rhapsody' won. This was the time of 'Our Tune' with Simon Bates, where you sat down and listened to a sob story in the middle of the morning with classical music playing underneath it. It was a time, as John Birt put it, when many of the DJs were 'older than the Director-General, the Prime Minister and the Archbishop of Canterbury'.

POLLY RAVENSCROFT Suddenly, there were all these sackings – Simon Bates, Dave Lee Travis, Gary Davies, Bruno Brookes. Steve Wright resigning. The press was really negative: 'Who is Matthew Banister, coming in and ruining our Radio 1?'

MATTHEW BANNISTER Some years earlier, when I was working in Nottingham, I came into contact with Radio 1 Day Out. All the DJs turned up in white satin bomber jackets with their name embroidered over their left nipples, and in the evening there was a party where Dave Lee Travis came dressed in a gorilla suit riding a child's tricycle as Noel Edmonds threw custard pies at him. It was end-of-pier, wet-T-shirt-competition humour. Radio 1 was in a time warp and had become a laughing stock. Andy Kershaw told me that a daytime presenter once told him proudly that he didn't own a record player because it gathered too much dust. My mission was to say, 'Let's make Radio 1 the sound of young Britain today.'

MATTHEW WRIGHT Radio 1 needed to be for young people. Radio 2 was for people who were dead but not dead enough to go onto Radio 3. And Radio 4 was for people who wanted to talk. But Radio 1 was getting rid of DJs that we had long relationships with, all of whom would quite happily tell you a story of who they'd shagged; but the real reason we were on the station's case was that the ratings were plummeting.

MATTHEW BANNISTER I was at the Christmas party in Broadcasting House and John Birt's PA said to me, 'I need to introduce you to someone because he's very upset with you about the changes you've been making. This is Tony Blair.' Blair said, 'I've got a bone to pick with you. I used to like *The Golden Hour* and you've changed it.' I said, 'I think you'll find we're modernising Radio 1 just like you're modernising the Labour Party.'

POLLY RAVENSCROFT No one really understood what we were trying to do. The press would just say, 'Yeah, but you're just losing loads of listeners.'

MATTHEW BANNISTER People turned on us. We were moving this juggernaut from the middle of the road to the fast lane, but everyone was saying, 'This is a disaster.'

STEVE LAMACQ It was the equivalent of kicking the England

manager; remember when the *Sun* put a turnip on Graham Taylor's head? Matthew was very brave. The changes he made were absolutely right. People should have been applauding him.

MATTHEW WRIGHT The headline 'Sliding Down the Bannister' was Andy Coulson's idea. That started in the *Sun*, a Murdoch paper. And Murdoch's ambition for the BBC was very well stated. So ratings go down on Radio 1. Great! It will make Rupert happy.

MATTHEW BANNISTER We had some very uncomfortable headlines, and yes, the *Sun* had me 'Sliding Down the Bannister'. It was incredibly personally painful.

POLLY RAVENSCROFT Years later, at Matthew's leaving do, when he was moving to be head of production at the BBC, we asked a few journalists, and Andy Coulson brought a piece of banister to give to Matthew. It was recognition of Radio 1's dramatic turnaround.

MATTHEW BANNISTER We brought on loads of new presenters, increased our commitment to live music, commissioned innovative comedy, and we radically changed the music policy to emphasise support for new British talent, which led to the success of Britpop and the dance-music boom of the nineties.

STEVE LAMACQ Someone I knew was a producer at Radio 1, and they said, 'They're planning a new evening show and it sounds like it's going to play all the music you're writing about. Jeff Smith is going to produce it.' So I wrote Jeff a letter saying, 'I'm at the *NME* writing about all these bands you might be playing. If you fancy coming out for a pint let me know.' We went out and I ranted about Teenage Fanclub.

JO WHILEY They had four weeks to fill and Jeff Smith had the idea to try out me and Steve together. That was how we began to do *The Evening Session*.

MATTHEW BANNISTER I heard them and thought, This is a really good combination. Steve had that Essex drawl and Jo had that rather creamy girl-next-door sound. And they looked the part:

Steve, like a long drink of water who hadn't slept for six months, smoking a rollie, living entirely on curry and cider; and Jo, the full indie-chick look of the time. They were passionate about music and absolutely right for Radio 1.

JO WHILEY We were gobsmacked. We didn't feel like radio DJs at all. I'd worked on *The Word*. Steve was a journalist. We felt like imposters. It was part of the Bannister revolution.

STEVE LAMACQ *The Evening Session* was an accessible pop music show when we started: M People or Chaka Demus & Pliers alongside Carter and Suede. It was like a Best Of . . ., pretty much an indie disco with some pop hits thrown in. It was ridiculous that we were seen as cutting edge, but even that was left of centre of what was happening on daytime.

JO WHILEY The producer got us doing this trail once. It was something like 'October's a booming good month' and it was 'Boom! Shake the Room', DJ Jazzy Jeff & The Fresh Prince; 'Boom Shack-A-Lak', Apache Indian; and 'Boom Boom Boom', the Outhere Brothers. Three records that had 'Boom' in the title. That's not what you associate me and Steve with. There was quite a transition from pop to Britpop.

MATTHEW BANNISTER. I was of the view that Radio 1 should be a tastemaker. I remember being with John Peel in Leeds for a Radio 1 Sound City. The Manic Street Preachers hadn't played live for years, and I said to John, 'Are you coming to see them?' He said, 'Oh, no, that's far too mainstream. I'm going up the road to the pub, there's a new band that I haven't seen before.' I thought, That's a John Peel moment. And indicative of what we should be doing, trying to find the next thing.

STEVE LAMACQ Everything changed in about six months. We couldn't have arrived at a better time: our seven-week trial is up; we get told, 'Yeah, you're going to carry on'; then Oasis record their first session for us in December – off we go from there!

JO WHILEY I remember our producer saying, 'Alan McGee has

just dropped off this 12-inch and he says it's the best thing you'll ever hear.' We were like, 'Whatever.' We put it on and it was 'Columbia'. We were like, 'Actually, that's pretty good. Let's play it on the show.' It wasn't like anything else on the show. It was the seed of what Oasis were going to become.

MATTHEW BANNISTER Oasis were a pivotal band for us. Before they even had a record out they played live on *The Evening Session*. We championed them first and they formed a relationship with Steve and Jo. *The Evening Session* was the engine room of that music coming through.

NOEL GALLAGHER I talked to Steve and Jo a lot, seemingly every fucking night of the week.

JO WHILEY We sensed a change. The music coming through was British and being made by people like us; people of our own age in various different cities around the country. Steve and I just liked great songs, and we became friends with these bands because we interviewed them so many times.

STEVE LAMACQ By '95 it was berserk. You'd find a band one week and two weeks later they'd be on the playlist. 'We've only just found them!' There was such an appetite for what was now dubbed Britpop.

KAREN JOHNSON Steve Lamacq was absolutely key. He was an anorak, through and through. He would be about every night seeing new bands. Every time I went to Camden, Steve would be at the gig, at the heart of it all.

STEVE LAMACQ I was out so much people said, 'Why don't you live in Camden?' 'Because I don't want to bump into one of Menswear on a Friday night.'

JO WHILEY The key moment for Radio 1 was when Chris Evans took over the *Breakfast Show.*

STEVE LAMACQ You know sometimes a football team makes a

signing and it galvanises everyone? 'If we're not going to succeed with this guy then we're all doomed . . .' For Chris, getting the *Breakfast Show* was probably the culmination of his teenage dreams.

MATTHEW BANNISTER The turnaround really comes with Chris. He had developed a cult following and was a *wunderkind* of television entertainment. I thought, Well, there's no way we can get him. But in the end, I thought, Nothing ventured, nothing gained, and picked up the phone to him. Chris said, 'I know what you want to talk to me about, come round to my flat this afternoon.' He had a penthouse overlooking Tower Bridge with fantastic views. I arrived, and before I said anything, he said, 'You don't have to sell this to me, I'd really like to do it.' I was like, 'Wow! That's fantastic.' Then he said, 'The condition is I want £1 million. It will be the publicity that makes it big for me.'

POLLY RAVENSCROFT Chris's quote was, 'I'm so excited I can't stop going to the toilet.' He really wanted to do it.

MATTHEW BANNISTER Chris was good friends with Matthew Freud, the PR agent guy. Matthew rang me up and said, 'It's beginning to leak. We need to get it out and make a big splash. Could you go to see Chris and we'll have a photographer outside so they can get a secret snapshot of you two doing the deal?' I arrived at the LWT film studios and this man came up and said, 'I'm the photographer, where will you be?' We said, 'We'll come out on the balcony and sit at the wooden table. Is that okay by you?' He said, 'Yeah, I'll hide behind this car and take the picture.' On the Monday it was full-page in the *Sun* under the headline 'The £1m Cup of Tea'.

POLLY RAVENSCROFT The day of the launch we had all the press and photographers in the studio jostling, and there was a bit of argy-bargy. They were being arses, and Chris shouted, 'THIS IS MY STUDIO. YOU CAN GET OUT.' I thought, Good for you. Chris was fantastic. He was so full of energy.

MATTHEW BANNISTER It was like a shot of adrenaline into the

veins of Radio 1. He was so full of optimism and *joie de vivre*. The spirit and morale of the whole station lifted – and indeed the audience figures.

STEVE LAMACQ. All of a sudden you had bookends to the day at 7 a.m. and 7 p.m., and that's what radio stations really thrive on. Records were banging around and going backwards and forwards.

JO WHILEY Chris was incredibly astute. He could see the scene and started playing great bands on his show. It became like a tag team. He was really amazing, promoting what we were doing in the evenings, playing them on his show and becoming part of that world. And he was the master of generating ideas for publicity.

WILL MACDONALD When I worked on *The Big Breakfast*, I remember sitting in the office once at eleven o'clock one night after a five-minute section of the show had collapsed. I phoned up Chris, this was when he was presenting the show with Gaby Roslin, before he joined Radio 1, and he said, 'Let's invent something!' We created this imaginary sport called bum wrestling, where two people would step into a ring, turn around and bend over so that their arses were touching. The winner was who could push the other one out of the ring. Then Chris said, 'Let's pretend bum wrestling really exists and it's a soon-to-be Olympic sport gaining underground status.' We booked the Olympic javelin-thrower Tessa Sanderson, and in the car on the way to the show I had to explain the rules to her so that she could pretend to be an advocate of bum wrestling. It encapsulated the slightly mad, punk 'fuck it' spirit of Chris Evans. And it filled five minutes of television.

MATTHEW BANNISTER The Radio 1 *Breakfast Show* quickly evolved into being a rather exhilarating soap opera about Chris and his team's lives. They were young people who all worked, went out drinking, saw bands and had adventures together. It often caused a huge amount of headlines, like the Christmas Party when they didn't turn up for work the next day. I rang up Chris to bollock him, and he said, 'I've just done what millions of other people have

done up and down the country, which is to get pissed and then throw a sickie. Look at the headlines we've got, aren't those priceless?' I was like, 'Okay, but you might have told me in advance.' He said, 'But if I'd told you in advance you wouldn't have been cross, and your authentic reaction was as important to this working as anything else.'

STEVE LAMACQ When Jo was on holiday we got Chris to come and co-present *The Evening Session* for a night. He turned up with two carrier bags and told the listeners, 'I've got a Tesco bag and a Crispins Food Hall bag. And in this bag, because you've got to have respect for *The Evening Session*, I've got half a bottle of warm cider, ten Embassy Regals, and for some reason there's bits of card ripped off the top of it, don't know why. I've got a copy of *NME*, *Viz* and *Marxism Today*.' It was a terrific show.

MATTHEW BANNISTER Out of the blue, Chris decided there should be a London Grand Prix. That started on the air on a Monday morning, with the listeners' help, to map out the route: down the Mall and up Regent Street. And then Chris said, 'Let's do it! Thursday.' They rang the police and got them to shut the roads at 4.30 a.m., and Chris and about 250 listeners all turned up in their fancy cars and drove the route, and they broadcast it all live. There was another wonderful moment when somebody sent a message from Driffield and Chris said, 'What a dreadful tin-pot place.' The Mayor of Driffield got very upset, so Chris apologised and said, 'Let's take Radio 1 to Driffield next week.' It was like the Pied Piper: the whole town was inundated with young people, and Chris led them on this glorious pub crawl down the high street and then broadcast the show the next morning with live bands and all sorts of things.

POLLY RAVENSCROFT It was like Chris was a different celebrity and we made it more open for the tabloids to meet him and to find out what Radio 1 was doing. It was a different way of PRing. Every time he moved, the press would just follow him, photographers everywhere. If he was in a bar with *x*, that would

be written about.

MATTHEW BANNISTER This was the time he was trying to force one of his team, Dan, to propose to his girlfriend on air. It went on all week, and by the Friday, Chris said, 'I'll pay for you to go to Richard Branson's island for the honeymoon if you propose.' With three minutes left of the show, Dan said, 'Yes, I'm going to get married to her.' It was all very dramatic. After the show Chris said to me, 'They'll all be talking about it in pubs and questioning whether I was right to put Dan under that pressure. Are you okay with it?' I said, 'Yes, it's the most compelling radio I've ever heard.'

JOHNNY HOPKINS Much like Radio 1, *Top of the Pops* was one of those programmes constantly facing problems because of its longevity and people getting bored of the format. Ric Blaxill came in and injected a whole new energy into it, bringing in younger presenters and emerging bands from the so-called Britpop world. It was another critical link in the Cool Britannia story.

BRETT ANDERSON *Top of the Pops* was an institution when I was growing up; every Thursday night I'd sit there and obsessively tape it, sitting by the TV speaker. Ric was part of the tide of change that brought about the shift. Bands like us, that were previously seen as marginal, were penetrating the mainstream and were suddenly in the top ten, top five.

RIC BLAXILL There was all this exciting stuff going on, and I was giving all these bands exclusives without their songs necessarily charting. I was loosening up the rules. 'Supersonic' charted, and I remember going to my boss and saying, 'It's at thirty-one, but there's something building around Oasis; the band are really edgy.' They came on the show and we staged them on different levels: the drummer at the front, and Liam on a top tier in front of a spiralling Union Jack backdrop. It was trying to recreate how bands like the Who and the Kinks used to be presented.

NOEL GALLAGHER We would just be sitting around, smoking. 'What we doing?' 'Do you want to do this thing?' 'Nah.' 'What

about playing both sides of your new record on *Tops of the Pops*?'
'Why's that, then?' 'Because only the Jam and the Beatles have
done it before.' 'Fucking hell! That'll do me.' So we did 'Don't Look
Back in Anger' and 'Cum on Feel the Noize'.

SIMON FOWLER The Jam were the pivotal band between those
eras. They were a sixties-style band but they'd got a punk edge as
well. We were all touched by the hand of mod.

RIC BLAXILL Paul Weller said in Q magazine, when asked if he
would do *Top of the Pops*, 'It's shit to mime. I'd only do it if I could
play live.' So I approached Weller, 'Fuck it. Come and do it live if
that's all that's stopping you.' He agreed and did 'The Changing
Man' and 'Peacock Suit'. It was amazing. Ocean Colour Scene were
on the same show doing 'The Day We Caught the Train', so Steve
Cradock played in both bands. It was a great talking point.

KEITH ALLEN I was the guest presenter the first time the Spice Girls
ever did *Top of the Pops* and I went on as 'Keithski', as a wordplay on
the rapper Normski. I'd been playing poker at the Groucho the night
before with Stephen Fry, and I was absolutely twatted. My missus
phoned me and said, 'What the fuck! You're supposed to be filming *Top
of the Pops*.' I went to the studio with a shirt stuffed full of £20 notes.

RIC BLAXILL *Top of the Pops* was linking in with Cool Britannia, using
presenters who were excelling in different cultures and walks of
life. I started off with musicians: Justine Frischmann, Suggs, Damon
Albarn, Shaun Ryder and Jarvis, who suggested he held a gold mic.
And there was just as much new energy and personality coming
out of the comedy scene. We had Vic and Bob, Harry Hill, Baddiel
and Skinner, Lee Evans, Jack Dee, Angus Deayton from *Have I Got
News for You*. When Julian Clary did it he turned up with his mum
and dad; they were so proud of their son.

JO WHILEY Ric was very punk rock in his attitude. He loved
shaking it up.

RIC BLAXILL I was always amazed at how much effort the comedians

put in to those tiny links. I would say, 'I don't want, "They've sold twenty-five million records and they're touring." Just say what the hell you like as long as you say the band's name at the end of it.' Dennis Pennis[1] came on and was outrageous: 'Now, some bands are very appropriately named. Skunk Anansie are a classic example. They're black, they're white and their music really stinks. Here they are with "All I Want."' I thought, That's absolute genius. Then he introduced Peter Andre, 'The new number from Peter Andrex with a song that goes on and on and on.' We used to have five-a-side football games during rehearsals. I remember East 17 playing Wet Wet Wet, who were pretty tasty – they'd been at number one for weeks with 'Love Is All Around' – and Marti Pellow skied a ball over a fence into someone's back garden. I followed him round and this woman opened the door. Marti was like, 'Can I get my ball back, please?' She was open-mouthed.

STEVE LAMACQ Ric phoned up and said, 'I'd like you and Jo to do *Top of the Pops*.' I thought, ME AND JO! PRESENTING *TOP OF THE POPS*! The Spice Girls were on, and in the bar afterwards the five of them were all having the greatest time of their lives. Mick Garbutt, the radio promo guy, said, 'Ah, look at them. Bless. First number one.'

JO WHILEY It was surreal and hilarious that we should be presenting bands like the Spice Girls, and then Flaming Lips or Ash. It was so much fun and felt very subversive.

RIC BLAXILL Steve and Jo were the real deal. They were partly responsible for what was going on and I was trying to join some dots up. Those guys doing a passionate link about a band would be worth its weight in gold. That whole Cool Britannia thing embraced a lot of different elements of culture; I even used sports people as presenters, like Chris Eubank and Frankie Dettori. Shane MacGowan, from the Pogues, came up to me one week and said, 'We've got a mate turning up to play guitar.' I'm like, 'Who's your

1 The comedian Paul Kaye.

mate?' He said, 'Johnny Depp.'

JO WHILEY It definitely felt like things had changed. Suddenly our bands were in the mainstream and they were on *Top of the Pops;* our little underground bands that we used to play on night-time Radio 1 were now in everyone's living rooms. You'd have Shirley from Garbage alongside the Spice Girls, there on your television, and you were part of it.

SIMON FOWLER And then *TFI Friday* launched on Channel 4.

PHILL SAVIDGE Whereas *Top of the Pops* was about what was already in the charts, *TFI Friday* championed things that were going to happen. But the irony was that Chris Evans's music taste was dreadful: Jamiroquai, Texas, Kula Shaker. A lot of our bands ended up on *TFI*, but that was more to do with the bookers, who were really on it and knew their stuff.

SUZI APLIN Chris's music taste! All the music industry loved *TFI* because suddenly they had another show. They all used to come down. There was a lovely vibe. It didn't feel like a TV studio. Chris was the darling of Channel 4. He had done *Don't Forget Your Toothbrush*, which was a phenomenal success, and then the producer, Andrea Wonfor, said, 'What do you want to do next?' I remember being on a sofa with Chris in our flat when the name for the show just popped out. 'I've got it! Thank Fuck It's Friday. That's what it's got to be.' Weirdly, Chris was not a big swearer.

WILL MACDONALD It was the stars aligning: *TFI* coincided with Britpop, with Brit Art, with New Labour, with Euro 96. It was the show that allowed all the different facets of Cool Britannia to come together. We got lucky. There was space for an entertainment show to bring in the weekend. If *TFI* had appeared in 1986 or 2006 it would have been very different. It captured the spirit of the age. We were the perfect platform for all these guests, and we basked in their glow.

JO WHILEY I remember watching it in my kitchen, thinking, This is exactly what we've been waiting for.

WILL MACDONALD. It was like, 'The weekend starts here.' The show was young and funny and fun and mad.

JO WHILEY Chris was fantastic at gauging what was going on; he reflected the Britpop movement and gave the bands a platform.

WILL MACDONALD We saw it like a Trojan horse: smuggling on music that we loved. You could put Spiritualized on because two minutes after you'd get Michael Caine. It coincided with the music mainstream getting more interesting. Whereas before it had been grunge, now it was Britpop.

SUZI APLIN It wasn't a deliberate thing. We didn't go, 'Let's make this a cool British show.' We did a show that was celebrating all the things that we liked. *TFI* wasn't about looking back. It was about now – Pulp, Blur, Echobelly – but also a lot of electronic bands – Pet Shop Boys, Bernard Sumner, Mark Morrison 'Return of the Mack', All Saints, Texas, Jamiroquai.

WILL MACDONALD Chris's personality was very much in the present. If you played something to him and he liked it, he'd love it and play it a million times. There was a radio plugger called Ian Goddard, who was a drinking partner of Chris's, and MCA Records told him, 'Don't come in the office. Just spend all day with Chris,' knowing at some point Ian would go, 'Oh, you should listen to this.' Ocean Colour Scene were one such example. Chris loved them and they became integral to *TFI*.

SIMON FOWLER We'd been together for seven years when we met Chris through Ian and he asked us to do the pilot show for *TFI*.

SUZI APLIN Ocean Colour Scene were rehearsing 'The Riverboat Song', and Chris said, 'That should be the theme tune when guests come on.' He shouted across to Simon, 'Can you play that riff again?'

WILL MACDONALD Ocean Colour Scene played on the show more

than any other band, and then we'd always end up in some West End bar three hours later with Simon drunk, invariably rolling out of a car.

SIMON FOWLER We did the first show and Chris made 'Riverboat' Record of the Week two weeks running on Radio 1, and that was it. The following week it went to number fifteen in the chart; without Chris that wouldn't have happened. Everyone in the press used to talk about the patronage that we'd had from Paul Weller and Oasis, but without Chris, 'Riverboat' would no doubt have gone in somewhere in the low twenties. Oasis ploughed the furrow and Chris was the fertiliser. Every week *TFI* played 'Riverboat', I'd rub my hands and say, 'That's another half-an-ounce from the Performing Right Society.'

NOEL GALLAGHER Guitar music was selling. That was it. I'd place more importance on Jo Whiley and Steve Lamacq than Chris Evans or daytime radio. If Oasis weren't number one in the charts and selling hundreds of thousands of singles do you think they would have played us?

STEVE LAMACQ If you were on *TFI*, certainly you'd sell some more records the following week. *TFI* becomes the *Tiswas* or *O.T.T.* to *Top of the Pops*. It becomes a way of showcasing bands for people who wouldn't necessarily watch *Top of the Pops*.

BRETT ANDERSON Chris Evans had to play us because we were in the charts, but he didn't champion Suede in the same way he did Ocean Colour Scene. We weren't part of that whole New Labour, Cool Britannia clique; we were looking in from the outside. People had to include us slightly begrudgingly, I think.

WILL MACDONALD Chris was integral to creating many bands. We used to have stacks of promo CDs in the office, which I'd listen to when I was working. I loved 'Something for the Weekend' by the Divine Comedy and played it to Chris. Then, on Monday morning, I was asleep at home and I got a phone call. 'Will, it's Chris. You're live on Radio 1.' 'What?' 'Do you remember that CD you played

me?' 'Yeah.' 'I want to make it Record of the Week. Have you still got it?' 'Yes.' 'Have you got a stereo?' 'Yeah.' 'Will you go and put it on?' This was live national radio. I got out of bed, wandered into my living room, stumbled through my CDs, put it on the stereo, and for next three minutes Radio 1 was my phone held up to my speaker playing the Divine Comedy. Chris was saying, 'Record of the Week, playing live from Will's living room.' The song finished, and Chris said, 'Bring the CD to the studio so I can play it before 9 a.m.' At the same time, Divine Comedy's plugger, Eric Hodge, was having a shower, hears this and can't believe his ears. He frantically got dressed, jumped in a cab and arrived at Radio 1 as I pulled up. Chris played the track twice, the song became a hit, and a fortnight later Divine Comedy were on *TFI* playing it live. It was symptomatic of the way everything worked.

SUZI APLIN All it would take was for Chris to go, 'I went to this gig last night and it was amazing. Can we put them on?'

NICK HORNBY Chris Evans was almost single-handedly responsible for *High Fidelity* going to number one. The paperback had been out for two or three months and was doing well, and then Chris started to say to his listeners, 'I'm reading this book. Have you read it?' Then the next day, 'How far have you got . . . have you got to the bit where . . .' Each week it went up a bit more, until it went to number one. A film was made of the book and John Cusack went on *TFI* to promote it. That was when I realised how incredibly niche it was. You'd got that zoo-like atmosphere in the studio, and then they showed a clip where John's character says, 'Top five side ones: "Janie Jones", the Clash. "Let's Get It On", Marvin Gaye. Nirvana, "Smells Like Teen Spirit" off *Nevermind*. "White Light/White Heat", the Velvet Underground. Massive Attack . . .' I thought, No one's going to understand this film.

SIMON FOWLER We did the *TFI* New Year's Eve special off our faces, and Chris was holding my mouth and telling me not to swear on camera, while Steve [Cradock] was shouting, 'Arse,' in the style of *The Fast Show*. Apparently, I introduced Chumbawamba's

'Tubthumping' and said, 'This is the best song of the year. It's called "I'll Get Pissed Up",' and Chris had to drag me off with us both laughing our heads off.

TJINDER SINGH Whatever fucking drugs they were taking off each other's bodies, it wasn't what I was in to. People who take coke, it's rent a personality; a lot of dickheads who needed something to help them mingle.

WILL MACDONALD Chris didn't do life in a conventional way. He just did what he wanted. We ended up once on a three-day bender in Glasgow with Gazza and the Rangers football team. We hired a boat to go to an island in Loch Lomond, and I remember waking up in a forest at five o'clock in the morning with Sara Cox and Trevor Steven, the former England footballer, all huddled together in this ball of human flesh because it was so cold. It was like, 'Oh shit! We've got to get back and make a TV show tonight.'

MATTHEW BANNISTER When you looked at all the cultural influences – the rise of Britpop, the football, the magazines – Chris Evans was on that tip. Radio 1 wasn't leading it or promoting it, but we weren't ashamed to be alongside it.

WILL MACDONALD There was a time when me, Chris, Gazza and Danny Baker arranged to meet in a pub on the corner of Shepherd's Bush Green. We had a pint and then we carried on, and it got to the point where we thought, Let's go into town. We were driving down Bayswater and Gazza jumped out of the car and into a workman's hole with a pneumatic drill. Then we got stuck in traffic and a double-decker bus pulled up beside us. Gazza knocked on the window and said, 'Can I drive your bus, mate?' Amazingly, the bus driver said, 'Yeah, all right.' Gazza got into the cab and started driving the bus. We were pissing ourselves. My favourite image was a bloke reading the newspaper on the top deck blissfully unaware that below him England's most famous footballer was in control of the bus. We ended up going to an awards ceremony

at Grosvenor Square, where an infamous photograph was taken that ended up on the front page of the *Mirror* of us all looking very much worse for wear. The night ended in a thirty-foot white stretch limo, with me lying on the roof, driving down Piccadilly, with Neil and Chris from the Pet Shop Boys and Gazza and Chris holding my hands and feet. We got to Notting Hill and Neil said, 'Let's go and see Damon Albarn.' We ended up in the basement with Justine Frischmann making cheese sandwiches and us all recording a song.

SUZI APLIN I don't think we knew at the time how much *TFI* was at the centre. I remember Chris and I going to the south of France with Bono then the next night going out for dinner with Andrew Lloyd Webber. Chris was at the epicentre of Cool Britannia because he had a loud voice and was outspoken. He used to say, 'I've always been a cartoon character.' He was enjoying life and he didn't care who joined in. He treated anyone the same.

MATTHEW FREUD I've never known anyone who had just an innate sense of being able to live on this expanded stage. I don't even think it was conscious.

STEVE LAMACQ What Chris did with the *Breakfast Show* and *TFI* was making radio and telly that wasn't aloof, that wasn't condescending. He didn't mind being the butt of the joke, which makes him like everyone who's ever stood around a pub on a Friday night.

SUZI APLIN *TFI* was Chris's DNA. That's the reason why it was a success. There's a difference between owning a show and just being a mouthpiece. Chris used to say, 'Always make the show you want to make.' If you look at *TFI* it was him. He said, 'What do we do on a Friday night? We go to the pub. We hang out with our friends.' *TFI Friday* came from that culture of a gang, and switching off for the weekend and being carefree. It wasn't manufactured. If Chris got annoyed with Will or if a VT had not happened on time, you'd know about it. There was this image of Chris as the centre of it all as the entertainer: 'There's Chris, happy go lucky, living the

moment.' All of that's true, but he worked very hard for it. He would eat up ideas. And if ideas weren't good enough he'd think of more and expect you all to think of more.

SIMON FOWLER Chris had a tantrum once during filming. He wasn't happy with camera shots or something, and he shouted, 'Seven fucking cameras and that's your bloody lot.' I went up to him after and said, 'Could you be our tour manager?' We had a drink together and we became drinking pals.

WILL MACDONALD *TFI* wasn't an antiseptic TV show where people would turn up, play their song and then fuck off. We created this environment and we were lucky enough to attract this heady mix of actors and musicians.

DAVID BADDIEL I was interviewed on *TFI* two or three times. It was a great show. It felt like the centre of Cool Britannia culture. My main memory of it was performing 'Three Lions' and the audience all waving flags of the Cross of St George. I remember thinking, This is absolutely brilliant. And then watching it back and thinking, This is one of the worst things I've ever heard in my life. It sounded like the Lightning Seeds were playing one song and me and Frank were singing another. It really was appalling.

SUZI APLIN We would do stupid things like hire fifty guitarists to play 'The Riverboat Song' riff to see what it sounded like.

SIMON FOWLER John Cleese ran out to it with his fingers in his ears. Chris said, 'Did you enjoy your guitar salute, John?' He said, 'I . . . enjoyed it . . . very . . . much.' It was hilarious. I took P.P. Arnold[2] down there, and we went into the green room and met Chris, Gazza and Rod Stewart. When we came out she said to me, 'Foxy, I used to fuck Rod Stewart and he didn't even recognise me.'

2 A former backing singer for Ike & Tina Turner, P.P. Arnold had her first solo hit with 'The First Cut Is the Deepest' in 1967. Thirty years later, she regularly performed with Ocean Colour Scene and contributed vocals on hits such as 'Travellers Tune' and 'It's a Beautiful Thing'.

WILL MACDONALD Shaun Ryder came on. We knew he had Tourette's so Chris said, 'If you don't swear tonight I'll give you my shoes.' Chris took them off his feet, put them on the table, and said, 'All you've got to ask yourself is would you like these shoes?' Shaun said, 'They're Patrick Coxes, man! They're a fucking good pair.' A few weeks later we wanted to have Shaun back on with Black Grape to sing 'Pretty Vacant', but Channel 4 vetoed it. We said, 'Here's a solution. We'll pre-record the interview and then, like *Stars In Their Eyes*, he'll say, 'I'm going to be Johnny Rotten,' walk through the smoky door, and we'll cut to him live. What could possibly go wrong?' They went, 'All right.' The interview went to plan, Shaun didn't swear, and then on air we said, 'Cut. Shaun, you're now live.' Shaun is a lovely man, but we'd effectively asked him to be a Sex Pistol and as soon as he got on stage he started singing, 'We're so pretty, so fucking pretty, we're fucking pretty vacant.' Somebody added up that he said 'fucking' fourteen times. Chris sat with his head in his hands, just saying, 'We're sorry. We're very sorry.'

SUZI APLIN The show was only an hour. It was stuffed, wall to wall: 'Show Us Your Face', 'Ugly Blokes', 'Baby Left Baby Right', 'Freak or Unique', 'It's Your Letters', 'Sink or Swim', 'Fat Lookalikes'. There was even one called 'Black or White'. What were we thinking! The participant would have something over their head, and it was based on whether they could dance.

WILL MACDONALD Some of that stuff you look back on and feel uncomfortable about. The phrase 'laddism' was knocking around, but we didn't particularly think that described us at the time. It's like Britpop; if you were a band you said, 'We're not Britpop,' but, in hindsight, you end up agreeing. *TFI* inevitably had people on who were associated with that world and so therefore we were by association. We would have David Baddiel, who you would meet and think, He's not really a lad. But he was very definitely associated with that world because of *Fantasy Football*; two blokes living together with a love of porn.

DAVID BADDIEL The whole idea of us as the champions of laddism is slightly misplaced. There are always complexities – Frank was

an alcoholic and a devout Catholic who hadn't had a drink since 1987, and both of us were in and out of quite serious monogamous relationships – but we were unashamed to make jokes around the fact that we were blokes and we liked football and women.

TIM SOUTHWELL If *Loaded* had been a television show it would have been like *TFI Friday*. It opened the doors in terms of people's perception about what entertainment meant for blokes in their twenties and thirties. They want to be entertained, to laugh, to watch great music and to have a beer while they're doing it. Chris Evans owed a lot of that idea of bringing people together in a sense of celebration and fun to *Loaded*.

BRETT ANDERSON Why would anyone be impressed by the whole *Loaded*/lad culture phenomena that *TFI* was tied up with? It was part of a very big herd.

STEVE COOGAN If everybody is saying, '*TFI* was an amazing show,' they need to take a truth drug. It just felt smug and self-satisfied and loud.

SUZI APLIN Steve was part of that culture. He came on the show. I was obsessed with *Knowing Me, Knowing You . . . with Alan Partridge*.

STEVE COOGAN It's like the line in *Macbeth*: 'Told by an idiot, full of sound and fury, Signifying nothing.' There was a lot of that at the time, 'What's it about? Does it have a point of view?' It was just lots of people making a lot of noise and being self-consciously irreverent. It was Chris Evans saying, 'Hey, look how crazy we are.' There was something a bit mannered about the whole thing.

WILL MACDONALD You can look back and say, 'It was a time of unenlightened blokes and women in Wonderbras,' like when Eva Herzigová came on the show and we did jokes around 'are push-up bras a good thing?' Stuff we definitely wouldn't do now. We reflected the culture that was in front of us at that point.

SUZI APLIN It was a lens for that world and what was going on in music, film and fashion. It wasn't lad culture. It was just people having a good time. There were also loads of girls. Patsy Kensit. Naomi

Campbell came on in a stunning red dress and flirted with Chris like mad. Eva Herzigová was brilliant. Also, the tabloid Page Three model world: Kathy Lloyd, Melinda Messenger, Melanie Sykes. There was a slight touch of *Carry On* to *TFI Friday*, but I don't think the show objectified women. Those women were part of that time. They were all having fun, and people loved the energy of it and the madness.

TJINDER SINGH It was full of people praising themselves; patting themselves on the back for being white, mainly. It tried too hard. You can't be everything to everyone, but it tried to be.

JARVIS COCKER I'd gone off the whole scene, the *Loaded* laddish mentality, and my disenchantment with the whole thing was growing and growing. It really started to rankle me that every time I watched *TFI Friday* there was this cut-out of me in the centre of it all that they'd got hold of from the cover shoot of *Different Class*.

SUZI APLIN Chris's desk area was cluttered with all things related to what we liked: posters on the wall, and Jarvis's life-size cut-out was always there.

JARVIS COCKER When we were half-heartedly trying to do our promotion of *This Is Hardcore*, the song 'Party Hard' came out as a single and we were asked to perform it on *TFI*. Chris Evans wanted to interview me, and I took that as my opportunity to get rid of the cut-out. I go up, and Chris Evans introduced me and said, 'What we need in this world are attitudes and opinions. One man has buckets of them and he's been away for over a whole year, so we want him back . . . here he is, it's Jarvis Cocker.' The first thing I did, before I sat down, was go over, pick the cut-out up – it was surprising how heavy it was – and then I dropped it out the window. Chris said, 'I can't believe it, Jarvis Cocker just threw himself out of the window!' I said, 'It's a lot safer than doing it the real way.' He asked me if it annoyed me having it there, and I said, 'Well, I've seen him there with football shirts on and various things. It's like Oscar Wilde, you know, *The Picture of Dorian Gray*, and the picture gets more and more twisted and horrible and the person stays looking great. Well,

it's the other way round with me. So I thought I'd get rid of it. The future starts now.' After the interview, I went downstairs and Lars Ulrich, the drummer in Metallica, runs up to me and says, 'What the fuck you doing, man?' Apparently, he'd gone outside to have a fag and, just as he stood on the front step, this cut-out came down like a fucking guillotine, an inch in front of his nose. Luckily it was raining a bit, so he was sheltering. If he'd been outside and it had fallen on his head that would have been it. Lars Ulrich killed by a wooden Jarvis Cocker! It was a close shave.

WILL MACDONALD I think we replaced Jarvis with a cut-out of Des Lynam.

KEITH ALLEN I never liked Chris Evans. I was invited on to promote a series I was doing. I said I'd do it as long as there were no questions about illegitimate children or being a gangster hard man because I was beginning to get typecast. Anyway, the week before they had Peter O'Toole on in a feature called 'Peter O'Toole Delivers Lines That Are Plainly Beneath Him', and he'd done the Spice Girls 'Wannabe': 'I'll-tell-you-what-I-want-what-I-really-really-want . . . I-wanna-I-wanna-I-wanna-I-wanna-I-wanna-really-really-really-wanna-zig-a-zig-ah.' Then I went on and there was a 4-inch step up to the interview desk, which Evans was standing on, and he did the worst thing he could have done and said, 'Ladies and gentlemen, TV hard man Keith Allen . . . he's not that tall, is he?' and touched my head. I thought, You cunt, right. I sat there monosyllabic, definitely not giving him what he wanted. I can't remember the exact sequence, but he asked me to drill a hole and sign my name on his desk and then he asked me about illegitimate children. He then said, 'You're a bit quiet, Keith.' I said, 'Well, I'm in mourning. I'm very saddened by what's happened.' He said, 'What's happened?' I said, 'Have you not heard about Peter O'Toole?' He said, 'What . . . what's happened?' I said, 'Well, he's in hospital. He just got admitted yesterday.' He said, 'You're joking! I didn't know about this. What happened?' I said, 'They had to remove a large piece of your head from up his arse,' shook his hand and walked off.

OFF HIS COCKER
BRITs 1996

ALASTAIR CAMPBELL The only two times I've seen Tony vaguely star struck was when we bumped into Barbra Streisand in a make-up room somewhere, and David Bowie when he presented the Outstanding Contribution to British Music award to him at the BRITs in 1996. He was like, 'Oh my God! David Bowie.'

ALAN EDWARDS We were looking for a Bowie moment. I knew Alastair Campbell a bit by then and we cooked up this idea of Tony presenting an award to David.

KAREN JOHNSON It was a very toxic mix of people that year. The BRITs had started inviting people who were nothing to do with music: footballers like Steve McManaman and Robbie Fowler; and Tony Blair. I remember thinking, It's celebrities because they're celebrities. That culture was really coming in then.

TONY BLAIR I was a genuine Bowie fan. I'd been to his concerts. One of the things that was changing was a genuine interaction with people in a much less 'here are we, the political class; here are you, the people'. There was a much closer sense around the social and cultural change that was a very genuine feeling. We were a much younger group of people. I was the first Prime Minister – and possibly John Major, but to a limited degree – who would have been genuinely listening to pop and rock music. That would have been more my life than listening to classical music. I listened to Oasis. I listened to lots of people. And I was

in a band, so I was probably the first Prime Minister who had done that too.

ALASTAIR CAMPBELL Tony was really worried about getting booed that night. He was really nervous, partly because it was high profile and live on television, and partly because of Jarvis Cocker and Oasis's behaviour. I didn't like the atmosphere one bit. He did a short speech, came off and said, 'Thank God that's done.'

ALAN EDWARDS It wasn't a gigantic success. There was some booing. The music industry was very much an old boys' club, and everyone was Tory.

KAREN JOHNSON It was a drug-fuelled crazy atmosphere.

MATTHEW BANNISTER It's the record industry en masse; never a pleasant sight.

JO WHILEY The BRITs was a big deal. It was very showbizzy and pretty debauched; everyone just schmoozed from table to table and would talk through the acts. It was anarchic.

KAREN JOHNSON Oasis won three awards. Pete Townshend presented them Best British Group and Noel made a speech about shaking Tony Blair's hand and that he was the man.

NOEL GALLAGHER I don't remember doing it, but I know it happened. What did I say?

KAREN JOHNSON He said, 'There are seven people in this room who are giving a little bit of hope to young people in this country. That is me, our kid, Bonehead, Guigs, Alan White, Alan McGee and Tony Blair. And if you've all got anything about you, you'll go up there and you'll shake Tony Blair's hand, man. He's the man! Power to the people!'

NOEL GALLAGHER Did I say that? Wow! That's mental. Never mind. I was probably high as a fucking kite.

ALAN McGEE Noel was fucking on about three Es. He was off his tits. Usually, you can be off your tits and make incredibly stupid

statements, it doesn't matter, but Noel managed it with a hundred million watching him. 'Alan McGee, Tony Blair, our kid,' I was like, 'Fucking shut up, you mad bastard.' It was a good comment at the time but it was not based on reality.

DAVID KAMP I asked Blair after, 'What did you think when Noel Gallagher said that there are only seven people who care about the young people in this country?' He laughed and said, 'It was kind of him to say so but I'm sure there are more than that.'

JOHNNY HOPKINS Noel is the absolute master of the sound bite. It was so of the moment. There was a real feeling of hope and optimism and possibilities that Blair appeared to promise and embody. By that point it had been almost seventeen years of Tory government; absolutely right to throw your weight behind that. Enough was enough. We needed the Tories out. Noel's speech was an open invitation.

CHRIS SMITH It was tremendously exciting. We were in opposition, hoping to get into government, and here was a huge crowd of people involved in a really important part of British culture and economy, and they're getting up on stage and endorsing the leader of the opposition – on the whole that doesn't happen.

WILL MACDONALD If John Major turned up at a gig of some hip band it would be ridiculous. They embraced Blair and he embraced it. It was cool. Suddenly you were allowed to be involved in politics and support it, and go, 'Yeah, the next people in power are people we're going to like.' It was a symbiotic relationship.

CHARLIE PARSONS It worked both ways. Those music-award events would have wanted to have the bright young thing. Politicians have to be seen. The world of PR was changing. They were thinking much more carefully about who they were appealing to.

JARVIS COCKER It wasn't appropriate that Blair was at the BRITs. When you get someone, 'Hey, kids . . . come on,' you think, Fuck off. It's so obvious they're trying to get something from you. It shouldn't be that. It should be like, 'Okay, I'm going to try to do

grown-up things and kids, you get on with doing your own thing and I'll try to create some freedom for you.' Trying to piggyback on some energy that's going on is the ultimate party pooper. There is nothing guaranteed to destroy a vibe more than somebody coming in and approving of it. 'Oh yeah, it's great! Wow! It's fantastic that you're swearing. I love the pungency of your language.' Blair probably spotted that there was genuine hunger for some change and thought, I can tap into this and use it. But that's opportunistic, isn't it?

TONY BLAIR You can have something that is a genuine feeling that nonetheless is also a political opportunity. People become far too binary about it: was it real or was it opportunistic? Well, it can be both. You can exaggerate the degree to which these things are ruthlessly examined as political opportunities. I could have gone to lots of different places, but I went to the BRITs because I felt at home there. There was a new feeling, that we felt and participated in, but at the same time you were also creating a mood of change. It helped boost that mood of change.

RIC BLAXILL It was another sign. It fitted the moment.

SIMON FOWLER Blair at the BRITs and Noel endorsing him was the big story. That was until Jarvis Cocker took umbrage to Michael Jackson's performance.

WILL MACDONALD I heard all these stories about how Michael Jackson had demanded a whole floor of Earls Court to hang out in, and mountains of teddy bears. It was madness!

JARVIS COCKER I'd always been a fan of Michael Jackson's music and was very excited that he was playing. When we were rehearsing for our part of the show I tried to stay behind to watch his rehearsal, but I was chucked out. It was a closed set and no one was allowed to see.

JOHNNY HOPKINS I was at a table with the band and Alan McGee watching the Jackson drama going on. Everyone was gobsmacked: the Christ-like imagery, the dancers; pictures of starving kids. It was so

over the top. There was a sense of, 'This is just ludicrous. Make it stop.'

SUZI APLIN It was an amazing performance. It was Michael Jackson. I don't think I thought too much about the agenda. It was just an astonishing performance: dramatic and otherworldly; some would say quite indulgent.

WILL MACDONALD We were twenty feet away, saying, 'This is pompous nonsense, all these kids and this overblown song.'

JARVIS COCKER The thing that got my goat was this messiah act – it really was about that performance; it wasn't a protest against him. I just thought the performance was dodgy because he was pretending to be able to heal the sick. It's like saying, 'I am Jesus,' as if you've been beamed in from outer space. I didn't like that.

JOHNNY HOPKINS All of a sudden Jarvis was on the stage flashing his arse.

POLLY RAVENSCROFT It was the funniest thing. Michael was doing his thing and then you just saw Jarvis.

KAREN JOHNSON He came out of nowhere, in the middle of this pretentious presentation, and started wiggling his bum. Everybody thought it was hilarious.

WILL MACDONALD It was quite a fleshy arse.

JO WHILEY You saw this ridiculous kerfuffle. 'What's happening over there? Jarvis? What's he done?' It just seemed insanely ludicrous: Jarvis, who had co-presented *The Evening Session*, was on stage with Michael Jackson waggling his bottom. It was very funny.

JOHNNY HOPKINS It was a stroke of genius. He stole the show.

MAT COLLISHAW Michael Jackson needed taking down. His preposterous poverty cause was offensive. Jarvis did that quite elegantly; dropping his pants and mooning.

JARVIS COCKER I really didn't expose my backside. There are plenty of photos to prove it.

WILL MACDONALD Then there was the commotion: 'Jarvis has been arrested', 'He's been taken away.' He was held until three o'clock in the morning and outside there was a 'Free Jarvis' campaign going on, led by Neil Morrissey and Martin Clunes, who, ironically, were the stars of *Men Behaving Badly*.

SUZI APLIN Bob Mortimer tried to rescue Jarvis because he had worked for Peckham Council in the legal department. Jarvis said, 'All the policemen kept asking him for his autograph so he couldn't concentrate on his job.'

MATTHEW WRIGHT I completely missed it, along with just about everybody else from Fleet Street: we were in the toilet, near the toilet, on the floor, getting pissed and having the time of our life. The ceremony finished and Gary Farrow, who was a Sony PR, said drunk, 'WhatdidyoumakeofMichaelJackson?' I didn't have a fucking clue. I had to file hastily made-up stuff the best I could glean it.

SUZI APLIN At first the press turned against Jarvis. The *Sun* said, 'HE'S OFF HIS COCKER' – because the television broadcast had cut the incident.

MATTHEW WRIGHT We became part of the Britpop machine. It starts off cool with some arty people doing really clever things, then there comes a tipping point when it becomes mass, and we were part of that process: the magnification, the exploitation. Jarvis Cocker was virtually unknown out of Sheffield. He didn't have to get on stage and dance with the world's most famous pop star. Obviously the moment you do that you are rewriting your own history into the pages of the tabloids.

WILL MACDONALD On *TFI* that Friday we played the footage and Chris did a live link with Jarvis from his dressing room at Manchester Arena, where he explained what had happened: 'I was just sitting there watching it and feeling a bit ill because he's there doing his Jesus act. And it seemed to me there was quite a lot of other people who found it quite distasteful as well, so I

just thought, The stage is there, I'm here, you could actually do something about it and say this is a load of rubbish if you want to. Candida, our keyboard player, kept saying, "You'd never dare do it though, would you?" So I thought, Oh well, just to show her. I got up and bombed it because I knew I'd have to move fast, because if anybody cottoned on to what was happening I wouldn't get on. I was quite surprised because suddenly I was there and I didn't really know what to do, so I thought I might as well bend over and show my bum. The horrible bit for me was that they arrested me and said, "You ran onto that stage and assaulted some kids." I couldn't really believe that they were saying that at first. But then they carted me off to the police station, so it wasn't so much of a joke then.'

JARVIS COCKER The thing that I've come to maybe comfort myself about it was a feeling that what I liked about pop music was that anybody could be part of it, and anybody could dream of being a pop star and maybe make themselves one. It was open to everyone. It was possible. Michael Jackson's BRIT performance perpetuated this idea of the pop star, or the famous person, as being a special person, almost of a different species to the rest of humanity. I've always thought it was the other way round. The fact that anybody could become that is what makes it magical.

LORENZO AGIUS It was crazy. Suddenly, Jarvis Cocker is front-page news and people are talking about Noel Gallagher and Tony Blair in the same breath. Everything that had previously felt like marginalised culture was making headlines. It hadn't been labelled as 'Cool Britannia' yet, but it was such an exciting, exhilarating time to be young and British.

SIMPLY EVERYONE'S
TAKING COCAINE
Drugs. Met Bar. Groucho Club

BRETT ANDERSON There's only four drugs, really, and they go round and round and round. After rave and Ecstasy it happened to be the time of cocaine again. It's the cyclical nature of fashion. You can draw parallels with how alternative music and the mainstream shifted with cocaine. Cocaine was seen as an ugly, greedy, eighties drug that was used by people with big mobile phones and ponytails and only available to the rich: the Yuppie drug; or in the seventies the rock-star drug. In the nineties cocaine penetrated working-class culture. Suddenly it became the plasterer's drug, the electrician's drug. It went across the social divide and became all pervasive. The pendulum had swung.

OLIVER PEYTON You had the Ecstasy thing first, which was for younger people for falling over in a field. Then it sort of changed into cocaine after everybody went, 'We've done all of that.' There was a natural gateway: cocaine just became part of the new culture.

DAVID KAMP I was reared in the cauldron of Nancy Reagan's 'Just Say No' campaign and raised to believe that if you were taking Class A drugs you had a disease. I couldn't believe it when I got to London and people were openly taking cocaine, unashamed of it and so incredibly full of themselves.

KEITH ALLEN The Stock Exchange pre-Thatcher was the domain of bowler-hatted gentlemen. Post-Thatcher it was just fucking kids,

working-class traders who suddenly got access to an unregulated market. I knew loads of them who were on coke every day. Once you get a sizeable number of people in a given industry it will leak out. Soho was flooded.

MAT COLLISHAW There were a lot of wage accelerations, so more people were using it in the City and that demand made cocaine far more accessible and cheaper to get hold of. It went from being an exclusive drug that was used in Chelsea to being commonly available.

KEITH ALLEN It was the glue that combined everybody. London was afloat on a sea of second-rate cocaine. It was a natural progression from E, which was a classless drug. Historically, coke wasn't a classless drug. It was for rich people. And suddenly, with the availability of it, it wasn't an elitist drug. Criminals realised there was a market there too: you could sell cheap, cut cocaine on an estate as much as selling it to people in private members' clubs. It's Murray Lachlan Young's poem, 'Simply Everyone's Taking Cocaine'.

WAHEED ALLI The cocaine-fuelled 'me' generation was the eighties. That was the City boys. It was a culture of selfishness. The nineties was an enjoyment of life in a much more selfless way. It was about sharing joy as opposed to preserving unto yourself.

LORENZO AGIUS It all felt like buddies together. I didn't know anyone who wasn't doing drugs. It was commonplace.

BRETT ANDERSON Brian Harvey from East 17 came out and said, 'Ecstasy makes you a better person'. He was jumped upon by the press and pilloried for saying it. Even John Major said in parliament, 'I would regard any comments of that sort as wholly wrong.' Ecstasy was developed as a drug to help marriage counselling, and you can understand why it was used like that. It does dissolve these walls that you build up between people.

JOHNNY HOPKINS Noel was on BBC 5 Live, and said, 'If Brian Harvey did do twelve Es in one night, if he's being honest, then fair enough [. . .] there's people in the Houses of Parliament who

are bigger heroin addicts and cocaine addicts than anyone in this room right now. It's all about honesty at the end of the day. As soon as people realise that the majority of people in this country take drugs, then the better off we'll all be [. . .] drugs is like getting up and having a cup of tea in the morning.' It was a powerful sound bite and obviously got a lot of coverage. It was his John Lennon 'we're more popular than Jesus' moment.

MATTHEW WRIGHT There's this fantastic hypocrisy in Fleet Street, which the *Mirror* finally faced up to with Noel's 'drugs cup of tea' front page. But up to that point pop stars on drugs was bad, but we love writing about them because the readers can't get enough of them. Then, of course, you have the issue of how many drugs were being taken on Fleet Street?

JARVIS COCKER The sleeve of our single 'Sorted for E's & Wizz' showed you how to fold a wrap, which we thought was quite funny. And then it was on the front page of the *Mirror*.

PHILL SAVIDGE The *Mirror* needed a splash. Kate Thornton had written a light story about the origami on the cover in her 'Sorted' column, and when the deputy editor saw it, said, 'This is a scandal!' and came up with the headline 'BAN THIS SICK STUNT'. We had to issue statements all over the place: they're not showing anybody anything they don't already know.

MATTHEW WRIGHT It was old-school tabloid hysteria: 'Isn't this outrageous, this pop band – at this moment unknown by anybody under the age of sixteen – telling people how to take drugs.' Jarvis walked into it. He was erudite and smart. He knew that if you release a single called 'Sorted for E's and Wizz' in a drug wrap it's going to end up in the tabloids, guaranteed. That's courting notoriety. Ironically, the song actually takes the piss out of people on drugs, but that was wasted on the tabloids. Jarvis created the problem and was tabloid fodder thereafter.

BRETT ANDERSON When I was talking about drugs in the early days I was determined to be quite honest about it. I saw the music

industry as this refuge for liars, where people were presenting themselves as clean but behind the scenes were not. Drugs were part of life, but I was naïve in thinking I could talk about these things without them getting into the headlines. Like the *Daily Star*, 'Brett snorts up a storm'. I don't even know what the core of that story was. They probably picked up a few of the lines from 'Animal Nitrate', added two and two together and made five. I wanted to document drug use like I documented anything, 'This is the crappy world I live in and occasionally there's a couple of lines of coke on the table. It's not a big deal. It doesn't define me.' Unfortunately, it's impossible to talk about these things without them becoming headlines.

SONYA MADAN The whole culture was rife with cocaine and explains a lot of the energy behind Cool Britannia. I never took it but watched a lot of people who did. It makes you arrogant and gives you bravado.

SIMON FOWLER We did all the things that people did at that time to a horrendous degree. They were fun. And you were with your mates, up all night in hotels all over the world; what could go wrong? One night Steve tried to jump out of a seventh-floor hotel window in Paul's [Weller] room, off his face on coke. He was jumping up and down on the bed and launched himself at the window. Mercifully, instead of the window going out it was coming in, and Steve smashed his head and fell down. There was shattered glass and blood everywhere. If he'd gone out the window he would have killed himself.

KEITH ALLEN Cocaine made you sexually active, loud, drink more and for a while you think it makes you more interesting. I wrote 'Vindaloo' and 'World in Motion' on coke and E together. But it's interesting the marketing side of cocaine; for years it didn't change price.

BRETT ANDERSON It's always been £60 a gram. That was always how I judged things: it was like, 'How many wraps of cocaine does that shirt cost?'

TIM SOUTHWELL Cocaine was considered a drug for people who were successful – £50 for a wrap of charlie was a lot of money. It was the drug of celebration.

DAVID KAMP I talked to James Brown at *Loaded*, and he said, 'There's a heroin addict, a cocaine addict and a marijuana addict on my staff. Sometimes it's difficult. Sometimes it's great fun.' He was saying it casually as a badge of honour, as it was among a certain set of young Londoners.

TIM SOUTHWELL We worked hard and we played hard. When *Loaded* went to the PPA [Professional Publishers Association] Awards, for some reason James persuaded me beforehand that we weren't going to win, so we should drop some acid as it'd be all right anyway. I hadn't had it before. It was very surreal because we won and we were tripping like mentalists. We disappeared into this upstairs bar and all the walls were velvet and, of course, everything fucking came alive. The next thing, I was outside trying to catch my breath. We were in danger of becoming quite uncool at the time.

KATIE GRAND It got pretty nasty at *Dazed*. They were all doing loads of drugs and being quite annoying. On a Friday night me and the fashion assistants would bomb it into the toilets to pick up all the tenners that they'd left because they were so off their heads.

OLIVER PEYTON We were the first people to put attendants in the toilet at the Atlantic Bar, which I'd opened in Soho in 1994, to stop what Damon Albarn called 'a fucking blizzard of cocaine in London at the moment'. On one hand, I was operating a licence and had a legal obligation to make sure the place was run correctly, but it was a very hedonistic time and we were young and single. People didn't give a damn. We were all starting to make an awful lot of money. One night, somebody came up and complained, 'There are two people in the bar and they're having sex.' The security guard said, 'What do you want to do?' I said, 'Don't do anything. It's great.' We were that sort of crowd.

KEITH ALLEN There was loads of sex going on in toilets. I used to climb out of the Colony back window, come across the roof to the Groucho, tap on the ladies window, go in, have a line and a fuck, and then go off into the club. It was fucking insane.

LORENZO AGIUS It was a decade of madness. I used to go to the superclubs – Ministry of Sound, Cream in Liverpool – 20,000 people popping Es and going crazy.

OLIVER PEYTON It was the making of some people and the killing of others.

STEVE COOGAN I did a lot of cocaine. It made you feel elated and confident, but for several days after you were full of self-loathing. It definitely began to affect my work. The second series of *I'm Alan Partridge* would have been better if I hadn't been doing coke. Some of the live shows I did I was still intoxicated from the night before. I didn't care. I had a feeling of indestructibility. But the bottom line is the drugs don't work. It might be that it gives you chutzpah, a braggadocio, in the short term, but it's also dangerous: hubris makes you fly too close to the sun. You could equate the post-high of intoxication with what happened to New Labour and Cool Britannia.

TOBY YOUNG Were people taking cocaine more than they were in New York, or in other European capitals? Probably not. It's tempting to ascribe some of the energy of that particular moment to coke, but I think that Cool Britannia probably would have happened with the absence of cocaine. While certain drugs are associated with certain pop-cultural phenomena, usually it's not the drugs that are driving those characteristics; it's the drugs taking on those characteristics in retrospect.

JARVIS COCKER When there's an energy around you feel it, you tap in to it, but I don't think it was all drug induced. Drugs only open up or exaggerate what's already there. It's unfortunate that cocaine became prevalent in the mid-nineties because that did have an effect in putting the dampeners on it and making it less

inclusive, and making it more Tony Montana. Maybe each genera-
tion gets the drug it deserves.

POLLY RAVENSCROFT Cocaine wasn't fuelling everything. There
were a lot of people who didn't take it. What did become interesting
was the press. They were out to get people who were doing it. I
had that conversation generally: 'Whatever you do in your own
time is up to you but be careful when you're out.'

KEITH ALLEN I'd go into the kitchen of the Groucho, wet my face, get
a bag of flour, put it over my face and walk out with Damien knowing
the press were there, and say, 'All right!' They'd say, 'Is it cocaine?
No, it can't be.' They knew if they fucked around with us there'd
be certain clubs they wouldn't have access to. It was very difficult
for them to write a story about me. 'Keith Allen takes drugs', 'Keith
Allen fucks in toilets', 'Keith Allen pissed'. So fucking what! Tell me
something I don't know. 'Keith Allen is a nice guy' – fucking hell!

IRVINE WELSH Journalists were writing about the fucking Groucho
and the Met Bar because somebody snorted a line off the bar or
somebody threw a picture out of the window, I mean, big fucking
deal. The Groucho had about as much to do with Cool Britannia as
I did with country and western. It was exhibitionism. When you
were fucked up in the Groucho you wanted to be seen.

MATTHEW WRIGHT You've always had rock 'n' roll bars that are
here today and gone tomorrow. For two, three years the Met Bar
was the place to be. It was a scene influencer. You could be there
three, four in the morning, and people were, regularly. Niki de
Metz was the celebrity 'gatherer'. It was musicians and TV people,
stars who went out: Fun Lovin' Criminals, All Saints, Leonardo
DiCaprio, Martine McCutcheon getting off with Michael Douglas;
lots of drugs, lots of drink, lots of madness. My favourite memory
was after a BRIT Awards, Jay Kay from Jamiroquai wearing a perfect
1970s white suit doing extraordinary dancing up and down the bar
for what seemed like hours. It was high-class anarchy. The Met
Bar gave mid-nineties London a focus.

FRAN CUTLER For the first time ever there was a hotel with a cool bar. And it was Park Lane. You could dance, but it was more about who was in there looking at you. It was wild and really good fun. People needed somewhere where there were no journalists. Outside, there were photographers, but no one would ever talk to them.

MATTHEW WRIGHT Inside there were a whole load of drugs going on, and fairly overtly. I saw packs of wraps, people by the sinks sniffing lines. What can you say? 'I saw Liam Gallagher doing it, again.' Liam every other day was talking to people about how much cocaine he'd done. It was a non-story.

FRAN CUTLER We used to do every Thursday night at the Met Bar and it just took off. You name it, everyone would be in there: Kate and Johnny, Noel. It was part of an organic scene. We were the trendsetters, not the magazines. It's a really important distinction. I was very strict who came to parties and always kept them quite small. I was very protective. We wanted to keep the attention away from us and provide a fantastic party for the inner circle, as we called it. The most important thing when you're putting an event together is who's talking to who and who's having an affair with who? You can't invite the wife and the mistresses. I had to know my stuff. I put people together and made things happen.

GREGOR MUIR The idea that there were places like the Groucho and the Met Bar, it was all part of a glamorous new London picture. But I'm not sure how much importance we should place on the more crazy behaviour of certain individuals. There is a tendency to overcook that in a way that it becomes sensationalist. I do remember artists working very hard as well. It is never said how isolating and difficult it is to be an artist. If you've just had a great show or you've spent four months in a studio on your own listening to LBC, you might want to go out.

IRVINE WELSH Suddenly I had all this acclaim. It's not a good thing, the whole trappings of fame and celebrity. I would be in my garret typing and be thinking, Why am I doing this, sitting

around in this boring fucking house? I'm famous, I should be going out and shagging everything in sight and taking every drug I can get my hands on. So I would do that for a couple of weeks then I would come back and think, No, I'm a serious artist. I was always struggling with that duality.

TRACEY EMIN I used to drink and party a lot. The term 'runaway train' is an understatement. The only thing that made me different from that whole scene was that I never did drugs. Everyone was taking so many Es and the proliferation of cocaine was unbelievable; people would be chopping out lines wherever you went. I don't understand how we got any work done. I asked Nicholas Serota[1] about our generation. 'How could you have had so much faith in us? Did we actually ever do any work?' He said, 'You were all up twenty-fours a day. You definitely worked sometime.'

IRVINE WELSH What I noticed about the guys who I really admired was that they would go out and have fun and party, but they went back and fucking worked in the day. Tracey never fucking stopped. I would go out to her place in Miami and she was at it all the time.

TRACEY EMIN We burnt the candle at both ends. We worked hard and we played hard. There was this vortex, this thing pushing us like a force. Everything was pumped up. There was definitely twenty-four hours in a day. It was a sexy time to be in, it really was.

MAT COLLISHAW We'd heard about Francis Bacon and Lucian Freud and all these places they used to go to, and we wanted to be part of that seedy Soho scene. We used to go to the French House and the Coach and Horses, or, if we could get in, the Groucho and the Colony Club; or very cheap, illegal dive bars, which you'd go to till six in the morning.

SADIE COLES This posse would just arrive. It was quite something, this very visible group of people, and quite intimidating for other people.

1 Director of the Tate.

NORMAN ROSENTHAL I once saw Damien [Hirst] so fucking pissed outside the Colony. I was coming back from the opera and he was literally in the gutter. I thought, If he's with us for another three days he'll be lucky.

KAREN JOHNSON The Groucho Club was set up in response to writers not being able to get into places like the Colony or Blacks. Private clubs became havens for people to party and mingle without any intrusion. Blur were very central to the Groucho; the Pet Shop Boys, Bernard Sumner and Johnny Marr would come down. It was Vic and Bob's second home.

LORENZO AGIUS Everyone gravitated toward the Groucho; crazy things went on in there. Oh my God!

DAVID KAMP The Groucho was the height of very libertine. The first thing I saw was an encapsulating moment: an inebriated and possibly substance-altered Stephen Fry at 2 a.m at the table, smugly arranging his shot with a pool cue, with men and women draping themselves on him.

KEITH ALLEN To me there was no difference between night and day there. The snooker room was the place. There were three games to be played: snooker, perudo and poker. You could barely see for cigarette smoke. My eyes used to water like fuck. Groucho's was where you could let your hair down and behave like it was your own home. I didn't give a fuck what anybody thought, but quite a slice of its membership was made up of the very people who were supposed to be employing you, i.e. producers and directors: 'Did you see the state of him last night? In and out of the toilets.'

PAT HOLLEY Keith Allen and Alex James decided they wouldn't drink for the month of January, and at the end of their abstinence they opened a bottle of champagne each at one end of the snooker table and made a line of coke down the whole length of it. Then they hit a ball slowly, snorted the cocaine and drank the champagne before it hit the cushion. Whoever lost had to pay for the whole thing.

KEITH ALLEN Nonsense. He's just making shit up. Alex might have done it with somebody else but he didn't do it with me.

DAVID BADDIEL I was quite out of it for quite long periods. I never drank very much but I took a fair amount of drugs. There's a picture of me and Frank Skinner with Liam Gallagher, and just behind him is George Martin and I have no memory of it. I remember seeing this extraordinary-looking young girl in there playing snooker. I was thinking, Who is she? She's incredibly confident. It was Lily Allen, Keith's daughter.

ALAN McGEE Every time I went to the Groucho, Damien and Alex and Keith were off their fucking nuts. It was hard to go, 'Damien: worldwide successful artist. Damien: off his tits underneath the table.'

STEVE COOGAN The whole Groucho scene made me go, 'Yuck'. When one member of Blur is delighted to be providing cheese at a summer fete to David Cameron you know that any cultural edge a movement may have had has been dead for a very long time.

PAT HOLLEY Alex James famously said he burned a million pounds a year on coke and champagne. There was a division. People who had succeeded financially moved up into the Groucho and Soho House. The rest of us stayed behind in various clubs and just disappeared.

GREGOR MUIR London was at low tide. It felt like we all wanted to float the boat. It was that sense of you could go all-night long. There was nothing to stop you. It was exciting. There was a driving force. There was an energy. Things were getting done. You would read about them in magazines or see shows or hear about them. You weren't just throwing something into nothing. It was visibly changing. You were contributing to something and you saw evidence of it on a near-daily basis as this thing was growing.

FRAN CUTLER The different worlds didn't overlap, but then suddenly we all realised, 'Oh, we're all into the same things.' It

happened organically. Everybody congregated in the same places. Everything was a natural progression. Things revolved in circles. It was like a whirlwind that incorporated and dragged more and more people in as it got bigger and bigger.

OLIVER PEYTON What people who run clubs and bars and restaurants do is create environments for people to release and enjoy themselves. You give people a moment away from their job and create this little bubble. That's very important. People need to feel secure in those environments in order for them to thrive.

TRACEY EMIN I had a birthday party at a local pub in Waterloo that held the southeast London karaoke championships. My song was Elton John and Kiki Dee's 'Don't Go Breaking My Heart', and I sang both lines. Mat [Collishaw] said it was 'the most pathetic thing he'd ever seen'. The pub used to take it really seriously, and someone suddenly said, 'Right, that's it, Trace. We've had enough. You're going to have to stop now. We've got some joker here saying he's Jarvis Cocker at the door.' I said, 'It *is* Jarvis Cocker.' The next thing was, 'Right, who's the smartarse saying he's Neil Tennant singing the Pet Shop Boys. You know the rules. You've got to put your real name down.' It was Neil Tennant. Everything was all mixed in.

DAVID KAMP There were all these places, particularly in Soho, which provided a meeting place for people from all different backgrounds to mix, out of which connections were made. It fuelled the idea that Cool Britannia was a scene and everybody was a member.

GREGOR MUIR You needed to act: you had a brief window of time to do it before that window would close; before people became more risk averse. We were coming from a place where there was a lot of cross-border dynamics and using the same spaces or chasing the same people. There was an extraordinary sense of exchange across the worlds of art and pop. It's hard to imagine that you would be in the same room as art students, musicians, fashion designers, creative people and liggers from other walks of life. It was not a

monosyllabic state. It was incredibly exciting to be in these pockets of creativity, and the combined energy of all this creative talent meeting in the same place at the same time would spur everyone to even greater heights of hedonism and excess.

LONDON SWINGS AGAIN!

Swinging London. *Newsweek.*

GQ. Vanity Fair

CARLA POWER The whole labelling and concept of 'Cool Britannia' was due to three magazine features – *Newsweek*'s 'London Rules' in November 1996, *GQ*'s 'Great British Issue' in December 1996 and *Vanity Fair*'s twenty-five page special 'London Swings Again' in March 1997. Thereafter, all the cultural activities that had been going on independently beforehand were unified, and the decade was defined by a spirited media-invented catchall phrase.

KAREN JOHNSON Cool Britannia was made up by the media to tag all the different movements. Bringing everything together under one title made it easier for them to sell the idea and sell papers, and put it in a nutshell for America readers.

STRYKER McGUIRE Britain was changing. You would read stories about culture and about certain artists, but no one had ever put it together. Hope and optimism was the zeitgeist. It was something you could just feel in the air. London was buzzing with excitement. The fashion world had gone gaga over Galliano and McQueen. You could eat as well in London as you could in Paris or New York. Matthew Bourne staged *Swan Lake* at Sadler's Wells with all-male dancers. There was Britpop. But what I was most struck by was the physical culture; I mean the streets and how the neighbourhoods were changing. Immigration was the prime mover behind what became known as Cool Britannia. It was diversity that made London a really unique place.

JOHN NEWBIGIN For all the fact that Major's government seemed to be drifting, the economy was going like a train.

STRYKER McGUIRE Major should get credit for the growth in the economy and the prosperity, and Thatcher before because she broke the shackles that had been holding it back. People were coming into the country to work in the City. It's important to remember that immigration affects all strata of society, from the people who come to do relatively menial low-paying work, like cleaning hotel rooms and things like that, all the way up into finance. I wrote: 'Eurostar had brought the continent right into the heart of the capital. Arriving in droves, young advertising creative types come to London to hone their skills and soak up its famous nightlife. Immigrants from around the world pump new skills, innovation, enthusiasm and just plain hard work into a labour-hungry, creatively starved economy.'

CARLA POWER This was very much about the cash nexus. London was roaring along after they deregulated the City. *Newsweek*'s 'London Rules' feature was very much about a vibe, and politics hadn't caught up with it yet. Our conception of the story was much more about buzz than content. Not to say that there wasn't content beneath the buzz, but what we were trying to convey was the energy. Who's not going to write about a cow in formaldehyde or a Kate Moss sculpture?

STRYKER McGUIRE We had a striking front cover of a model wearing a Philip Treacy Union Jack-styled hat and the strapline 'LONDON Rules: Inside the World's Coolest City'. Interestingly, we decided not to call it 'Cool Britannia' because there had been a movement in the sixties and we felt that this was something quite different. And it was about London. Our joke always was as soon as a big American news magazine makes a judgement about popular culture, or pronounces a place as cool, popular culture has probably already moved on; 'coolness' is something that comes and goes with the wind.

CARLA POWER The cover was different in the States. That happened a lot. It was a reflection of *Newsweek* often being myopic and the

US not being particularly interested in foreign news. Foreign news was 'American troops in Afghanistan' or something like that.

STRYKER McGUIRE The article made a huge impact. There were something like thirty-five articles written about it. And then people started talking about Cool Britannia. Conservative central office called and asked for a copy, and the following week, when John Major gave his annual speech at the Lord Mayor's Banquet, he quoted from the article: 'Our pop culture rules the airwaves. Our country has taken over the fashion catwalks of Paris. And our capital is described in an American magazine as "the coolest city on the planet".'

JOHN MAJOR Quoting *Newsweek* was a courtesy to the Lord Mayor, really, to be graceful about my city. It wasn't an attempt to make political capital out of it. Had I seen the edition of *Newsweek* or not? I can't remember. It was one of ten-thousand speeches.

CARLA POWER John Major was anything but cool. London was doing this thing despite the Conservatives. Tony Blair may have been waiting in the wings, but it was a shock that this dourly Prime Minister was overseeing an explosion of grooviness.

DAVID KAMP I remember *Newsweek* coming out while I was researching the story for the *Vanity Fair* portfolio. It's no surprise that a lot of magazines and news organisations were noticing something in Britain at the same time. Before we published, *GQ* did a Cool Britannia special called 'The Great British Issue'.

JO LEVIN I said to Angus MacKinnon, the editor at *GQ*, 'I've got an idea, let's do a huge British photographic issue. Why don't I get Terence Donovan?' That kind of sparked it off and it evolved from that. It started with music and the front cover of Jarvis Cocker. We shot Bryan Ferry, Courtney Pine, Ronnie Wood, Elvis Costello, Jazzie B, Edwyn Collins, Supergrass, Mark E. Smith, Georgie Fame, Goldie, Terry Hall, Matt Johnson, Steve Winwood, Underworld, Wilko Johnson, and Lemmy, who was hilarious. 'I'll only do it if you get me shooting tweeds from Holland & Holland, a greyhound,

a plate of cold meats and a shotgun.' I said, 'Sure, whatever you want!' And Shaun Ryder was totally out of it. Oh my God! He hadn't showered and smelt awful. I had to light Diptyque candles. He came in with his eyes closed and he was swaying, and then disappeared into the loo. He opened the door, screamed, 'I'M A-LIVE!' walked on set and Terence took the picture. He loved it. The musicians were thrilled to be photographed by Terence Donovan – he was a great sixties photographer, one of the cockney bad-boy rebels.

JARVIS COCKER It was not long before Terence Donovan died, again this thing of trying to say, 'We're bringing the sixties back. London will swing again.' But I'm sure *GQ* didn't say to me, 'This is going to be called the "Cool Britannia" issue and we'll have a Union Jack and all the lettering will be red, white and blue.' It was probably just, 'You can be on the cover.'

JO LEVIN Jarvis arrived and was filthy and had a dirty collar, so I told him off and said he should be ashamed of himself. I said, 'That's disgusting, Jarvis.' He said, 'It is, isn't it?' I said, 'You should have a good bath'. It was an extraordinary shoot. He wore a Richard James white-and-candy-striped shirt and he looked gorgeous with his little pointy shoes.

JARVIS COCKER I remember seeing a billboard of the front cover near my house in east London, and looking at it, thinking, There's nothing going on behind the eyes; there is a hollow man. There was a deadness in my eyes. I was a bloated mess. I thought, You'd better do something with yourself, otherwise you're fucked. And the fact that then it had the flag plastered all over it, I thought, What are you doing? You shouldn't be involved in this kind of thing.

JO LEVIN Jarvis was not well. Often when you're so drugged out of your head, you're not aware.

JARVIS COCKER The point for me was always that if you were going to get famous you should use that position to try to make a change. That's why when Pulp were first on *Top of the Pops* – this wasn't going to make a massive social change – I stuck that piece

of paper inside my jacket saying, 'I Hate Wet Wet Wet'. It could have led to us being banned for ever, but I felt that when you get to a position you shouldn't sell out and you shouldn't become part of the establishment. You should use that position to change things – the Michael Jackson thing, I suppose, was a big part of that – and when I saw the *GQ* cover I thought, Well, that hasn't happened. Look at you. You're part of it. That was the beginning of the end.

NICK HORNBY The problem was you didn't know how you felt about the Union Jack. And that was how everything was being promoted by the mid-nineties.

JARVIS COCKER In the accompanying article I wrote, 'I'm not really in the habit of eulogising this place we call the UK – jingoism and flag-waving make me sick.' Then I listed a few things about Britain that I'd missed or thought kindly, because I'd been out of the country for most of the past year: 'Double-decker buses; concrete bus shelters (good places to kiss on cold autumn evenings); chips; the BBC; *Top of the Pops;* pointless exercises such as trainspotting, plane-spotting; televised snooker; bitter shandy; Simpsons of Piccadilly; proper cafés; *Radio Times* trivia machines; Day Nurse; DG Old Jamaica ginger beer; Marmite; PG Tips; the fact that you still have to get to know people a bit before they'll tell you anything personal (i.e. not like in the US). Yes, if I put my mind to it, there's quite a lot about this country that I like – but you wouldn't find me admitting that in public. I mean, that just wouldn't be British, would it?' I then listed what I didn't like about Britain: 'Nowhere else in the world, for example, do you get as much abuse if people think you're wearing something "weird"; it's like it's a personal insult to them, as if you're wearing it just to spite them. This intolerance to difference is one of the sides to the British character that I find very unappealing. It also depresses me when people think they're part of some Great British heritage and they've got a God-given right to go ahead and beat people up if they can't get a pint and some chips at ten o'clock at night. It all came out

again during Euro 96, didn't it? I mean, I was excited by England's performance and I really wanted them to win, but stabbing people after the match because they've got a German accent or they're driving an Audi – it's not really on, is it? I think it's the unpleasant things about Britain that force people to create the good things. The reason that Britain has produced so much innovative music is that if you come from a crappy nowhere town (and most of the best music does) you have to create something to compensate for the lack of anything going on. Music is probably the biggest area in which we piss on the competition, but in the world of art, books and design I think we're ahead too. Pity about the food.'

DAVID KAMP Shortly after *GQ*'s 'Cool Britannia' issue *Vanity Fair* published its twenty-five page special on how London had got its groove back, called 'London Swings Again!'

AIMÉE BELL It was momentous. We featured Liam Gallagher, Patsy Kensit, Damien Hirst, Alexander McQueen, the Spice Girls, Tony Blair, Jarvis Cocker, Damon Albarn, Richard Curtis, the list just went on and on. It was a huge collaborative effort. It was a big undertaking to cover the waterfront of this moment in cultural time, figuring out who we wanted to feature, getting the mix right and getting them to say yes. It was before email and Skype. It was bike messengers and writing request letters. It was very intensive, but also a great adventure.

TOBY YOUNG Part of my job at *Vanity Fair* in New York was to suggest ideas and get them green lit. I had submitted a detailed typed memo called 'Swinging London Mark II'. I was summoned to persuade a collection of sceptical editors that there was something really happening and worth covering. Having studied moral philosophy at Oxford I was reminded that the simplest way of convincing people of your moral point of view is to assert it emphatically. 'THIS-IS-REAL. LONDON-IS-REALLY-HOT. WE-CAN'T-MISS-OUT-ON-THIS. THIS-IS-A-PHENOMENON. NO-QUESTION.' I pulled these different threads together referring to Vivienne Westwood, *Trainspotting* and the rivalry between Blur and Oasis. I brought in

the Spice Girls and the new generation of Savile Row tailors and various nightclubs and restaurants. I exaggerated the phenomenon and made a stronger case than I actually felt was justified. After some indecision, Graydon Carter[1] said, 'Fuck it. Let's do it.'

CARLA POWER Talk about the penumbra. You had all these Brits coming to the US and saying, 'London's not so dreary. It's not as button-down as it was in the eighties.' There were a lot of high-profile British editors in New York who were seen as tastemakers editing magazines. So whether it was Mike Elliott or Tina Brown or Anna Wintour, it was like the British invasion producing copy and looking back to London.

AIMÉE BELL Graydon Carter was a devotee of the British papers, so he was very aware, and had a copy of *Time* magazine from 1966 when they devoted a whole issue to London: the Swinging City. There was definitely a drum beat; things were percolating in London. There was this energy and resurgence and excitement in every area of the culture. There can be a moment when all exciting things are happening in one industry, but to have exciting things happening across all industries was wild. It really was a moment in time.

DAVID KAMP The 1966 *Time* article was a major reference point. The idea was not to recreate it, but to recognise that we were going through something very similar thirty years later, and to do a modern and a bigger version.

AIMÉE BELL Our press release read: 'These are great days for London, arguably its greatest since the mid-60s epoch of "Swinging London"; for the first time since then, the entire Western world looks to London for inspiration in music, fashion design, art, architecture, literature, restaurants, film, and television. Above all, London is once again a young city in thrall to a vibrant youth culture, one that has even permeated politics via the New Labour movement of 43-year-old Tony Blair. In words and pictures, *Vanity*

1 Editor of *Vanity Fair*.

Fair will capture the essence of London resurgent – the people who make it exciting and the creative movements that have made its cultural scene the envy of other cities.'

DAVID KAMP Aimée was instrumental in pulling together the portfolio. She made all those photo shoots happen.

AIMÉE BELL We had a suite in the Dorchester where we cleared the bed and set up an office. Isabella Blow was consultant and stylist on the portfolio, and she would come over and we'd hash out ideas. And then she would take a bath. She loved bath salts. She was always up to something. You knew if she said, 'Look at this person,' that that was someone worth looking into and they would go on to do great things.

DAVID KAMP Isabella was Alexander McQueen's muse. She was pure sunshine. She would walk in wearing some dress made of satin and ostrich feathers, and maybe a revealing bit of mesh in the middle of her body. And always some bizarre Philip Treacy hat, with a long feather pluming out of it that usually involved an opaque cloth over her face.

AIMÉE BELL The first shoot we did was Alexander McQueen and Isabella Blow. I wanted Issie to be dressed as a knight and Alexander to be dressed as Queen Victoria. David LaChapelle took it ten levels up. It was a big splash of a picture.

DAVID KAMP David LaChapelle was the hottest and most subversive fashion photographer out there. McQueen ended up dressing as a woman holding a violently flaming torch in his hand while Isabella, in a characteristically bizarre ensemble, held his train. A castle burned behind them, and an armoured horse reared menacingly over a fallen knight. It was an extraordinary image. It must have cost a fortune to stage.

AIMÉE BELL We had to have a fire truck on the scene. It's beyond measure; just the two of them at their best.

TOBY YOUNG I didn't have a great time on that shoot. There was

this very clear hierarchy: the subject at the top followed by the photographer followed by the stylists and their assistants, and the celebrity's entourage, and I was pretty close to the bottom of the food chain, which I found difficult. Celebrities assert their status by arriving late or staying too long in their trailer, and when they come out take umbrage at something very slight and then go back to their trailer for another hour and a half. McQueen behaved like that. I wanted to knock on his door and say, 'Mr McQueen, everyone's waiting. You said you'd be ready ninety minutes ago. Can we start now?' He behaved like a spoilt celebrity brat from central casting and I felt like a courtier in the court of Louis XIV. Isabella was fairly down to earth but the difficulty was that she had hitched her wagon to McQueen, so her fortunes were entirely dependent on him continuing to value her. So she just crawled all the way up his arse and wouldn't say boo to him. She was not about to go to the trailer and say, 'Get the fuck out here. You're wasting everybody's time. Stop being a cunt.'

FIONA CARTLEDGE Isabella was a maverick. She reminded me of something from the Cecil Beaton era. She would say, 'I'm finding new designers like hunting for truffles.'

TOBY YOUNG After the shoot I got a lift back to London in a Jag with the models. I was sitting in the front, and I remember thinking, I could steer this car into the path of an oncoming lorry and the obituary would say, 'Toby Young killed with three supermodels', and wouldn't my friends be envious? No. They'll just actually say, 'Three models killed with unknown journalist.' I won't do that.

DAVID KAMP As much as Toby paints himself as this derided figure of fun, he played an important, instrumental role in the portfolio. But he wasn't always the most tactful person. He wilfully played this role of irritant almost as if anticipating he was going to write a book about it someday.

TOBY YOUNG When *Vanity Fair* gave my pitch the thumbs up, I thought, Wahey! I'm going to write the cover story. Then Graydon

explained that he wanted David Kamp to write it. He didn't think that English journalists could be relied upon to report things properly. It was disappointing. David did a very well-researched job, but I think he found the slightly louche, chaotic atmosphere of Swinging London Mark II quite shocking. He's quite a repressed, typical Midwestern American.

AIMÉE BELL I would take everything Toby says with a grain of salt. The chaos was not so much at the shoots, but getting to them. Toby would have an assignment to get Damien Hirst to show up at a certain date and forget to call him. Damien was difficult to persuade. I wanted Marco Pierre White.

LORENZO AGIUS Marco Pierre White was the bad-boy chef: good looking, lots of attitude. It didn't work out because Damien insisted Alex James and Keith Allen be in his shoot.

TOBY YOUNG The official version was, 'I don't want this to be just about me. I'm not that important.' But actually it was a way of Damien asserting his importance: 'I'll only do it if you agree to these idiotic terms because I'm that big and you want me that much so you'll agree to this.' And, of course, we did.

LORENZO AGIUS Growing up, it was my dream to work for *Vanity Fair*. It was always Herb Ritts, Bruce Weber and Annie Leibovitz; the upper echelon of photographers. I met Aimée, and she was like, 'We want you to do some shoots for us.' I did my first session in the Groucho because Damien said, 'I go there all the time with Alex and Keith.'

TOBY YOUNG They arrived bleary-eyed and unshaven with a long list of demands that started with a bottle of vodka followed by four grams of cocaine, which I had to procure and pay for. It wasn't quite 'only one colour of Smarties', but it was almost on that level.

KEITH ALLEN As usual, I was twatted.

LORENZO AGIUS The three of them were like delinquents, and as the day went on it got progressively worse. They just turned into themselves and didn't give a fuck. They were playing snooker and

I'm amazed they didn't rip the table.

TOBY YOUNG They were like these egocentric monsters. Keith Allen behaved as if he had similar status to Damien Hirst and that we wanted him as much as we wanted Damien. We couldn't say to him, 'Actually, Keith, you're only here because Damien said you had to be as a condition of agreeing to do it. Frankly, I've never heard of you and neither has anyone else at *Vanity Fair*.' Instead we had to pretend he was this A-list celebrity, which added to the frustrations. At one point Damien urinated on a passer-by from an upstairs window.

LORENZO AGIUS He pissed in a pint glass and then poured it into an ice machine that was used for people's drinks, and we nearly got kicked out.

KEITH ALLEN People were using the ice not knowing what Damien had done. When the Groucho found out he was banned. Later, he received a letter from them saying, 'Dear Damien, How would you like it if one of us came round to your house and pissed in the sink. For the most part I feel everyone at the club treats you with respect; do you ever feel that we deserve the same respect in return?'

TOBY YOUNG The shoot took all fucking day. It was only meant to last a couple of hours.

LORENZO AGIUS We finished at about six o'clock. Then they said, 'Do you want to stay and hang out?' I said, 'Sure, let me buy you guys a drink.' The bar tab ended up being something like £1,600. Copious amounts of things were consumed. I was doing lines of coke with Keith Allen in the toilet the length of my finger. It was nuts. No one cared. It was like Caligula; a madness ensued. I went home at four o'clock in the morning. The shot they ran with was when they were all off it. I wanted it to be colourful and poppy, and I had to light it in such a way to make these ugly guys cute.

KEITH ALLEN Those fucking suits were very itchy but it's a great picture.

TOBY YOUNG Needless to say, Damien refused to sign the picture

consent form. And because he refused to do it James and Allen refused to sign too. No opportunity to make the underlings feel small was passed up; they were even rude to the people delivering the sandwiches.

KEITH ALLEN We made Toby Young cry because we wouldn't sign the release forms properly. He was like a little baby: 'Pleease! They won't accept that.' The only reason we didn't do it was because we all thought he was a cunt. We fucking hated him.

TOBY YOUNG Damien had brought his mother along and I thought the way to get him to sign the form was to charm her. I thought, If I can't get him to behave like a normal human being maybe his mother can? In the end he signed it, but then when I read back what he'd written, it said, 'Suck my big dick.'

AIMÉE BELL I still have it. Damien wrote, 'Suck my fucking dick and drink the spunk.'

DAVID KAMP There was a very important quote in the *Vanity Fair* piece from Elvis Costello: 'If a city makes you arrogant and cruel, then something's happening in it.' I met lots of gracious people, but also people who were outright sinister. Alan McGee was a nice person with a tincture of malevolence. I met him at the Creation offices in Primrose Hill, and while we were gabbling on Bobby Gillespie shambled in wordlessly and then shambled out again, like a cameo, almost for my benefit. Alan said, 'He does that all the time.' The office had no desk, just couches, and on the coffee table was a Subbuteo pitch. Alan said, 'It's always good to make shite football metaphors when trying to rally the troops.' He was another person who spoke freely, almost gleefully, of drug use. For him and other people their Herculean drug intake was a sign of their manliness.

TIM SOUTHWELL We were photographed in the *Vanity Fair* portfolio. That was mental. We had no idea that *Loaded* had made any kind of a ripple on the other side of the pond.

AIMÉE BELL *Loaded* was a big thing of the moment. It invented

the lads' imprint, which was a major part of the attitude that was happening. So we shot four members of their staff – Martin Deeson, James Brown, Michael Holden and Tim Southwell – 'with some girls of their dreams' – Sophie Dahl, Sophie Anderton and Annabelle Rothschild.

CARLA POWER Sophie Dahl was one of the bright young things. She was breaking old stereotypes; curvier than most models but still stunning. It was bold and wonderful to see someone not waif thin and emaciated. She broke the mould.

TOBY YOUNG The shoot was at Park Royal Studios in Harlesden. David LaChapelle had this concept to recreate a set based on the Milk Bar in *A Clockwork Orange*, but in my opinion he was a massive cock and behaved like a complete prima donna.

TIM SOUTHWELL It was mad because *Loaded* had just been on tour with Irvine Welsh – Glasgow down to Portsmouth, Nottingham, up to Newcastle – and we'd been partying hard. Then we had to be in this studio at nine o'clock on a Saturday morning. We were all absolutely bloody wasted. It took all the make-up in the world to make us look anything. LaChapelle was there with his bloody great big props and all these models and giving his assistants the run around. And then James and Martin suddenly started fighting and throwing stuff at each other and chasing each other round, knocking things over. It was fucking mental.

TOBY YOUNG James Brown thought he was fucking Tom Cruise. It was just extraordinary: turned up late, made a great song and dance about not wanting to do this pose and that pose, and then got into a fight and punched Deeson in the face. It was something to behold. The whole shoot was fuelled by booze and drugs. At one point, Brown requested some cocaine, and when I suggested going to the loo he said, 'Don't be daft, just rack 'em up here,' and handed me a rolled-up £5 note.

TIM SOUTHWELL It was outrageous that *Loaded* would be represented by four berks like us; the very idea that the country would

be celebrated in such a way was crazy.

AIMÉE BELL That was our zaniest picture. The homage to *A Clockwork Orange* and the giant baked beans can in the background. It was a 100 per cent David LaChapelle: surrealist, big energy, next-level stuff. His involvement made a big difference. He was incredibly imaginative. Isabella Blow styled the shoot and it was her idea to have Iris Palmer, Honor Fraser, Jodie Kidd and Jasmine Guinness in the portfolio as 'The Blueblood Beauties'. All four models born to aristocratic families. We added the by-line, 'If this was a British men's glossy, we'd be obliged to say, "Cor, if this is the product of interbreeding, then let cousins shag each other in perpetuity! Blimey!"'

LORENZO AGIUS The phone calls kept coming from *Vanity Fair*. They wanted to shoot Stella McCartney and Jade Jagger for the portfolio, but Stella didn't like Jade so it didn't happen.

DAVID BADDIEL Me, Frank and Ruud Gullit were going to be 'The Footballers'.

DAVID KAMP David Baddiel was happy to do the interview, but Frank Skinner's publicist basically said, 'Frank thinks it would soil his image to participate in your vulgar glossy American exercise glorifying what's going on here.' My big idea was to try to get Paul McCartney, Paul Weller and Noel Gallagher together because they represented three generations of great British songcraft, and they all looked vaguely similar too, with dark hair and expressive eyebrows.

TOBY YOUNG We got Weller and McCartney, but Noel wasn't willing to engage.

JOHNNY HOPKINS Aimée approached me to have the whole band. I said, 'No fucking way.' I could see where it was going. Cool Britannia was a dead duck. I was trying to define Oasis in their space and in opposition to everything else that was going on.

NOEL GALLAGHER We didn't want to get involved in a 'London Swings Again!' thing. We were bigger than all that. 'They're not

using us to sell their fucking magazine.'

LORENZO AGIUS Noel said, 'It's a sell-out.' So instead *Vanity Fair* said, 'We want Liam Gallagher and Patsy Kensit to be on the cover.'

DAVID KAMP There was some skulduggery going on and it had to be done in secret because it did not have the blessing of Noel or Creation.

KATIE GRAND I was in love with Patsy Kensit. That's who I wanted to grow up and be. I'd seen *Absolute Beginners* seven times. I was this huge fan. The first time I did a shoot with her was for *Dazed* and I was star struck. This was before she got together with Liam. We drank tequila champagne slammers all day and got drunk listening to Oasis with her going, 'I'm going to marry him,' which later she did. Of course, the film came back and Patsy looked wrecked. Rankin went mental: 'I can't believe you fucked up my shoot.'

JOHNNY HOPKINS Patsy was rebuilding her career and she had the opportunity to be on the front cover of *Vanity Fair*. She wasn't going to turn that down. Star goes to photo shoot, takes partner. It just happened to be Liam Gallagher.

AIMÉE BELL The shoot had to be postponed by a day because Liam got arrested after misbehaving at the Q Awards when they won Best Act in the World Today. There was some big drama and it was in all the papers.

DAVID KAMP The Q Awards was in the ballroom of the Park Lane Hotel. Shaun Ryder, Elvis Costello, Mick Jagger, Rod Stewart, George Martin, Peter Blake were all there. I introduced myself to Liam and Patsy, and said, 'So, you're doing the photo shoot tomorrow.' Liam immediately went, 'Shhh! It's a secret. Noel's not meant to know about it.' Later, Noel went on stage to receive their award, and said, unsmilingly, 'Best act today. Tomorrow. The day after that. And the day after that. And the day after that.' Liam added, affably, 'I'd like to say thank you very much. I was about to smash the gaff up anyway if you didn't do it.'

KAREN JOHNSON That was when Graham [Coxon] got hideously

drunk. Danny Baker had just done the 'Daz Doorstep Challenge' adverts, when he knocked on people's doors, and Graham jumped on his back shouting, 'DAZ!' Danny was not happy.

PHILL SAVIDGE Tony Blair was walking around with his jacket over his shoulder. He reminded me of an estate agent, but I was impressed enough to take a Polaroid.

STEVE LAMACQ I tried to get a quote from Tony Blair, and Alastair Campbell put us in a holding pattern. Blair seemed quite well versed in being able to answer questions about music. My pay-off line was, 'If you ever put the band back together you're quite welcome to come and do a session for us.' He liked that. He was obviously there because he was the cool figurehead for a party that a lot of people who were into alternative music identified with.

ALASTAIR CAMPBELL I always advised Tony not to go to these awards because I was worried that the public would end up thinking, This guy's just a celeb. And I was aware of Red Wedge and what Neil Kinnock had tried to do from when I was on the *Mirror*. But it was clearly a success. Tony made an important speech about the creative industries.

TONY BLAIR I said, 'I just want to say two things to you here. First of all, rock 'n' roll is not just an important part of our culture, it's an important part of our way of life. It's an important industry, it's an important employer of people, it's immensely important to the future of the country. In parliament, you can have debates about all sorts of industries and people will think it's entirely normal. If you had a debate about the music industry, they'd think it rather strange, but that actually shows how far parliament is behind the times [. . .] The great guitar bands I used to listen to – the Stones, the Beatles and the Kinks – their records are going to live forever. And the records of today's bands, the records of U2 or the Smiths, and Morrissey, will also live on because they're part of a vibrant culture. I think we should be proud in Britain of our record industry and proud that people still think that this is the place to make it.'

DAVID KAMP After the ceremony Liam went out on a bender, smashed up the snooker room of the Groucho Club and then got arrested on Oxford Street on suspicion of possessing drugs by a policeman who mistook him for a tramp.

JOHNNY HOPKINS There was a scuffle with some photographers and the police were called. Oasis was seen as a honey pot. The paparazzi would wind Liam up and get in his face, and if they didn't manage to get a photograph they'd get a slap. It was a win-win situation for them.

LORENZO AGIUS I got a call: 'The shoot's off. Liam's been busted for cocaine. He's in a cell.' Stupid dude. Why would you have it on you? You've got a bouncer; let him carry the drugs. Fortunately, he got let off with a caution and the shoot went ahead. First we went to the Hempel Hotel. Patsy was naked in the bath and Liam was sitting on the edge having a fag. It was the idea of Beauty and the Beast: Patsy gorgeous; Liam thuggish. Then I shot them in the studio. I wanted to make it really sixties and I got someone to make a Union Jack duvet. It was amazing. I had a big scaffolding tower built over the mattress. I was shooting down, and I said, 'I want you to look like you've just had sex.' At lunchtime, Liam was like, 'What the fuck's this?' Patsy said, 'Liam, it's called quiche. Have some, it's really nice. It's French.' 'It's fuckin' horrible.'

JOHNNY HOPKINS We heard about the shoot before it was published but not in time to shut it down. I said to *Vanity Fair*, 'What the fuck are you playing at? You've gone behind our backs.' It linked Liam, and by default Oasis, to Cool Britannia.

NOEL GALLAGHER Liam's missus fucking got him in a headlock. She was like, 'I'm going to be on the cover, but they'll only put me on the cover if you're on it.' Liam's a weak man so he went along with it.

JOHNNY HOPKINS Liam said, 'I just went down to show support for Patsy.' I don't think he intended to have his photo taken otherwise why have a fucking beanie hat on? Noel said, 'Liam looked like an absolute fucking idiot with a nipple on his head looking like

a fucking baby's bottle with his fucking missus in a Union Jack bed, topless. Ooh. Rubbish.'

DAVID KAMP This was the most vibrant cultural and political moment in Britain's history since the sixties. But it's emblematic that the iconic image of Liam and Patsy on the cover of *Vanity Fair* that everybody thinks of as a demarcation of Cool Britannia was not the cover in the US; that edition had Julia Louis-Dreyfus with the headline 'That *Seinfeld* Girl'.

TOBY YOUNG They thought the Union Jack would put people off. In New York the world ends outside Manhattan. It was disappointing.

AIMÉE BELL The cover with Liam and Patsy was completely iconic.

LORENZO AGIUS Graydon said, 'I want "LONDON SWINGS AGAIN!" in letters stuck on the cover like *Never Mind the Bollocks*.'

KEITH ALLEN 'London Swings Again!' Really, does it? You mean all those fucking traders putting bags of charlie up their fucking nostrils. I never bought into any of it.

KAREN JOHNSON I didn't have anything to do with Damon's involvement. From my point of view I didn't want Blur on the inside of *Vanity Fair* with Oasis on the cover.

AIMÉE BELL We wanted Damon with Jarvis and Justine Frischmann, but she wasn't around.

DAVID KAMP Damon was the one person I interviewed who sensed that it was all about to go wrong. He talked about the embrace of Englishness, despite coming from a good impulse, had gone too far and 'was tipping into an ugly nationalism'. Steve Coogan felt the same way, too. There was a sigh when I asked Damon about Tony Blair; an expression that he just wanted to keep the whole Cool Britannia thing at arm's length. We got him to pose with Phil Daniels for the portfolio. It was almost his farewell to the era. He recognised that something was cresting. Maybe it was the cold realisation that comes with heroin addiction; something's got to

change or else it will die.

DAMON ALBARN I didn't think about being photographed in *Vanity Fair* in terms of Cool Britannia or the Union Jack or the defining of London Swings Again. Somebody just said, 'You've got to do a photo session.' It was like, 'Great! I don't mind hanging out with Phil; he's a good laugh.'

TOBY YOUNG We had a big debate whether to involve the Spice Girls.

AIMÉE BELL The Spice Girls hadn't broken in the States at the time of the shoot[2] and we needed some more interesting women. They were photographed at the Eve Club on Regent Street. We described them as the 'out-of-nowhere, all-singing, all-dancing, all Tory-supporting teenybopper pop sensation of 1996. Victoria is the posh one; Geri, the fiery redhead; Emma, the bubbly innocent; Mel B, the loudmouth; Mel C, the athletic one. Prince William's favourite? Emma, a poster of whom adorns his wall at Eton'. By publication 'Wannabe' was a Billboard number one.

TOBY YOUNG They were at least two hours late and I remember saying to one of their entourage, 'Any idea when they're going to arrive?' He said, 'Mate, there's time and then there's Spice Time.'

DAVID KAMP I wrote in the portfolio, 'The Spice Girls, a quintet of latter-day dolly birds whose music is a forgettable mix of anodyne lite-funk and MOR balladry, have become pop sensations by projecting an image that is at once sexy and laddish, talking about "shagging" and football while wearing virtually no clothing.' The Spice Girls were like a Rupert Murdoch fascistic creation; like something that had been cynically cooked up in a laboratory.

SHERYL GARRATT I wrote about the Spice Girls for *Big Issue* and said, 'Almost every minute of every day is mapped out. This afternoon, they've got their kits *on* for the cover of the football magazine *90 Minutes*. Then they rush to another studio to do the photographs

2 3 December 1996.

and interview you see here. Straight after, they change clothes again to pose for *Vanity Fair's* upcoming swinging London issue, a session which starts at the ultra-kitsch Eve Club (where Christine Keeler once partied) and ends with them hanging off Eros in the middle of Piccadilly Circus at 9 p.m.' The Spice Girls was shameless pop. A really good mix of personalities: north, south, black, white, blonde, dark. They even tried to mix class by making Victoria posh. They just looked like they were having a whale of a time.

MELANIE CHISHOLM Although *Vanity Fair* was part of something, we were on our own journey and felt very separate. We were just on the rise. It was survival mode at this point: exhausted, working like dogs.

DAVID KAMP My very last interview for *Vanity Fair* was with Alexander McQueen. By then I was run ragged and I'd come down with a dizzying flu. The only reason I made it to his studio was that I was personally shuttled in a limousine by Isabella Blow, who had arranged the meeting. I couldn't sit up, so I lay in her lap and she was stroking my head: 'Oh, poor David, poor, poor David.' We arrived at an unmarked graffiti-covered building, and some *Clockwork Orange*-styled droog let me in. I lurched in and my first question was, 'Alexander, do you ever worry that the hype to which you've been subjected could hurt you; that they'll build you up today only to dismantle you tomorrow?' He adopted a super-cilious, Gielgudian tone, and said, 'That's very pessimistic of you! I've been working nonstop since I was sixteen and I'm twenty-seven now. I'm not an overnight success.' I said, 'You're obviously not from a wealthy background, so I wanted to know . . .' McQueen erupted. 'What d'you mean, *obviously*? What a snobby thing to say!' He stood up and demanded to know what kind of writer I was. I said, 'Look, I'm no Amy Spindler . . .' He said, 'I love Amy Spindler!' So I said, 'Come on, enough of this. I'm fucking ill.' He said, 'I am too,' and broke character. We talked about influences. He said, 'I'm influenced by anything. I saw a tramp with a string tied round his coat. I did the silhouette of his coat, but with a

Mongolian-fur collar and cuffs, and a belt where the string was. I wasn't laughing at him. Who should be laughing? My coat cost £1,200, his cost him nothing.' I told him about John Major's speech at the Guildhall, where he'd said, 'Our country has taken over the fashion catwalks of Paris.' McQueen said, 'Did he say that? Fucking plank! I'm not one of his own! He didn't get me there, the fucker! Fuck him! So fucking typical of government! They do nothing to help you when you're trying to do something, then take credit when you're a success! Fuck off!'

TOBY YOUNG Cool Britannia happened in spite of John Major.

GEOFF MULGAN Interestingly, the phrase 'Cool Britannia' was first used by Virginia Bottomley in the dying days of the Major government.

CHRIS SMITH Over a four-month period, Virginia Bottomley issued five press releases lauding the approach of what they called 'Cool Britannia'. At various times describing London as 'the coolest city on the planet'; that 'Cool Britannia rules the way', that 'we must ensure that more overseas and British tourists make "Cool Britannia" their first choice', and that 'Cool Britannia is now an internationally recognised phenomenon'. I used to carry them around with me for whenever anyone said, 'This was all about New Labour.'

VIRGINIA BOTTOMLEY I used the phrase Cool Britannia to say, 'London was universally recognised as a centre of style and innovation. I took great pride in our history, architecture and cultural traditions, and wanted to convey the message that we were creating a country that was innovative in film, tourism, hospitality and food. Cool Britannia was Britain not just being about our proud heritage, but being a very dynamic, exciting place to be as well.

JOHN MAJOR Virginia may have taken to Cool Britannia as a concept, but the party as a whole quite deliberately didn't take ownership of or credit for Cool Britannia. But New Labour did attempt to do that and make it part of their 'brand'.

ALASTAIR CAMPBELL *Vanity Fair* came out before we were elected, so how did it come to be that people thought we were the Cool Britannia?

TONY BLAIR It was very unusual that I should be defined as part of Cool Britannia in *Vanity Fair* as the leader of the opposition, but it seemed natural at the time. It was one of these things where it felt that it was more attuned to us than the Conservatives. We were offering something new, not just in terms of policy or politics, but socially and culturally. There was a sense that we were both moving with the times and helping push the times to move in areas like gay rights, women's equality, racial equality. Suddenly the country seemed more egalitarian in its outlook.

TOBY YOUNG There was a big debate whether celebrating Cool Britannia would benefit or harm the Labour Party. I was arguing that Blair could ride the coat tails of Cool Britannia into Downing Street; that by linking himself to this phenomenon he could actually enhance his brand and it wouldn't be a way of indirectly complimenting John Major.

STRYKER McGUIRE New Labour were worried that this sense of optimism would actually benefit the Conservatives because the economy was growing. And yet the Tories were quite divided and had several scandals and the usual European stuff going on. Labour, on the other hand, were very European. I remember a story about Tony Blair spending a holiday in Córdoba in Andalucía and being taught flamenco guitar by Paco Peña. He was international.

TONY BLAIR I felt that it was highly unlikely that the euphoria, the feel-good factor, would benefit John Major. The whole aura around Cool Britannia was one of change, and so I never thought it was probable the Conservatives could, as it were, take this mantle. It was just too inconsistent with the rest of the clothing.

PETER HYMAN You forget about all the scandals. When you get accident-prone it sort of rolls on and on. The amount of affairs that were

happening, people caught in extraordinary compromising positions and this and that. It was daily decaying under a very weak leader.

DAVID KAMP It was really great *Vanity Fair* got Blair. It was crucial to add gravitas to the article, but the irony was he said nothing of substance. The most he said was, 'I think it would be very arrogant to assume that we've created this sense of excitement about change, but I think the idea of a new and revitalized Labour Party saying, "Britain can be better – we can do things and we can be more confident about our own future." I think these things interact with what's happening in culture and arts and what's happening not just in London but in other cities. If you look in Glasgow, Manchester, Newcastle, similar things are happening.' I then asked him, 'Will rock stars be welcome at Downing Street?' He said, 'Well, I think we'll wait until we get there before deciding that! But look, I'm a product of my generation. I'm delighted at the success of British pop music. And fashion and design are tremendously important. We're providing really high-quality goods and ideas the world wants to buy. So I suppose, in that sense, yes, I am more immersed in it.'

AIMÉE BELL When the portfolio was published our caption read: 'Lead over the current Prime Minister, John Major, in the polls: 21 points.' Michael Roberts had about two seconds to do the picture at the House of Commons. It was super quick.

JOHNNY HOPKINS In the 'Vanities' section they had a feature called 'London Calling: 60s London vs 90s London'. It was things like 'Mick Jagger and Marianne Faithfull = Liam Gallagher and Patsy Kensit, Twiggy = Kate Moss, David Hockney = Damien Hirst, Peter Sellers = Steve Coogan, Andrew Loog Oldman = Alan McGee, Merseybeat = Britpop, LSD = E, *Oz* = *Loaded*, *Ready Steady Go!* = *TFI Friday*'.

DAVID KAMP The mitigating factor was acknowledging the sixties but giving it a new spin. I wrote, 'There's more than a little self-conscious similarity between the sixties and nineties because Britons in their twenties and thirties had studied their forebears well. You pick up hints of it everywhere – in the smart, slim cut of the mod

suits; in the renewed vogue for Vespa scooters; in the continued excitement over the Beatles *Anthology* series; in the inexplicable presence in a Covent Garden hardware store window display of a still of Julie Christie and Dirk Bogarde in *Darling*, John Schlesinger's landmark Swinging London film; and most conspicuously in the music that became known as Britpop.'

ALAN EDWARDS The parallels were uncanny. It was like a mini-renaissance: Harold Wilson, this sort of cool Prime Minister who liked football and hung out with the Beatles; George Best, who was a pop star as much as a footballer. The nineties absolutely drew influence from then and brought it forward, and it all threaded together in a cultural explosion.

DAVID KAMP Terence Conran said to me, 'What you must understand is that Swinging London was an absolute microcosm compared to what is going on now. Back then it was just a few shops and clubs to latch onto.'

CARLA POWER One of the central images I have was meeting Sam Taylor-Wood. She came down the street with a cell phone and orange mohair coat, swinging her handbag, and she was all rushed and it refracted in my brain with Julie Christie swinging her handbag in the sixties film *Billy Liar*. It was as though she came in her own force field.

DAVID KAMP I had immersed myself in all this stuff and watched Pathé News footage of Swinging London, so I had the idea to present the beginning of the *Vanity Fair* portfolio as this panoramic vision: 'Flicker . . . whirrr . . . move it along, Granddad, you're getting in the way of The Scene! The London Scene, that is! From Soho to Notting Hill, from Camberwell to Camden Town, the capital city of Dear Old Blighty pulses anew with the good vibrations of an epic-scale youth quake!' Then I name-checked Oasis at the Q Awards, the bohemian cafés of Notting Hill and *Four Weddings and a Funeral*, Stella McCartney, 'whose fitted frock coats and smart suits betray an intimate knowledge of the time-honoured techniques of

London's venerable Savile Row', the newly refurbished restaurant Quo Vadis with Damien Hirst's installed paintings and sculpture, the Heavenly Social in Clerkenwell, and finally a short-sleeved, smiling Tony Blair, who is quoted as saying, 'The hope that change will bring is outweighing the fear of change.' The introduction concluded, 'Change is in the air in London, and the kids, as their idol Liam is wont to say, are mad for it! [Brass fanfare, end credits.]'

CHAMPAGNE SUPERNOVA

Oasis at Knebworth.

Labour youth conference

STEVE LAMACQ The main thing about Britpop as it gets bigger is that bands, from playing to five-hundred people, are suddenly headlining Brixton Academy. The audience is not just the people who have grown up with the band and bought the records; it's the guy at work who's going with his missus, and his workmate says, 'I fancy going up West. I've heard two songs by them.' And then his other half, says, 'Well, if you're all going . . .' Then they're in the pub, saying, 'We've got tickets to see . . .' and so their friends say, 'We'll come too.' All of a sudden, the one guy who's into the band has got five people coming with him: two who have seen the band on *TFI*, and two who have heard them on Radio 1.

POLLY RAVENSCROFT Live music had really changed. On one hand you had Status Quo protesting outside Broadcasting House saying they'd been banned from the Radio 1 playlist, and then we had this massive event of Oasis at Knebworth, which we broadcast, live. It was so exciting.

NOEL GALLAGHER For people looking back on Knebworth they want to believe that you sat round, going, 'Right. We're going to define this era.' It wasn't like that at all. We were that big, where were we going to play? Two-hundred nights at fucking Wembley Arena? Forty nights at Wembley Stadium? Can't get the availability.' I guarantee nobody said to me, 'These are going to be the

biggest gigs of all time.' It was just, 'This is what we'll do. We just do two fucking big gigs at Knebworth.' 'Great, let's get it done.' It was just a thing.

JOHNNY HOPKINS Knebworth was a quarter-of-a-million people over the course of two days. They could have done a week of gigs and still not satisfied demand. A fifth of the population applied for tickets. It's hard to comprehend that level of achievement.

NOEL GALLAGHER My whole attitude to all of those things – it was the same when we did the first ever arena – 'If you're daft enough to put it on, I'm stupid enough to fucking play it.' I remember going in a car on the way to Southampton and we stopped at Knebworth. We drove into this field, I got out and I said, 'Where's the gig going to be?' They were going, 'You're in it.' I was like, 'This big fucking field of nothing?' They were like, 'We put the stage down there and the crowd will be here.' I was like, 'What? That fucking big!'

ALAN McGEE Every time we hit one of these places, I thought, It can't get any bigger. And then they just kept getting bigger. No one was plotting it. People were just going, 'You can do this.' The only surprise was when it sold out.

NOEL GALLAGHER You knew it was a big thing because every TV station in the world wanted to broadcast it. The bill was a who's who of Britpop, bar Blur and Pulp.

ALAN McGEE They had the Prodigy, Cast, Charlatans, Kula Shaker, the Manic Street Preachers, Ocean Colour Scene. They even had the bloody Bootleg Beatles.

SIMON FOWLER I was terrified. I remember standing on the side of the stage wondering whether I could actually do it. Our manager had an old-fashioned cine camera. I grabbed it and said, 'How do you use this?' He said, 'You just press that button there.' So I walked up to the front of the crowd and filmed them and they went mental. That was it for me. I thought, Brilliant. We were the second-biggest band in Britain at the time. We'd been at number

two for six months and were selling more records than Blur. Jamie Theakston[1] asked me, 'Will you be nervous stepping out in front of 125,000 people?' I said, 'It's all right, there's four of us.'

JO WHILEY Knebworth was madly exciting. The scale of it was ridiculous. It was so far from putting 'Columbia' on the turntable on *The Evening Session* and hearing Oasis for the first time, to watching them on this massive stage and everybody wanting a piece of them. I can't imagine what that does to your head; all the pressure and insanity that was going round.

SHERYL GARRATT What we thought was going to be the coming together at Spike Island turned out to be Oasis at Knebworth.

SIMON FOWLER The Stone Roses at Spike Island had been key to my band forming, but in all truth they were bloody awful that day – you could see people looking at one another, thinking, Is it just me? It wasn't the big event it should have been. Knebworth was like the fulfilment of the Roses promise. Oasis even got John Squire up on stage, like a symbolic recognition of a baton being passed between generations.

NOEL GALLAGHER It's only afterwards that I started saying in interviews that John Squire was a connection to Spike Island. We were hanging round with him, and 'Champagne Supernova' had that guitar solo on that none of us could play. Weller played it on the record but he wouldn't have anything to do with it, so I asked John, and Weller was a little bit jealous. It was a passing of the torch, maybe, but if I'd been hanging out with Johnny Marr at the time I would have asked him. We just did what we fucking did and the whole thing took place around us. People like to look back and think that it was all calculated, 'You must have done this because you did that.' You sit there shrugging your shoulders.

POLLY RAVENSCROFT We got there early and, seeing Meg [Matthews] and Noel riding around on their moped, who wouldn't want a job

1 Presented *The O-Zone* with Jayne Middlemiss on BBC2.

like that? You're in your twenties, single, no kids. The atmosphere was amazing.

ALAN McGEE We hired this ridiculous tent and the security was fucking insane. You needed three passes to go back and see Noel and Liam. It was fucking nuts.

DARREN KALYNUK I managed to get in the Creation tent and I remember seeing Darren Day being shouted at by Anna Friel from *Brookside* and almost all of Chelsea football club.

FRAN CUTLER Meg and I organised the tent. It's a big blur but it was great fun. Chrissie Hynde was there. Kate Moss. There were such a lot of people. It was just fucking greatness.

JOHNNY HOPKINS There were thousands of people on the guest list. Football stars, film stars, TV stars, Naomi Campbell, Helena Christensen. It was mental: people arriving in helicopters; hordes of people all descending on one relatively small space down country roads. It was the defining moment of the decade, of Oasis, of Britpop.

KATIE GRAND I went in a camper van with Patsy Kensit and a load of other people. Patsy was in a ghost dress and a big straw boater. I dressed her for both days and she paid me with tickets. It was this huge, huge thing. It was one of those surreal days.

SIMON FOWLER That was when I met John Lennon and he asked for my autograph. His real name was Neil from the Bootleg Beatles and he actually looked like John. Evan Dando[2] tapped me on the shoulder, I turned round and he said, 'I thought you were Liam. You've got the same haircut as him.' I said, 'I've had this haircut a lot longer than Liam, you know.' We got chatting and he asked me whether I thought you could still get high off the bodies buried on Blackheath from the plague. I thought, You wanker.

2 Lead singer of the Lemonheads. In 1993 the band had a top-twenty hit with a cover version of Simon & Garfunkel's 'Mrs. Robinson', released to celebrate the twenty-fifth anniversary release of *The Graduate*.

NOEL GALLAGHER The first night we stayed in a caravan behind the stage. I went up to Knebworth House the next day for a wash. I was in the bath and there was a knock on the door, and a butler came in with a tray. He put it down beside the bath and said, 'Awfully sorry to disturb you, sir, but here's your champagne.' I was like, 'So this is how they live . . . thanks very much.' After, I was told it wasn't a butler; it was the owner.

FRAN CUTLER The one thing that stands out was they threatened to turn off the generators because we were all singing and dancing and they couldn't get us off the site. This was backstage, *backstage*. Nobody wanted to leave.

IRVINE WELSH It was a bunch of us partying and fucked up. Knebworth was an end of the line. It had that feel to it, 'This is an apex of this era.'

RIC BLAXILL It was mind-blowingly incredible. It was the unification – even though it was a big crowd. The sense of community and celebration was amazing, and how people connected to Oasis through their attitude and the power; the strength and the quality of Noel's songs. The attitude that came snarling off the stage was amazing; the giant footballs they booted into the crowd as they came out. It was a wonderful moment in time. It was only three years since they'd played at King Tut's to a handful of people. Their rise was incredible. That's when you go, 'Will this ever happen again?'

ALAN McGEE It wasn't even a great gig. I remember it because I was sober. It was good, but it wasn't amazing. They were probably hammered with drink and drugs.

NOEL GALLAGHER We hammed it up a little bit. We were fucking pissed all the time or hungover or both or on the racket or stoned.

MATTHEW WRIGHT There was nothing cool about playing a fucking mega-festival like that. That sort of bloated Led Zeppelin seventies excess: it had been done. I wrote Knebworth was 'flat as

stale champagne'. Noel phoned me up and said, 'That's the last time you have anything to do with my fucking band . . . we've been good to you.' I felt fucking awful. I genuinely liked Noel. But I still stand by every word of it. I was bored out of my mind. It was a really dull stage show. They didn't move around. Maybe they were too cool for school; a front man that just stands at the microphone, hands behind his back. They played the songs well enough and everyone has a big singsong, then you go and pay £5.80 for a burger and have a nightmare going home. Too big. No longer cool.

JOHNNY HOPKINS There were much better Oasis gigs, but it was a huge cultural moment. It was that social cohesion that the politicians were so keen to tap in to.

JARVIS COCKER I was in a funny paddock in front of the stage. I think I enjoyed the gig. When they did the film *Supersonic* it was a smart idea to use Knebworth as a cut-off point.[3] It was an undeniable fact that this now was a phenomenon. It wasn't just a sideshow. They did that. Nobody else did it to that extent.

SIMON FOWLER It was Oasis's triumph. And then Robbie Williams trumped it and did three nights in 2003, 'the biggest event in music history'. I bet he did that because Oasis did two.

DARREN KALYNUK Knebworth was an extraordinary experience. I met Alan McGee there and we had a chat. I said, 'Seeing as Noel has said various things about Tony Blair would you be open to having a chat?' He said, 'Yeah, absolutely.'

ALAN McGEE I was sitting in the fucking VIP, and Darren said something like, 'Have you ever thought about joining the Labour Party?' I went, 'I am a member of the Labour Party. You haven't sent me your fucking membership card.'

DARREN KALYNUK I had a meeting at party HQ with Margaret McDonagh, and by coincidence she said, 'We'd like to contact

3 Documentary about the rise of Oasis, released in 2016.

Oasis and get them involved in something.' I said, 'I just met Alan McGee! Do you want to meet with him?' She said, 'Absolutely.'

MARGARET McDONAGH I'd seen an advert Alan had taken out in the *NME*, and I thought, My gosh! That guy, he's someone of opinions. He's really got a view of the world.

ALAN McGEE The reformed Sex Pistols were getting shit reviews. I saw them at Shepherd's Bush with Noel. I said to Andy Saunders,[4] 'Tell the *NME* I want to review them.' *NME* said, 'Tell him take an advert.' I went, 'I fucking will,' and bought the back page. It cost me five grand. Then I got a phone call: 'Margaret McDonagh, the General Secretary of the Labour Party for Alan McGee.' She said, 'Are you the Alan McGee that's a member of the Labour Party?' I went, 'Yeah, you cashed my £15 cheque and haven't sent me my membership card.' She went, 'It'll be around in half an hour.'

MARGARET McDONAGH My first impression of Alan? I thought he was amazing. He didn't do things because they were effected or 'this is what people want to hear'. He had a view of the world. He was a leader rather than a follower and saw music as a way of expressing what was going on and lifting people, and understood what it was like to be working class and for people to better their lives; understanding how going to see a band on a Saturday night could transport you, whether in the specific moment, or for your life in general. He represented some of the things we were trying to do.

ALAN McGEE About half-an-hour later she came round with two guys and my form. She filled it all in, and then goes, 'Will you get involved?' I went, 'Yeah.' She went, 'Can we get Noel to come on at the Labour Party annual youth conference on Saturday night and do a couple of songs?' I phoned Noel and said, 'Are you into it?' He went, 'Alan, I'm fucked.' I went, 'Blair's coming.' He went, 'Give him a disc.' I went, 'Right, okay, I'll give it to him.'

4 Joined Creation as assistant press officer in 1992.

MARGARET McDONAGH Alan got 18 Wheeler instead, and Tony introduced them as 'Wheeler 18'. And then Alan presented Tony with a framed platinum disc of *(What's the Story) Morning Glory?* This was at the Norbreck Castle Hotel in Blackpool, at the same time as the national conference. There were more than two-thousand young people there. It was big.

ALAN McGEE I went up, dressed immaculately in a Paul Smith suit. Steve Coogan was there, Waheed Alli and all the *Loaded* guys queuing up for the toilets. Peter Mandelson was dancing really flamboyantly. I was thinking, Who the fuck is this guy? Then it was like, 'Five minutes to Tony . . . three minutes to Tony . . . Tony's on site . . . Tony's in the building.' We had a brief chat then we went on stage and I gave him the disc. Tony did a short speech, and said, 'Creation is a great company. We should be really proud of it. Alan's just been telling me he started twelve years ago with a £1,000 bank loan and now it's got a £34 million turnover. Now *that's* New Labour.' He was like the indie version of Bill Clinton. I was thinking, I've got the most successful band in the world and I'm now fucking hanging out with the guy who's going to be the next Prime Minister. This is fucking strange. It was fucking ridiculous, the nineties, on that level. The headline was 'What's the Story? Don't Vote Tory'.

MARGARET McDONAGH There was a week of fringe events. On the Saturday we had Alan Partridge interviewing Tony. Armando Iannucci wrote a ten-minute sketch.

TONY BLAIR Armando wrote it? That's amazing! I forgot that. I don't think Steve [Coogan] was that well-known at the time, but I remember thinking it was a very novel form of humour, those types of characters that play on the ordinary person.

STEVE COOGAN I'd done *The Day Today* and *Knowing Me, Knowing You*, so at that point Alan Partridge was cool and a bit cult and not at his height yet. The Labour Party wanted to do something unorthodox but there was a bit of anxiety about it. They said,

'These are the kind of things we want to get across, but you come up with the questions.'

ALAN BARNARD Steve turned up as Alan Partridge. It wasn't until some time after that he allowed Steve Coogan to come back out.

STEVE COOGAN Armando and I missed the flight so I had to get made-up as Alan in the toilets at Heathrow and board the flight in character; no one batted an eyelid. When we arrived, Alastair Campbell said, 'Steve and Tony, twenty minutes in the corner together.' Tony was a bit anxious that I was going to make fun of him, and I made it quite clear that Alan Partridge was a Conservative and that any of the jokes would reflect on Alan's prejudices and wouldn't be mocking him. I said, 'Would you say this to answer this question, and so on, as a set-up for Alan's punchlines?' Tony went, 'Yeah, I can do that.' Then Alastair and Peter Mandelson walked over and stood over me and Tony with their arms folded listening to everything being said. That was a bit heavy.

MARGARET McDONAGH We had built an Alan Partridge-style TV set with two chairs on a low-lit stage.

STEVE COOGAN There was a moment when I was on my own with Alastair and he started to brief me. What would I say if the press asked how much was spontaneous and how much was invented? I said, 'I would say, "All Tony's stuff was spontaneous and all my stuff was written."' He said, 'Good.' Then he said, 'And were you surprised at how spontaneous Tony was?' I said, 'I was very surprised. He was very, very funny.' Alastair was asking me in the past tense before it had happened.

ALASTAIR CAMPBELL Steve and I have always been ahead of our time!

MARGARET McDONAGH It was hilarious: Tony coming on in real life and being interviewed by a fictional TV character.

DARREN KALYNUK I was sitting next to Mo Mowlam. It was the funniest thing. The opening was, 'Knowing me Alan Partridge,

knowing you Tony Blair, a-ha.' And Tony went, 'A-ha.' It gives you a sense of the symbiosis that it didn't seem odd for one of the most popular TV characters to be interviewing the Prime Minister in-waiting at a party conference.

TONY BLAIR It was just really funny. Thatcher had been on *Yes, Prime Minister* in the eighties and Harold Wilson on *The Morecambe & Wise Show* in the late-seventies, so it was not completely unknown.

STEVE COOGAN Tony was very relaxed and in the groove. Then, for the Q&A, they had placed people in the audience to ask the right questions. Just before we'd gone on, Tony turned to Mandelson and said, 'Jacket on or off?' Mandelson said, 'Keep it on, but when you walk in front of the crowd take it off and throw it over the back of the sofa.' I was like, 'Wow! Fucking hell!' – aghast at the detail. To script, Blair did exactly that. It was like, 'I'm noble. I'm not messing around. I'm not observing normal protocols. This is a little bit off-piste.' That was coupled with Alastair having said, 'At the end, Tony will stand up and walk down among the Labour youth,' which he then did. It was like the coming of the messiah.

TONY BLAIR It was a bizarre thing to do, but part of the trouble with that whole Tory generation was that they were very emblematic of the old Britain, where politicians didn't really engage with people, except in a very *de haut en bas* type of way. All of these things were really a recognition of society and the times were moving on. It was all part of saying, 'The modern Brit is not your stuffed shirt.'

MARGARET McDONAGH Tony represented the first modern leader the country had ever had, in the way that JFK had been a break from the past in the US. Tony was young and would watch Alan Partridge and find it funny, although I think he found doing headers with Kevin Keegan rather more terrifying than being interviewed by Steve Coogan.

DARREN KALYNUK Tony being interviewed by Alan Partridge was Labour dipping its toe in popular culture. In the evening 18 Wheeler played, and everyone was dancing.

ALAN McGEE It was all Labour Party indie kids. I thought, Fuck this shit, I'm going to bed. I went to my room in this fucking shit hotel and put on Sky, and it was the first time in my life that I felt famous because it was me giving Blair the disc. I was the lead item on the fucking news. I stayed up till six in the morning watching myself every hour. I was thinking, How long can you run this story?

MARGARET McDONAGH Alan got more involved and we developed a good relationship.

ALAN McGEE We were selling a lot of records and making a lot of money. I felt I should give back.

ALASTAIR CAMPBELL Alan donated £50,000 to the party.

ALAN McGEE Campbell said, 'Why don't we put a piece in the *Daily Record*?' I said, 'How can you be so confident?' He said, 'I'm going to write it.' I was like, 'I wish I could do that.' Sure enough, the article appeared with the headline 'Look Back in Anger: Labour Man McGee Puts His Money Where His Mouth Is'.

KAREN JOHNSON Alan was from the estates of Glasgow. Like all of us, we were taken in by the Labour Party and thought this was an opportunity at last to get a government we wanted. Of course, artists loved that they were being wined and dined and all the rest of it, but if you were slightly older you could see what was going to happen.

DARREN KALYNUK Jonathan Powell[5] had been a diplomat in the US and had seen how Rock the Vote worked and impacted. He would say, 'Have you got any thoughts on what we should do? Do you think Blur would write Labour Party's campaign theme tune . . . would they do a gig?' I would talk through what I was doing or give him CDs with some blurb, and say, 'Try track three.' I tried Blur's 'The Universal'. He said, 'It's not quite right.'

5 Tony Blair's Chief of Staff in opposition and government.

MARGARET McDONAGH We were going to use 'Faith' as the campaign theme because George Michael was a supporter. Tony met George and had him round for dinner.

ALAN McGEE M People's 'Movin' On Up' was muted. We asked them to go with 'Wake Up Boo!' by the Boo Radleys. There were loads of meetings at Millbank with Margaret and Mandelson.

MARGARET McDONAGH Alan wanted 'Wake Up Boo!' but there was a rights issue. I wanted 'Things Can Only Get Better' by D:Ream. In previous elections, people hadn't voted Labour because they were nervous, 'Labour will screw the economy'. 'Things Can Only Get Better' de-risks it. This current government is so bad Labour can't do any worse. I was arguing a lot with Alastair about it, and I remember putting my foot down and saying, 'This is going to be it.' Alastair said, 'Well, it better go to number one, then.' The new charts were coming out, and Alastair and Tony and Anji [Hunter] had been out on the election bus all day. They came back late, and they'd obviously been talking about it and all wound each other up. They came in, one by one, and said, 'It only made number seventeen!'

ALAN EDWARDS Music spoke loud to the eighteen to twenty-five-year old demographic. At that age, I probably didn't know who was Prime Minister half the time.

MARGARET McDONAGH I remember *EastEnders* played 'Things Can Only Get Better' by D: Ream in the café. It was nothing to do with us, but of course the Tories made an outcry about the BBC backing Labour. There was an omnibus on Sunday and the BBC changed the music. These poor people had only put the song on in the background.

DARREN KALYNUK You'd run into people all the time. I wasn't backward about coming forward and just going up and talking to people, and saying, 'I work in John Prescott's office, would you be interested in supporting the Labour Party?' I met Kate Moss once. She was absolutely lovely. She was saying, 'I'm a big Labour

supporter,' but it didn't go anywhere. But more often than not I didn't have to work too hard to get people interested. It was tuning into what felt like a natural fit; pushing at an open door and saying, 'Would you like to help us kick the Tories out and elect the Labour Party?' It was using every tool in the box to try to elect a Labour government. There were kids in '97 who were going to be able to vote for the first time, who had lived their entire lives under a hard-right-wing Tory government.

JARVIS COCKER I have very vague memories of going to an event in a weird building near Downing Street. They'd invited quite a lot of musicians and creative people to sound us out. Something didn't ring true about the situation, and that led to a song we wrote called 'Cocaine Socialism': 'I thought that you were joking when you said, "I want to see you to discuss your contribution to the future of our nation's heart and soul." "Six o'clock, my place, Whitehall."' The Britpop years were consumed by cocaine consumption; there was something very contradictory about people saying, 'Yes, I'm Labour, I'm left wing, I'm a man of the people,' while ingesting a drug that made you not care anything about any other person but yourself. It's the ultimate egotistical drug.

STEVE COOGAN There was definitely a paradox between narcissistic behaviour and political idealism. It's about personal morality and the morality of how society is meant to be cohesive. The fact that hedonism was coupled with an idealism seemed like a contradiction.

JARVIS COCKER 'Champagne socialist' was an insult which used to get bandied around back in the sixties and seventies, so I thought, Well, obviously we've got to the next level now. There was a good line towards the end, 'You can be just what you want to be just as long as you don't try to compete with me'. That was me imagining the Labour grandee trying to get me on board.

PHILL SAVIDGE Jarvis escaped to New York to deal with his 'fear', and New Labour somehow tracked him down and he was pissed off.

JARVIS COCKER I was in hiding because I wasn't very well, and I kept getting these calls, which made me incredibly paranoid: 'The phone must be tapped . . . how do people know I'm here?' It was a real issue for me. How much of that was real and how much was just the paranoia going on in my head, who can say? That was when I'd decided that I should attempt to stop doing cocaine and get my head together.

SIMON FOWLER The concoction of drugs and music and political involvement was a confection. Labour were clearly trying to associate themselves with a young, hedonistic generation who no doubt wanted change but ideologically, in truth, didn't give two fucks.

ZIG-A-ZIG-AH

Spice Girls. Girl Power

MATTHEW WRIGHT Pretty much as Knebworth settled, the next big popular phenomenon was the Spice Girls. I can remember thinking, Christ, one minute I'm actually standing in a field with some reasonably cool people, and the next I'm interviewing five brain-dead girls about songs, which I still very much doubt they wrote.

RIC BLAXILL The other side of Britpop was an incredible explosion of pop music. You'd had Take That and then the Spice Girls came along. There was this excitement, where only a few years before all the investment had been going into dance music. Suddenly labels were putting some money into developing artists and looking at longer-term careers, rather than one-off hits you can get in the top ten. The whole A&R philosophy changed.

MELANIE CHISHOLM We were originally auditioned by a management team. There were a few different line-ups of the band before we became the Spice Girls. And then when Emma joined something clicked. There was something about the dynamic and the energy that we all had together. We were all very ambitious and we all shared a vision. Part of our success was that we were so single minded and had this belief that we were going to make it happen. We were oblivious to failure. It wasn't an option. Arrogant little shits!

MATTHEW WRIGHT You have the emperor, Simon Fuller, a very bright man, and he's looking at all these management companies that come through his door every day pitching their ideas, and he

says, 'Yeah, I'll go with that one.' He took the girls, paid off the management and put the songs on it. It was a manufacturing process.

DAVID BADDIEL When I first met the Spice Girls they were nineteen, twenty, and their whole being was, 'We are on a hen party and we are going to get drunk and we are going to be really loud.' Simon Fuller would take them round record companies and they would dance on desks and tear up executive offices and be crazy Girl Power girls.

SUZI APLIN Their plugger, Nicki Chapman, rang me and said, 'We've got this girl group.' I said, 'We don't have those kind of bands.' 'Can we come in anyway?' I said, 'Of course,' and all five of the girls came to my office.

MELANIE CHISHOLM It's like the scene in *Spice World* when we perform 'Wannabe' in the café: we'd literally turn up, go into a boardroom, stick the tape on, sing along and I'd do a back flip on the table. It was fucking insane.

SUZI APLIN They were doing their dance and I could see Chris coming down the corridor. He opened the door and shouted, 'Fuck off back to *Live & Kicking*.'

MELANIE CHISHOLM We were like, 'Fuck off, you twat!'

WILL MACDONALD Three months later we were begging them to be on the show. I had to fucking wear a mock Geri Halliwell Union Jack dress and walk round Piccadilly Circus holding a sign, 'I'M WILL MACDONALD OFF *TFI FRIDAY* AND I'M NUTS ABOUT THE SPICE GIRLS'. Normally when you're shooting a daft thing you've got a camera man right next to you so people see it's for TV, but on this occasion they were using a long lens so it looked like I was wandering around by myself, off my mind. But it worked and we did a Spice Girls one-hour special.

RIC BLAXILL The Spice Girls pitched to me at my office at *Top of the Pops*, which was like a sixth-form common room with guitars and crap all over the place. They all came trailing in and ended up jumping on my desk and sitting on my lap and picking up the guitars and turning everything on. The plugger was just saying,

'This is the Spice Girls!' They were like a whirlwind. I'd never experienced anything like it.

MELANIE CHISHOLM We were so obnoxious, God knows how we got away with it. Me and Mel B would rock up on rollerblades. It was ridiculous. We just didn't care about protocol. We wanted to stick two fingers up to everyone. Our attitude was if people didn't like us, 'Well, fuck you, then. It's your loss.'

RIC BLAXILL You then get played the song. 'Wow! This is just what we need.' So I gave 'Wannabe' an exclusive. It was just great pop music with character.

MELANIE CHISHOLM The ultimate was to be on *Top of the Pops*. 'Wannabe' shot to number one and stayed there for seven weeks, but it took us about three weeks to get into the *TotP* studio. We were in Japan and did a couple of satellite link-ups from outside a temple – I was wearing a Liverpool kit. We'd come straight from the airport after a killer fourteen-hour flight, and I was thinking, Oh, fuckin' hell, the fucking back flip.

DAVID BADDIEL There is something feminist about 'Wannabe'. It's a song about 'I'm going to prioritise my girlfriends'.

MELANIE CHISHOLM 'Wannabe' was written in the studio in about fifteen minutes as a bit of a joke. Our whole process was very collaborative. We'd sit round with paper and pens and talk; someone would have a little melodic idea, then we'd start working on some beats and get a track together. With 'Wannabe' we were writing our manifesto and we had this Spice Girls dictionary – stupid things that we'd come up with – that's how 'zig-a-zig-ha' came about. We did a demo of it and then left it thinking, It's not one of the greatest songs ever written. Matt Rowe[1] worked on the production and sent it back to us. We were like, 'Fuck!' It's one of those annoying songs that captured people's imaginations.

1 Together with the Spice Girls, 'Wannabe' is credited to the songwriter and producer duo Matt Rowe and Richard Stannard.

DAVID BADDIEL I ended up in bed with Mel C and Mel B. They made so much noise during the small amount of snogging that went on that the hotel security phoned up and said, 'We're going to remove you from the hotel if the noise doesn't stop.' I unsuccessfully tried to get them to be quiet and eventually chucked them out of the room – and thus failed to have a threesome with the Spice Girls.

MELANIE CHISHOLM It was quite innocent really; one of those silly drunken things.

LORENZO AGIUS The energy the Spice Girls had reminded me of the Beatles. You never saw them in a down moment. They were very much united. Mel B: a northern loudmouth, cheeky and rude in a naughty way. Victoria: quiet and unassuming; a nice girl. Emma: very shy. Geri: not. In essence they were their characters. Everything the Spice Girls did was the best of the best of the best. That's why they became the biggest girl band in music history.

MATTHEW WRIGHT No one could object to Emma Bunton. But let's put it this way, they got very lucky. It could have been literally anyone. There was nothing organic about the Spice Girls. *Smash Hits* came up with the nicknames; it wasn't even conceptually theirs.

MELANIE CHISHOLM *Top of the Pops* magazine came up with our nicknames. They used to give pop stars nicknames: Britney Spears was 'Broccoli Spears', Natalie Imbruglia was 'Natalie Umbrella Stand'. They had a 'Spice Rack' for us; five jars, with one of our heads on each, labelled 'Scary Spice', 'Baby Spice', 'Posh Spice', 'Ginger Spice' and 'Sporty Spice', and a short description. Mine was 'Ball control is her speciality!' Peter Lorraine and Jennifer Cawthron did it. We thought it was hilarious. The names just stuck and I suppose we became caricatures of ourselves.

JO GOLLINGS We all revered them. If any one of them turned up at a party it was like, 'The Spices are here!' It's interesting that they were all girls and Britpop was principally boys.

MELANIE CHISHOLM It was really exciting to be in environments where Jarvis Cocker was hanging out, or bumping into Liam Gallagher and having a few words. I inherited the nickname 'Indie Spice'. We were very mainstream but we became part of that scene.

JARVIS COCKER I never bought into the fact that there was anything radical about the Spice Girls. It was just a shiny pop thing, like the Osmonds. Just a group of all-right looking people who can jump around and sing.

CARLA POWER The average Spice Girl fan was twelve years old. It was first-kiss music: earnest and ridiculous with lines such as 'do you still remember how we used to be? Feeling together, believing in whatever'. We all were slightly embarrassed.

ALAN EDWARDS They did a gig at Dublin Point and Victoria said to me, 'How's the audience?' I remember saying, 'Well, I wouldn't say it's young, but there's lots of people with prams out there.'

MELANIE CHISHOLM It was the first time a fan base had started that young. We knew that we were role models to really young girls. People would say we were dressed inappropriately in crop tops. It was something we had to be conscious of.

SIMON FOWLER I went to see them in Birmingham and there was no beer backstage. I thought, No beer at a rock gig! Oh, it's not a rock gig, is it? I left after about twenty minutes. It was all school girls in the audience screaming.

MEERA SYAL I went to see them at Wembley with a load of other mums and dads. It was great. It was full of happy screaming kids. Anything that raised the awareness among little girls, I mean, God knows feminism had taken such a battering. It felt good. You could argue that the little girls that were running about shouting 'Girl Power' are the Caitlin Morans and the Laura Bateses and all the women now who have made feminism cool again.

MELANIE CHISHOLM Girl Power was about equality and about acceptance of just being whoever you were; being your best self.

We were battling against people telling us, 'Girl bands don't sell records. You can't grace the covers of magazines because the numbers will be down.' Girl Power became something we felt a responsibility to shout about.

SIMON FOWLER They said Mrs Thatcher was the first Spice Girl. It was a load of old tosh.

MELANIE CHISHOLM We did an interview with the *Spectator*, and Geri said, 'We Spice Girls are true Thatcherites. She was the first Spice Girl, the pioneer of our ideology – Girl Power.' That sat very uncomfortably with me. I grew up in Liverpool when it was a tough time for the city because of Margaret Thatcher and her government. But we weren't overly political people. In 2001, Geri did a party political broadcast for Labour. She saw the light.

GREGOR MUIR Girl Power was synonymous with West Coast artists when feminism was tougher and a lot more militant.

FIONA CARTLEDGE There was the whole Riot grrrl[2] thing that came over from America: Bikini Kill, Courtney Love and Hole. Girl Power and the Spice Girls came out of that. Shampoo had a hit with 'Girl Power' the week before 'Wannabe' was number one. It's very rare one person starts anything. There's a mood. There was a Girl Power feeling. And then people in the record industry spot that, and they think, Let's manufacture a band about that.

MELANIE CHISHOLM What Girl Power became was never planned, 'This is our slogan. This is what we're all about.' It just happened. We hijacked the phrase from Shampoo. Geri saw it and used it. Then it became such a huge thing.

TJINDER SINGH Girl Power was a soft, bubble-gum version of Riot grrrl and the Spice Girls showing their knickers.

2 Riot grrrl was an underground feminist movement that formed on the West Coast of America in the early nineties.

JO WHILEY Girl Power was, to me, Justine and Annie from Elastica or Louise from Sleeper. There were a lot of really cool women who were passionately into music and wanted to be in a band and do their own thing. Back then there weren't many really cool girls. Then the Spice Girls came along and hijacked the whole thing. It was like, 'What are you doing? Really?'

MELANIE CHISHOLM All we wanted to do was sing, dance and travel the world; all the trappings and imaginings of being a pop star. But quite early on we were confronted with quite a lot of sexism. It made us go, 'COME ON, THEN!' We had this fire in our bellies. So Girl Power was a symptom of our experiences. Women's rights, equality, even feminism: it's something that's been going on for thousands of years. It was this continuous journey.

TRACEY EMIN Women under thirty today would not tolerate the sexism and misogyny we were putting up with. It came from all places.

STEVE COOGAN I remember doing Paul Calf at a student union gig – he would say things like, 'Women, you can't live with them . . . can you?' or 'I'm a radical feminist . . . I think you've got to be these days if you want to get your end away' – and being harangued for being sexist and bigoted. I had to take my wig off and shout back, 'It's a character. I'm being ironic.' Later, some of the hecklers came over and said, 'We're sorry, we didn't realise what you were doing.' Paul Calf was a character, so it contextualised it in a way that was safe because you're laughing, partly because you think, He's very unselfconsciously misogynistic, but also, actually, that's what a lot of people do. A lot of men appear to be empathetic with women because ultimately they've still got the same old objective; they just dress it up in different clothes, as it were.

SHERYL GARRATT I liken it to what boys get when they're taken to football matches: being part of this big mass. Girls don't experience that very often. Suddenly here was a group that teenage

girls were buying into and saying, 'Girl Power,' and, 'You can be anything you want to be.' What a powerful message to get across to young girls. Of course, it was a marketing tool, but I don't think the line was as firmly drawn as Alan Edwards and Simon Fuller would have liked. What was magical was that the Spice Girls were manufactured and the people who manufactured them lost control of the process. No amount of, 'We'll do a girl equivalent to a boy band and we'll sell some units,' could have predicted what they became. They were very lucky with the chemistry and to get someone as feisty and as pushy as Geri.

ALAN EDWARDS Geri was very serious about Girl Power. And Mel B. Underlying the slogans, they weren't mucking around; they were trying to sweep away the cobwebs of blokeish culture, especially in the music industry.

CHARLIE PARSONS The Spice Girls were about empowerment. A lot of the confusion of the previous twenty years about feminism had been cast off. You could be a feminist and be proud of your body.

FRAN CUTLER It was girls doing their own thing; girls being independent and self-sufficient. I flew the flag.

GURINDER CHADHA It was girls feeling emblazoned and emboldened to speak out and have opinions. The Spice Girls were an amazing breath of fresh air and they were uncompromising. They were northern and southern, dynamic, opinionated, sassy women entering a male domain.

JOHNNY HOPKINS In the years after that, many girls said, 'It made us think. It gave us confidence.' That can only be a good thing.

MELANIE CHISHOLM The legacy of the Spice Girls is making feminism more accessible to young people, to kids. Over twenty years later, every day people approach me and say, 'You guys inspired me to do what I wanted to do,' or 'You gave me the strength to come out to my family.' That's incredible. That was very much

about the feeling of that time, a feeling of, 'We can break down barriers. We can change things.' It felt like there was all this strength and positivity to make change.

JO WHILEY I interviewed Adele, many years later, and she had photographs of the Spice Girls on her fridge with her dressed up as one of them. She was saying how they had changed her life and really empowered her. 'Seriously? It wasn't Justine Frischmann that empowered you; it was Ginger Spice.' That's incredible. It really messes with my head.

TIM SOUTHWELL Girl Power was a load of bollocks. All it meant was someone clenching their fist and saying, 'I can do things that a man can do.' It all goes without saying. It's like smashing a heavy hammer to do something you could have done by talking. I'm not saying that girls shouldn't be powerful, but you don't need a catchphrase for it. But, maybe in some superficial way, it empowered little girls to be more confident, and that's a positive thing.

MATTHEW WRIGHT 'GIRL POWER! GIRL POWER!' I thought, I fucking don't know what you're talking about. Five numpties whose nickname was 'the Piggies' by the record company because everywhere they went they took whatever was there. What is Girl Power? 'Yeah, positivity!' If you can find one line of explanation from any one of the Spice Girls on what Girl Power actually is, that makes sense, I'd love to read it. Everybody I could see around them was a man: the songwriters, their manager, the record company.

ALAN EDWARDS To say everything was a male construct around them is harsh. That was the industry. It was a boys' club. You couldn't say to the record company, 'We're not going to allow you to put our records out because your CEO's not female.' You just had to be practical.

TOBY YOUNG Girl Power was a brilliant marketing ploy because here was this group of not particularly talented dancers who were

transformed into an international phenomenon because of some spurious link with feminism. They didn't seem like they'd read Germaine Greer or Simone de Beauvoir. Girl Power was a diluted, poppy version of second-wave feminism – hats off to Simon Fuller for coming up with a brilliant marketing wheeze.

MATTHEW FREUD Simon Fuller is definitely one of the architects. It's not quite Bauhaus, but there were a few of us trying to reconfigure the way that celebrities and businesses dovetailed in a way that made money for everyone. When Fuller began to exploit, in the nicest sense of the word, the Spice Girls by doing commercial deals – with Pepsi and perfumes and clothes endorsements – it was a natural cycle. It wasn't that celebrities hadn't been doing product endorsement, but there was a muscularity to the way the Spice Girls brand was managed.

MELANIE CHISHOLM Everybody in the music industry is manipulated to a point. It's difficult. Once you become a commodity there's a lot of 'yes' people and everybody has an agenda. You just have to find the people whose agenda benefits yours. We were so lucky to find Simon because he had the belief in us and he could facilitate everything that we wanted to achieve, but there comes a point where the lines are blurred: is it what you want to achieve or is it what the people around you want to be achieved with you? It's hard. You get completely caught up in it.

CARLA POWER They may not have had much to offer musically but they were smarter than you think. Unlike other successful pop acts who pay no attention to the business end and cry broke years later, the Spice Girls negotiated a slew of lucrative merchandising and endorsement deals that set them up for life: Pepsi, Spice Girl fashion dolls, Spice clothing, Spice fragrances, stationery, the girls exposing their cleavage over Sony videogames, posing with Polaroid cameras, and chomping on their own Cadbury chocolate bars, crisps, backpacks, lollipops. Although their wallpaper range had to be recalled when people realised Baby Spice's nightie said 'Fuck Off' on it.

MELANIE CHISHOLM The relationship broke down with Simon: we moved forward in parallel lines, and then the lines began to widen apart and we ended up leaving him. We were doing less and less music and more and more branding. It was endless. Saturated. We started to get on people's nerves. You couldn't go down a supermarket aisle without us blaring out at you to buy whatever fucking flavour of whatever you want. Initially, we were on the ride, and it was really fun. 'Do you want to do a Pepsi commercial?' 'Fuck, yeah!' We wanted to be household names, but there are negatives and we started to sense that. It wasn't about music anymore: it was milking it. It was financial greed because, of course, it's big pay days and greed for attention and notoriety. It gets a little bit dark, and we got caught up and carried away with things and started to feel like a product. The tipping of the balance is when you have that realisation that you're lining lots of people's pockets.

MATTHEW FREUD We started treating brands like celebrities and very often putting celebrities next to brands. The cycle went: celebrities want to be celebrities and then brands want to be celebrities and then celebrities want to be brands. In essence, it was the beginning of celebrity culture.

EVERYONE I HAVE
EVER SLEPT WITH
Sensation. The Turner Prize

TRACEY EMIN Around the time I made *The Tent* I showed my film *Why I Never Became a Dancer* at the Screen on the Green in Islington, and outside the cinema, in lights, it said 'TRACEY EMIN'. Nobody came. I was there all afternoon; two people walked in and then walked out again. My point here is, could you imagine if I showed that film now? There would be queues round the block. Whatever anyone thinks, there were times when nobody saw anything. There were areas of great vacuums of nothingness.

GREGOR MUIR The press bass line towards contemporary art hadn't much changed since the Tate had purchased Carl Andre's 'Bricks' in 1972: that this pile of rubbish, bought for an enormous amount of money, equals you should be upset, reader.

TRACEY EMIN People thought it was the emperor's new clothes or that none of us were talented or that it was all just hype. Suddenly, BAM! Art was in fashion magazines and newspapers and Sunday supplements; in *i-D, Vogue* and *Dazed & Confused.* It expanded into everyday life and went mainstream: an artist is going to do a fashion shoot; an artist is going to make a TV commercial. I was on about a hundred front covers. It was insane. I've got boxes and boxes and boxes of archive press. The *Guardian* said, 'She's nothing but a media whore.'

GREGOR MUIR It was a burst of energy starting in '87 and ending in '97 with *Sensation* at the Royal Academy. Charles Saatchi realised he could round up this generation and these artists within the increasingly recognisable dynamic.

NORMAN ROSENTHAL An exhibition fell through and suddenly I had to put together a show in nine months. The only thing you can do quickly is contemporary. I happened to meet Charles [Saatchi], and he said, 'I'd like to see what I've got, all together.' I said, 'That's a good idea.' I put it to the RA committee and, although they were very sceptical, it was agreed that we should do a show of Charles's collection. Damien Hirst, Michael Craig-Martin, myself and Charles sat at a computer and looked at every single object in his collection and we put together the exhibition.

MICHAEL CRAIG-MARTIN *Sensation* was an attempt to define a generation. I realised that as it started to take shape. Charles had collected so much work. Who knew? It was amazing that every single thing belonged to him. He might have owned twenty or thirty pieces by one artist. The question was which ones to put into the exhibition.

OLIVER PEYTON Some artists felt like Saatchi was a puppet master. But this was a Norman Rosenthal show. He knocked it out of the park. It was another turning point.

MAT COLLISHAW The Director of the Royal Academy is a very important person and Norman wasn't a stuffed shirt. He was a gregarious and affable man with a lot of contacts and not a snob at all. He was a man who could see the potential in some scruffy northern kid like Damien, and see he wasn't just an upstart.

MICHAEL CRAIG-MARTIN Until the eighties, no serious British artist had been seen in the Royal Academy for nearly seventy years – not Henry Moore, Barbara Hepworth, Jacob Epstein, Paul Nash – because it represented regressive conservatism. The artists agreed to *Sensation* because Norman forced them.

GREGOR MUIR It's interesting that it was the Royal Academy of Arts. It was the moment the establishment and the YBAs met and were inserted into the Cool Britannia vernacular. It was the pinnacle and, in a way, it was the spiritual end; everything after that is a falling away.

MICHAEL CRAIG-MARTIN There was resistance to the Royal Academy doing such an exhibition. Sam Taylor-Wood questioned being appropriated by the establishment. But as it came into focus it was clear that this was going to be a staggeringly comprehensive exhibition of a generation, until Norman and I recognised that two people, unfairly, were not on the list. We suggested to Charles that he needed to buy something by Michael Landy – he bought *Costermonger's Stall* – and *Everyone I Have Ever Slept With*, Tracey Emin's *Tent*.

NORMAN ROSENTHAL There was no way one could do the exhibition without Tracey.

TRACEY EMIN You couldn't have had *Sensation* without me. I was like this female Rambo artist. Charles Saatchi knew that so he had to acquire *The Tent* on the secondary market, where he paid a hell of a lot more money than I was paid for it. That made me angry. Regardless of what I thought of Charles Saatchi, I knew there was something wrong with the system. We both lost out.

GREGOR MUIR Saatchi bought Tracey's *Tent* from the private dealer Eric Frank for £40,000 at the last minute. There was a period when Tracey felt it was difficult to do business with Saatchi for political reasons, which I feel she still has a little bit more to say on the subject.

TRACEY EMIN Charles Saatchi really supported the arts. He bolstered lots of people's careers, and by buying their work helped many people to buy their first homes. I wouldn't initially sell my work to him. He asked me why, and I said, 'Because you did the campaign that put Thatcher into power.' He said, 'My dear, I've done campaigns for Kit Kat, tampons . . .' I said, 'You should

have stuck to them, they were a lot more honorable.' Over time, I thought, I'm not going to be able to change anything by being broke, so the next time he called me up I sold him my work.

MATTHEW WRIGHT I've been told this story and I so want it to be true: that Saatchi and various other wealthy people got together after the first Brit Art exposure and, as a joke, said, 'Who can we elevate to the status of the next Damien Hirst and make money out of? Who has no talent?' They picked Tracey Emin. I find it fantastically appealing as a story. The idea that you're not investing in someone you like, you're investing in someone as a project. If you move money from country to country, modern art's an amazing way to do it because essentially you're saying, 'This is worth £10 million and who are you to say it isn't?' It became a massive commercial enterprise that was being played out in the pages of the colour supplements and the broadsheets.

OLIVER PEYTON There were a lot of artists who became sensations. It was to do with the people who had a strong sense of the changing nature of the art market. The fact that hedge funds started coming up and had £5 million to spend. They'd just walk into a gallery and say, 'I would like two of these . . .' Art became a commodity.

CARLA POWER The irony was, the hit West End play of the moment was *Art* written by a French playwright called Yasmina Reza, starring Albert Finney, Tom Courtenay and Ken Stott. People were self-consciously thinking, What is art? Where does it stand in our culture? Is it about commerce or is it about expression or is it about consumerism?

MAT COLLISHAW Saatchi had this fantastic collection that really changed the way people saw art. We had a lot of respect for him for doing that. But we didn't have anything to do with *Sensation*. It was a collection, like a David Bowie greatest-hits album. Who buys one of those? They're just for the uninitiated - a collection of songs by a curator. If you're a proper fan you buy *Aladdin Sane*

or *Hunky Dory*. A hits album is chosen by a marketing person to shift units. There's no art in that. And that's what *Sensation* was.

MICHAEL CRAIG-MARTIN Charles never let artists be involved in his exhibitions. I'm sure he never met most of them, just like he never went to his own openings. He always kept a distance. I remember Charles suggesting *Sensation* as a title, and thinking, It's too sensational. But he was the public-relations man. He knew what he was doing.

GREGOR MUIR There were artists in there that weren't YBAs, yet it is without doubt the landmark YBA show and captured the spirit of the age.

NORMAN ROSENTHAL *Sensation* was the broad validation of something that existed already. It was a moment for the greater public.

SARAH LUCAS For the public, it all came together at *Sensation*, but for us it didn't because we were already doing loads of things and had been for a long time by then. It was exciting to do, but it was also a part of the racket.

SADIE COLES *Sensation* was the tipping point, but it became something else. It became a different train that was being driven by someone else.

JARVIS COCKER It was a moment when that scene went overground: when the warehouse moved into the Academy. I remember the opening night and there being so many famous people there. You could tell something had changed. It was more of a social occasion than an artistic one. It was like, 'Whoa! This is not how I'm used to thinking of art openings. This is a new kind of thing.'

ALAN McGEE I remember Nick Cave bending down and there was a dead body. If you touched it, it bounced. Nick touched it and jumped six foot back.

GREGOR MUIR Walking into *Sensation* was like seeing old friends: artworks that I remembered seeing in situ, like Damien's *A Thousand*

Years and Sarah's *Two Fried Eggs and a Kebab*. It was a shock to see them in isolation. There was a sense of deathliness. The further they are away from the studio there's a certain life that leaves them. It's not to say they're not powerful artworks still, or that they can't move people.

MAT COLLISHAW The tabloids picked up on various things, such as Damien's shark and Marc Quinn's blood head *Self*. It trickled into various news stories.

NORMAN ROSENTHAL We had a press conference in March where we showed various things, including Marcus Harvey's infamous painting of Myra Hindley, and nobody said a word. Then it became the silly season and the story erupted because the *Daily Mail* decided to make it into an issue. I was on holiday up in the Basque country when I got a phone call: 'Crisis, crisis, what shall we do?' I had to fly back to London pretty quickly.

SHERYL GARRATT The reaction in the tabloids was hilarious – to tie it back in to rave culture, when all the big raves happened and the tabloids did all these stories about ravers biting heads off pigeons and Ecstasy wrappers all over the floor when it was just tinsel – they just got everything wrong and stoked up outrage. Over what? A shark in a tank and a picture of Myra Hindley that everybody had seen a million times from newspapers.

NORMAN ROSENTHAL Mothers Against Murder and Aggression protested on the steps of the Academy, but the bigger deal was when somebody threw a pot of black ink at the *Myra* image. The *Mirror* headline was 'DEFACED BY THE PEOPLE IN THE NAME OF COMMON DECENCY'. And then a box of eggs was thrown at it and the painting had to be taken down for a week and cleaned. It freaked out Marcus Harvey.

TRACEY EMIN I didn't feel particularly good about that work. I have no idea whether he did, but sometimes people just made work to be shocking and provocative. Using children's hands to make a picture of Myra Hindley has really big question marks for

me. But then you've got the Manson murders, you've got Hindley and Brady, you've got all these people. What is it about society that makes people behave like that? Those are the questions that should be asked, not whether or not a painting should be hung in an art exhibition. I'm not saying there's anything good about it, I'm just trying to say why work like that can exist.

SHERYL GARRATT I went with my son in a buggy and a woman tried to hit me as we passed the painting, saying, 'How dare you. This is outrageous.' I was like, 'You're upsetting my eighteen-month-old son far more by shouting and screaming than a picture of a lady.'

NORMAN ROSENTHAL Myra Hindley wrote a letter for the painting to be removed and four Royal Academy members resigned. My father-in-law saw the catalogue – he was Spanish and had no connection to British culture – looked at the portrait of *Myra* and, not knowing anything about the scandal, said, 'What a nice picture of the Princess of Wales.'

MICHAEL CRAIG-MARTIN I saw the work as a deeply touching critique of Myra Hindley. There was something so damning by using hand prints of children. It was the ultimate condemnation, but obviously other people felt differently. In general, just the fact that something's in art elevates it. If I make an artwork using a paper cup I'm elevating a paper cup and making an artwork of it. In that sense, people saw a portrait of her as being an elevation of her. If it was just the image it would have been different.

NORMAN ROSENTHAL Whether we like it or not Myra Hindley is an image. It was not justifying her. On the contrary, the painting was very critical. I think it was a very beautiful picture. It was provocative. Like all art it's supposed to make you think. Are we objecting to sliced cows when we slice cows all the time? Everybody is potentially a murderer. It's about provoking. You need to upset people to get them out of their lethargy.

MICHAEL CRAIG-MARTIN When *Sensation* went to America there was controversy around Chris Ofili's *The Holy Virgin Mary* and his

use of elephant turds. They worried about something completely different. National exposure is what Charles wanted. He was a PR man. He understood public relations.

CAROLYN PAYNE It was taking what wasn't that controversial in the art world and putting it on the most public stage to a very broad audience. It was provocative and good art. The Chapman Brothers' pieces were more shocking because it was actually people being beheaded and speared on trees and having their entrails hanging out; and *Hell* was an enormous environment of tiny little figurines. It was like Nazis and the most awful atrocities but done with such care. Later, it got destroyed in a fire in a warehouse where it was being kept, and they said, '*Hell* was destroyed by an act of God.'

VIRGINIA BOTTOMLEY The whole thing about art, a lot of the buildings that were listed people didn't like at all at the time. They hated St Paul's. They thought it was completely out of scale. It took many years for it to become a much-loved building. Often art takes time. I give all credit to Sir Nicholas Serota and Neil MacGregor and the people at the Royal Academy. This was a moment when the arts establishment and the arts leadership saw an opportunity and took it. I would argue that it was partly in society coming through, but the fact there was this new resource, to be competed for, it just energised everybody.

MICHAEL CRAIG-MARTIN Another absolutely critical link in the YBA story and contemporary art's positioning in the Cool Britannia phenomenon is the Turner Prize. Nobody paid much attention to the prize during the eighties, and then Channel 4 sponsored it and did two key things: they broadcast the event so it got national exposure; and they made ten-minute shorts about each nominee, so for the first time ordinary people could watch artists in their studios. That was unbelievably important. Art became credible.

DAVID KAMP Nicholas Serota said about the Turner Prize, 'It has been in existence since 1984, but in 1991 the rubric was changed so that only artists aged fifty and under could win. Suddenly it had a cachet like the Booker Prize in literature.'

GREGOR MUIR There was a younger generation coming through and changing the dynamic. If you look at the artists who were nominated and subsequently won the Turner Prize before the early nineties and those after, there was a definite shift in sensibilities.

NORMAN ROSENTHAL I was on the Turner Prize jury in 1991. I said, 'The person who ought to get the prize is Damien Hirst because he's the man making the running of the future.' He wasn't nominated. Nick Serota was determined that it would be Anish Kapoor. He was a completely other generation; another world. We had a big, friendly argument and, of course, because he was Director of the Tate he got his way.

GREGOR MUIR I've often thought about the Turner Prize in relation to this period. There's no way Nicholas would have been able to predict the way in which this particular young generation of British artists would suddenly sweep through and make themselves known. But it accidently became a way of mapping that. It was almost like trawling the seas and you've got something very unusual in your net all of a sudden. That's how it felt.

MICHAEL CRAIG-MARTIN Rachel Whiteread, Douglas Gordon, Gillian Wearing, Damien Hirst, the list of people who won over about a five- or six-year period was sensational. Out of the YBAs probably every one of them was nominated. I was doing a project in the City, and a workman said to me, 'I saw you on the telly last night, didn't I?' I said, 'I guess so.' He said, 'It was that Turner Prize, wasn't it?' I said, 'Yes.' He said, 'I really liked that one guy. His work was fucking great.' We had this conversation about art and I'm with somebody on a building site. I thought, This is a miracle! He knows about the Turner Prize and had decided who deserves the prize. It was absolutely fantastic. I'd never known anything like it.

TRACEY EMIN The year Gillian [Wearing] won the Turner Prize in 1997 for *Sixty Minute Silence* I got in a pickle. I did a live television debate drunk on Channel 4 after the award ceremony, and it hit all the headlines.

NORMAN ROSENTHAL It was after the Turner Prize dinner. We went to a little studio, sat down, and Tracey gave me a little kiss and I had lipstick all over my face.

MAT COLLISHAW There were some very self-important, pompous elderly men discussing art in a dry manner.

TRACEY EMIN It was all men on the show – Roger Scruton, Waldemar Januszczak, Richard Cork of *The Times*, David Sylvester, Tim Marlow, Norman Rosenthal. If you watch it, it's so funny because it's so fuddy-duddy and fastidious. I was the only thing on it that was reasonably interesting.

MAT COLLISHAW The whole thing was compounded by the fact that Tracey had fallen over in New York the week before and broken her finger. She had this aluminium splint on the end of her finger, so she was drunkenly pointing at all the elderly males on the panel with this huge gothic spike, which made the whole thing even more absurd.

TRACEY EMIN I was on really strong pain killers and I was drinking. The combination of those things, I thought I was round someone's house but I was actually in a TV studio. I remember them saying, 'Just give her a cup of coffee, she'll be fine.' It was like a mad play. I said, 'I am the only artist here from that show *Sensation*. I want to be with my friends. I'm drunk. I want to phone my mum. She's going to be embarrassed by this conversation. I don't care. I don't give a fuck about it.' I was basically saying, 'This is wrong. I'm not comfortable with it,' and they just egged it on.

MAT COLLISHAW It was how you expected Oliver Reed to behave.

TRACEY EMIN I shouldn't have been there in the first place. I said, 'I want to leave. I've got to go somewhere. I'm going to leave now. Don't you understand? I want to be free. Get this fucking mic off.'

MAT COLLISHAW We were all at the Atlantic, and Tracey arrived and was annoying everybody by complaining that she'd missed out on £500 by not going to this TV discussion show. She was very pissed off.

GREGOR MUIR She was slurring and kept talking about going off to do a Channel 4 interview. I was saying, 'I'm pretty sure you've just done it, Tracey.'

MAT COLLISHAW The next morning Gillian called and was saying, 'You were hilarious on TV last night.' Tracey was confused. 'What are you talking about? I didn't go.' Gillian said, 'You'd better have a look at the newspapers.' We went to a café and Tracey was in all of them with photographs of her drunk on this programme. That made her a household name.

TRACEY EMIN It became like a Kafka nightmare. I was walking down the street and everyone was going, 'All right, Tracey! Nice one.' People loved it. Suddenly I was 'that artist'.

MAT COLLISHAW It deflated the pomposity of these very cerebral and superior art snobs. People related to 'Drunken Tracey from Margate'.

TRACEY EMIN It's kind of irreverent and mad. I caught people's imagination. People changed their attitude about art. Art wasn't something that was ivory tower and elitist; art was suddenly on the streets. It was something that could belong to everybody. That made a big difference. I think people then became more open and receptive to my work. I was lucky enough to be part of the zeitgeist. My work correlated with what was happening. People wanted to be touched by emotion. They wanted things to be more real and more authentic.

GREGOR MUIR Tracey still hadn't seen the programme, and I acquired a videotape. It was about three months later, and I said, 'Do you want to see it?' We sat together and watched it in a corner of the Lux Gallery on a monitor. She didn't say a word throughout. Then at the end she turned to me and looked rather pleased with herself.

TRACEY EMIN I said, 'God, it's not as bad as everyone says.' Channel 4 got fined about £80,000 but it was nothing compared to the

amount of coverage and the advertising they sold from it. They showed the clip again and again. I asked them not to. I said, 'If they did sell it could they give money to the Terrence Higgins Trust AIDS charity?' They didn't, which I thought was really bad because it derided me. Then, two years later, *My Bed* was vandalised at the Tate by two Chinese artists, two idiots riding on my back trying to get loads of publicity. It killed any chance I had of winning the Turner Prize. I said, 'It should be taken really seriously and charges should be pressed.' If they'd done that to a painting the Tate wouldn't have let them off. I had loads of adverse publicity, which wasn't particularly healthy for me. I was too vulnerable and, in a way, too innocent to be able to deal with it all.

MAT COLLISHAW There were quite a few interventions – black ink was tipped into Damien's sheep tank at the Serpentine and the caption was altered to read 'Black Sheep'. I found it tedious and tiresome. If you want to make an art statement make an artwork. It was boring. The fact that you can walk into an art gallery and look at a pile of bricks on the floor and walk round it and meditate on it and think and come out having had an experience is a very precious thing. I wouldn't have the arrogance to interfere with the work that someone has created. Fuck off to them.

THE ENORMOUS ELECTION

Conservative Party.

General Election 1997

MARK LEONARD It was the dying days of the Tory government. You could see them crumbling. John Major gave this absurd speech about Englishness to the Conservative Group for Europe: 'Fifty years from now Britain will still be the country of long shadows on county grounds, warm beer, invincible green suburbs, dog lovers and pools fillers and, as George Orwell said, "Old maids bicycling to Holy Communion through the morning mist," and if we get our way – Shakespeare still read even in school. Britain will survive unamendable in all essentials.' It had nothing to do with the country I was living in.

JOHN MAJOR I was quoting George Orwell from his 1941 essay *The Lion and the Unicorn,* which I assumed that political commentators would recognise. But they didn't. Jeremy Paxman, on *Newsnight,* thought I had taken leave of my senses and begun talking in a language of decades ago. Well, of course, I was. I was quoting language from sixty years earlier, and to illustrate that the basic essence of our country hadn't changed – and wasn't going to be changed – by our membership of the European Union. When you consider the social reforms we were pushing through parliament, together with any policy that we should take a bigger role in Europe, it would be bizarre to suggest that I was not looking forward.

TONY BLAIR John Major was the first leader of the Conservative Party to be the victim of this extraordinary narrow nationalistic virus that got into the Tory party. The Tories went into self-destruct mode. It's an incredible thing because it was a harbinger of things to come.

CHARLIE PARSONS I quite liked John Major compared to Mrs Thatcher, but I thought the government was tired. Britain wasn't very modern. It wasn't looking forward. We were desperately in need of change.

STRYKER McGUIRE When you heard Mr Major talk about the youthfulness and vibrancy of London, it had a hollow ring.

TONY BLAIR John Major, I always said to people, was underestimated. He was liked as an individual. He never provoked dislike. His problem was the Tory party: because of Europe, it was ungovernable.

GEOFF MULGAN As soon as the Exchange Rate Mechanism happened it was fatal.[1] You only need to make one big economic error and you never recover.

JOHN MAJOR Ever since the 1960s our country had been bedevilled by inflation, and every time we had the economy going well, we got an inflationary spiral. Economic well-being went up, down, up, down like a roller coaster. I was determined that, this time, we would beat inflation down and wouldn't be forced off course. That is why we joined the ERM. That ended in disaster, of course, when we were forced out on Black Wednesday – 16 September 1992.

JOHN NEWBIGIN There was a long period of drift after Black Wednesday when the pound had to be driven out of the ERM, the government was just floundering around and the whole country was in limbo.

1 The Exchange Rate Mechanism (ERM) was first introduced in 1979, in an attempt to reduce *exchange-rate* variability and achieve monetary stability.

VIRGINIA BOTTOMLEY The longer you are in government, you have more and more people on the reject bench – they've been ministers or they're never going to be a minister – and the parliamentary party becomes disenchanted and slightly resentful.

DARREN KALYNUK The Tories couldn't do anything right. Major was ridiculed. He had rebellion on his backbenches. He resigned and then re-stood as leader. It was chaotic.

ALASTAIR CAMPBELL I could feel Major's desperation. They were running out of road.

JOHN MAJOR Any government that had been in government for eighteen years would have been tired. Ministers are human. The role of a senior minister is all pervasive. It takes over your life. It is the alpha and omega of everything you do. I lived for over ten years on five hours' sleep a night, if I was lucky. You do get tired, and there comes a time when it is healthy to have a change. In 1997 electors were right to think, It's time for a change. During the process of killing inflation a lot of people were hurt who didn't forgive us. Ironically, we were trying to leave the ERM when an economic tsunami – that started in northern Europe – forced us out and made us look incompetent. There are explanations for all of that but for the man in the street it just hurt.

JOHN NEWBIGIN It really did feel like the government had completely run out of steam. There had been the Cones Hotline, presented as a great government initiative for members of the public to phone Whitehall and inform them where traffic cones on roads were not effective. It was a symbolic failure. But for all the fact that the Major government wasn't doing anything much, the economy was doing extremely well, and, as is so often the case, people vote for change when they're feeling confident.

JOHN MAJOR By 1993 the economy began to get materially better. There's a time lag between the economy recovering and money filtering into people's pay packets. The public were beginning to feel better by 1995, but people had made up their minds to vote

against us by then. People felt, It's safe to have a change now. We are out of our difficulties, and the New Labour Party look safe. They are not the old socialist party.

VIRGINIA BOTTOMLEY The irony was we were doing brilliantly well. The economy was going well, unemployment was down, but nobody wanted to give the Conservatives the credit.

TONY BLAIR Fairly or unfairly, the Conservatives by that time were never going to be able to represent something new. They'd been in power eighteen years. They looked in pretty bad shape. The political times and the era was changing, and the country obviously wanted a change.

MATTHEW BANNISTER And here was this young leader, who seemed more like one of us, turning up with this vision which seemed compelling. I was at the party conference in '96 when Blair gave the 'Education, education, education' speech. It was spine-tingling.

NOEL GALLAGHER 'There are but a thousand days preparing for a thousand years' – I took that line from Blair's speech at Blackpool in '96. He's not getting any fucking royalties for it.

CHARLIE PARSONS Tony Blair came in as the great moderniser. He became a figure everybody could stick their colours to.

STEVE COOGAN With Oasis and Tony Blair and New Labour it definitely felt like we were in the driving seat and were seizing the initiative. The Tories looked tired and outdated. It was like everybody else had moved on and it was our future.

JOHN MAJOR We were destined to lose the 1997 election. We understood that from 1992. We had stretched the democratic elastic as far as it would go. We could not see any way in which we would win a fifth election unless the Labour Party imploded. If we had been led by the Archangel Gabriel – and if the economy had been the best the world had ever seen – we would still have lost that election.

TONY BLAIR Nothing's ever inevitable, but if the Labour Party was reasonably sensible and continued on its path of modernisation it was going to win. I think even a relatively more traditional Labour Party would have won, but with a much smaller majority. But John's right, by then they'd won four elections in a row; to win five in a row was obviously going to be difficult.

JOHN MAJOR The Conservatives had been in power for an unprecedentedly long time, and people were avid for change. There was a changed atmosphere, a changed feel. People, even Conservatives, were beginning to say, 'Are we a one-party state now?' 'Is the Labour Party finished?' 'Have we got the Conservatives for ever?' That was not an attractive political option in a country that had always thrived by having movement between the two major parties. It was a material part of the Conservative vote melting away. We lost the most precious gift any government ever has: the benefit of the doubt. We received no forgiveness from electors for anything that went wrong after 1992.

ALASTAIR CAMPBELL Alex Ferguson said, 'It felt like we were 2–0 up, and now we had to sit back, let the others make mistakes and probe their weaknesses [. . .] be ruthless.' I used to welcome Alex's calm advice. He advised Tony that he would 'feel stress levels rising' and he had 'to learn to become vacant [. . .] appear calm by cutting out everything that didn't matter'. During the election campaign I can remember feeling really pressured. People were treating Tony differently because they realised he was going to be Prime Minister. People who might normally have gone straight to him were coming to me: 'Can you do this . . . can you do that?' Alex basically said, 'Pretend you're a race horse and put blinkers on. Be in a tunnel. And when you're in your tunnel don't let anybody in who doesn't need to be in'. That was helpful at the time. Football is very different to politics, but the pressures are equally intense.

MARGARET McDONAGH Things were bubbling up. There was huge enthusiasm. Wherever we went there would be thousands of people out on the streets. But we never allowed ourselves to believe we

were winning simply because we didn't want to take the public for granted. You cannot predict what they're going to do.

SIMON FOWLER It was obvious they were going to have a land-slide. There was general warmth towards New Labour. They took the middle ground and appealed to the middle class; that's what swung it.

TONY BLAIR Labour won for two reasons: people were tired of the Tories and they also thought that putting in New Labour was a safe thing to do. We managed to broaden our appeal to a lot of the aspirational working class that had voted for Thatcher, and the middle class.

TRACEY EMIN You had people who were Tory voting Labour for the first time. There was this massive political shift. There was movement and energy for the first time. Everything about Tony Blair was good.

STEVE COOGAN You could see that Labour were going to win because they were seizing the initiative and playing to win. Alastair Campbell was like, 'We're going to do whatever we can to get these guys out.' There was that feeling, success breeds success. There was an exciting momentum behind them.

DAVID BADDIEL The week before the election BBC2 broadcast *The Enormous Election*, a terrible pun on 'erection'. Dennis Pennis was the host. It was all a bit laddish and wink, wink. Ulrika Jonsson interviewed John Major and asked him about drugs. Major said, 'They are wicked,' with no sense of irony. I interviewed Tony Blair. It was a strange interview. I started off by saying, 'I like you, Tony, for a very specific reason, which is that you seem to be like a real person.' Someone quoted that critically and said, 'Not very Paxmanesque.' Then I asked him about people faking their class origin. I said, 'It seems to me class in this country now is just incredibly fluid.' He said, 'A lot of our trouble in creating New Labour has been that people think if you move away from old class distinctions it somehow means that you've left your roots behind,

Left and above: Jarvis Cocker and Brett Anderson from the *GQ* Great British Issue shoot, 8 and 19 June 1996.

JARVIS COCKER *I remember seeing a billboard of the front cover and thinking, There's nothing going on behind the eyes.*

Hand signed consent form by Damien Hirst for *Vanity Fair*.

TOBY YOUNG *Damien had brought his mother along. I thought, If I can't get Damien to behave like a normal human being maybe his mother can?*

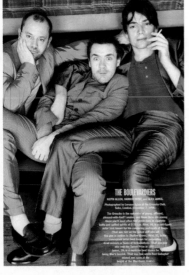

Keith Allen, Damien Hirst and Alex James shot for *Vanity Fair* at the Groucho Club, 7 December 1996.

KEITH ALLEN *We made Toby Young cry because we wouldn't sign the release forms properly. He was like a little baby.*

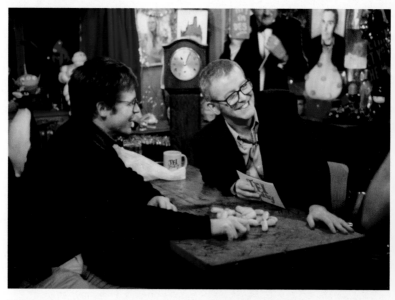

Will MacDonald and Chris Evans on the set of *TFI Friday*, 1996.

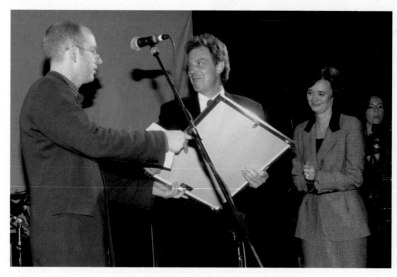

Alan McGee presents Tony and Cherie Blair with a framed platinum disc of (*What's the Story*) *Morning Glory* at the Labour Youth Experience Rally, Blackpool, 28 September 1996.

ALAN MCGEE *Tony Blair was like the indie version of Bill Clinton.*

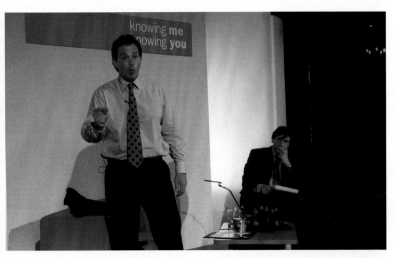

Tony Blair and Steve Coogan (as Alan Partridge) at the Labour Party Conference, Blackpool, 28 September 1996.

STEVE COOGAN *Tony was a bit anxious that I was going to make fun of him. I made it quite clear that Alan Partridge was a Conservative.*

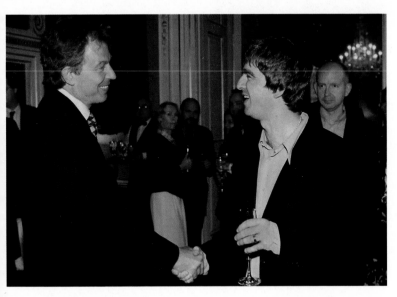

Left: Tony Blair, Noel Gallagher and Alan McGee at a Downing Street reception party, 30 July 1997.

NOEL GALLAGHER *I said to Alan, 'They're going to destroy us for this.'*

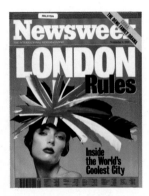

Above: A model wearing a Philip Treacy hat on the front cover of *Newsweek*, 4 November 1996.

Left: Patsy Kensit and Liam Gallagher shot for the front cover of *Vanity Fair*, Glasshouse Studios, Shoreditch, 12 November 1996.

NOEL GALLAGHER *Liam looked like an absolute fucking idiot with a nipple on his head.*

Noel Gallagher at Maine Road, Manchester, 27 April 1996.

NOEL GALLAGHER *Oasis were the biggest band in the country, soon to become the biggest band in the world.*

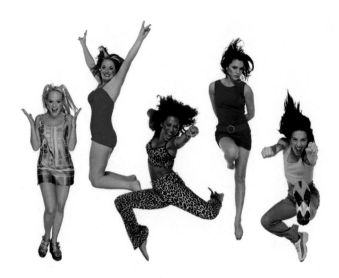

The Spice Girls (l-r) Emma Bunton, Geri Halliwell, Melanie Brown, Victoria Beckham and Melanie Chisholm, 1997.

MELANIE CHISHOLM *'Wannabe' was written in the studio in about fifteen minutes as a bit of a joke.*

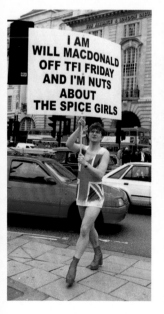

Suburbia (1996) exhibited at *Jeremy Deller: Joy In People*, Hayward Gallery, London.

JEREMY DELLER *I liked the idea of the flag celebrating a state of mind.*

Left: Will MacDonald dressed as Geri Halliwell, Piccadilly Circus, 1997.

Tony Blair and Alastair Campbell, London, April Fool's Day, 1997.

TONY BLAIR *I used to spend a week, ten days, working on a conference speech. It was an agonising process. There would be drafts, redrafts; it would be an incredibly difficult, time-consuming, anxious period.*

Mat Collishaw and Tracey Emin at the opening of *Sensation* at the Royal Academy, 18 September 1997.

TRACEY EMIN *I caught people's imagination. Art wasn't something that was ivory tower and elitist; art was suddenly on the streets.*

Myra by Marcus Harvey displayed at *Sensation*, Royal Academy, 1997.

TRACEY EMIN *Using children's hands to make a picture of Myra Hindley has really big questions marks for me.*

You were the Peoples Princess,
Loved by the press,
Yours was a lottery of Death
not numbers,
And that has numbed us,
The Queen of Hearts,
Who died in France
With the man you love
Now you both rest above,
Far from the Papparazi
who acted like Nazis.

R.I.P.

Poem written by Jeremy Deller, 'The Mall', London, 3 September 1997.

JEREMY DELLER *I typed a 'bad' poem as a small act of opposition to the prevailing mood.*

Jeremy Deller's poem covered by flowers. The Mall, London, 3 September 1997.

Above: David Beckham is sent off for England in the World Cup quarter final match against Argentina, Stade Geoffroy-Guichard, Saint-Étienne, June 30 1998.

MELANIE CHISHOLM *We were in a bar in New York watching the game. David became public-enemy number one, so he flew over to join us.*

Gurinder Chadha at the Sundance Film Festival, 2003.

GURINDER CHADHA *It doesn't matter who you are, what age you are, what background you are, there's an innocence about Bend It Like Beckham that refuses to let the world of racism or prejudice against people of different backgrounds figure.*

The Queen with Tony Blair at the opening of the Millennium Dome, 31 December 1999.

TONY BLAIR *I became absolutely transfixed that one of these acrobats was going to fall from a great height and squash Her Majesty.*

your traditions.' Then I asked him what type of Christian he was, adding, 'Presumably you don't go out playing the tambourine and singing "Kumbaya, My Lord"?' He was uncomfortable answering because he had a brand, which was 'regular guy'. As he used to say, 'Likes football, likes music.' Christianity doesn't fit in with that. I came away thinking, I'm not sure there's a person in there, but he's very good at giving a sense of being a 'regular guy'.

DARREN KALYNUK I was working in party HQ, and after all that had been going on I got a call from Blur's manager a week before polling day, saying, 'How do you register to vote?' I said, 'You can't. It's too late.' Whether you'd have got Alex James voting for Labour at that stage, who knows? I think he'd always been a Tory.

NOEL GALLAGHER I voted at every election, and local elections. Abso-fuckin-lutely. I was on the dole. And it was something to do. I might have got a job out of it, or met a woman. I walked to the polling station in Primrose Hill and it was empty. I thought there'd be loads of press. They were clearly all busy doing something else.

ALASTAIR CAMPBELL Alex Ferguson was watching the live coverage on the BBC, and phoned me and said, 'They're filming you and Tony through the curtains . . . yes, that one.' I closed it and he said, 'That's better.'

JOHN NEWBIGIN I was at Labour HQ that morning and Tom Sawyer, the General Secretary of the Labour Party, was looking down. I said, 'Tom, what's up?' He said, 'We've booked the Festival Hall, and it looks like it's going to be a really massive victory and now the whole world wants to come. We haven't got any fucking money.' I said, 'How much do you need?' He said, 'Twenty grand'. I said, 'David Puttnam and I will raise it.' And, over the course of the day, we did.

MARGARET McDONAGH In a way, choosing the Royal Festival Hall as a location represented the coming out of Cool Britannia as a link to when it was built for the Festival of Britain in 1951; that hope and culture for the masses.

ALASTAIR CAMPBELL It was a really strange night because I was exhausted and probably depressed. I wasn't feeling the euphoria and I was anxious that I had a new job starting in the morning. There was just so much to do. We had agreed that Tony would do an interview with John Simpson on the BBC, but when we got to the count Tony said, 'Oh, I can't be bothered.' I said, 'Well, I'd better do it.' I didn't do many interviews and I was miserable. John Simpson was trying to get me to be happy: 'You've won, haven't you?' I said, 'Mr Blair's constituency is not yet declared but we're having a pretty good night. We'll get through tonight and then we'll think about whatever problems may lie ahead.' Simpson handed back to the studio and said, 'It sounds very much like bitter introspection there.' And David Dimbleby, in the studio said, 'Labour sound very downbeat . . . perhaps they know something that we don't.' I got loads of messages from people watching, saying, 'What the fuck is wrong with you?'

GEOFF MULGAN I'd been through so many defeats that part of me thought, We'll be screwed again. But it quickly became obvious what was happening.

ALASTAIR CAMPBELL I didn't behave euphorically all night. I was absolutely focused and on it. Interesting, isn't it? The only big moment of emotional release for me was the night before, when my son, who would then have been seven, said, 'Are we going to win?' I said, 'Yeah, I think so.' He said, 'That's good.' And then I started crying. That was it. I didn't do the celebration thing at all. It was partly because Tony didn't. He saw the exit poll and said, 'Do you think that's right?' It wasn't like, 'YEAH!' If you watch me at a Burnley game and we score a goal, I'll go absolutely mental. There was no punching the air. There was nothing.

TONY BLAIR I was quite subdued for two reasons. Suddenly you're about to become Prime Minister. I'd learnt enough by then to realise that was a wholly different thing from being leader of the opposition; you're about to be, literally, in charge of the country. And I'd never been a minister before, never mind a senior minister. So obviously that was a huge thing. Then, as the first results came

in, we were so far ahead. It was like we had over 120 seats and the Tories had 8 or something. I was thinking, Oh my God! I want a large victory, but I don't want to do something that distorts the entire constitution in some way. So I was in the bizarre situation of being quite pleased when a few Tory wins started to come in.

PETER HYMAN We were at Millbank at central office, and had been so schooled in 'don't take anything for granted'. Once the exit polls predicted a landslide and the first results started rolling in, you thought, This could be very big. There was an overwhelming sense of achievement and tiredness.

TONY BLAIR I never allowed myself to speak or think like this at the time because of my fear of giving off a vibe to the people around me that said, 'This is in the bag.' I hated any notion of complacency, but the reality was I thought that we were going to win. What I didn't know was whether we could pull off a landslide.

ALASTAIR CAMPBELL We were watching the telly and there was just this rush of seats falling to Labour. There was one, and Tony said, 'Who's that?' We hadn't even campaigned there. Tony was wearing the most ridiculous clothes you've ever seen: a rugby shirt, dark-blue tracksuit bottoms and these kind of fluffy granddad slippers, and he was on the phone to Major, who was conceding defeat.

TONY BLAIR John was very gracious, and I think I was very gracious back. It was a really rough moment. I felt sorry for him.[2]

ALASTAIR CAMPBELL Then we got flown on this little plane from Sedgefield to Stanstead. My pager was on and it was endless. 'Labour gain. Labour gain. Portillo lost.' It was just crazy. Landed. Got in the car. Into the convoy. As we approached the Festival Hall the lead car went down the wrong road and we got stuck. We could hear them playing 'Things Can Only Get Better', and on the radio they were saying, 'Tony Blair is here . . . he's very close now.' The convoy had to do a three-point turn and then get back into

2 Labour won 418 seats (273 in 1992). Conserives 165 (343).

the right order, with Tony's car at the front. We'd scribbled these thoughts down on the plane, and as we arrived I thought, Shit, I've got his words. So I jumped out of the car while it was still moving and it went over my foot. It was agony.

DARREN KALYNUK 'Things Can Only Get Better' played on a loop before Tony came on stage. It went on for ever.

CHARLIE PARSONS There was an amazing atmosphere inside the hall. It was like being in a Wham! video. It was so lively and everyone was extremely excited. When Blair arrived it was like a phenomenon, like being rescued on the *Titanic*.

TONY BLAIR I knew that I couldn't come out and be downbeat because that would be ridiculous, so I was in the spirit of the occasion, but I was sort of knowing I had to be in the spirit of it. It was really two parallel universes: everyone euphoric, delighted, over the moon, and the celebrations were extraordinary; but I felt very detached. Was there any feeling of euphoria? If I'm really honest about it the answer is no.

DARREN KALYNUK Tony's speech was extraordinary. He came on stage and said, 'A new day is dawning, is it not?' It sent shivers down my spine. It felt like you were at a moment in history, and literally the dawn did just break; whether it had been timed by Alastair, I don't know. It was just the most extraordinary experience.

CHARLIE PARSONS All these people who had been party activists for months, if not years, and suddenly their dreams had come to fruition. The celebrations lasted all night.

DARREN KALYNUK It was dreamlike. The cream of the entertainment world was there and the alcohol was flowing. One moment I'd be with some friends who worked for MPs, and the next I'd be chatting to Janet Street-Porter or Neil Tennant or Eddie Izzard. It was that kind of night. Pete Cunnah[3] came bounding off stage and we gave each other a bear hug. 'That was fucking brilliant.

3 Lead singer of D:Ream and co-writer of 'Things Can Only Get Better'.

Thank you *so* much.' I shouted back. 'No. Not at all. Thank *you*.' Everyone was on such a high.

JOHN NEWBIGIN It was total madness. At about five o'clock in the morning I came out of one of the side entrances with John Prescott and there were thousands of people on the South Bank going, 'Yeaaah!' It was incredible.

JEREMY DELLER It was a scene of chaos; all these people getting drunk on champagne. We were stealing bottles going, 'It's all right, it's the new dawn,' and spraying champagne everywhere. At one point, we started climbing the steps onto John Prescott's election bus, which was going back to Hull. We ended up in the basement of Festival Hall with Neil Tennant and Mick Hucknall drinking.

STEVE COOGAN I was watching the result in the bowels of the BBC in a screening room with a bunch of people, sitting on a carpet next to Valerie Singleton from *Blue Peter*. It wasn't lost on me that this was an icon of my childhood. It was a very magical evening and very exciting. When Michael Portillo lost his seat there was a huge cheer in the room.

DARREN KALYNUK Stephen Twigg turned up as we were all coming out, having beaten Michael Portillo. Twigg was standing up through the sunroof of a car and someone was driving him round and round and beeping the horn, and we were all giving him huge cheers.

ALASTAIR CAMPBELL Do you know what was funny? During all the noise and commotion Tony and I were taken up to this little room. I said, 'I just want to go home.' He said, 'Yeah, I know.'

TONY BLAIR One of the advantages I have in temperament is that that kind of adulation doesn't really turn my head. I realised that this was a great moment, but I was focused on the fact that I was about to go into Downing Street to start governing. I was happy, don't misunderstand me, and I was pleased we'd fulfilled our purpose, but I wasn't euphoric. I was just very sober; in the real sense and terms of my mental approach. I didn't have anything to drink the entire night. I think I was the only sober person in the Festival Hall come the morning.

MARGARET McDONAGH At about six-thirty Peter Mandelson said, 'We'd better go and see who we've elected.' We went back to Millbank Tower, and people were ringing up who hadn't expected to get elected, in absolute shock. I then went up to Downing Street and the world's media was there. I was standing opposite Number 10 and John Major came out with his family. He made a great speech, but I was thinking, I've got all this to do, you need to get a move on. Then I slapped myself in the face. This is history. This is going to be us one day.

SHERYL GARRATT I was at home with my newborn baby but most of my friends were at a party, and every time a big Tory went down they wrote their name on a rocket and let it off. There were fireworks all night! We felt like it was a new start. We were so euphoric. I was just old enough to vote when Margaret Thatcher won in 1979, and then from the age of eighteen my party had lost every election.

NOEL GALLAGHER I'd been invited to the Festival Hall, but I stayed at home with a load of people and we played 'Revolution' by the Beatles in the back garden.

JARVIS COCKER We were living in this posh block of flats in Maida Vale, in the top-floor apartment with a shared garden in the back. My girlfriend was so excited she got all the toilet rolls in the house and went out onto the lawn and spelt 'I Love You All' with them all. I remember us going for a walk the next day and, because it was such a revolutionary thing that a Labour government had got in, we were trying to look for the world to be reborn.

CARLA POWER I was in a taxi going down the Strand, and for a brief, shining moment it looked all sunny and clean and fresh and like the possibility of a bright future.

MATTHEW WRIGHT Remember the famous photograph with Cherie outside Number 10 with a nightgown on putting the milk out, looking really fucked up? That summed up how we all felt the next day. It felt like the most amazing change politically of my conscious life.

STRYKER McGUIRE Those images of Tony and Cherie going into Downing Street that first morning and there's all the people waving little flags. Labour had stage-managed that.

MARGARET McDONAGH It wasn't stage-managed. We were thinking, We don't want people to get crushed. There were thousands of people outside the gates, many of them hadn't gone to bed and were really drunk. We got all the staff from Millbank and invited activists and placed them outside Number 10, and then we let everyone else in behind them.

DARREN KALYNUK It was such a clear blue sky and everybody seemed to be smiling. I went to a brunch at a friend's house who worked for an MP, and we got a call saying, 'Anyone who's got party passes, they're letting them in outside Number 10.' We jumped into taxis down to Downing Street and we were handed Union Jacks. Tony arrived with Cherie and did his speech. And then, when he went inside, I had my picture taken outside with my flag.

ALAN BARNARD I stood at the gate handing out little Union Jack flags, and then I started singing, 'We're coming home, we're coming home, Labour's coming home,' and the whole of Downing Street took it up.

ALASTAIR CAMPBELL I phoned David Hill, who was the Labour press guy at Millbank, and said to him, 'Can you stop them all celebrating? It's looking really complacent.' He said, 'Listen, we've just won a landslide! Do you realise?' I said, 'I know, but I think we should calm down.' I was in the mode of campaigning still. I resent the fact that I didn't enjoy it.

TONY BLAIR We had a great time that morning going up Downing Street. There were a lot of people there and that was all nice. And then crossing over the threshold into Number 10. I went down the corridor to see the Cabinet Secretary, Sir Robin Butler, who was sitting in the cabinet room alone. He motioned me to the chair next to him and said, 'Well done.' I said, 'Oh, thank you.' He said, 'Now what?'

THE MATCHMAKER

Downing Street reception party

TOBY YOUNG There is this myth that there are a few really smart people who sit around in a room and decide on how the époque is going to be defined, and then just go about creating it and making as much money as they possibly can, having sold everyone on their vision which they've pulled out of their belly buttons. It doesn't work like that. The people who really profit from phenomena like Cool Britannia don't think of themselves as the Promethean creators of it. Rather, they see themselves as having spotted the potential in something sooner than anyone else and know how to bottle and sell it better than anyone else.

MATTHEW FREUD Prior to the nineties, the entertainment industry didn't have much to do with politics, for good reason. The media was not integrated. Fleet Street was a self-contained fourth estate. The media were doing their job, which was reporting on what happened, as opposed to becoming a principal player in what happened. There was a muscularity in newspaper editors suddenly sitting in social environments, off duty, with prime ministers and senior politicians and rock stars and CEOs.

STEVE COOGAN Matthew Freud was connected and knew everyone and knew what was cool and how to position yourself. He was one of the people directing this new vanguard.

MATTHEW FREUD The trick is to have everyone feel off-duty. You can disarm people by who else is in the room because

they cancel each other out. The billionaire is impressed with the rock star, the rock star is impressed with the politician, and the film star impresses the politician. Everyone walks in and thinks, It's not about me. If you allow people to interact naturally then interesting connections come out of it and stuff happens. It's matchmaking, but where the matchmaker has no inherent power.

WAHEED ALLI Matthew engineered: he put together people for political purpose; for commercial purpose; for financial purpose. He really did change the way those people behaved towards each other. Some of those newspaper editors: Rebekah Brooks's relationship with Tony came from the Freud connection; a lot of those big Rupert Murdoch connections are through him.

MATTHEW FREUD Rebekah is not an insignificant person in all of this. Her ascendency from being an entertainment journalist on the *News of the World* to editor of the *Sun* who was friends with prime ministers and movie stars and CEOs and captains of industry and sports stars; that had never happened before. Those boundaries came tumbling down at a point where everyone was having a good time hanging out together.

KEITH ALLEN I remember saying to Rebekah Brooks at a party, 'Your cunt stinks,' and she tried to laugh it off.

JOHNNY HOPKINS New Labour was extremely good at working the media, all the razzmatazz and glamour and positivity. They were riding the back of everything that was going on under the banner of Cool Britannia. Blair was able to harness that feeling of healthy national pride to build support. Everyone was buying into his dream.

NICK HORNBY I had lived all through my adulthood where the Prime Minister was a philistine. Margaret Thatcher's knowledge of the arts was Jeffrey Archer, Andrew Lloyd Webber and Cilla Black. There was no one else.

JOHN NEWBIGIN Thatcher was not interested and made that very

clear. And although Major came from a circus family, he was not particularly interested either.[1]

ALASTAIR CAMPBELL To some extent, you've always had celebrities; it was challenging the Tories on their own turf. It will sound ridiculous now, but Jim Davidson, Cilla Black, Michael Caine had always been around them. It's back to the change in the media. We were becoming a much more celebrity-focused culture. But I don't think we should overstate what these celebs do. I've never met a single person who has said to me, 'Oh, I hanged my vote because *x* celebrity said so.' I don't think I ever thought, If Noel Gallagher told all those people to go and vote Labour they would. A lot wouldn't. But equally they do have a place and it's good to know that they're there and they're supportive.

CHRIS SMITH There was a search for celebrities who were willing to be seen as part of the overall New Labour project. That was all generated by Alastair Campbell and the people around Blair. It was certainly approved of that ministers were seen associating with people who were big in the public eye.

ALASTAIR CAMPBELL You can create a sense of momentum by the people you identify with. It's strategic communication: you're painting a never-ending mosaic and you're trying to land all the messages on your terms. Having people around gives energy to the thing. I don't think it creates it. It adds to something.

MATTHEW FREUD It was natural to bring media and celebrity and entertainment clients together under one roof. It was about providing an environment where senior politicians could meet and interact with people who were useful to them, where those opportunities don't naturally occur. The right way to do it is to be in an environment where you're not Prime Minister and they're not a rock star. You're both just two people who happen to be at

1 JOHN MAJOR My father was a trapeze artist when he was young. Then he was diagnosed as having an arrhythmic heart problem, so he went into show business as a comedian and a singer, and formed his own travelling show. My mother was a dancer in the show.

a party, both off-duty, and you meet on neutral territory to see if there's mutual interest. Here's the wrong way to do it: throw a party at Downing Street and invite a lot of people who don't quite know what they're doing there.

JOHN NEWBIGIN One of the first things that happened after the election, as a symbol of change, was the suggestion to Downing Street to have a big event and invite all the movers and shakers from arts and culture to celebrate British creativity. We were responsible for putting the guest list together. The cultural life of the country had not been celebrated for a very long time, despite the arts being a growing part of the economy.

TIM SOUTHWELL It was a hedonistic time. It really was. You even had pop stars going to 10 Downing Street and doing a line of cocaine in Blair's toilet.

ALAN McGEE Me and Noel got an invitation to go to Downing Street. Alastair phoned me up and went, 'Is Noel going to behave?' I went, 'Yeah, he's going to wear a Gucci suit.' He went, 'No, is he going to *behave* . . .?' Meaning drugs. I went, 'Oh! No, no, he'll be fine.'

ALASTAIR CAMPBELL I said, 'Look, he's not going to do anything daft, is he?' Alan said he would make sure he didn't mess about but it would be different if we'd invited Liam. He said, 'Noel has got his shit together.'

JOHNNY HOPKINS I voiced serious concerns about Noel going to Downing Street. I felt that sense of triumph of getting the Tories out and Labour in, but I still had a bad feeling that they would not be everything that we hoped for and that people would see Oasis as part of the establishment.

NOEL GALLAGHER I'd only signed off the dole three years before, and we arrived at Number 10 as the guest of a Prime Minister after ousting the Tories, in this Rolls-Royce that Alan had bought for me. We were laughing and saying, 'This is insane.'

ALAN McGEE It was a ridiculous moment.

TONY BLAIR I didn't actually know Noel was coming to Downing Street that night. I think Jonathan [Powell] invited him. We literally bumped into each other in the course of this evening. We had a very nice chat.

NOEL GALLAGHER I realised thirty seconds before he walked into the room that this was going to be the moment. A scene happened. I was stood around a load of people, and then they all moved back, and at that point, I thought, Oh, okay. This is going to be the picture, then. We talked about the election night, and I said, 'It was brilliant, man. We stayed up till seven o'clock in the morning to watch you arrive at the [Labour Party] headquarters. How did you stay up all night?' Blair leaned in and said, 'Probably not by the same means as you did.'

ALASTAIR CAMPBELL It's funny because you never know what the picture's going to be. You can never plan it completely. There were lots of people there but that picture of Noel and Tony looking at each other became a symbol of something. It gave the message a different dimension and we got it on the TV news. You're just looking for things the whole time.

NOEL GALLAGHER The only thing that really annoys me about that picture is what I chose to wear. I've never owned a suit in my life. Paul Weller was disgusted.

TONY BLAIR I think Noel may have signed something for the kids.

ALASTAIR CAMPBELL Cherie took him upstairs to see Kathryn and Nicky [Blair's Children]. They were gobsmacked when he walked in. Noel was pretty laid-back and funny. He took a wander into the cabinet room, and was going, 'Wow! This is pretty impressive.' He said he thought Number 10 was 'tops' and he couldn't believe there was an ironing board in there.

NOEL GALLAGHER Tony had a red Fender Strat on his bed, which was in tune. I was like, 'That'll fucking do me.'

JOHNNY HOPKINS Noel scrawled a Hitler moustache on a framed photograph of Margaret Thatcher. Maybe it was worth it just for that.

ALAN McGEE Did Noel say he graffitied a picture? I don't remember that. Johnny wasn't there, so he wouldn't know. Noel was pissed, so fuck knows. I don't think he did. It just made a good story.

NOEL GALLAGHER I've heard that off three separate people who are not even connected. There's no fucking way!

LORENZO AGIUS Noel told me they did coke in the toilets.

JOHNNY HOPKINS I could imagine he might have done. You'd have to ask Noel.

NOEL GALLAGHER Did I do coke in there? I knew about the Beatles at Buckingham Palace and having a spliff. You can draw the comparisons if you want. I'm saying fuck all. I've got three kids now.

ALAN McGEE He never done fucking coke there – fuck off!

KAREN JOHNSON It wasn't just Noel. It was the Pet Shop Boys and Vivienne Westwood, Simply Red, Eddie Izzard, Sinéad Cusack, Lenny Henry, Maureen Lipman. In a way, it was easier for the other artists, but for Noel it haunted him. He tried to laugh it off: 'I wasn't going to go at first because I thought we would get slagged off, but I rang my mum and she said it was a great honour for her to say one of her sons was going to see the Prime Minister.'

NOEL GALLAGHER I didn't give a fuck. I was neither proud nor embarrassed. I was just there because in some small way they were thanking me for getting elected, which is ludicrous. The door of Downing Street is historic, Churchill and all that. I'm a keen historian. I went because I'm nosey and inquisitive and I wanted to see what was in there.

NICK HORNBY It was a big thing. It seemed to be a celebration of British art in some form. The people there were all writers, musicians, filmmakers, designers. I remember Mike Leigh and Mick Hucknall being there. There was a formal line of some kind and I shook Blair's hand. He said, 'Hello, Nick,' because somebody said, 'This is Nick Hornby.' I had no idea if he had read my books.

Margaret Forster said he made an obscure reference to a book she had written about the Carr's biscuit factory.[2] She thought that was extraordinary and showed he had done his homework.

SUZI APLIN Chris went with Zoe Ball. I thought, Why not? It was New Labour. It was an exciting time of change. If you were a new, young broadcaster why would you not go to Downing Street? You wouldn't want to go and meet John Major. Blair was someone who wanted to change the country; someone who had more liberal views.

WILL MACDONALD It seemed so normal Chris should be invited; that the world of politics and music and fashion and TV were all colliding. It was an exciting time. Tony Blair was a young, groovy guy.

JOHNNY HOPKINS It was a once in a lifetime opportunity; very few people turned it down.

KAREN JOHNSON My advice to Damon was, 'You should pull back. You'll never hear the end of it if you go. They're using you to make themselves look cool.' The argument that won him was, 'If something comes up in the future that you object to and you're seen as part of the establishment, will you have credibility to fight against it? Won't it feel hypocritical?'

DAMON ALBARN I'd received a letter telling me not to talk in the press about the Blairs' decision to send their children to the London Oratory School. That was the point I started to go, 'Hang on, this is a bit weird.' I started to realise that there were darker forces afoot. That played into me not going to the reception party. It was fantastic the Tories had finally been removed, but thankfully I was self-aware enough to realise that there was a seduction at play. It would have been too easy to go there and bathe in the radiance of this new dawn for the country. I'm glad I didn't go. Instead I sent a note that said, 'Dear Tony, I'm sorry, I won't be attending, as I am now a Communist. Enjoy the schmooze, comrade!'

2 *Rich Desserts and Captains Thin: A Family and Their Times, 1831–1931.*

DARREN KALYNUK Whether he really did or not, I wonder. By that stage, the Labour Party's money was on Oasis rather than Blur. Oasis had won the war rather than a couple of the skirmishes. They were a lot cooler. They were much more in touch with Labour's working class and seen as more authentic than Blur, who were a bit more flaky, middle class. With Oasis and Alan McGee you got what you saw on the tin: working class made good. That was the distinction. It just felt like a more natural fit.

DAVID BADDIEL It was a specific attempt to occupy the cool ground: 'I'm going to invite and hang out and be photographed with pop stars.' The nineties' *enfant terrible*. I wasn't invited, despite having been one of the few people who could be said to have actively helped the Labour Party get in power, in so far as Tony Blair nicked that line from 'Three Lions'.

STEVE COOGAN I was a bit miffed. 'I fucking helped you lot out, why didn't you invite me?' The whole Cool Britannia thing started to lose its sheen. I remember thinking, I'm glad I wasn't there.

KATIE GRAND I'd been brought up very socialist, but Tony Blair had nothing to do with what I believed in. I thought it was ridiculous that he was using all these fashionable pop stars to hang out with. Blair destroyed my socialist values. New Labour was another slogan. It was an ad-agency thing. I was really pleased that Labour had got in, but I lost interest in politics at that point.

JOHN NEWBIGIN There was a rather predictable cynicism: 'This is politicians trying to climb on the bandwagon . . . trying to cosy up to the public by inviting rock stars and footballers to come and have tea.' The point is, if you're going to represent popular arts and culture you had to represent music, and there was nobody better than Oasis. The fact that there were several hundred other people there representing all kinds of areas of fashion and the arts got forgotten in the story.

NOEL GALLAGHER I remember standing on the doorstep when we were coming out, and the world's press were there. I said to Alan, 'They're going to destroy us for this.' He said, 'No, I don't think

they will.' I went, 'You fucking mark my words.' I knew people would be cynical about it. Give a fuck!

IRVINE WELSH These guys, they're like all salesmen. They want you to write a cheque. Then they want you to tell them how brilliant they are and give you fuck all back in return. Noel had more confidence in Blair than I did. That political thing was very much his generation, I'd seen it before. You looked at Blair and knew exactly where he was coming from. Alan, I was more disappointed with. He'd been around long enough to know better.

ALAN McGEE I just wanted to go and see what the fuck it was like. I didn't see it as selling out.

KAREN JOHNSON It was on a constant loop; it was always Noel's picture. It was a mistake. He was being used for political gain, which is understandable.

SIMON FOWLER I thought it was great Noel went because Tony Blair was the first Prime Minister who represented my generation. But Noel was used, to a degree. It blew a hole in the idea of music being anti-establishment.

NICK HORNBY Rather than saying these people all jumped on a bandwagon, the key is to look back to a time when they were ten and eleven and see what was going on. Blair was a teenager watching George Best. He was a teenager when England won the World Cup. He was a teenager when the Beatles were going through a freakout stage and meeting Harold Wilson. Pop culture was affecting these kids very deeply. And they then go on to write books or make films or become prime ministers.

PETER HYMAN The most famous post-war picture of celebrity plus Prime Minister is obviously Harold Wilson with the Beatles. It was nothing new for politicians to attach themselves to glamorous pop stars.

TONY BLAIR It was very impactful because people like that had not been invited into Downing Street probably since Harold Wilson. And

in any event, probably someone like Noel wouldn't have come if he'd been invited to a reception of a Tory government.

SIMON FOWLER Harold Wilson was the Tony Blair of the time: the 'white heat of technology'; the new start; and presenting the Beatles with MBEs, trying to get a bit of their coolness rubbed off on them – or was it trying to neuter them to make them establishment? Noel knew all that. He loved being Lennon, 'I'm fucking John.'

STEVE LAMACQ In October 1997, I interviewed Noel on *The Evening Session*. I asked him about going to Number 10. He said, 'I've taken a lot of flak for going to 10 Downing Street. I never considered myself a rebel anyway. I'm thirty years of age. I wasn't going there representing a load of shit-kickers who sit in bedsits in Dagenham. I was going there for me. You have to understand, right, that from when I went to school, and from when I was born, all that we ever knew was Conservative, Tory, right-wing government. What people say is, "He went to meet Tony Blair." No, I went to meet the Labour Prime Minister. The thing is, for eighteen years, people in this country moaned about wanting to get a Labour government into this country, and as soon as they got it they're all moaning about it . . . our parents always drummed into us that the Labour Party was for the people and the Tory Party was not. And I went to meet the Labour Prime Minister. Period. To anybody listening to this . . . have you been to 10 Downing Street? No! Well I have, so shut it!'

MARGARET McDONAGH If you listened to Noel's interviews, he was that embodiment of a working-class guy: he keeps his culture and his class heritage but has an aspirational desire to have a nice house and nice things and to do well for his family. That symbolism was important. It was an embodiment of Cool Britannia: that renaissance of the sixties; of getting on, aspiration, going somewhere as a country, an individual, a community.

PETER HYMAN I don't think we always got it right. We were opportunistic about putting out comments on things that were in the culture. We put out a comment on the *Coronation Street*

'Free Deirdre' campaign and when Glenn Hoddle made ill-advised comments about people with disabilities. We wanted to be part of the mix, but we did too much of it.

ALAN McGEE It was opportunistic and using the situation. Blair probably believed it. He'd always wanted to be in a band and then he wanted to be the cool guy that runs the country, which he was until he bombed Iraq. He was using it.

MARGARET McDONAGH You're coming to this in a boxed way: 'These people have got a lot of fans, let's go and court these people.' That's not how it was. Our politics, our passion, our purpose, it's how we think: in music, in words. It was about collaboration and forging relationships to communicate. A song is to communicate. A political party is to communicate. I saw as one, the message and symbolism of Oasis and what Labour was trying to achieve. If you look back to previous elections, so many working-class people didn't see Labour as the way out of the situation for their families or communities. It was a way of reaching that. It wasn't some cynical ploy; 1997 was a celebration of what was good in Britain. Britpop was aspirational. Cool Britannia was aspirational.

ALASTAIR CAMPBELL I liked the sense of having a bit of 'a man of the moment' feel to it. That was an important and powerful thing. I'll give you an example. It was Tony's first European Summit in Amsterdam, and the Dutch, being very proud of their cycling culture, had this photo call where they had bikes for all the leaders to cycle over this bridge. I'll never forget Helmut Kohl looking thoroughly pissed off; massive guy, twenty stone. Tony said, 'How the hell is he going to ride a bike?' We had to walk over a bridge and there were some girls screaming, 'Tony, Tony.' I grabbed him and said, 'Just get on a good bike and win. It may be ridiculous but it will be a fantastic picture! Kohl and Chirac held back and the Italian, Lamberto Dini, fell off. But Tony went for it and won. It's all imagery, but it sort of said, 'Blair leading in Europe.' If you did that sort of thing later, when Tony's stock was lower, it wouldn't have worked. You had to seize the moment.

PART THREE

END OF THE PARTY

> > >

SOFTHEADED SOCIALISM

The Project. Class

TONY BLAIR Cool Britannia was something that I understood and received and saw, but it wasn't something I was consciously trying to develop. By the time I got into government I was focused on government. It was bloody difficult. It was even more difficult than I'd thought, to be honest. When you go from opposition to government you switch psychology. The buzz and the zeitgeist plays its part, but the moment you're in government you suddenly realise that what is important is the actual change you can make.

PETER HYMAN We can debate whether Cool Britannia is a useful title and whether it describes what we really meant by it, but what seemed to me essential for 'The Project', as we called it, was that Britain became a more modern country; that it became fit for purpose for the twenty-first century and that we were not just living off past glories. We were trying to forge a country that could compete but also be a cultural centre and do well in the future.

GEOFF MULGAN One thing that modernisation meant was being engaged with the culture of now. People were desperate for a shift in politics. What I think Blair felt they learnt in the eighties was that to have a mandate to govern you needed to be seen to be more in touch with the future. That was a crucial switchover. The Tories became a backward-looking party of village greens and cricket and so on, which worked a little bit for Major, but in a deeper sense backfired. That was the context for Cool Britannia. It was part of a much broader attempt not to be a backward-looking party.

STRYKER McGUIRE 'Cool Britannia' turned out to be a dangerous phrase; it was used to dumb down Blair's whole campaign to modernise the economy, adopt constitutional reform and rebrand the nation with a clear identity. Just as bands of English hooligans marauding through World Cup venues do not advance the cause of rebranding Britain, the lightweight 'Cool Britannia' does no service to serious reforms.

TOBY YOUNG There was an interesting paradox about Cool Britannia, which is on the one hand it felt like an assertion of Britain's status on a global cultural stage, and London in particular: 'We're back. Pay attention to us. We're a vital, creative force in global popular culture.' If *Newsweek* and *Vanity Fair* had not shown the slightest bit of interest it would have felt somehow less real and less valid. It depended on international recognition and validation for its sense of importance; to give it shape and meaning. In a way, the fact that everyone in that scene was ultimately so grateful for all this international attention but pretended not to be, brought home how slight and fragile Britain's self-confidence was.

ALASTAIR CAMPBELL I was always a bit anxious about the Cool Britannia thing. Latterly, we all felt that there was a danger in that people thought, That's all they care about, being cool. They don't really care about schools and hospitals and building new roads. It's all a bit trendy.

VIRGINIA BOTTOMLEY 'Cool Britannia' was an appropriate phrase to promote the tourism industry, but it was not the way to badge a government and be hijacked and abused by the Labour Party.

CHRIS SMITH Nothing appears as silly as politicians using phrases that they think are cool in an attempt to seem in touch with popular culture. I never liked the term 'Cool Britannia'. Of course we wanted to be popular, but not by trying to hijack other people's language. We debated the issue in parliament in July 1998 and I refuted the claim that we were leaping on some bandwagon.

VIRGINIA BOTTOMLEY I argued that New Labour really went for Cool Britannia. The whole style of Blair, copying the Clintons, it was sort of Camelot. It was beautiful people meeting beautiful people. When we were in government I tried to persuade John Major to have a reception for all the film stars who were off getting Oscars. He wouldn't do it because he didn't want people to feel he was cashing in on their celebrity. He was a much more modest man, whereas, when New Labour were in power, every time there was any celeb in town, in they went to Number 10.

JOHN MAJOR Virginia was keen to have a great reception at Number 10 and invite the arts world. I declined because I feared it would be construed as a cheap stunt to capture the glamour of the arts. That wasn't my style. In the middle of a parliament, with no elections due, I would have regarded it as perfectly proper to honour the people who were benefitting our country by their talent.

VIRGINIA BOTTOMLEY It's just a matter of style and taste. I stated in the Commons debate, 'On the day when the House was cutting lone-parent benefit, the Prime Minister was entertaining another four-hundred celebrities, media personalities and pop stars at Number 10. This is a Prime Minister who has systematically sought to exploit the Cool Britannia phrase, which has been spun out of Number 10. It has boomeranged into Labour's face because New Labour dislikes the past – anything that represents the flourishing economy that the Conservatives left in place and anything that represents old Labour. Each is equally unappetising to New Labour.'

CHRIS SMITH It was a complete load of old cobblers. The idea that Tony Blair 'systematically sought to exploit the Cool Britannia phrase' is an unfair judgement. One of the mantras during the election campaign had been 'the future not the past'. To try to pin the Cool Britannia label on Tony Blair or on the New Labour government as something they were infatuated and obsessed with is complete nonsense.

PETER HYMAN Tony consciously didn't use the phrase 'Cool Britannia'; it was absolutely a journalistic invention. It's not about being 'cool'. The idea that Britain wanted to be 'cool' was excluding of people. 'Are you in the "cool" group?' If you're not living in metropolitan circles, 'cool' has a feel of Downing Street parties. That wasn't the point. The point was a serious look, regionally based, to say, 'What are the great strengths of the country?'

ALASTAIR CAMPBELL If you say that Tony 'systematically sought to exploit' the feeling in the country that we needed change; the feeling that the country wanted to shake off this long period of Tory government; the feeling that we wanted to show there was more dynamism or energy and all that – yeah, I'd go with that. But I don't think we hung it on the Cool Britannia idea. Peter Hyman was the person who felt that the Cool Britannia thing had a real purpose and power to it.

PETER HYMAN We did try to shape Cool Britannia in ways that were tapping into the creative talents, the designers, all the different sectors, to say, 'We're a creative, forward-looking country.' If that's called exploitation I'm fine by it. Bottomley wasn't credible. The Tories weren't credible. We were the credible people, to say, 'This country can be modern and forward-looking. We've got a Prime Minister and a programme and we're going to make that a reality.' In the fag end of the Major government they tried to leap on it in a very tired way because they were crumbling. It was never going to work. Virginia Bottomley can be resentful, but the combination of Blair and what he represented, plus what New Labour was about, was always going to capture the mood better than the Tories.

WAHEED ALLI There was a mood and Tony Blair was playing into that. He was going to change Britain.

STEVE COOGAN It felt like something could change politically, but the caveat to that is, if you're cynical and you think, It's just going to be the same old shit, then life becomes rather bleak. You have to hope that someone will buck the trend and things are going to

be better or maybe there'll be an attitude change.

MEERA SYAL It just seemed like it would all change, because of all those years of Thatcherism. Finally, there was someone young and idealistic and smart representing us on the world stage who seemed in touch, much more than any other party leader had been. His youth was a lot to do with it. Generationally, he just seemed much nearer us than anyone else. He was getting down with the common people . . . a little bit.

MATTHEW BANNISTER The new government was trying to show its populist credentials. It was part of a new generation. It felt like the kids had taken over Downing Street: 'We're going to be allowed in where the grown-ups used to be.'

RIC BLAXILL Politics was as much a part of Cool Britannia as what was going on culturally. Blair reflected that new energy and brought the disenfranchised population back into thinking about politics. Everything was becoming so relatable. He was a very charismatic leader.

STRYKER McGUIRE When Blair became Prime Minister, of the seventeen countries of Western Europe, only Spain didn't have a centre-left leader. The whole world seemed to be changing. You had Cardoso in Brazil. Clinton in the US. People talked about the Third Way for centre-left parties to occupy the middle ground by trying to retain their historical social policies but adapting their economic ones. New Labour found a promising middle way: between soulless capitalism and softheaded socialism.

GREGOR MUIR The nineties was an amazing moment when there was extraordinary social mobility between class and profession. There was a sense of the possible. It was a rare moment in time when people from every walk of life came together and didn't hold back. One night I was with Damien Hirst, and some bankers sent over a bottle of champagne and said, 'We just wanted to say we really like what you do and wish you well for the future.' There was social cohesion. It was a coming together.

TRACEY EMIN There was a breakdown in the class system. The seventies had a lot to do with what was happening in the nineties. The comprehensive education system made it possible for a lot of working-class people, people from different backgrounds, to be very creative and do things which normally wouldn't be expected of them, and to rise to the top of their field. Comprehensive kids came of age.

NOEL GALLAGHER The people I met – Damien Hirst, Jarvis Cocker, Damon Albarn – are all of a similar age, similar artistic influences, doers not fucking talkers, and never felt that class was going to hold them back.

TOBY YOUNG There was a class dimension to Cool Britannia – as there had been to the Swinging Sixties – and to an extent fuelled by a hostility towards traditional elites. Thatcherism was definitely of a piece with that: that celebration of Del Boy cockney wheeler-dealer criminality. Most people spoke in Mockney accents, even public-school boys, like Guy Ritchie.

DARREN KALYNUK I went for a drink with Damon Albarn and Alex James at Soho House – they were desperate to get me drunk. Alex said, 'Have a gin and tonic.' I said, 'I don't drink gin and tonic.' He said, 'It's rocket fuel.' We were having a discussion about class and Damon thought he was working class. I said, 'You're definitely not working class. Your parents were teachers.' Alex was saying, 'You're definitely middle class, Damon.'

STEVE LAMACQ It's almost like there was a breaking down of class in the nineties. It mattered more what bands stood for or what they'd been through.

MELANIE CHISHOLM We were taken over to LA, picked up in a big stretch limo, and completely and utterly schmoozed. I hadn't experienced anything like it. I was being taken to some of the best restaurants in the world and learning about wine and food. It was a real education. But it was a bit wasted on us. We didn't give a shit about hundreds-of-pounds bottles of wine and knowing which

knife and fork to use. It didn't mean we weren't good enough; we just saw it for what it was – overpriced.

STEVE COOGAN I had a schizophrenic relationship with class: my Oxbridge gang – Patrick Marber, Armando Iannucci – were more of a Tony Blair mould, and my northern gang – Caroline Aherne, John Thomson – felt more like Oasis. Or, put another way, Pauline Calf was my northern gang and Alan Partridge was my Oxbridge gang. On the one hand, you don't like the inverted snobbery and the limited thinking of where you're from, but the insular echo chamber of *Guardian* readers who live within the M25 and never venture beyond annoys me.

IRVINE WELSH I felt too much of an artsy ponce to be a proper geezer and too much of a proper geezer to be an artsy ponce. Growing up, I'd always been obsessed with football and boxing, but I also loved painting and writing – I was pulled between the two stools. I felt that a lot of people around at the time were in a betwixt and between place, and had to stake out their own territory where they were comfortable.

STEVE COOGAN There's a perennial love affair that posh people have with working-class artists. 'Common People' was about that. It's like a fascination with those creatures from another planet. Their ordinariness seems so alien to them. It's like the adulation that gets shown to Tracey Emin: it's interesting but people go over the top with it.

JARVIS COCKER 'Common People' was about a kind of cultural slumming, of middle-class people being voyeuristic and sneering at the crudity of working-class people; taking pictures and then fucking off. 'Let's leave these people living in shit.'

NOEL GALLAGHER I always thought Jarvis was posh. He wore corduroy blazers and a fucking tie, that's as posh as it gets. And he wore glasses.

BRETT ANDERSON Oasis's shtick was to play the working-class card: the honest working-class boys from Manchester.

NOEL GALLAGHER I don't think I could ever be accused of trading on my class. Other people who are in bands from a council estate wear it like a badge of honour. I was neither proud nor embarrassed by it. I didn't think that my class was either going to propel me forward or hold me back. I wanted a big fucking telly, a massive house, a fucking private jet, and a monkey in a top hat with a cape. Class meant nothing to me. You are what you are. I never felt that I represented anything. Fuck everybody else. People said, when I went to Downing Street, 'You could have worn a fucking Liverpool dockers T-shirt.' 'What would I want to do that for?' ''Cause you're fucking working class, man.' I'm not a spokesman for anyone; never was and I never will be. *Definitely Maybe* was about escaping the surroundings you were in. I didn't want to define who I was. I was just a songwriter in a band. That's it. I've never considered myself a working-class hero. The times I've strayed into that, pissed at award ceremonies, you wake up the next day thinking, What the fuck am I doing?

STEVE LAMACQ If anything it was about us against them, the establishment. Britpop was a weird gang of people who probably weren't that popular at school. Suddenly all the walls were coming down. Everyone was so over the moon that we were breaking into the mainstream that nobody cared where people had come from. That was success in itself.

JARVIS COCKER When Blair came out with, 'We're all middle class now,' I thought, Jesus Christ, so everyone will own a pepper grinder. It was so boring. Let's all be dull. There was that gradual dawning that it was a Labour government in name only.

PETER HYMAN John Prescott said, 'We're all middle class now,' and Tony, possibly, repeated it. The Prescott one was more significant because he was seen as working class.

TONY BLAIR I said at Conference, 'The class war is over. But the struggle for true equality has only just begun.' It needs explaining otherwise it gets misinterpreted, as though you're saying, 'The age

of inequality is over,' or, 'There's no further necessity for social or economic progress.' What I was saying was that the class system should have had its day. The purpose of a Labour government was not to keep people working class and celebrate it, but to give them the opportunity to become middle class, to be better off, to be better educated and to have more opportunities. Working-class people had 'jobs', middle-class people had 'careers'. I wanted all people to have careers. One of my frustrations was that too many Labour people wanted to celebrate the fact that they're working class or they're in a position of poverty, and say, 'Look, isn't it terrible?' Our purpose was to lift the people out of that situation. The class system shouldn't define our future. The other thing I was doing was saying to people, 'You've got to create the conditions in which there is genuine social mobility, and it's our task to give the people who don't have opportunity, opportunity.'

STEVE LAMACQ What Blair should have said was, 'We're all class-less now.'

BATTLE OVER BRITAIN

DEMOS. Union Jack.

Creative Industries

DAVID BADDIEL Cool Britannia wasn't about class. It was about identity. Instead of political parties being defined almost entirely by their attitudes to the economy, suddenly it was about branding. That was identity politics. Cool Britannia was about the first flush of identity becoming a different thing from class. The Labour Party may have won the '97 election partly through the beginnings of identity politics.

MARK LEONARD The think tank DEMOS was set up by Geoff Mulgan in the wake of the defeat of the Labour Party in 1992. The idea behind it was to find a new radicalism, to 'reach beyond left and right' and look at where the energy was for rethinking about Britain. Geoff got people involved ranging from some of the more radical Thatcherites to DEMOS' co-founder Martin Jacques, who was a member of the Communist Party and editor of *Marxism Today*. They were challenging some of the precepts of economic thinking to look more at people's values and cultures, and using focus groups and opinion polls as a way of looking at where the lived experience of politics interacts.

ALAN BARNARD I'd heard of DEMOS. They'd got long words.

MARGARET McDONAGH DEMOS emanates from Greek – 'the common people'. We wouldn't read intellectual stuff like that.

GEOFF MULGAN DEMOS got a lot of airtime in the mid-nineties. A lot of the politicians and people who were going to be in government had absorbed a lot of the thinking. There were many direct connecting threads. In the years after the fall of Margaret Thatcher there was this odd disjunction between a rather stuck political class and a sense there was a bubbling up in British culture, but it wasn't being reflected in the establishment structures and institutions.

STRYKER McGUIRE What Blair recognised that the country had been wrestling with was the question, 'What is our identity – what is our place in the world?' Blair figured out that the way for the country to become more prosperous was to become international, and secondly, to attach itself to the United States. He saw Britain pretty much the way the United States in the post-war years had seen Britain, which is as a bridge between the US and Europe.

MARK LEONARD I'd been doing quite a lot of work on identity and the problems Britain was having in Europe. Geoff had arranged to do a project with the Design Council on the idea of rebranding Britain and asked me if I wanted to work on it.

GEOFF MULGAN We set up a little project to look at Britishness and to articulate a British vision which more accorded with the kind of emergent, growing, dynamic, exciting aspects of culture rather than the backward-looking ones, which was how the rest of the world saw us. I wrote a thing called *Britain TM*, which in the end I had to take my name off because I was working in government. So Mark worked on it.

MARK LEONARD My starting point for *Britain TM* was more a sense that the country was going through a profound period of malaise: nothing seemed to work very well anymore; politics was very stuck and grey; and most of the national institutions had lost enormous respect, from the monarchy to the House of Commons. Loads of companies were hiding their Britishness: British Telecom, British Gas, British Home Stores and the British Airport Authority all dropped the 'British' from their names; and Dixons set up a fake

Asian brand called Matsui because no one would buy a British television. There was a domestic crisis of national identity after over a decade of Thatcherism.

PETER HYMAN Mark came in with some very useful stuff, which gave some depth to this.

MARK LEONARD Part of what I was reflecting on was how a lot of those stories, which were incredibly powerful in their time, were no longer true anymore: 'Where Britain is recognised, it is seen as a country whose time has come and gone – bogged down by tradition, riven by class and threatened by industrial disputes, the IRA and poverty-stricken inner cities. The British people, meanwhile, are seen as insular, cold and arrogant – the inhabitants of a theme park world of royal pageantry, rolling green hills and the changing of the guard.' It was an idea of Britishness that was created when Queen Victoria was on the throne and was reinvented when Elizabeth became Queen. It was a pastiche.

GEOFF MULGAN Britain was selling itself to the world as royalty and stately homes; a very backward-looking version of Britain. The old props of British identity were all problematic. There was a need for a renewal of national narrative and identity. I wanted to be forward-looking, but also to reinterpret a history: traditions of being a cosmopolitan, entrepreneurial trader, traditions of migration, traditions of creativity and experiment and radicalism. We were trying to say that radical history is every bit as much a truth of Britain of the last three-hundred years as the Britain of monarchy and stately homes. We needed to link what was dynamic in the present to what was a really dynamic story of the past.

PETER HYMAN It seemed to me that a lot of what Britain was about was the nostalgia industry, and that other countries had managed a better fit of its history and heritage with a forward-looking nation. For example, Italy with Armani and furniture design alongside Michelangelo statues and Leonardo da Vinci and old churches. They

had blended 'where we've come from' and 'where we're going', whereas Britain was still hankering after the Empire.

MARK LEONARD I wasn't that interested in doing a snapshot of Britain in 1997; it was about trying to create a version of the story that I could be part of and not feel alienated from by John Major's version of Englishness. There was lots of data in *Britain TM* trying to understand not what a small elite think about what the country is, but to look at the lived experience of Britishness. I had this fact about Indian restaurants 'turning over more than coal, steel and shipbuilding combined, and employing over seventy-thousand people'. It was telling a story about how Britain had changed from being a heavy industrial economy into a service economy, but also the multicultural nature of Britain in the nineties.

GEOFF MULGAN Britain was very well placed for where the world was heading at that particular moment, with these much more globalised cultural industries. A lot of factors coincided to make London, in particular, a much better place to do stuff than Paris or Berlin or LA, in many ways. We were partly feeding off that as well.

MARK LEONARD I wrote, 'Britain has a new spring in its step. National success in creative industries like music, design and architecture has combined with steady economic growth to dispel much of the introversion and pessimism of recent decades. "Cool Britannia" sets the pace in everything from food to fashion.' I didn't want to do a thing about Swinging London, which captured an ephemeral cultural moment and disappeared almost as soon as it started. What I was talking about were much more fundamental changes in our society.

PETER HYMAN The spirit of Cool Britannia was saying that we were leading the world in so many areas, whether it was through design or fashion or actors taking Hollywood by storm. In our DNA was a creativity and a sense of Britain and London being the hub to the world.

MARK LEONARD *Britain TM* came out a week after Diana died[1] and seemed to capture the zeitgeist. The country was in a total state of agitation. There was real uncertainty about who we were and what the monarchy stood for. There were five-hundred newspaper articles written about the report. I was on television and radio every day. There was a marriage between what was happening in the cultural climate and what I was doing in the political world. It had a big impact on Tony Blair as he tried to reshape politics in his own image. It's not just about winning elections in a narrow policy agenda. The goal was to shape the national story.

PETER HYMAN New Labour was big on narrative: what was the story that we were telling and how could it be more open and outward-looking? DEMOS definitely influenced the speeches we wrote and the positioning of Britain.

MARK LEONARD Philip Dodd wrote a great pamphlet for DEMOS called *The Battle Over Britain*, and when Tony Blair gave a leader's speech about making Britain 'a young country' Philip took part in a brainstorm as preparation for it.

PETER HYMAN The phrase 'young country' was equally as unhelpful as 'Cool Britannia'. It was implying the year-zero point that nothing of worth happened before New Labour came into power. We were as proud as anyone else of our heritage, Shakespeare and the Royal Family and the Cotswolds and all the rest of it. Things that imply year zero or you've got to be 'cool' totally missed the point of what we were trying to do. Britain was a multi-layered country. It seemed not to be beyond our wit to say Britain was a country, yes, of Shakespeare, but also of Vivienne Westwood and Stella McCartney.

TONY BLAIR The 'young country' speech was very important but much criticised at the time. My view is that Britain . . . because of the strength and richness of Britain's history and past, the danger always is that instead of respecting it you live in it. I was

1 31 August 1997.

always thinking, We've got to have the energy and vitality and optimism of youth. It doesn't mean to say that your policies aren't respectful of your history and tradition. The character, the soul of the country has got to be that of a country that sees its greatest days ahead of it, not behind it. This was very important. You've got to respect the past and regard the future as the place you're going to be playing in. The young people of the country wanted to move forward. That's one of the reasons why they rejected the Tories in such large numbers.

MARK LEONARD Britain had powerful identity that had been crafted over hundreds of years, but for fifty or so had been wearing thin. There was a failure to celebrate some great things which were not being recognised as British. I was reaching back into an older national story: there were a lot of interesting parallels between the Union of the Crowns and the Acts of Union in 1707 and the way the UK was brought together; stories about creativity and connections to the world were as true of the Elizabethan age as they were of the 1990s.

GEOFF MULGAN In the eighties, I remember conversations with Red Wedge about exactly these questions of a different Britishness, but the timing wasn't quite right. What was then fascinating was seeing a few years later Oasis and the Spice Girls doing that for slightly different reasons. Go back two-hundred years and you'll see that Britishness was an invented identity. Take the Union Jack, for example. It didn't just grow from the soil; it didn't become the symbol on the British flag until 1801. The reason to look back to the past was to realise how a number of people essentially invented almost every element of Britishness, from the flag to the anthem. National identities are consciously created. Canada was an interesting example, which reinvented its national identity in the sixties with the Maple Leaf flag and other things. We thought Britain was ripe for a conscious reinvention. And the flag was an important part of that because it was at risk of being owned by an atavistic right.

TONY BLAIR It was important for us to say, 'Look, we're proud of the British flag. It doesn't mean to say as a result of that we were espousing some form of nationalism.'

MARGARET McDONAGH The last Labour Party Political Broadcast before the 1997 election had a bulldog with a Union Jack waving behind – Richard Curtis wrote it, which was a Matthew Freud connection.

CHRIS SMITH This was all about saying, 'We're a diverse nation and we're a united nation and we're not going to allow people to use this symbol for expressions of hatred or bigotry.'

MARGARET McDONAGH Pre- this period, there was no way you would have the Labour Party embracing the flag. We took it back and said, 'No, this is what represents all that's good about the drive, the innovation and the people in this country.'

WAHEED ALLI Tony simply said, 'The right have taken the symbols of Britain and they claimed them for themselves. I'm not having it. That flag belongs to me as much as it does anybody else.' It was shocking to see a Union Jack flying over the Labour Party Conference.

DARREN KALYNUK It was all about Tony instilling a sense of hope and optimism.

IRVINE WELSH There was a political agenda of 'let's detoxify the Union Jack and make it not so much about imperialism and nativism and dominance of other cultures, but more about big singing, dancing, smiling inclusivity'.

CHRIS SMITH Was it ministers reacting to a mood of the nation or trying to lead the nation? That's difficult to say. I think it was probably a bit of both.

MARGARET McDONAGH Alan Barnard was the guy who put the flags on everything.

ALAN BARNARD We'd been to America in '92 to work on the Clinton campaign, and I was quite taken by the power of flags. You would

see the Stars and Stripes draped at every Republican or Democratic convention. And they would always end their speech by saying, 'God bless America.' There was no right or left difference. It struck me that the Labour Party weren't prepared to utilise a symbol that was actually quite powerful, so I just started using it. Some of my colleagues got upset but it was a real symbol that Labour was changing; that we were reaching out and getting back in touch with the wider population.

PETER HYMAN We had a more inclusive patriotism, willing to accept that the Empire wasn't all good. You don't give away patriotism. You tell your story of patriotism.

TONY BLAIR You had to reclaim that language from people who saw patriotism as nationalism. At Brighton, in 1995, I said, 'Let us say with pride, we are patriots. As the Tories wave their Union Jacks next week, I know what so many people will be thinking: it is no good waving the fabric of our flag when you have spent sixteen years tearing apart the fabric of the nation.' This was very deliberate, and stems from a basic conviction I had that the Labour Party was never going to win an election unless people understood that we were patriotic about the country, in a sense of pride in our country and what it was, what it is and what it stands for. And that our task should not be to say talk of patriotism is not left wing; our point should be to say that patriotism should be measured in how the social cohesion of the country has improved, and that the most patriotic thing is to improve the lives of the people of the country.

DARREN KALYNUK All of a sudden the Union Jack was reclaimed by popular culture and there was a rise of national pride. There were Union Jacks on trainers and T-shirts. Euro 96 was key, and a lot of it came from Britpop.

MARGARET McDONAGH Sometimes things can be happening in a society that lead people simultaneously to the same point. Labour weren't copying Oasis and Oasis weren't copying Labour. Oasis, independently of the Labour Party, claimed their sense of Britishness.

ALAN BARNARD I've no idea whether we had an influence on popular culture. It was in the media and political people were reporting on it because it was happening for Labour. Maybe it did have an influence.

STEVE COOGAN The flag was reinvented. It meant you were proud of a certain kind of cultural heritage that was to do with the Beatles and an idea of identity that was community based, somehow, and ordinary people finding a voice. It legitimised a national pride. There was a different kind of Britain to be proud of, which wasn't the Britain of bigots and Empire.

SONYA MADAN We did a gig in Paris – and the French are very proud of their culture – and there were loads of kids with Union Jacks. It was like people had appropriated it. Perhaps the sixties helped because that was the last time when the Union Jack was a big thing: on Minis and Beetle cars.

BRETT ANDERSON When everyone started waving Union Jacks I just thought it was so crass. 'Really! That's the limit of your expression, waving a stupid flag?' Wanting to celebrate Britain just seemed so ugly to me.

IRVINE WELSH Noel had his Union Jack guitar. Geri had her Union Jack dress and David Bowie wore the Alexander McQueen Union Jack coat on the front cover of *Earthling*.

MATTHEW WRIGHT There's no Britpop without a British identity. Paul Weller would be a link between the decades; the mod roundel. Noel worshipped Paul. And then there was Geri's Union Jack dress. Cultural appropriation was going on.

MARK LEONARD What matters is not actually the flag, it's the story it incarnates when you wave this fantastically powerful icon. When Geri Halliwell wore the Union Jack at the BRITs in 1997 it became a symbol of a creative, open, multicultural, cosmopolitan country that was looking out to the world.

MELANIE CHISHOLM We'd been away so much that past year, so the BRITs was like a coming home for us. Geri planned the dress.

She was savvier than I was and would think about reactions and how things would play out. It was iconic.

MATTHEW WRIGHT It was made by her sister Natalie, who ran a label called Firecracker.

MELANIE CHISHOLM It was a cheap little dress with a Union Jack tea towel stitched on the front and a CND sign on the back. I thought, Nice one, that's cool.

ALAN EDWARDS Geri was an incredible PR. You could put Geri in an ad agency and she'd be running it in a couple of years.

MATTHEW WRIGHT Geri said, 'We owe all our success to Britain. We're just proud to be ambassadors of pop for our country.'

MELANIE CHISHOLM We were really proud that we were British. We were literally flying the flag around the world, breaking America, doing things that British pop bands very rarely do. I always had this sporty thing that I was like an athlete and was performing for my country.

KAREN JOHNSON This was the year Caroline Aherne went on stage at the BRITs as the mock-elderly talk-show host Mrs Merton, and was going, 'Charlie, wherever you are, can you make yourself known. They're all asking for you backstage.'

MATTHEW WRIGHT Everyone was looking for Charlie. It was ridiculous!

MELANIE CHISHOLM We had been nominated in five categories and were up against 'Don't Look Back in Anger' for Best British Single. Liam Gallagher said he was going to 'smack us', which really riled me. So when we won I thought, I've got to get a little dig in here. We went on stage and I said, 'Liam, come and have a go if you think you're hard enough.' Then, about a year later, I was at Natalie Appleton's house and there was a knock at the door. It was Liam. I opened the door and went, 'COME ON, THEN!'

RIC BLAXILL The Spice Girls were so wrapped up in Cool Britannia.

MEERA SYAL When we did *Goodness Gracious Me* on tour our big finale was the Kumars singing, 'We're British, oh so British,' and we wore Union Jack mini-dresses. It was homage to the Spice Girls and Cool Britannia.

JEREMY DELLER I liked the idea of the flag celebrating a state of mind. I was interested that when people travelled around Europe for football matches they would put 'WEST HAM' or 'PORTSMOUTH' on a Union Jack – this real pride of where they were from coupled with maybe a sense of insecurity of travelling into enemy territory – so I made a Union Jack flag that said 'SUBURBIA'.

CHRIS SMITH The person who was really influential was Charlie Leadbeater,[2] who wrote *Living on Thin Air* about how creativity was the new raw material. That economic value was frequently being created, not by taking something out of the ground and making it into something, but by conjuring something out of thin air, which is where the phrase came from.

JOHN NEWBIGIN When Tony Blair spoke at the British Screen Advisory Council lunch at Mansion House, we persuaded him to make it a speech about the creative industries as part of the future of the British economy. He said it was a sector that had economic significance, and it needed to be celebrated and its value assessed to ensure its future success. It was floating the idea of the creative industries as legitimate for government policy making.

MARK LEONARD This was the first government that took the arts seriously as an industrial sector: as an employer; and as a creator of revenue. It understood that the nature of the British economy had changed fundamentally and culture was no longer peripheral. That it was a central part of our national economy as well as of our national identity.

2 Journalist at the *Financial Times* and the *Independent* before becoming a government advisor.

WAHEED ALLI It's quite hard to believe that in 1997 there was no such thing as the creative industries. There wasn't the sense that there was a creative set of industries that made a significant contribution to the economy. This is the point where the idea of Cool Britannia surpassed being a media tag to becoming something of substance and worth.

MICHAEL CRAIG-MARTIN I loathed the term 'creative industry'. It seemed to be an anathema to creativity. It's like its primary function is an equivalent to the car industry. It doesn't work like that. It was people exploiting success for their own ends.

CHRIS SMITH I felt that all the things that the DCMS[3] was responsible for – culture and creativity in the broadest sense – weren't just important aesthetically but were really important economically to the country. But what I discovered was that no one knew what the value of the creative sector to the economy was. The figures just didn't exist. So I set about trying to do two things: to raise the profile of the creative sector within government as a whole; and to try to establish what the actual value of these sectors was to the economy and the issues they faced – hence the establishment of the Creative Industries Task Force.

WAHEED ALLI It was about saying, 'Look at the creative industries in the way in which you look at coal mining and aerospace and pharmaceuticals. It is by far one of the biggest sectors this country has. And also to value the contribution they are making to the creative nourishment of the nation.'

JOHN NEWBIGIN Our purpose was to ask, 'Is there a role for government supporting these industries, and if there is, what is the role? Are we feeding the talent pipeline?' For the first couple of meetings we had representatives from seven or eight departments around Whitehall: Culture, Education, Treasury, Business,

3 The Department for Culture, Media and Sport (DCMS) was established in 1997 by the newly elected Labour government and replaced the Department of National Heritage.

Foreign Office.

CHRIS SMITH We also brought in a range of creative practitioners from the outside world, like Richard Branson, Alan McGee, Gail Rebuck, Paul Smith and David Puttnam. It was transformational.

ALAN McGEE I had been to three or four Labour conferences, I'd been to 10 Downing Street, Chequers, and then I joined the government, for fuck's sake.

WAHEED ALLI I'd never been in the gates of Downing Street or the cabinet office meeting rooms before; this huge room with wonderful wooden tables. It felt like Victorian England.

CHRIS SMITH The first meeting, the ministers sat there with their briefs written by their civil servants and just read out what was on the sheet of paper in front of them. But then gradually, as the outsiders began to talk about what it was really like and what the challenges were and how they were making a living and employing people and making a contribution to the economy, you could see the ministers folding up their papers and engaging in real discussion.

JOHN NEWBIGIN The task force pretty quickly got down into detail. Paul Smith wanted to know, 'Why aren't we promoting British fashion internationally?' Alan McGee's concern was, 'Are we protecting live music venues enough because that's where creative quality comes from?' They all had slightly different interests, and inevitably it became less sexy and the Bransons and the Smiths stopped coming. Fine.

WAHEED ALLI In the creative sector, we want to make a contribution, but we're all quite selfish: 'If you don't like it our way you must be wrong. Clearly you're idiots.' We're not built for committees. Don't be surprised if you take a group of unmanageable people, put them in a room, and they behave badly. If we didn't have that emotional energy we wouldn't create anything new. We resist the status quo and our boredom threshold is low.

ALAN McGEE I was quoted in *NME* saying Labour's proposed Welfare

to Work scheme is, 'Soul destroying, incredibly naïve, ill-judged, unfair and Draconian [. . .] penalising the lifeblood of our cultural future.'

CHRIS SMITH Alan identified a problem quite early on when Gordon Brown and the Department of Social Security were cracking down on the accessibility to benefits of young musicians. From time to time Alan would publicly make his views known in anti-establishment ways. But it was valuable having him there.

JOHN NEWBIGIN There was a lot of naïvety about being seen to unreservedly support the arts because people felt that politicians were trying to colonise and own them for themselves.

IRVINE WELSH New Labour were all about assimilation and control. When politicians get involved in culture they generally see it as something that can be sold.

CHRIS SMITH What I said frequently during that period was 'government cannot create art'. It shouldn't try. What government can do is to provide a platform on which artists can stand and thrive. Government can put the framework in place. I met with the Department of Social Security and with the Treasury, and we came up with a special benefit provision for young musicians. It's a good example of people from the real world intruding on what government was doing and changing things as a result.

ALAN McGEE This is why Chris Smith was fucking great and just shows you how Tory the British music industry was. Smith went, 'Alan wants to do this thing to help young musicians . . . instead of them having to do shit jobs.' Rob Dickins, the chairman of Warner Music, said, 'Rod Stewart had to work his way up. Why should we make it easier for these young kids?' George Martin was throwing in his lot, agreeing. They went right round the room, and me and John Glover, the Managers Forum guy, were the only two people for it in the entire room. Chris Smith went, 'Passed.' It was like, 'What did we fucking pull off!' The New Deal for Musicians was probably the best thing I've ever done for my generation. We

managed to get a whole load of conditions. Musicians could get paid for being a musician for thirteen months instead of being kicked off the dole. It was fucking unbelievable.

JOHNNY HOPKINS Alan did something positive and constructive, and if it meant going into the belly of the establishment then fair enough.

ALAN McGEE After sounding off in the *NME*, that was the government going, 'Shut that fucker up. He loves the sound of his own voice.'

WAHEED ALLI Chris Smith was brilliant at setting out a process. Everybody had their own orbit and we collided in the meetings, but what came out was very good.

CHRIS SMITH One of the fundamental realisations was that the creative commercial sector will flourish if the traditional subsidised arts are flourishing: if people are learning to play musical instruments in school there will be more people becoming musicians later in life; people who learn about lighting and set design will end up lighting and designing in theatre and television. There is a flow through from what one might regard as traditional arts into more commercial, entrepreneurial activities. The second thing that emerged was identifying a whole range of issues in specific sectors. For example, we were making terrific television programmes but we weren't being terribly effective at selling them around the world.

JOHN NEWBIGIN Work was done on quantifying the value of the arts, to say, 'Every £1 that the National Theatre received generated another £2 in the economy.' The Treasury previously had rubbished all those attempts as 'dodgy arithmetic' put together by 'luvvies'.

CHRIS SMITH We produced the Creative Industries Mapping Document, which was the first comprehensive analysis of economic contribution of creative activities to the overall health of the country. This was the first time anyone had done this in the world. What we discovered was that this was far bigger than we

had imagined. The creative sector was one of the powerhouses of the economy: it was between 6 and 7 per cent of GDP. It was employing over a million people and it was growing at twice the rate of growth of the economy as a whole. This was really significant stuff that we were establishing.

ALASTAIR CAMPBELL All these groups like the Creative Industries Task Force were feeding into that sense of a new way of doing things, getting new people in, trying to develop new ideas. Really being unafraid, but also actively looking for innovation and wanting it. I think it flowed from the fact that Tony had a pretty clear idea of what he wanted us to do.

GEOFF MULGAN Almost immediately after Blair came to power an official version of what we had been doing informally around DEMOS was set up about how Britain portrayed itself globally. That led to quite a big shift in the narrative.

JOHN NEWBIGIN This was not about soundbites and media headlines. This was Cool Britannia at the coalface of government thinking.

MARK LEONARD The government set up Panel 2000. It was very much about the hyper-traditional identity: red pillar boxes and buses and beefeaters and Buckingham Palace; the idea of Britishness that you could see on a box of shortbread biscuits, telling a very partial bit of the national story.

JOHN NEWBIGIN Panel 2000 was Robin Cook's desire to make the Foreign Office feel more relevant. It was part of, 'How do we leverage the value of all this creative activity in the UK to our advantage overseas in terms of the image we present to other countries?'

MARK LEONARD The key thing about Panel 2000 was getting the different agencies charged with promoting Britain together: we had government ministers, including Peter Mandelson, heads of British institutions, and to throw in a little bit of excitement there

were a few faces from contemporary culture, like Jet from the TV game show *Gladiators*, and Stella McCartney, as a symbol of the New Britain. We also did a series of lunches at the ICA with a lot of people from branding and advertising and marketing worlds, to think about the craft of 'how do you sell a country?'

GEOFF MULGAN We really tried to emphasise that Britain had always been globally connected through trade and migration and so on, and Britain needed to embrace that.

MARK LEONARD There were thousands of practical projects that came out of that, which carried on in all sorts of different ways, right the way through to the London 2012 Olympics opening ceremony. It wasn't because there was some masterplan that came out of Panel 2000, but there was a dramatic difference in how the British story was told, which was embraced by Tony Blair and successive government. It was a more inclusive and forward-looking story.

HUNDRED MILE HIGH CITY

Supernova Heights

LORENZO AGIUS By 1998, Cool Britannia was well on its way: Britpop was massive and Oasis were selling literally millions of records. *Trainspotting* was a smash hit. Alexander McQueen had gone to Givenchy and was the darling of fashion. You're kind of looking at each other going, 'Wow! You're doing well, aren't you?'

JOHNNY HOPKINS Fashion and music and film were an embedded part of the national confidence. Noel and Meg started hanging out with Guy Ritchie, who was being hailed as Britain's answer to Quentin Tarantino. It was great cross-promotion.

FRAN CUTLER Meg went to school with Guy. It was like, 'Wow! This is a new type of filmmaking.'

LORENZO AGIUS *Lock, Stock and Two Smoking Barrels* came out, and then Guy Ritchie was part of the in crowd: all these people who were shaping London and shaping England. I got a call. 'We want you to do this film poster. It's Guy Ritchie. It's for his new film.' I'd had a motorcycle accident and smashed my leg up in seven places and had to meet Guy on crutches. I was in so much pain. I had to say, 'I can't do the shoot.'

SUZI APLIN If you ask the producer Matthew Vaughn he'll say Chris Evans was pivotal in *Lock, Stock* becoming what it was. Chris went to a screening and absolutely loved it. He was like, 'You've got to see this film.' I went, and then he was like, 'You've got to take everybody in the office.' Suddenly, everyone's seen it. Then Chris

said, 'I want to make Friday's show a *Lock, Stock* special. Let's get everyone on it.' We had the whole cast, and as a homage Vinnie Jones held Chris's head down the toilet and flushed it like he did in the film.

FRAN CUTLER Everybody was part of the gang. We'd all be at each other's events and then all go back to Noel and Meg's at Steele's Road; everyone would be there. Noel had a pivotal role in bringing people together.

NOEL GALLAGHER Supernova Heights was a big, heavy fucking house. It had a fish tank in the hallway that was like a James Bond baddy's fish tank: thirty-foot long and six-foot deep. The house was always full from about six in the evening to seven, eight in the morning. It was less hassle staying in than going out. We got to the point where I was so famous that you couldn't get out of the house because there were fifty, sixty kids omnipresent all the time. The council ended up putting a bench outside the front door and two waste-paper bins for the litter. The house was graffitied all the time. There were always complaints from the neighbours: 'Will you paint the fucking wall?' I was like, 'You paint the fucking wall.' I had to paint it black, then fans wrote on it in white. I painted it white and they wrote on it in black. We had to switch off the doorbell because people were pressing it all the time. There was a secret bell round the back of the wall that only friends knew about, and then we had to get rid of that because somebody was seen pressing it. It was exhausting but a lot of fun.

FRAN CUTLER Meg had enthusiasm and could get things done. McGee gave us an office at Creation in Primrose Hill and we did anything to do with Oasis.

JOHNNY HOPKINS Meg brought a spark and was plugged into a completely different world of clubs and fashion and supermodels. It elevated Oasis into another world. Suddenly you'd go to an Oasis gig and there would be Kate Moss and Naomi Campbell and Devon

Aoki.[1] Meg and Fran organised the *Morning Glory* album launch in a grand Georgian house: ice sculptures and a string quartet and extravagant food. It was like *The Last Days of Pompeii*.

FRAN CUTLER It was a natural synergy. Bands were making lots of money and they were really cool; if you were a girl, a model, an actress, you wanted to go out with boys in bands, or actors. People wanted to be around those worlds. It was new and exciting. I did all of McQueen's after-parties. That was another area where fashion and music came together in an eclectic mix: get the right people there, get them drunk and make sure they remember it for the rest of their lives. Everyone would want to come: Kate and Naomi, Sam Taylor-Wood, the art lot.

NOEL GALLAGHER I don't think we ever spoke about what we did. The regulars would have been Kate and Johnny, Jude [Law] and Sadie [Frost]. Keith Allen was from a different generation but was always there, and his little fucking annoying child, Lily, who grew up to be a pop star. There was a fucking lot of people. We used to have parties all the time. People who'd be out, we'd say, 'Come back to ours,' and then fucking thirty people would show up. Brad Pitt turned up one night. 'Is there a party going on here?' I didn't realise who he was until years later when someone said, 'You know who that guy was?' I was like, 'Fuck off!' They were great days. Even the police were quite respectful. They used to ring the buzzer: 'I'm sure you don't want us coming in . . . but can you turn the music down?'

SHERYL GARRATT Noel said, 'Have you been round my house?' I said, 'I don't know.' He said, 'Quite likely you have, then.'

KAREN JOHNSON Kate Moss mingled with that crowd at Supernova Heights and lived with Noel and Meg for a while. She hung out with Damon a bit too. It went under the radar, but I don't think

1 American-born fashion model Aoki featured in the 1997 Primal Scream video 'Kowalski' alongside Kate Moss, and in 1998 succeeded Naomi Campbell as the face of Versace.

she was his type. Fashion and music connected because they'd go to the same parties. Famous people want to talk with famous people, especially if they're cool.

NOEL GALLAGHER It didn't feel like a scene. It was just my house. That's for other people, like Serge and Tom from Kasabian, for instance. They were at school reading all this in the *Sun*. When I first met them, they were like, 'Is this true. Is that true?' They said, 'We lived for opening the papers and seeing what everybody was up to.' That's why they wanted to be in a band. They're like, 'We'd run to the newsagents, "Fucking hell look what these fuckers were up to last night."' Of course, what they read was all bullshit. Then a new generation came afterwards. They're like, 'Did you really have a four-grand-a-week coke habit?' I'm like, 'You work it out. It's fucking impossible.' 'Ohhh, didn't ya?' 'No.' 'Ahhh.' And they'd get really upset. In the end you start saying, 'Well, yeah,' so as not to upset them.

FRAN CUTLER All that crap about Primrose Hill. They called us the 'swingers'. It was a load of bollocks. It was another piece of salacious press from the stupid newspapers.

IRVINE WELSH Primal Scream's studio was up in Primrose Hill. That's where all the real mischief went on. Creation's offices were just round the corner and you had all the actors like Jude Law and Sadie Frost and Anna Friel. Initially, there wasn't much of an interface between Creation and the rock 'n' roll crowd and the Primal Scream crowd and the actors. It was a very different set. Creation was more of a working-class thing, whereas the actors were more established and middle class. Slowly it broke down because of Oasis, because they became such a big fashion brand and the gateway to these two groups coming together.

JOHNNY HOPKINS Once Creation moved to Primrose Hill, or rather once the band becomes so successful, our presence was noticed. People flocked there: famous people hanging out, paparazzi, fans, nutcases. There was a massive shift of people in their orbit.

Vipers appeared and they were surrounded by professional liggers providing services of support and just blowing smoke up their arseholes. That changed everything.

ALAN McGEE I was never part of it. Everybody thought I was. But I was sober. They were all taking drugs. I never went to Noel's house. In a way, my nineties were fairly different from a lot of people than you'd have thought. I was quite outgoing, for me, but I was still pretty fucking weird and exclusive. I was just busy being me, whatever that means.

JOHNNY HOPKINS The hunger for the band, and specifically Noel and Liam, was off the scale because they were such brilliant tabloid fodder. If it had been possible they would have had them on the front cover every day. Everyone wanted a piece of them. The industry was in transition, and along comes a group that fulfils all media fantasies: one, they write good songs; two, the live shows are brilliant; three, the band look good; four, they speak honestly and misbehave. It was a gift. And it wasn't just the press and TV and radio in the UK; it was all the media in America, Japan, Australia, New Zealand, Hong Kong, Singapore, Brazil, Argentina, Mexico, France, Germany, Norway, Sweden, Spain, you name it. It was bonkers.

IRVINE WELSH Media arrogance is a common position adopted by successful artists from working-class backgrounds wary of being condescended to by those of less talent but from more privileged homes. You think to yourself, I'm going to be misunderstood anyway, so rather than try to explain where I'm coming from, I might as well just act a cunt and give the usual sound-bite stuff and at least get some attention. That's how I saw Noel and Liam. You read these interviews from all these guys, then you meet them face to face and they're so different you don't recognise them.

STEVE LAMACQ I'd never interviewed Noel and Liam together until the infamous Radio 1 outburst on 23 October 1997.

MATTHEW BANNISTER Noel had been invited on *The Evening Session* and Liam turned up and went off on one.

STEVE LAMACQ The first 'fuck' whistled past: Liam was offering to have a fight with George Harrison and 'the other cunt who gives me shit [. . .] be at Primrose Hill, Saturday morning at twelve o'clock. I will beat the fucking living daylight shit out of them. That goes for George, Jagger, Smichards [sic].' This was twenty-past seven. Believe it or not, there was no edict for a live interview if someone swore. I was trying to work out how to best manage what was becoming increasingly clear were two quite volatile characters.

POLLY RAVENSCROFT I got a call from the head of press, Paul Simpson, panicked: 'Oh my God! Are you listening? Liam has turned up. It's all going wrong.' The first thing I said was, 'Have they said "cunt"?' Paul said, 'Yes.' The question was whether you carry on.

MATTHEW BANNISTER The language was terrible. Should it have been stopped? Yes, of course, and Liam should have been shown the door. But that can't always be done with someone as vociferous as Liam Gallagher. Under the circumstances they had to do what they had to do. The biggest sin was to be boring. It was riveting radio.

STEVE LAMACQ Claire Pattenden came in and said to Liam, 'I'm the producer and asking you to tone it down.' Liam said, 'Well, I'm the fucking singer in Oasis and I'll have you and your fucking family.' It sounds ludicrous now, but I didn't realise how drunk they were – I was focusing on what they were saying and not the way it sounded – but obviously they'd been drinking all afternoon. Noel thinks he's still in control and then realises he's not. There are a lot of cases where he says, 'Shut up, man.' At one point he offered Liam a wedge of cash from his trouser pocket: 'All that says you'll shut your mouth.' At times Noel sounded quite miserable. He's resentful of the fact that Liam can just swagger around being Liam while he had to be 'Noel – the songwriter'.

POLLY RAVENSCROFT It was all happening live so there was very little time. It would be very difficult trying to exit someone from the studio.

STEVE LAMACQ By the time Liam left the building there were paparazzi waiting to get a photo. It was front page of the *Sun*, 'Four Letter Oasis in Radio 1 Shocker . . . the most foul-mouthed pop broadcast since the 1976 interview which made the Sex Pistols famous overnight'. Quietly, I was pleased with that. It said something about how big Britpop had become by that point; half the nation owned an Oasis record.

PHILL SAVIDGE It was sharing it with the mainstream. We wouldn't do tabloid press with any of our bands. They were totally the enemy. They wanted a part of Britpop and felt excluded. They were desperate and would write anything. They turned on Jarvis after the Michael Jackson thing. Andy Coulson was telling *Sun* readers, 'If you see Jarvis out at a gig, ring us up and we'll give you a tenner.'

KAREN JOHNSON There was one incident that really worried me, when Graham got knocked down by a car outside a venue. The pictures of him in the road were all over the papers the next day. You'd have a lot of paparazzi outside various hangouts all the time, and following them down the street. Me, Damon and Phil Daniels were photographed coming out of the Groucho one time, 'Mysterious dark-haired woman,' that kind of thing.

NOEL GALLAGHER We came along at the same time that celebrity culture was invented and satellite and these mobile-phone things. The Internet was just about to happen. Now, they don't write about bands anymore, they write about the Kardashians. But back then the biggest band in the country were also the fucking biggest drug takers in the country and didn't give a fuck. We didn't censor ourselves. The tabloids thought, This is great, we don't even have to make stuff up. What we didn't know at the time was that everybody's phones were tapped. I used to phone people, 'I'll meet you at such and such a place at two o'clock,' and you'd get there and there'd be fucking twenty cameramen.

FRAN CUTLER The tabloids were hacking us for years. They were writing lies and shit about everyone.

CHARLIE PARSONS In those worlds they're quite isolating. You don't really know who your friends are. If you're Chris Evans you have loads of people coming up to you. But every single one of them could be somebody who's about to leak something to the press, or spoil it for you, or accuse you of something. It was the same with politicians.

JOHNNY HOPKINS Stories leaked right, left and centre. People were blabbing. There was someone taken out of the picture at Creation because they were suspected. You were constantly fighting a rearguard action.

MATTHEW WRIGHT We just started running the stories and verifying them as best we could. I remember writing, 'Noel is a very shrewd, intelligent man, I can't believe it's all impulse. There has to be an element of consciously allowing situations to develop.' Oasis were working-class people who actually read tabloids. Blur aren't going to fucking sit there and read the *Sun*. I remember before Knebworth, Johnny Hopkins said, 'You'll never get to chat with Noel.' Then at the gig I bumped straight into Noel: 'Your press officer bet me twenty quid that I'll never get to chat with you.' Noel said, 'Have you got the twenty quid?' I said, 'Yes.' And so we posed up with the twenty quid, shaking hands.

I'VE GOT SUNSHINE IN A BAG

Britpop demise. *Be Here Now*.

Zoe vs Chris

STEVE LAMACQ I don't think there's a definite Britpop endpoint, 'Britpop is now the establishment' moment, when you think, Britpop has got so commercial that it's defeated itself by becoming what we wanted to overthrow.

JARVIS COCKER When the *Select* cover happened in 1993 there was a scene and an energy, an atmosphere of possibility and anticipation: 'Ooh, something could happen here.' It felt like the more awkward kids could take over. That's where you get the optimism in a song like 'Mis-Shapes'. I remember being very keenly aware that we'd finally got an audience, so you can write a song like this now because people are actually listening and this could be a revolution in some way: 'We won't use guns, we won't use bombs/We'll use the one thing we've got more of, that's our minds'.

JEREMY DELLER The messaging had gone elsewhere, and it was being imposed upon these people rather than creating their own scene. The artists lost control of how it was interpreted and written about. It became a media event.

JARVIS COCKER As often happens, the wrong people get in control and it gets steered in a different direction and the energy gets dissipated or misdirected and you get a false dawn. The possibility

to make a change got sabotaged. It ended up being this backward retro movement when it should have been a forward-looking movement.

STEVE LAMACQ By this point Britpop was everything from Radiohead to Ocean Colour Scene. It was huge and made no sense. The initial purist definition of Britpop – Suede, Elastica, Blur and probably bands that came next, like Sleeper and Echobelly – just got bigger and bigger. Like all generic descriptions, it starts off as something which is very specific, and then ends up being a larger umbrella term. It's a hard one trying to work out how certain bands fitted in – all the bands were British and they were all making good records. I think it's that simple. Britpop became all encompassing.

SONYA MADAN Britpop was trivialised. It happens with every scene: a poptastic version for people who don't think as much. There are always people who just want to be famous. A lot of the earlier Britpop artists were trying to make a difference to people's lives, writing about subjects people hadn't covered before. My own perspective was there wasn't anyone like me. I was female. I was Indian. It wasn't 'Baby, I Love You'. The spark of passion for what I was doing was always far deeper: it was a cry for recognising your own ability and your own strengths, and desire to do something with your life.

JARVIS COCKER There was an excitement but somehow it didn't quite happen. It was frustrating. It was set up. It started to bubble and then somehow something stopped it. I don't know whether that's because the mainstream is so strong and powerful it can't be destroyed.

JO WHILEY When the bands become the mainstream you get sucked along, and you go along to Knebworth and get involved in these massive events. In the eye of the storm you have no idea what's going on; it's only in hindsight you realise something was happening.

PAT HOLLEY When everybody started making money it killed itself. The moment it lifted out of the club into the penthouse you're not connected anymore. It destroyed the struggle. And when you add in drugs; people stopped dancing and just started hiding in corners.

STEVE LAMACQ Cocaine killed Britpop. It took everyone's natural sense of victory, elevated it, and then people used it to make up for lack of ideas and moral compass to give them confidence to get through. People became more insecure and paranoid. Everything got big and very competitive, and they were looking behind them all the time, worried about their next record. Or it's social cocaine, which means you're not having such good ideas and the music is beginning to lack the natural verve and spontaneity that it once had.

PAT HOLLEY Cocaine killed off the innocence of the scene.

BRETT ANDERSON However extreme cocaine is, it's still a social drug, but heroin, by its very nature, is a dark, murky and very destructive drug. I can see how that was responsible for lots of bands falling apart. I saw it within my own band.

PHILL SAVIDGE Heroin entered the worlds of Suede, Blur and Elastica, but it was a more secretive thing. *Select* magazine did a cover feature and Jarvis didn't deny that there was heroin around Pulp. The headline was, 'Death, porn, heroin . . . what's eating Jarvis Cocker?' Andrew Perry did the interview, and said to Jarvis, 'The rumour persists that Pulp and heroin are no strangers . . .' Jarvis said, 'It's peer pressure. It's like when your mum says to you, "If Martin Hunt jumped in some dog dirt, would you?" The answer is probably, "Yeah, I would, if he said it were a good laugh." You have to make your own decision. It's not for me to say.'

JARVIS COCKER I have never been a heroin addict. Phill Savidge fed that line to *Select* magazine cos he thought it was cool.

PAT HOLLEY It's about inner sanctums: where you get to; which room you're in. You'd go to parties in certain houses and there were kind of levels of entry. At one point, you just didn't want to go into a room where Elastica were. It was filthy and horrible.

NOEL GALLAGHER I'm too vain to be a heroin addict. Any drugs where you're gonna get dirty fingernails isn't for me. I don't like scruffy shit, fucking dirty flats. You'd see Shaun Ryder walking round Manchester like a zombie. It's not very glamorous. The accepted face of a heroin user was some scabby, spotty fucking Scouse cunt. I'm not going to be that guy.

KEITH ALLEN There was one person in our group who was into heroin. And then Damon got on it, which was hilarious because he was so anti-drugs. The next thing, he's written 'I've got sunshine in a bag'. 'Did he just say that?!'

DAMON ALBARN There was Blur. There was heroin. And then there was Gorillaz. Drug use changed the lens for a while. I came home one day and it was on the table, so I tried it. A lot of people's lives were muddied by heroin.

STEVE LAMACQ I think we really see Damon's crisis on *The Great Escape*. There are points on the album where it seems lost. Who had time to write songs? You were either on tour or doing press; people were turning around records three times as quickly as they do now.

KAREN JOHNSON When a band does pop songs it's really difficult to keep on one level. They're in. They're out. If it goes too pop you have to pull back. After the much-hyped battle with Oasis, Blur retreated and tried to opt out of the whole media contest. They were then written off and actively sneered at.

BRETT ANDERSON There was a real hubris in the nineties, where lots of barriers were being broken down and people were being deliberately shocking; and taking up heroin was another stage in that process, where people were just trying to push it as far as they could and indulge the beast within them. 'What's the most shocking drug I can use?' Drug use got out of control, and instead of being a fun thing it became a very destructive thing.

STEVE COOGAN Oasis, *Be Here Now*: the cocaine album.

JEREMY DELLER Oasis were loved comprehensively. The media overcompensated for writing bad reviews about *Morning Glory* by writing over-the-top ones for *Be Here Now* without even hearing it. Journalists trashed their own art form and lost any idea of objectivity: it was Oasis, they were great.

STEVE COOGAN The reason Oasis were authentic was that they had something relatable: 'I know these people, they're like me.' But as soon as you're driving around in limousines and living in the lap of luxury, and the distance between you and where you come from gets greater, then what you have to say gets less and less relevant and less and less interesting because you're just part of the whole circus.

NOEL GALLAGHER There was a magic six months when we were the biggest band in the world, but we hadn't been properly paid, so we were still dressing like football hooligans. Then the money came in. We all became multi-millionaires overnight. All of a sudden, it's like, 'I'm gonna buy a fur coat and I'm going to see how much a helicopter costs.' After that it all changes. I was like, 'I don't know what it fucking is anymore.' I couldn't write for the man in the street because I wasn't the man in the street. We had everything. Anything we wanted, we got. And we fucking hit it hard every night. By the end of the *Be Here Now* tour I'd changed as a person.

ALASTAIR CAMPBELL I went to see Oasis at Earls Court and I remember thinking, I wish we could bring some of that energy to our operation.

JOHNNY HOPKINS The two nights at Earls Court, the guest list was crazy: Madonna, Kylie, Mick Jagger, George Best, George Michael, Elton John, Kate Moss.

ALASTAIR CAMPBELL It wasn't just the energy of the crowd, it was the energy of the performance. When they did 'All Around the World' this globe came down and then it started to spin around. It was a fantastic presentation. I thought, Yeah!

NOEL GALLAGHER We had all these meetings about the stage design. We were talked into it: 'You've got to have something.' 'Who gives a fuck about that?' 'Well, what about we recreate the album cover?' 'Yeah, all right, whatever.'

JEREMY DELLER It was one of the most hilariously terrible concerts I've ever seen in my life. They had a big clock on stage that was going backwards. This black guy came on – probably the only black person there – in tails and ran around like the rabbit in *Alice in Wonderland*, going, 'What's happening?' The clocks going backwards, all these things started moving on the stage, it was insane. Then the band lumbered on out of a phone box and go into some dirge song.

NOEL GALLAGHER We were doing a huge stadium in South America, a hundred-thousand people, and halfway through the gig I started 'Don't Look Back in Anger' on an electric guitar through a Marshall Amp. I thought, Where's the piano? Never thought to bring one.

JEREMY DELLER The new songs were not received well. At one point, Noel actually told off the audience for not cheering enough. It was awful. It showed the excess had made them rotten.

NOEL GALLAGHER Somebody said that the mood of the nation changed and nobody was interested in euphoric guitar music anymore. I just don't think *Be Here Now* was a very good album.

JOHNNY HOPKINS Chris Evans got pissed off about Oasis turning something down and he did a sketch about *Be Here Now* on *TFI*.

WILL MACDONALD Chris was in hospital holding a defibrillator with this thing on the table, next to a nurse and me in scrubs. Chris pulls down his mask and says, 'I'm sorry, ladies and gentlemen, it's definitely dead,' and held up a copy of *Be Here Now*. Noel never forgave us.

NOEL GALLAGHER Chris Evans thinks that's why we fell out. It's not at all. It's because we wouldn't let him broadcast live from

Knebworth because I thought he was trying to use my band to further his own career. He did a very shitty interview in a newspaper where he savaged me personally. I was like, 'Okay, if you want to be like that.'

SIMON FOWLER We knocked *Be Here Now* off number one and Noel sent us a plaque that said, 'Congratulations to the second-best band in the world.' But Oasis's reputation had started to flag, to a degree, and they weren't seen as potent as they were at the beginning.

ALAN McGEE As much as *Be Here Now* is looked on as a failure, it was an eleven-million-selling failure.

JOHNNY HOPKINS *Be Here Now* was released to unanimously brilliant reviews. Ten days later Diana died. It killed it dead. It completely changed everything, overnight. It was the end of the party. Hedonism was out. People needed something that was more intimate and internal – that's why *Urban Hymns* cleaned up. Verve unconsciously caught the mood of the time – and the tabloids' focus shifted from covering Oasis to it all being Diana.

OLIVER PEYTON You thought you were going to live forever, but then if you're smart you grow up. Some people came through, some people didn't. I know it sounds weird, but people died as a result of not being able to live through that period. There were a lot of casualties, as there always are with drugs and drink.

NOEL GALLAGHER I stopped taking drugs at half-time of a quarter-final World Cup match between Italy and France. I don't know what happened. Just a moment of 'Whoah! Hang on a minute.' I had a moment of clarity. I'd passed out the night before and I woke up the next afternoon. I remember getting up, going downstairs, going to the fridge – there were drugs all over the place – and I had a Red Stripe, a line of coke and a cig for breakfast. There were still loads of people in my house, strangers; I clearly fucking knew them the night before. That was it. It was only ever meant to be for a couple of weeks until I straightened out. Then a couple of weeks became a couple of months, that became six months, then,

of course, there comes a point when you cross a threshold and you stop craving them anymore.

PHILL SAVIDGE The records became more reflective. If you look at the difference between *Different Class* and *This Is Hardcore*, you'd probably say that's what it was. Whereas *Different Class* was Jarvis writing about things he had wanted to do for a long time, *This Is Hardcore* was quite a confused and reflective record about fame.

JARVIS COCKER The escape for a while was to hide and work on *This Is Hardcore*. It happened to everyone. And then that vacuum was filled by the Spice Girls and Robbie Williams, who basically just said, 'You guys have created this opportunity but you're too fucked up to take advantage of it, so we'll just be pop stars. We won't worry about social ramifications. We won't worry about anything. We'll just turn up. We'll do interviews. We'll wear the clothes. We'll have the Union Jack dress. We'll do all the stuff and clean up.' They took the tropes of Britpop, took any interest out of it, and just did it. They should have given us a percentage. I don't say that with any bitterness. It was fair enough. People don't really want to buy records about people moaning about themselves. They want entertainment. So you may as well get it from people who are happy to give you entertainment without trying to make it into something else.

STEVE COOGAN The trouble is when something is spontaneous and authentic it ends up being co-opted by commerce. It's like when you hear a song you really like on a TV commercial; it pisses you off. It's sullied: I don't want to associate this song with you trying to sell me a fucking car. That's what happened with Britpop, and Cool Britannia on a grander scale. You just felt like, 'You're behaving like all the other cunts.' Cool Britannia hung around its own party so long that it became pathetic.

PHILL SAVIDGE The change was when all the bands started sounding the same. John Harris[1] dates it back to when they played

1 Music journalist and author of *The Last Party: Britpop, Blair and the Demise of English Rock* (2003).

'Walkaway' by Cast on TV when England got knocked out of the semi-finals of Euro 96.

IRVINE WELSH Post-Oasis and *Trainspotting*, things that came out started to feel very much like they were being pushed down our throat rather than something that we really valued.

WILL MACDONALD Pop was coming back.

RIC BLAXILL There were bands like Travis coming through; quite melodic, but not Britpop. It swung away from guitar music and moved on. There were a lot more one-off and solo artists. It was easier, quicker and more cost-effective.

IRVINE WELSH Louise Wener said that Sleeper were recording in the same studio as Robbie Williams and he wanted them to listen to his new song. She went in all sniffy because it's the dancer from Take That, and as soon as she heard the chorus of 'Angels' she knew it was all over.

KATIE GRAND I got lumbered with Robbie at a shoot. Obviously he hadn't been to bed, and he just wanted to sit and eat curry. It's one of my favourite memories: all the cute young girls coming in, literally in tiny bra tops and jeans down to here, all excited, 'Oh God, I'm going to meet Robbie Williams!' He comes in and all the cute girls turn round: 'Can we tidy the cupboard, actually. He's awful.'

SUZI APLIN I thought 'Angels' was beautiful. I played it to Chris and said, 'I think we should put it on the show.' No one else was booking it and I really pushed it. He said, 'Okay, if you really think it's good.' He came on *TFI* and it became a hit.

JOHNNY HOPKINS If Chris Evans symbolised the hedonism of Cool Britannia, he also symbolised the hubris that cemented its downfall. It's a cautionary tale.

MATTHEW FREUD Chris Evans became the equivalent of a money-printing press because the media's appetite for him was

inexhaustible. It didn't really matter what he did. The media's belief was that the public had this unquenchable thirst for stories and pictures and the malarkeys going on around him. We were able to control that tap to make sure that every time he had a TV programme coming out, that every time he had a new radio show, we could get the level of public interest in what he was doing to a frenzied degree. It was mad. He suddenly went from being a well-paid DJ to having a hundred million fortune and his own media company.

MATTHEW WRIGHT Chris Evans in many ways was the personi-fication of the nineties. He was a huge talent but, by and large, he squandered it and let a lot of people down, including himself, abusing his national voice. He went from being an innovator to being offensive with a loutish unpleasantness.

MATTHEW BANNISTER When Chris got *TFI Friday*, I thought, This is fantastic. The Radio 1 *Breakfast Show* host doing the music show that you have to watch with the bands of the moment playing live. It was a double whammy.

POLLY RAVENSCROFT Chris was a massive star. You'd never had anyone as big as him on radio and TV before. He was surrounded by people wanting to do everything for him. But there was defi-nitely a change, and the radio show became quite uncomfortable to listen to. Matthew would say something, but you've got somebody with a mind of his own on air every morning, live. You've got to be careful what you say because you don't want internal politics to come out. That got increasingly difficult. You felt something was going to happen.

MATTHEW BANNISTER There were some painful moments and times when it got out of hand. Chris ticked off a member of staff for fiddling her expenses on air. I thought it was inappropriate and told him that. And then there was a morning when I had to go to the Board of Governors to defend Radio 1 after he told a terrible joke at five to eight in the morning: 'What do Brussels

Sprouts and pubic hair have in common? You push them both to one side and keep on eating.' Another time Chris attacked Trevor Dann over an article in the *Evening Standard*, which he read out to listeners: 'Dann has been the invisible hand of success behind Radio 1 [. . .] he has quietly stopped the station's ratings freefall and helped the controversial Evans win record ratings.' Chris said, 'Extraordinary, because we unreservedly loathe the man [. . .] he's tried to put this show down more times than anyone else I've ever come across [. . .] I'm sick of this [. . .] I'm boiling over.' Chris was getting out of control and too fond of the sound of his own voice. He admits he was going a bit mad.

MATTHEW WRIGHT I can remember going to a Montreux TV Festival and Evans was flown over by Channel 4. We went out for this really nice dinner and he just talked the whole time. I thought, You are my hero. It was like a schoolboy crush. I hung on his every word. I supported him through *The Big Breakfast* and then on Radio 1, but he just took the piss. He was holding court like a fucking king, where you became a courtier and had to kiss his butt. The quality of his work started to go down, and he abused the wonderful privileges that his talent and his popularity had bestowed on him.

SUZI APLIN Chris was seen as a bit of a rebel because he was out drinking and socialising. If I was living outside of London, and I saw famous people at parties, I would say, 'They live in a different world from me.' Chris sort of normalised it all because he came from Warrington. He was a boy made good and he was honest. I don't think people cared that he was out on the piss or thought he was part of the elite. He was part of Britain changing, until he crossed a line and his life imploded.

MATTHEW BANNISTER There was the famous incident in Scotland that began when he was complaining that the air quality was terrible in London. It was the height of summer and he couldn't breathe. I said to him, 'Why don't we take the show to the most remote place we can think of? Radio Inverness.' He said,

'Great idea.' So the whole team went and the world press circus followed them. It went wrong when a local DJ, Tich McCooey, turned up at the hotel. Chris was in a meeting and he tried to muscle in and get some publicity from it. Chris went on the air the next morning to belittle this man: 'You're worse than the dirt beneath my heel [. . .] I could buy you tomorrow'. It was vicious and inappropriate.

MATTHEW WRIGHT Evans turned into a nightmare. It was difficult to stomach much more. He became a monster. It was inevitable that he had to go.

MATTHEW BANNISTER The strain started to tell on him because he was partying and having to get up very early. The show depended upon his adrenaline. Then, just when he'd come down from five days of presenting on the radio, he had to go back up the hill again to do *TFI Friday*. He started to get genuinely ill. I went to see him and he was pale and sweating. He said, 'I feel dreadful, Matthew.' I sent him to my doctor who prescribed him vitamins, which Chris, of course, then took to the studio, lined them up on his desk and told the listeners all about them. I thought, This is not good. So we renegotiated his workload, cut back the *Breakfast Show* by half an hour and gave him more holiday. I thought we'd solved things a bit and taken some of the pressure off.

WILL MACDONALD Chris was still drinking every night and sleeping very little and then famously asked Matthew for Fridays off.

MATTHEW BANNISTER I said to his agent, 'I can't do that.' I was then handed a letter which said, 'Unless Chris has tomorrow off and every Friday for the rest of his contract, we're giving you notice to quit.' The letter was leaked so I was put under enormous pressure to respond, so I said, 'I've given in to a lot of his demands but I can't allow this.'

POLLY RAVENSCROFT If Matthew had given in it would have been, 'Who's in charge?'

MATTHEW BANNISTER Chris came in on the Friday and spent the whole show having a go about being shafted, playing Engelbert Humperdinck's 'Please Release Me (Let Me Go)'. I didn't know whether he would come in the following week. I rang him on Sunday and he said, 'I can't talk to you,' and put the phone down. He didn't turn up on Monday, or indeed ever again. Kevin Greening covered the show and started with 'Don't Look Back in Anger'.

POLLY RAVENSCROFT I had to read a statement on the steps outside the BBC. There was a mass of press and photographers. It was bonkers. We were then quite bullish and put an ad on the neon billboards in Leicester Square. It read, 'Breakfast presenter wanted. Must work five days a week . . . Ginger hair an asset.'

MATTHEW BANNISTER There's an old shibboleth that women don't like listening to women on the radio; that women want male companionship to flirt with. How do you change that? You change it by changing people. So we employed Zoe Ball as the first woman to do the *Breakfast Show*. Zoe had just come off *Live & Kicking*, where she'd been incredibly popular, and was trying to make her way as an adult broadcaster. She'd got a reputation as somebody really engaging and warm, and was part of what was going on. And then Chris announced that he was joining Virgin and was going to launch a rival breakfast show on the same day. It was like Blur and Oasis – the battle of the radio breakfast shows.

POLLY RAVENSCROFT Both breakfast shows going head to head. That was like, 'OH MY GOD! Right, bring it on!'

POLLY RAVENSCROFT We had a press launch at the Langham with Zoe at the same time as Chris's for Virgin. The press were going from one conference to another.

MATTHEW BANNISTER It was the most extraordinary circus. I'd never seen so many journalists and photographers. It was like being hit by a wall of flashbulbs. And then they all sodded off to see Chris. Zoe, alongside Kevin Greening, did a really great first show, and when the figures came out we had more than doubled the audience.

WILL MACDONALD I was woken up by a phone call from Chris. He said, 'I'm in the Met Bar. You've got to come down. I've called up Zoe. She's going to come down after her show and then I'm going to call the *Sun* and pretend to be someone who's just spotted us drinking together.' Sure enough, I went down. We had a few drinks and then, once we knew the photographer was there, we went outside where a cab was waiting, Chris and Zoe got in, a picture was taken and we all went to the Harvey Nichols bar and got pissed. The picture got published the next day. The whole affair was so cartoon pantomime. The air was going out of the whole Cool Britannia balloon. It was time to move on. Tony Blair was maybe not as cool as we thought he was, and everybody was bored of Britpop. Oasis seemed unable to do anything new. Elastica imploded. Blur moved on and there were a lot of pretty average introspective bands around. Every week on *TFI* there'd be a string quartet of four women. And then *Big Brother* came along, which was more mean-spirited. Everything was shifting.

RIC BLAXILL It was all about TV entertainment; the beginning of reality TV. *Pop Idol* was the polar opposite of grunge and Britpop. By its definition it was manufactured pop music. What's your connection now with an artist? You might have voted for them but are you going to be a fan? It made it very safe. There wasn't any edge or attitude.

STEVE COOGAN Cool Britannia was killed with kindness. A collusion of vested interests intuitively co-opted it. The past had shown that what you do with any youth movement is you welcome it; you don't fight it by being angry. 'Come on, we'll all be like you. Let's all join in.' You go, 'Well, hang on a second. I thought we were supposed to be in opposition to something . . . who are we fighting now?'

TJINDER SINGH People look back and say, 'What a scene it was, I would have loved to have lived in that time. It was really great.' Just how people talk about punk. After twenty years even Sid Vicious's life looks good, and his life was terrible. History is always fucked up.

IRVINE WELSH Britpop was the last big, major fest. It was the last time that music papers and magazines had any real influence and power and were involved in shaping culture. The future was social media.

STEVE LAMACQ Jarvis said, 'It was like the lunatics had taken over the asylum.' All the people who five years previously would never have had a hope in hell were there when the doors opened as part of this fever. We love bands and we want more people to love our band, until it gets to the stage where it's no longer in our control and you just see the band being shot into the stratosphere, where you no longer have any particular relationship with them. All of a sudden there is a weight of opinion from the media that you don't recognise. The record industry became too self-satisfied and smug. Also, some of the people who were part of the revolution became too comfortable and took too much cocaine. Maybe the end game is just being in the tabloids every day. Ultimately it becomes the cult of celebrity. I remember talking to Graham Wrench[2] and he said, 'We've sold no tickets for Echobelly. When did Britpop end?' I said, 'I don't know.' He said, 'Well, it's over.'

SONYA MADAN Britpop crashed and burned. It was an audience shift, alongside journalists and everything else. It had lasted for four years. The party was over.

2 Promoter at Sheffield Leadmill and later manager of former Longpigs guitarist, Richard Hawley.

THE PEOPLE'S PRINCESS
Diana

DAVID BADDIEL Cool Britannia was when Britishness became fun and ironic and had good music, as opposed to being something rather cold and bleak and grey that only your uncle with his pipe talked about. That loosening of the collar may have something to do with what happened with Diana and the mass hysteria.

ALASTAIR CAMPBELL If you're thinking of the Cool Britannia perspective – of the modern image that Britain was projecting to the world – there was definitely something about Diana being a symbol of a modern Britain, maybe a more compassionate Britain. She was part of the vision and also one of the most beautiful women on the planet.

TONY BLAIR Diana was the symbol of modernity for the monarchy. And even though it caused tension within the Royal Family, her appeal was that she was a member of the Royal Family, therefore part of a very old system of hereditary authority. But at the same time in her demeanour, in the causes she took up, in the way she was with the people; she symbolised an end to deference, a willingness to bond with ordinary people, and an image of the monarchy that seemed right and was certainly very popular.

PETER HYMAN Diana embodied that in a way that Blair embodied that; there was a synergy. Diana famously touching a person with AIDS chimed with a sense of greater compassion, greater tolerance. I know Alastair and Tony discussed 'Could Diana get involved?', but whether that would have ever come off, we'll never know.

TONY BLAIR It's two different things. There was an alignment of zeitgeist between her modernising role within the institution of the monarchy and our modernising spirit of politics and for the country.

ALASTAIR CAMPBELL You couldn't have got into anything formal, but some of the meetings we had with her were about teasing out her understanding of Tony and New Labour, and what we were trying to do. She liked the energy and dynamism of our modernisation programme: social justice; helping the poor; gay rights; women's rights; and having a more ethical foreign policy. It felt like there was a read-across.

DAVID BADDIEL I don't think Diana would ever have publicly identified herself as part of the Cool Britannia idea, but I think she was. She was young and glamorous and an unusual figure. She wasn't going to be a quiet member of the Royal Family. Like Tony Blair, she was suddenly hanging out with celebrities, rather than the King of Belgium or whoever. Jonathan Ross told me that he sat next to Diana at an event and she said to him, 'It's lovely to meet you, but do you know who I'd really like to meet? Noel Edmonds.' Jonathan thought, That's quite a strange aspiration; and surely organisable.

MEERA SYAL Diana was an icon for a lot of south Asian women. They said she could be Indian: arranged marriage, virgin bride, overbearing in-laws, has to produce a male heir, vilified because she wants to leave the family firm, photographed outside the Taj Mahal. She represented somebody who tried really hard to be a good girl and nothing worked; somebody whose emotional pain made her out to be a mad woman; somebody who wanted to shake the foundations of an unsatisfactory marriage and an institution that wanted to silence her. There were so many things that were points of contact. She was a very un-royal royal and made a stuffy institution feel very human.

SIMON FOWLER I watched the Martin Bashir interview with Diana while I was in the changing room at the Manchester Apollo, on tour supporting Paul Weller. 'I'd like to be a queen of people's

hearts . . .' I remember thinking she was a bit simpering, head tilted, doe-eyed: 'There were three of us in this marriage so it was a bit crowded.' A lot of people didn't like that.

DAVID BADDIEL The key with Diana is that she was a disruptive force without knowing what she was doing. She didn't have an overall plan or agenda. She wasn't trying to subversively wreck the House of Windsor. She was a young girl who was corralled into marrying Charles and then had a very unhappy marriage. She wasn't a great revolutionary. She was just a woman who said, 'I will not go quietly.' It was a time when young women didn't go quietly. In a way, you can tie it to the Spice Girls. Ordinary women will be heard. You didn't have to be a Thatcher or an intellectual figure like Germaine Greer.

MEERA SYAL We had specific points of empathy for Diana, for what her life symbolised and what it said about marriage and woman-hood and arranged marriage. And the myth of romance, the myth of the Prince Charming and all the stuff we'd been brought up on that went horribly wrong. There were a lot of us women going, 'Yep, I totally get why you swallowed that one.'

MARK LEONARD The soap operas coming out of Buckingham Palace had turned adulation of the Royal Family into voyeurism. I co-wrote a report called *Modernising the Monarchy*, which basically said that the monarchy was fundamentally out of touch with society. We had various ideas about how they could change, which included recommending William and Harry go to state school and the Royal Family being treated by the NHS. And then suddenly the news was that Diana had been killed.

JOHNNY HOPKINS The dramatic death of Princess Diana fed the burgeoning expansion of mass media. It was a gift of a story: death; an English rose and a Muslim prince; conspiracy theories abounded. In a blink of an eye everything changed.

JEREMY DELLER I was driving back from a wedding in Suffolk with the radio on. 'There's been a car accident.' Then the news got worse: 'very seriously injured'.

ALASTAIR CAMPBELL The moment I was paged 'Car crash in Paris. Dodi killed. Di hurt. This is not a joke', I was talking to Tony. There was this mix of stuff going on: reacting emotionally because we knew her; reacting professionally because you're having to deal with it in the moment; but also being conscious of the fact that this is going to be huge and Tony's going to be a big part of it.

IRVINE WELSH I was in a hotel room in Brazil and I phoned up my mate Paul in Leith to get the result of the Hibs–Hearts derby. I remember the conversation. I said, 'What was the score?' He goes, 'Got fucking beaten one–nil. They scored in the seventh minute and we never had one fucking shot on goal throughout the whole game. Oh, and that Princess Diana whore. She's dead.' I went, 'We never had one fucking shot the whole game, really? So what happened to Diana?' He said, 'Oh, aye, fucking car crash in Paris.' I went, 'A car crash.' My wife, who's English, was jumping up and down: 'WHAT'S THIS ABOUT PRINCESS DIANA?' She wasn't a royalist or a forelock-tugger, but it was that amazing embedded cultural difference. We came back and everybody was out on the streets.

MATTHEW BANNISTER I got a call in the middle of the night from the duty radio editor: 'Diana's been in a serious car crash in Paris. We've gone over to the emergency instrumental music.' The last time we'd used it was when John Smith had a heart attack and died. I put on the telly to see what was going on and there was such a huge sense of shock because of the violent nature of the death; a young woman in her prime of life and a huge international fashion icon. People were waking up on Sunday morning to this news.

NOEL GALLAGHER I do believe that the first run of one of the Sunday newspapers was me on the front page – I'd said something ridiculous to a reporter, there might have been drugs involved – and there were two half-page headlines. Then, very soon after, that was forgotten about and it was all about Diana.

ALASTAIR CAMPBELL We were very conscious from day one that it didn't look like we were writing our script, rather than hers.

There are elements in the right-wing media I call 'the forces of conservatism', who would be out to say, 'They're trying to exploit this.' We were very, very sensitive. Tony had to be part of it because he was the Prime Minister. He was the person that people are going to look to for leadership, up to and including the Queen; and part of his role was to advise the Queen.

TONY BLAIR It was a terrible and shocking event. It's hard for people, if they weren't around as an adult at the time, to realise the iconic status she had. She was a global figure. I felt genuinely sad because I liked her and thought this would be a huge loss for the country. I was very conscious from the beginning that it had the possibility of opening up a rift between the people and the monarchy. In a way, my role was to try to make sure that there was a way people could come together.

STRYKER McGUIRE If Campbell says that Blair saw the enormity of it straight away, I'm sure that's true. The Palace was out of its depth. It showed Campbell's astuteness in reading the public mood. He would have immediately known that this was going to be a huge media event and the government took full advantage of it.

ALASTAIR CAMPBELL I remember Sunday night, when I went out to RAF Northolt, a driver came to pick me up. It was a Jewish woman and she was crying. Up until then I'd been at home on the phone all the time, watching a bit of telly, flat out. Busy, busy, busy. You just felt, This is going to be huge. While we waited for the body to arrive back from Paris, the Lord Chamberlain asked Tony if he would help with the planning of the funeral. He said, 'This is an extraordinary situation. We realise this is not going to be a normal royal funeral. It's got to be dignified but it's going to have to be different because she was different.' That was their leadership saying, 'We need a bit of help here.'

SIMON FOWLER You must remember that before Diana died she divided opinion. Some people thought she was a divisive, troublemaking cow, frankly, that she was insolent because she'd disobeyed the royal

family. Then suddenly she became the 'people's princess'. I remember thinking, Well, that's not what everyone was saying last week.

ALASTAIR CAMPBELL Tony said to me, 'This is going to produce grief like none of us have ever seen.' We discussed his speech through the night and agreed it was okay to be emotional, but I have no memory of who suggested the phrase the 'people's princess'.

TONY BLAIR I wrote the speech, scribbled on the back of an envelope, before we went to church that day. I realised that you had to try to express what people felt about her. The phrase 'people's princess' now seems something from another age. But at the time it felt natural. It was how she saw herself, and it was how she should be remembered.

KAREN JOHNSON Blair made the speech outside the church in his constituency: 'We are today a nation in Britain in a state of shock, in mourning, in grief that is so deeply painful for us. [Diana] was a wonderful and warm human being. Though her own life was often sadly touched by tragedy, she touched the lives of so many others in Britain – throughout the world – with joy and with comfort [. . .] the people everywhere kept faith with Princess Diana, they liked her, they loved her, they regarded her as one of the people. She was the people's princess and that's how she will stay, how she will remain in our hearts and in our memories for ever.'

ALASTAIR CAMPBELL The next day the front-page headline of the *International Herald Tribune* was 'World Mourns the People's Princess'. You never know when one of these phrases is going to connect. Instead of, 'Oh my God! He spoke for the nation,' it could have been, 'Urgh.' You just don't know. The phrase took hold immediately. Tony had only been Prime Minister a few months, so that was him being projected globally.

VIRGINIA BOTTOMLEY I'm not comfortable with that style of leadership. Leaders need to show a degree of dignity and restraint. I totally understand the generation change and wearing your emotions on your sleeve is often required, but it's not my style.

JEREMY DELLER I was living near Brick Lane and I remember walking around and everywhere was silent. It was incredible. You could hear the national anthem being played on market-stall radios.

MATTHEW BANNISTER Every programme had to be listened to for inappropriate references: Radio 1 stayed with instrumental music – Apollo 440[1] and tracks from the film soundtrack *Merry Christmas, Mr. Lawrence*. On Radio 4 it was, 'Should we play the *Archers* omnibus?' You were feeling your way. Radio 3 was in the run up to the Last Night of the Proms, so a piece by John Adams called 'Short Ride in a Fast Machine' had to be taken off.

JO WHILEY I have no memory at all of playing the Smiths' 'There Is a Light That Never Goes Out', but apparently I did – 'to die by your side is such a heavenly way to die' – and had the producer and everyone running in: 'Oh my God! What are you thinking?' I had to play Puff Daddy's 'I'll Be Missing You'. The whole tone changed. It was melancholy sad ballad after melancholy sad ballad, day after day after day. It was just this massive well of grief.

MATTHEW BANNISTER On the *Breakfast Show*, Kevin Greening played 'Don't Go Away' by Oasis, 'High and Dry' by Radiohead, 'The Universal' by Blur and 'Candle in the Wind' by Elton John, which seemed to touch a chord with people and was one of the reasons why he performed it at Diana's funeral.

NICK HORNBY I went to Stockholm on the Monday to do promotion for *Fever Pitch*. I was with my wife watching the news and becoming increasingly alarmed. It felt like we were watching Iran or somewhere; all you were seeing were these grief-stricken lunatics chucking teddy bears and weeping and gnashing their teeth. I thought, God, I don't want to go home!

JEREMY DELLER Around the Palace they had closed the roads, and people were wandering about in this quiet daze: laying flowers and looking at tributes, waiting for poems to be placed down to read

1 Electronic group from Liverpool.

them. Someone had already been physically attacked when a tourist had taken a little teddy bear from one of the shrines and had to be escorted away by the police. I remember one guy walking around in a suit and a bowler hat, like an old-school civil servant, reading all the poems and stifling his laughter. So there were subversives there: people who felt similarly to me about how outrageous and odd the whole event was. I'd typed a 'bad' poem as a small act of opposition to the prevailing mood, which I printed and laminated and then placed outside the Palace. I wasn't sure if I would be lynched. I stood a few feet away and took pictures of people reading it, and then within a few minutes flowers covered it over.

MATTHEW BANNISTER I remember coming out of the Albert Hall in the dark and seeing hundreds of people flooding silently out of the Tube to lay flowers. It was the most eerie experience. I'd never experienced anything like it.

SIMON FOWLER I was staying at the Kensington Gardens Hotel and went on the Tuesday to put some flowers down; by the Thursday you couldn't see the grass.

MEERA SYAL For a lot of people it was a chance for their own grief to come out, while others found it mawkish and odd. It was all very un-British. That's what I found very interesting, that actually it was the proper way to grieve. Anyone from any old culture will tell you, nobody sits around eating cucumber sandwiches and not mentioning the dead person. You render your clothes and you wail to the heavens and you scream out your grief because that is better for you.

ALASTAIR CAMPBELL After a while it became impossible to get a car down to the Palace, so I would walk through St James's Park, through the crowds. I'll never forget, one day I talked to a group of youngish people who had come up from Croydon. I said, 'Don't take this the wrong way, but I really want to know why you came today. What's it about?' They talked like Diana was their best friend.

MATTHEW WRIGHT It was mass scenes of grief. My dad had died

two months before. What would motivate someone to go and stand for hours to throw flowers for someone they've never met? I can't empathise with it, but on a personal level it gave me some release from how I felt about my dad.

JEREMY DELLER It was a form of hysteria. People could express their own unhappiness with the world in general, and then it became this self-generating thing. It felt like what it must have been to live in Eastern Europe in Communist times, in that you couldn't have a different opinion. Everyone was just agreeing with this thing, with very few voices of dissent or people trying to give a different perspective.

TRACEY EMIN There was a transformation. It was okay to cry if you were a man in public. It was okay for whole families to cry together. It was okay to question the Royal Family.

ALASTAIR CAMPBELL I spoke to Prince William. He said, when he did the walkabout on the Friday, he was just thinking, Why are you all crying? You didn't even know her. He said, 'It changed the way that we grieve as a country.'

DAVID BADDIEL I thought the outpouring was to some extent contrived; seeing the country undergo this moment of absolute emotional hysteria. Now I see that there were a lot of people who could express the pain and grief and yearning in their own lives through this cataclysm. I wrote about a character in *Whatever Love Means* who doesn't feel upset by Diana's death. He feels like he's in an underground movement and the secret emotional police are everywhere, telling him he's not being upset enough. I felt like that. 'I'm not that bothered' was unsayable.

STRYKER McGUIRE I was mystified by the enormity of it. It was out of all proportion. I don't see it as a defining moment of British cultural history. I remember when Jack Kennedy was assassinated. And Bobby Kennedy and Martin Luther King. There was an equivalent sense of emotional outpouring, in the sense that everybody was totally fixated, but I didn't see how the death of Diana could be on the same level as such an important civil rights leader.

SIMON FOWLER Diana suddenly took on sainthood. I think a lot of that had to do with the two boys, which played very empathetically with women and mothers, in particular. And then, of course, the Queen was seen as a villain. She was up in Scotland and they didn't lower the flag at Buckingham Palace. Tony Blair saved the day.

TONY BLAIR The week was difficult, partly because I was very new in the job and didn't know the Queen very well at that point; difficult because the entire eyes of the world were upon us, and difficult because the public felt that they'd been robbed of their princess. They really did feel that, and therefore were distressed and grief-stricken in a way I can't recall, before or since, with any public figure. Then partly angry because of the way the media had hounded her. And then the Royal Family, because the initial response seemed insensitive to all of that – I think not fairly, but that's what people felt – so it was important to try to bring about that rapprochement between monarchy and people fast. Of course, the flag was an issue. But it wasn't just that. It was very difficult for the Royal Family because they were grieving.

ALASTAIR CAMPBELL The Royal Family staying up at Balmoral, nowhere to be seen – I know from what we did in Northern Ireland that flags become so important – it became a symbol of the gulf opening between the Royal Family and the people. Did I see that one coming? I'm not sure. Each day it was growing. It was just the sense of the crowd, this feeling developing: We're hurting and they don't care.

JEREMY DELLER There was anger with the Royal Family for not making a statement and lowering the flag. It was a huge misjudgement.

CAROLYN PAYNE Blair and Campbell had to stop the Queen becoming really unpopular by stepping in, 'You don't understand how the media works. You have to do something, right now.' She couldn't read the public mood and didn't know how to respond.

ALASTAIR CAMPBELL We had these meetings and conference calls with Balmoral. Prince Philip came on once about whether the boys

were going to march behind the coffin. I was always very forth-right about what I thought, but I was always very careful not to be saying, 'You should do this . . .' In relation to the flag, I was saying things like, 'The newspapers are getting much more aggres-sive on behalf of their readers. I think people are just looking for a sign, a signal, a symbol.'

TONY BLAIR The Queen, in the end, realised that she had to meet people halfway, as it were, and did.

ALASTAIR CAMPBELL On the Thursday they said, 'Okay, we've had a meeting, this is what we're doing.' And they just went, BANG! BANG! BANG! with a fight-back plan.

MATTHEW BANNISTER The images stay with you: Diana's boys walking behind the coffin; people throwing flowers onto the hearse as they drove the body to Althorp to be buried; and obviously Charles Spencer's speech in Westminster Abbey, which was really heartfelt and an attack on the Royal Family. And then hearing the applause from the crowds in Hyde Park coming into the building over the broadcast systems – absolutely spine-tingling.

VIRGINIA BOTTOMLEY I knew Diana pretty well but I knew the Prince of Wales better. I knew too much about what had been going on. We all knew that her brother had refused to have her to stay.[2] There's an insider and outsider feeling on this.

SIMON FOWLER I didn't realise, but we were standing opposite Downing Street and suddenly there was a commotion. I was thinking, What's going on over there? Bloody hell! It's Tony Blair. He'd come out among his people and he was touching them in a sort of messianic manner. I was standing right by where the princes walked past, and all the women burst into tears and were

2 In 2002, Paul Burrell, Diana's former butler, appeared in court on three charges of theft. During the case it was revealed that in 1993 Earl Spencer turned down a handwritten request from his sister Diana for a home on the family's Althorp estate, six months after she separated from the Prince of Wales.

shouting out their names. And then some bastard came up and asked for my autograph. I said, 'Come on, mate.' It was impossible not to be imbibed by the mood.

VIRGINIA BOTTOMLEY The public outpouring of grief for somebody they didn't know was striking and noticeable. I saw it on the Mall on the way to the funeral, which was a magnificent and very moving experience.

MATTHEW BANNISTER People criticised the media and suggested that they had in some way led people into a state of hysteria. Absolutely not. We were trying to follow the public mood and respond to it each day.

JEREMY DELLER It was hypocrisy. The press pushed it too far. They killed a princess that had helped them have huge circulations.

MATTHEW WRIGHT I arrived in New York on a job for some awards do at the same time as news of her death, went onto the streets taking photos of something and we started getting shouted at: 'Paparazzi scum'. There were three or four angry comments in just a minute or two. My relentless pursuit of certain people: I was doing it sitting in an office. I wasn't going out chasing people around. But the market for Diana was huge. I was amazed how many paps were ex-military. They were used to hanging around for hours at a time, in very uncomfortable conditions; standing outside a nightclub till three in the morning meant nothing to them. It wasn't the papers' fault for creating the market. It was the readers and the social hunger for the photographs. All the papers said after Diana's death, 'We're not going to buy paparazzi photos anymore.' I don't think that even lasted a week.

ALASTAIR CAMPBELL Diana said this amazing thing at one of the meetings we had: 'You have to touch people in pictures. They can take a lot from you, but they can never take away the pictures.' She was saying, 'It's really important to get them right because people remember pictures, not words.' Whenever we were planning visits or doing speeches I'd say to my team, 'What is the picture? What is it saying?'

MEERA SYAL Diana sold papers, and by buying those papers we made the journalists follow her more. Her flaws and vulnerabilities were played out in the public eye and we watched her being hounded. So there was guilt mixed up in the grief, too.

MELANIE CHISHOLM We were in New York for the MTV Awards and all wore black armbands. Madonna did a speech about 'the paparazzi and the irresponsible behaviour of tabloid editors'. We performed 'Spice Up Your Life', and when we won Best Dance Video, I said, 'We'd like to dedicate this award to Princess Diana. It was a great loss for our country. She was a fantastic ambassador for Great Britain . . .' Geri added, 'And also what we're really about, what Lady Diana had, she had real Girl Power.'

STRYKER McGUIRE It was a global event. The US couldn't get enough of it. They wanted as many Diana covers as possible. Diana had an intuitive understanding of the media's importance. She instinctively knew how to control her image in public. She would make private visits to Great Ormond Street Hospital and Centrepoint and tell the media beforehand. Just before her death, there were photos of Diana and Dodi on her yacht in the south of France. She told the paparazzi where she was going to be. There was one guy in particular, Jason Fraser, who was like the king of the paparazzi. I believe that Diana called him to tell him that she and Dodi were staying at the Ritz the night she died. Her sons have said her death was the paparazzi's fault, but it was a mutual using of each other.

ALAN EDWARDS There was an element of playing the game. Everybody knew on all sides of the fence: the media knew, the people knew, Diana knew.

KEITH ALLEN It's obfuscation: people think it's something to do with the Royal Family loathing Diana, and her taking revenge on them by fucking a Muslim and being apparently pregnant and the implications of an heir to the throne. But, in fact, what people tend to forget is that she had become a spokesperson and focal point

for banning landmines. There was so much money involved in the manufacture of landmines and Diana had got Clinton to sign a banning order. Within four days of her dying Clinton rescinded his signature. I would say Diana was murdered.

ALAN McGEE Diana dying heralded the end. It's quite significant in a weird way. The country went into national mourning. I'm not a royalist on any level – I couldn't give a fuck – but it did seem to bookend the whole time: 'That's over now.'

BEND IT LIKE BECKHAM

Celebrity culture. David and Victoria. World Cup 98. Media

STEVE COOGAN There's a rose-tinted nostalgia about being young and innocent and excited at being part of something, but some of the legacy of that is rather pernicious. There was something about the whole cult of personality, which social media reinforced when it arrived many years later. It was the beginning of celebrity culture.

MATTHEW FREUD The thirst for celebrity news was coming from newspapers. It was a derivative of a new dynamic in media. When I started Freuds in '85 there was a celebrity half-page daily column in the *Evening Standard*, a half-page column on Fridays in the *Sun* called Bizarre, Dempster's Diary in the *Mail* if it was posh celebrities, and every single page in every other newspaper was proper news, except for Page Three. By the nineties, the non-news drip turned into a flood when the tabloids worked out that they could put famous people on the front page and cater to a celebrity narrative.

PHILL SAVIDGE A lot of the entertainment journalists ended up editing newspapers because their stories tended to end up on the front cover. Then the proprietor of the newspaper would say, 'Who wrote that story? That's a great story.'

KAREN JOHNSON The tabloids started trying to muscle their way into indie pop culture. I saw Piers Morgan at a Happy Mondays party

wearing a straight suit and they were all in their baggy T-shirts. They were ripping the piss out of him. You can imagine.

KEITH ALLEN They all cut their teeth on celebrity gossip and rock 'n' roll. If you look at the mid-sixties to early seventies, which would be the closest period you could get to the zeitgeist of the nineties, all these rock stars were fucking girls underage. They were all at it, but there was a pact between the media and the press, which was, 'I'll give you this much but don't mention this much.' By the nineties that pact had disappeared. It became a free for all. Print and have done with it. No one gave a fuck.

MATTHEW WRIGHT The easy way to do a tabloid column is to have as many enemies as you can, because then you've always got stories. Sid Owen[1] was someone I used to take the piss out of: saw him at a TV awards, he throws a pint of beer over me, job done: 'Sid Owen chucks a pint of beer . . . what a cunt.' I was a provocateur. You're setting out for people to dislike you. For all the people who associate the tabloids with pernicious, vile, evil, sleazy, sensationalist, they hate you before they've even met you.

LORENZO AGIUS There was a massive turn around in catching celebrities out: 'Oh, look at this picture of so-and-so in their track-suit bottoms after a heavy night out.' People wanted to see the non-glamorous side and read about people's personal lives. People became famous for doing nothing.

MATTHEW FREUD To give a personal context, in 1900 the amount of people who were globally recognised in their own lifetime was very few. It was my grandfather Sigmund Freud, Charles Darwin and kings and queens. And then in the sixties, when my dad, Clement Freud, was famous, in that first wave of British television celebrities – David Frost, Eamonn Andrews, Mike Yarwood – hysteria existed and these people were elevated to near-deity status.

1 Played Ricky Butcher in the BBC I soap opera *EastEnders*.

ALAN EDWARDS That was the last era when you could create a myth, which started in Hollywood with Marilyn Monroe. That glamour came over to England: Swinging London; Michael Caine. And then the absolute high zenith of it was the nineties.

MATTHEW FREUD Then you saw the equity in what it took to become famous gradually get less and less, until the reality TV boom in the late-nineties, when the joke fell in on itself: which was, anyone could be famous. People were so upset by Paris Hilton. 'What's she done to be famous?' There was a picture of her getting out of a jeep; she just forgot to wear her knickers one day.

FIONA CARTLEDGE The underground became the overground, and there was a rapid escalation of hero-worshiping. Aaron, who worked in the shop, used to buy *Hello!* and we'd take the piss out of him: 'That's horrendous. That's never going to happen here.'

MELANIE CHISHOLM There was only *OK!* and *Hello!* for the poshos. There was no *Heat* or *Closer* or *Now*.

LORENZO AGIUS Then, all of a sudden, celebrity magazines started to surface. The culture started to change. Footballers became celebrities.

MATTHEW WRIGHT Wapping, 1992. Sitting next to Piers Morgan and Kelvin MacKenzie.[2] Piers says to Kelvin, 'Sport is the new rock 'n' roll.' I remember it as clear as day. Kelvin goes, 'Yes.' And that was the beginning. Piers was obsessed with sport and celebrity.

ALAN EDWARDS Fashion, music, sport – everything was combining. It was big business. One of the basic things I learnt about PR was that it's a combination of things. You can go back to Malcolm McLaren. He used to put the Sex Pistols in out-of-context venues, so rather than a residency at the Marquee he'd book them at the Conservative Club. You put people out of their environment and interesting things happen. It's like a chemical reaction.

2 Editor of the *Sun*.

SHERYL GARRATT Footballers weren't cool. They dressed terribly and looked like apprentice police inspectors. They had awful hair-cuts and still had bubble perms. Then suddenly you had Jamie Redknapp and David Beckham.

ALAN EDWARDS You had blokes suddenly interested in men's grooming – in clothes and suits. I go to an early meeting with David [Beckham], we talked about doing something with the *Sunday Times* style, and he said, 'I want to have a bit of an Elvis look. And I want a suit that's cut in this fabric and stitched like this and this, that and the other.' I've gone, 'Wow!' That's not how footballers had been.

STEVE COOGAN Every couple of weeks Beckham would have a different haircut. One week he had a feather cut with highlights, very much like Paul Calf. My brother came back from a match at Old Trafford and said, 'You're not going to believe what I heard today. They were singing, "Are you Paul Calf, are you Paul Calf, are you Paul Calf in disguise?"' I was like, 'Fucking hell! We've made an impact.'

GURINDER CHADHA It's hard to appreciate who Beckham was then. Young people see David and Victoria as very successful, very rich, very consumer-orientated people, but back then David was a young kid who had always dreamed of playing for Manchester United. He was living his dream and becoming quite the icon. He advertised underwear and a lot of gay men were going gaga for him. And he wasn't freaked out by it.

ALAN EDWARDS I had a meeting with him when he was in a 'one-up, one-down'. He'd just come back to Manchester having being on loan to Preston North End, and invited me round for dinner. It was like a Hovis advert with cobbled streets and David borrowing ten pence for the meter. Then it was baked beans on toast, but he couldn't find the can opener. I was sitting there, thinking, Can I get the last train back to London? Anyway, we started talking and his vision of football was inspiring; he wanted to fight against homophobia and racism in football and promote the women's game

and open football up in America. I was thinking, My God! I had worked for a few players before and it was usually, 'Can you get me into this bar . . . can you get a deal on a new sports car?' He was twenty years old and had a vision of culture.

JO LEVIN There has always been cool sportspeople. George Best. James Hunt. Ayrton Senna. There are certain heroes that have that 'it' factor. Beckham was talented, good-looking and about to marry a Spice Girl. It was the combination.

GURINDER CHADHA Whenever Victoria went to matches they used to sing 'Victoria takes it up the arse'. David saw an opportunity to try to change the view of football.

ALAN EDWARDS Richard Desmond, the owner of *OK!* magazine, called me up one night and said, 'I want to buy the rights if David and Victoria get married.' He said, 'Look out of your window. You'll see my Bentley. Come over to my office, now.' I'd never been in a chauffeur-driven car before, so I went over to see him in Docklands. Richard said, 'I'll give you a million quid but you have to do the deal on the spot.' I'm thinking, Right, well, the biggest offer we've had from anyone is £130,000. David and Victoria were on a flight out to America, so I said, 'We'll do it.' I called Victoria the next morning: 'Victoria . . . I've been offered . . . this deal . . . *OK!* . . . a million quid.' She said, 'YOU WHAT? Please tell me you agreed.' That edition went on to sell four-million copies.

MELANIE CHISHOLM It was one of the first big celebrity deals. It was the dawn of people being plastered everywhere and maximum exposure.

MATTHEW FREUD It was the point at which the British media, broadsheets down, decided that they were going to give people a diet of celebrity gossip on a daily basis, on the front page and across the news pages.

ALAN EDWARDS Alex Ferguson must have hated us. He had all these people around Manchester, kind of like spies, to make sure

his players weren't out on the town. David had this scam where his mate drove a white transit van and he'd lie on the floor and then pop up at some amazing party with Victoria in London. In Manchester they'd be saying, 'No, boss, he never left.' All this cat-and-mouse stuff. I don't think Alex thought it was funny.

STEVE DOUBLE We used to have evening meals at seven o'clock at Bisham Abbey – it was like a glorified school canteen – and quite often the players would have *Top of the Pops* on. I remember 'Stop' by the Spice Girls coming on and the whole squad was giving Beckham jip. He soaked it all in, but Hoddle didn't like it. I remember him saying once that he distrusted the music industry; 'It swallows you up,' he said, 'given the chance.' In football the team comes first, so you've got to rein it back.

NICK HORNBY If you go back to the sixties it was extraordinary to see an image of a football player outside of the immediate environs of their ground; like George Best doing an 'eggs for breakfast' TV advert.[3] You went from that to the reverse, where it seemed weird that the person you were watching on the pitch was the real person because you'd seen so many images of them in magazines. 'That's the real David Beckham! That's the real person!'

LORENZO AGIUS I shot David quite a few times: the golden boy of football; England's great hope. He'd just met Victoria and they came together. David was sweet, but very uncomfortable. We talked and I tried to relax him: 'Did you see that film . . . what do you think of this music?' There wasn't anything there, but put him on a football pitch and he was a genius.

JO LEVIN One of the first pictures I ever did of David Beckham was when he had been voted Sportsman of the Year by *GQ*. He was extremely shy. He came with Victoria, who spent the whole afternoon with her mobile glued to her ear, making last-minute wedding plans. Then I did a big shoot with him against a St

3 British Eggs advert featuring George Best created by Ogilvy, Benson & Mather in 1970.

George's Cross. I rocked him up – trouser button undone, hand on his crotch with scratched black nail varnish – and it made the front page of every newspaper.

ALAN EDWARDS The creation of the Beckham brand: it's a bit like who signed the Beatles? I was definitely a component in the beginning. And although Simon Fuller wasn't managing him at that stage, his influence was all-pervasive. There are probably hundreds of people in the Beckham industry now, but this stuff was all done on the back of Post-it notes in black cabs. You imagine some big ad agency planned a strategy, but it was very instinctive.

MATTHEW FREUD Brand Beckham is unquestionably the most brilliant iteration of taking awareness and turning it into a proper business. There were lots of footballers who were really good, and lots of singers, but for Simon Fuller to be able to create this juggernaut around a commercialisation of that fame . . . the fact that twenty years later Beckham is still probably the biggest marketing Exocet you can attach to any brand.

SIMON FOWLER I met David Beckham around the time of World Cup 98, when we made a record with the Spice Girls as England United, initiated by the FA. I went up to Liverpool to meet Ian McCulloch[4] and Tommy Scott from Space, and took some cocaine. Ian said, 'I've given up,' and as soon as his missus pissed off, he said, 'I haven't really.'

STEVE DOUBLE The management were keen to do 'Three Lions' all over again, but we were saying, 'Actually, let's try something new.' We had this vision of a Band Aid-style song, with all the main artists of the day like Blur, Oasis and Pulp, and had meetings with all these music business executives. The Spice Girls come in and everyone walked away.

4　　Lead singer of the band Echo & the Bunnymen. McCulloch left the band in 1987, but the band reformed a decade later and had top ten hits with 'Nothing Lasts Forever' and its accompanying album *Evergreen*.

SIMON FOWLER Johnny Marr co-wrote the song, '(How Does It feel to Be) On Top of the World', and as soon as the Spice Girls were involved he insisted his name was taken off the writing credit. I stuck with it because I was a football fan and it was England. I didn't give a toss the Spice Girls were involved; they were nice people.

MELANIE CHISHOLM England United was in the mix of the mayhem. It was a good and fun thing to do.

JOHNNY HOPKINS That's how mad the nineties got: Ocean Colour Scene and Ian McCulloch making a football song with the Spice Girls.

SIMON FOWLER The Spice Girls came to the studio and Ian leaned over to me and said in a thick Liverpudlian accent, 'They're like a real band.' I didn't really know their names and said to Sporty, 'Hello, Victoria.' She said, 'My name's not Victoria. I know your name. Learn mine.' Then, during a soundcheck at *TFI Friday*, Scary said, 'Have you got a girlfriend?' I said, 'I haven't, no.' She said, 'Would you like one?' Geri said, 'I think he bats for the other team.' Scary said, 'What's that meant to mean?' and Geri said, 'He's gay.' Scary said, 'He's not gay!' Then went up to the microphone and, in her broad Yorkshire accent said, 'IS THIS MAN GAAAY?'

STEVE DOUBLE England United didn't really work. When it was released it was very quickly third choice: the fans loved 'Vindaloo' and there was the remake of 'Three Lions', so it felt like a failure.

DAVID BADDIEL I wasn't wild about 'Three Lions 98'. We wrote the lyric 'Gazza good as before' and then Hoddle dropped him because he was spotted on a night on the town with Chris Evans. These things last organically for a very short amount of time before they become something that feels marketed and self-conscious. By '98 it felt self-conscious and Cool Britannia was no longer spontaneous. There were people deliberately milking it. Besides, critics and hipsters preferred Fat Les, so 'Vindaloo' became the new story.

KEITH ALLEN 'Vindaloo' started in the Groucho when Alex [James] said, 'We've got to write a football song.' Then he drummed a marching beat on the table and said, 'This should be the rhythm.' We were going to call ourselves Black Panties or something terrible like that, until we saw a fat lesbian in the Star pub on Portobello Road. You can guess the rest!

PHILL SAVIDGE Alex said, 'Phill Savidge has got to do the PR,' so I met Alex and Keith and Damien [Hirst] in the Groucho. Damien said, 'What are you going to do for us, then?' I said, 'I'll get you an *NME* front cover, *Melody Maker*, and in the tabloids every other day.' He went, 'You're hired,' and threw a bag of money at me. There was £15k in it. I'd never seen that kind of money before. Damien was playing snooker, and his agent, Jan Kennedy said to me, 'You should give it back to him. He'll respect you more in the morning.' I thought about it, and then said, 'Here you are, Damien. We should sort out a contract.'

KEITH ALLEN We did 'Vindaloo' on *Top of the Pops*, and one of the kids who was doing backing singing dislocated his finger. The Spice Girls were on the show and Ginger Spice took him into her arms and put it back in. I thought, Fucking hell! That's amazing. Of course, the boys were all like, 'Wow!' and salivating over her.

PHILL SAVIDGE Radio wouldn't play 'Vindaloo'. They thought it was jingoistic, even though it was a multicultural masterpiece, went to number two, stayed there for three weeks and sold 900,000 copies.

KEITH ALLEN To get reactionary football fans singing about a staple Asian dish was really funny.

DAVID BADDIEL 'Vindaloo' was self-consciously creating that Cool Britannia thing of 'I'm going to use British working-class, *Italian Job*-style reference points'. It presented the fetishisation of Britishness in a very straightforward way, virtually listing things that *Loaded* might have banged on about.

SIMON FOWLER 'Vindaloo' became synonymous with France 98, along with a new bout of football violence and David Beckham's untimely on-field misdemeanour.

STRYKER McGUIRE Hooligans running riot abroad was hardly the best advertisement for Blair's stated vision of Britain as, 'The best place to live, the best place to bring up children, the best place to lead a fulfilled life, the best place to grow old.' Nevertheless, Beckham grabbed all the headlines.

ALAN EDWARDS I was at the match against Argentina, standing behind the goal for Shearer's penalty and Owen's amazing goal. And then, of course, Beckham's sending off when he flicked his foot out and Diego Simeone went down.

STEVE DOUBLE It happened in a flash. You didn't realise what had happened.

ALAN EDWARDS It became a national tragedy. It was the lead story on *News at Ten*: 'David Beckham's apology for being sent off against Argentina after England crash out of the World Cup.'

MELANIE CHISHOLM We were in a bar in New York watching the game. David was vilified. He became public-enemy number one, so he flew over to join us. He was very down.

ALAN EDWARDS The reaction against him was extreme. There was an effigy of him hung outside his parents' front door. The whole nation was engulfed in this fury. It was incredible. He was battered and bruised and had to leave the country because of the lynch mob.

MATTHEW WRIGHT There was the infamous *Mirror* cover: 'Take your fury out on our David Beckham dartboard.'

ALAN EDWARDS I got all the English papers faxed out to the States. They were horrible, really vicious. I'd go through them one by one, analytically. That's when all your experience comes to play. You don't panic; you realise it's a storm but the storm will pass. PR can make two mistakes: it can overreact and get

hysterical and shout and scream at journalists and make it worse, or it can take the Hollywood route – 'no comment . . .' – and hide; and then you never fix the problem. There were a couple of months of hell and then the opening day of the new season was Manchester United away at West Ham. David was an east London lad. Everything was against him. The crowd was on top of him. Everyone was thinking, This could be meltdown. David played great. He had this incredible inner strength. Week after week he got incredible amounts of abuse, and in response he played some of the best football of his life.

MELANIE CHISHOLM It's incredible how David turned it round.

GURINDER CHADHA I had grown up with the idea that football equals hooligans equals National Front equals the underbelly of society. Then, after Euro 96, things started changing. I was in a pub in Camden for a World Cup qualifer match and I saw black people shouting, 'En-ger-land, En-ger-land!' It had a massive impact on me. I suddenly was, 'Oh my God! This is different.' And then, at the end of the game, Ian Wright ran around the pitch with a Union Jack. To see a black man do that was a wonderful image. It made me want to look at football in a different way, and that's when I had the idea of making a film set in the world of football.

NICK HORNBY I was always moved and struck by black athletes wrapped in the flag when they'd won something. It felt like a more inclusive version of Britain, like relay teams when there are two black and two white athletes.

GURINDER CHADHA I had been introduced to a writer who had a proposal about a girl who wants to play football, and the idea came to me to make it about an Indian girl in Southall and to use the analogy of her bending the ball like Beckham and bending the rules to get what she wants. After we made the film we took the first print of *Bend It Like Beckham* up to Manchester for David and Victoria to have a private screening. I was confused because David brought some young boys with him. I said to my partner, 'Who are

these kids?' He kicked me and said, 'It's Gary and Phil Neville!' At the end, Victoria said, 'It's much funnier than *East Is East*.'

MELANIE CHISHOLM Gurinder warned me about a line in the film.

GURINDER CHADHA Keira Knightley's character is practising with a ball in the garden, and her mum comes out and says, 'There's a reason why Sporty Spice is the only one of them without a fella.' Melanie was laughing her head off.

MEERA SYAL *Bend It Like Beckham* was a double whammy of football and girls. It was smart marketing.

GURINDER CHADHA I didn't realise it was going to be such a huge global hit. It was about making a film that reflected my Britain and my world. What we ended up doing was showing the world a version of Britain removed from Merchant Ivory or *Trainspotting*. The film was so unashamedly emotional. It wore its heart on its sleeve. It doesn't matter who you are, what age you are, what background you are, there's an innocence about it that refuses to let the world of racism or prejudice against people of different backgrounds figure.

ALAN EDWARDS David Beckham epitomised the common-man hero. There was this issue that Buckingham Palace kept receiving letters for David and Victoria. If I'd hear anything like that I would fuel the fire: 'Give it to the *Sun*.' It was an age of meritocracy.

SHERYL GARRATT Then you get celebrity as brand. People became brands.

MATTHEW FREUD The rise of everything that we did and the rise of the stature of this business was entirely derivative of the rise in the power of celebrity to assist the media in maintaining their relevance to their readers. We used to have news operation teams onsite on Chris Evans's *Breakfast Show*, which every single day mined three hours of live radio and came up with stories. On a film set it used to be called unit publicity. It was a very early form of social media to get people talking and do the marketing job for us.

CHARLIE PARSONS We first used the unit publicity team on *The Big Breakfast* to work out which stories might make the tabloids, and make people think, I must watch this show.

MATTHEW FREUD We became the most successful news agency in the country because every day we put these stories out and they were picked up by the papers. Bear in mind, a news story isn't a fucking news story; it's just a picture of a celebrity and a headline and some bit of nonsense: 'What Chris Evans did after he left the show'.

MATTHEW WRIGHT It was fucking annoying because every single day you'd get a call from the full-time Freud PR with a story they were pitching, whether it was true or something that could very well have been made up. I would be sitting in my ivory-tower office knowing that if you put the words 'Chris Evans' in a story and it went in the paper, 'Great!' You look back through the *Sun* and there's a Chris Evans story every single day.

MATTHEW FREUD Whenever someone was writing about Chris we were feeding it to them, enhancing it, spoiling it, blocking it – whatever we had to do. It was a marketing machine. It just became this unbelievable loud story generator that began to drive the whole national conversation: Chris Evans does something on radio, it's in the newspaper the next day, then he's talking about what's in the newspaper and so is everyone else. You get this very virtuous cycle because the media had yet to develop this cynical self-loathing of their own role, where they react against becoming part of that publicity machine and decide that their job is to hold these people to account.

CHARLIE PARSONS Many of the tabloids were the same generation as us and felt that it wasn't all about serious political things. It was like a Venn diagram, where we shared a common agenda; an exclusive interview with Kate Moss and Johnny Depp was great for us and great for whichever newspaper covered it.

MATTHEW FREUD It sounds fucking arrogant but it's probably true for a lot of the nineties: we were probably the number one content creator in Britain, in terms of the amount of material that

was going into the tabloid press. We controlled so many movies, so much TV, we launched twenty TV channels, from Nickelodeon to Paramount to Playboy to all the Sky channels, all the Chris Evans shows, plus *Who Wants to Be a Millionaire?* and *The Big Breakfast*. The relationship got a little twisted. We had too much power because the media became addicted to this easy soft-news flow. There was very little scrutiny. We could get logos and brand names where we wanted. There was a shared enthusiasm for non-critical subject matter. They weren't trying to expose the hypocrisy or the seedy dark side of celebrity life. It was a bit like Hollywood in the twenties and thirties: the media complicit in the machine that promoted the idea that everyone in Hollywood was beautiful, a Xanadu world of gorgeous people who were better than us. The celebrity wave across the nineties was exactly like that. It wasn't like there wasn't bad behaviour, but the majority of the journalists were inside and doing what everyone else was doing.

SHERYL GARRATT Record and film companies became bigger and had departments to deal with cross-platforms. It became really important to get your song on the right film soundtrack, in the right advert or in the right computer game. In fashion there were big amalgamations; you had these huge umbrella companies owning most of the fashion brands and buying up Galliano and McQueen. Everything was being co-opted by business. A public piece of art could revive a city. It gave a small number of people a great deal of power. It went from Take That in total joy because Adidas had sent them some cool stuff to wear, to the point where most artists were overwhelmed by brands sending them stuff in the hope they'd be photographed wearing their shoes or carrying their bag.

TRACEY EMIN I was the face of Bombay Sapphire gin in '97. I got paid a lot of money and my face was on huge billboards in airports around the world. It was so funny because there was a fire at Heathrow Terminal One and I was in the background on all the news reports.

ALAN EDWARDS I wanted to see entertainment, not news, on the front covers of the newspapers every day. I wanted it to be the

Spice Girls, not the budget. That was a deliberate driving force. My job was to fan the flames and make it as loud as possible.

WILL MACDONALD There's a dark art involved in it all. It's a big game.

MATTHEW FREUD It's a conceit in that the hypocrisy that the media exposed, the values they shot down, were values they attributed to these celebrities in order to fill their pages with stories, which they thought their readers were interested in. It started at Watergate with the idea that Richard Nixon, the President of the United States, was flawed. Talk to a gutter journalist on the *Sunday People* and they'll cite Watergate as why they're sitting in a hedge outside a Premier League footballer's house to see whether or not they're having an affair. 'Exposing hypocrisy . . .' You go, 'No, you're exposing the fact he's a human being and not perfect.'

MATTHEW WRIGHT At the end of the day, whether it was the Spice Girls, Robbie Williams, Noel and Liam, or any of the others, I don't think anything I wrote did any of them any harm whatsoever, and it's quite possible that it actually did them quite a lot of good. There was a lot of cruelty in that, but it was the Spice Girls PRs that started it: lying, cheating, turning me over and exposing me to enormous pressures at work, and basically putting my job on the line by humiliating me and not playing fair. Was I going to get bollocked by Piers Morgan every single day of the Spice Girls' career for not having the story of the day or was I going to get even?

MELANIE CHISHOLM Matthew Wright was horrible about us.

MATTHEW WRIGHT I didn't give a toss about the Spice Girls as individuals. They were multi-millionaires who were very, very lucky. So we just turned on them, just as we did with Robbie and Take That. It was the same pattern: work with us or you're our enemy. Everything was embroiled in the mindset of no more failure: if someone treats you badly, fuck 'em, get 'em back. We went to war with people who didn't play fair.

SHERYL GARRATT There was a shift from easy access to people, to hoops you would have to jump through to get a story. It was coming from the PRs and from far more magazines wanting the same people. There was a new aristocracy of stars and PRs became the gatekeepers. All the big magazines were getting these people onboard whose job it was to fly to LA and just sit in a PRs' office for days to get access to these names.

MATTHEW WRIGHT There was a *Smash Hits* Poll Winners Party in Docklands, and I did a Jarvis and invaded the stage. I wore a false beard and hid in the toilets, waiting for the Spice Girls to come on: hear the first beats of the music, open the door, swerve round security, hop over the barrier, up on the stage and unfurl a *Mirror* banner. Geri goes, 'There's Matthew Wright!' As soon as she said that, I thought, Fantastic! Job done. Arrest me if you like. That's the kind of thing I did to get a story.

MELANIE CHISHOLM I have no recollection of that, whatsoever.

MATTHEW WRIGHT In the end, the penny dropped, all encouraged by Piers the puppet master, that if I became the story then I'd always have something to write. I remember sitting in some restaurant interviewing Boyzone, and Robert De Niro was at the next table. I introduced myself as Boyzone's manager and said, 'Would you mind having a photo with the boys?' 'Not a problem.' He was really slurry. It became, 'My weird lunch with Robert De Niro.' The whole interview was just these 'zzz's: 'Robert, how are you enjoying London?' 'Zzzzzzzzz.' 'What do you think of Boyzone?' 'Zzzzzzzzz.'

MELANIE CHISHOLM What was the tipping point? It's really interesting because it's before social media and reality TV. I used to say, 'Blame the Spice Girls.' We were super-successful and we did incredible things, but we also really pushed the boundaries with sponsorship and deals. There was this overexposure.

MATTHEW WRIGHT Matthew Freud unveiled himself within major corporations and the tabloids. He provided safe passage for major corporations into the pages of the tabloids, like the *Mirror* turning

blue for Pepsi Cola . . .

SHERYL GARRATT Pepsi went blue. They'd already painted Concorde, and astronauts in the *Mir* space station had posed with blue cans.

MATTHEW WRIGHT A million pounds straight into the *Mirror* bank account; that gets an editor's attention. Matthew Freud pulled all the strings. He was very powerful within the story of the nineties, especially when you start looking at New Labour and their relations with the press. Freud was a force to be reckoned with.

MATTHEW FREUD It was a transaction. A transaction gives you real power because you go, 'I'm giving you this. You're going to give me that.' It's what you do with it. The zeitgeist is very difficult . . . you could be one of the greatest alchemists in the world but there's hardly anyone who's done it twice. It's the right thing in the right place at the right time, with quite a lot of luck. Chris Evans was a very talented TV presenter at a point where television was looking for a new voice and the world was ready for something different. But something happened to lift him from being niche to becoming this absolute sensation. *Four Weddings and a Funeral* is a really good film, but there's something about what happened with Liz Hurley wearing that Versace evening gown held together by gold safety pins at the film's premiere. There was a tonality that just landed. Suddenly, you became Camelot: you became this golden court where everything you did smelt of roses.

ALAN EDWARDS It's amazing. It all happened and it all connected and everyone knew everybody. When you look back on it, that world was probably one-hundred people: x many footballers; x many pop stars. Then you had certain key journalists: Piers Morgan, Andy Coulson, the 3AM Girls. At the time it just seemed like that's how the world worked. There was this amazing energy coming out of all these places, and big money in this strange combination of music and football and glamour and fashion: everyone rushing out to buy Paul Smith or wherever to get that look, to get the new Becks haircut. Papers and magazines couldn't print enough of everything. It was like the sixties moment: wall-to-wall interesting, creative, good-looking people.

EVER HAD THE FEELING
YOU'VE BEEN CHEATED?
Blair first term. Margaret Thatcher.
Spin. Ireland

JOHN NEWBIGIN Remember the *NME* headline 'EVER HAD THE FEELING YOU'VE BEEN CHEATED?' They wrote, '*Our* music, *our* culture, the collective sweat of *our* groovy brows has been bundled up and neatly repackaged and given a cute little brand name and is being used by New Labour spin doctors to give this hideously reactionary New Labour government a cachet of radical credibility.'

ALASTAIR CAMPBELL There was a little bit of a backlash. That was a difficult period; goodwill got us through.

STRYKER McGUIRE The Blair magic barely survived his first year in office. At the time a joke made the rounds. If the Prime Minister was not in callers to Downing Street would hear a recording: 'Please leave a message after the high moral tone.'

ALASTAIR CAMPBELL Once it became obvious that we were going to win the election the mood around Tony changed. Then, when we won, bigger than any of us expected, it went from being quite a positive mood to something that was unsustainable for any political figure. One of the bases on which we won the election was Gordon saying, 'We're going to stick to the Tory limits for

two years while we get the economy back to shape and then the public-service investment will start.' That's exactly what happened.

GEOFF MULGAN A lot of the people who were saying 'betrayal' etc. were very innumerate, to be blunt. It was people not able to see the long view or the big picture. New Labour presented themselves as centralists, almost wet Tories at times, and yet they implemented a quite classic Labour programme.

CHRIS SMITH It was part of the search for economic respectability that they believed was essential to help them win the election. Labour sweeps into government with this huge majority, and everybody out there thinks, Well, now Labour can do whatever it wants. But Blair and Brown insisted we still had to stick to the spending plans. That meant absolutely no increase in money. It made my life a nightmare. I got used to turning up at arts events and being roundly denounced from the stage. Peter Hall, who was a big figure in the theatre world, wrote in *The Necessary Theatre*, 'We have a civilised, articulate and reasonable Arts Minister in Chris Smith. He makes all the right noises. But he is given insufficient money and power.' As we approached the end of the two years I was able to get a lot more money out of the Treasury, and we were able to start making huge changes.

STEVE COOGAN I don't know any government where two years after they're elected, the ratings go up and people think, They're even better than we expected. That's just the nature of politics. Michael Heseltine once said, 'When you're in power you have a choice of three bad decisions; your choice is to make the least-bad decision.' When you don't have a track record you can be all things to all men. It's like anyone who's sat on the Tube and looked across at a stranger and fallen in love with them because they can project this perfect personality on to this person they don't know. That illusion can remain intact until they wander off at the next stop and you're left imagining the kind of life you could have had. That doesn't happen in politics. It's the curse of success.

JOHN NEWBIGIN It was a stupid promise to honour the Tory commitments, but you have to look at two, three years down the line. There was a longer-term story.

GEOFF MULGAN George Young talking about stepping over home-less people on the way home from the opera captured a certain view of the ruling class.[1] One of the first things I did when I got in government was set up the Social Exclusion project to deal with rough sleeping. The numbers were brought down 90 per cent, and it's never written about. Success doesn't get talked about. A positive part of that Cool Britannia image was a more equal, fairer place. There was a side of all of this which was pretty important to the motivation of those people in the creative industries who wanted Labour in power because they wanted that very visible poverty and inequality to be dealt with.

STRYKER McGUIRE It was pretty obvious, once you got out of London, that there was resentment towards London. There was this London-centric view of the whole country and a sense of economic inequality. There were a lot of IT start-ups in Manchester and Birmingham that didn't capture the attention. Labour's extended honeymoon couldn't disguise the fact that an old Britain and a new one existed side by side.

JOHN NEWBIGIN Government is an incredibly complicated machine, and because the expectation was so high it was inevitable there were going to be disappointments. Blair was a smooth guy, so people were looking for chinks in the armour.

TONY BLAIR There's an optimism born of 'we can really make changes', and there's an optimism that is sometimes delusionary, which is 'all the difficult problems have been resolved because I feel optimistic'. The truth is, government is a very sobering thing because you have to face difficult decisions. So you're always at

1 In 1991, while Minister for Housing and Planning, Young was inter-viewed on BBC Radio 4 and described the homeless as 'the people you step over when you come out of the opera'.

risk when a mood like Cool Britannia is created and people say, 'It didn't fulfil expectations.'

VIRGINIA BOTTOMLEY I don't want to come out as being negative about Tony Blair. Parties want to win. They've been in opposition a long time. Blair had been in the House of Commons for eighteen years and had never been a minister. I was very aware of that.

TONY BLAIR In opposition you wake up every day and think, What am I going to say? In government it's, What am I going to do? I had no idea how difficult government really was, at that point. It's only when you get into government that you realise it really is a lot different, and it really is much tougher. And in the end it isn't to do with creating mood, it's to do with changing the country. What I mean by that is, when you reflect back on it, a lot of it was about capturing the mood. If you look at, for example, the five policies that we used to brandish, those policies were incredibly modest, but the mood was quasi-revolutionary. Actually, we achieved much more than was on the cards, but the mood, the euphoria never lasts. What I'm really saying is that it's a cautionary tale; that it's important that you don't mistake the mood for the reality.

DARREN KALYNUK The backlash was always going to happen, particularly from the music industry. It was much easier to say, 'I hate the Tories.' Government makes controversial and difficult decisions that the opposition doesn't have to make. It's almost impossible for a government to retain the support of the creative industries.

SIMON FOWLER Chumbawamba's Danbert Nobacon threw a bucket of water over John Prescott at the BRITs in '98 on behalf of 'single mothers, pensioners, sacked dock workers, people being forced into "workfare", people denied legal aid, students denied free university education, as well as the homeless and underclasses suffering at the hands of the Labour government'.

JOHNNY HOPKINS They had licence to do whatever the fuck they wanted because everybody was too busy celebrating: 'Aren't we

great. We've got great music. Great art. Great films. We've got this new, young Prime Minister who used to play in a rock band.' It was part of the delusion. Everyone got swept away.

JARVIS COCKER There was this thing that we had actively been courted before the election, so it felt quite personal. When it didn't really deliver on what people maybe wanted to happen they took it personally. That's the biggest regret about those days.

JOHN NEWBIGIN When politicians are in opposition they have time to go to the theatre and awards ceremonies. Once they're in office they're chained to their desk eighteen hours a day. It's a problem. There was so much excitement around that election: it's inevitable the morning after never quite matches up to the way you felt the night before. Euphoria, by definition, is something that doesn't last: 'Everything's going to be wonderful. The sun's going to shine.' And, of course, it doesn't.

WAHEED ALLI The government mistook the temporary alignment of interest between this broader group of people and their objectives as being a continuous endorsement of what they were doing. Interest coincided for a period of time and then it didn't, partly because those people don't sustain interest for that long and partly because the government shifted and started to take actions with which people disagreed: social security, child benefit, Harriet Harman sending her child to a private school. We hadn't been in power for twenty years; governing was hard and tough choices had to be made sometimes.

KAREN JOHNSON A key moment was when Damon came swinging in the office from America: 'What's been going on?' I said, 'You'll never believe this. They're trying to introduce tuition fees.' He was absolutely livid. He thought it was a betrayal and that Blair's style was too presidential. It made the cover of the *Daily Telegraph* and he went to protest outside Downing Street.

MARGARET McDONAGH The reality was that it was very hard to keep that enthusiasm of '97. It's the famous Mario Cuomo quote,

'We campaign in poetry and we govern in prose.' Invariably something will happen in a government that artists and musicians won't agree with. It's reality. The reality is that, as a government, we changed Britain. We made it a more tolerant place. We took a million people out of poverty. We revitalised education. Introduced the minimum wage. All of those things you can't take away from Labour.

PAT HOLLEY In principle it was the Thatcherite ethos of 'make your own future'. There was more honesty in the Thatcherite ideal than there was in Blair's 'let's come together as a community'. No. Everyone was out for themselves. You make money for yourself.

JO GOLLINGS Shit! I don't want to be associated with Thatcherite. We had come from the north, for God's sake. We had friends who were coal-miners. Bloody hell! There was nothing right wing about our politics. Everything was on the up. 'Yeah, we can be socialists, but we can still be earning a living.'

JOHN MAJOR New Labour saw an advantage and they took it. They were political kleptomaniacs and took a lot of policies they dismantled with the criticism, 'These are stupid policies', and then reinvented them under a different name. That's what some politicians do if they see a good idea. They're not going to say, 'Ah, yes, well, I've decided that, in retrospect, the Conservative government were right. And I congratulate them on this idea and we've decided to return to it.' If anything, Tony Blair was to the right of me – I tease a little, but not that much. New Labour went out of their way to woo industry and convince them that it was safe to vote for them.

IRVINE WELSH Tony Blair and New Labour and a lot of the social-democratic parties in Europe folded; they capitulated to neo-liberalism. Blair was steeped in the whole Thatcherite kind of thing. It was all about acquisitiveness and personal gains. It was a massive opportunity lost. In my book *Ecstasy*, Heather says, 'You're New Labour. Tony Blair Labour. Which is the same as Tory, only Major's

probably further left than Blair. Blair's just a snider version of Michael Portillo.' Heather was definitely me and closest to my view of it.

GEOFF MULGAN One of the problems for Blair, in retrospect, is that the representations had a somewhat different strategy than the actions, and some people took them at face value and therefore thought Blair was more Thatcherite than he really was. They were looking at the *Mail* and the *Sunday Times*' refracted versions of things.

TONY BLAIR When people say about my government, 'You betrayed Labour principles,' I make it clear that when I got the leadership in 1994, when I won my election in 1997, we were going to be a different type of Labour Party. I was not going to disturb some of the reforms that Margaret Thatcher made. I was explicit about that. I didn't betray anything. I told you what you were getting before you got it. I wasn't going to spend my time renationalising the shipbuilding industry or British Telecom. And I wasn't going to give the trade unions back the power to have flying pickets and shut down business and so on and so forth. But what I was going to do was put massive investment into health and education and to focus on poor people, whether they were children who needed the Sure Start programme or pensioners who needed additional help. We were going to change the issues of social equality and inequality in the country. And we did. But I don't think we could ever have done that if we'd spent our entire time trying to undo all the Thatcher reforms.

ALASTAIR CAMPBELL I remember Tony spoke to me about wanting to say why it had been right to keep the best of Thatcherism. He said, 'We had to make people feel that just because they had voted Tory during the eighties, it didn't make them bad people.' Tony had this feel for people and understood why they went for Thatcher. He would say she did some things that had to be done, but he also felt that she paid insufficient regard to the cost of some of the economic policies, unemployment in particular, and that she

chronically underinvested in public services and the whole social justice agenda. Tony felt there was accommodation. He didn't want to have those people coming over to vote for him and then giving them a sense that he didn't respect their previous position.

TONY BLAIR I don't have a lot of patience with people who just say that Thatcher was a completely evil person and everything she did was wrong. The fact is the country needed real reform. What happened after the Second World War is that we created the great institutions of the state and the collective power to advance individual interest. But by the end of the seventies some of those institutions of collected power had become sporadic, bureaucratic, and sometimes looked after themselves rather than the people.

GEOFF MULGAN If Labour only stood for nationalised industries, big state bureaucracies against all of that, they would be completely on the wrong side of history. In that respect they were closer to Margaret Thatcher than Michael Foot. But to believe that therefore means they were neo-liberal Thatcherites is to miss the single most fundamental fact of this: Margaret Thatcher's main goal was to shrink the state. What happened to the state under Blair and Brown? It grew hugely. If you don't look at facts it leads to distorted analysis.

ALASTAIR CAMPBELL Tony had Thatcher in Downing Street in May '97 to pick her brains on foreign affairs. I remember her saying, 'The thing about Europe is the only people we can really trust are the Danes and the Dutch, but they're too small. The Germans are guilty about the war. The French cannot be trusted. The Italians only do clothes.' It was like this comic dismissal of all these other countries. But I wouldn't overestimate it. I think Tony felt he had to give her a bit of respect.

TONY BLAIR There were certain things that Margaret Thatcher did, and you can see them happening in all different parts of the world. That's just with the trend of history. Then there were other things that I profoundly disagreed with her about. She came into

Downing Street a couple of times. I wouldn't exaggerate it. But, on the other hand, I've always said that I respected her as a leader. She will go down in history, whether I agreed with her all the time or not, which I didn't, as a hugely significant Prime Minister. You can't take that away.

GEOFF MULGAN Thatcher coming to Downing Street was partly a mind-fuck to the Tories. Blair was brilliant at playing these kinds of mind games.

JOHN NEWBIGIN It's too easy to say it was all cynical spin and it's naïve to say it was all wonderful socialist virtue. It was a government with the times, thinking about the future of this country and our economy.

IRVINE WELSH Blair and Campbell were all about spin. 'Things Can Only Get Better': an idea that this was a whole new broom that sweeps clean; that this is modernisation.

STEVE DOUBLE I worked with Alastair Campbell on the *Sunday Mirror* when he was the political editor. His transformation was remarkable. When I first knew him he was a very good reporter, very much one of the boys, a dedicated Labour Party supporter. And then in the blink of an eye he was running the country.

CAROLYN PAYNE Alastair was the unelected deputy prime minister. There is no doubt about that. I worked for the Labour Party in 2001 at Millbank preparing for the daily press conferences. Campbell was speaking for Blair and organising everything. He was in charge and unelected, and yet he was so much more powerful than any other member of the cabinet.

TONY BLAIR One of the things that's important to realise is that there's a whole business going on in government that is policy: it's about what's actually happening; it's about making decisions of a difficult nature in foreign or domestic policy. Alastair might well have had an input into those, but it wouldn't nearly be the same as in his own domain. He would be in cabinet meetings but so would

Jonathan Powell and my political people. It wasn't unprecedented. Under John Major it would have been Gus O'Donnell. You normally have the press person in the cabinet because obviously they've got to go and brief the press afterwards. Don't let me underestimate it, Alastair was hugely important and an extremely critical member of the team, but primarily in that field.

ALASTAIR CAMPBELL I could speak in cabinet, but not strictly. It's just a meeting. I'd sit behind Tony and give him notes.

GEOFF MULGAN Campbell didn't have the knowledge to be involved in the decisions about what laws should be passed or what should be done with the NHS or schools etc. It's because the media interacted with him that he seemed more important, because they were interested in the written word and the representations, not the actions. There's always going to be this optical distortion.

ALASTAIR CAMPBELL I wanted to undermine the press; divide and rule. I felt the media was changing so fast that it was having a corrosive effect on the political debate. Tony felt it was too risky, it wasn't worth the aggro and we could continue to woo them. That became a running argument. I used to collect headlines and stories in my top drawer: 'It was his worst week yet'. That went on, on average, every four weeks of our first term. They kept saying, 'The honeymoon is finally over.' I remember having lunch with the editor of the *Daily Mail,* Paul Dacre, and he said, 'The trouble is you lot, you've got no opposition. Tories are useless. We'll have to be the opposition.'

CHARLIE PARSONS PR had come into its own. The management of news had come into its own. You had to manage it, whether you were a newsperson making a TV programme or you were a politician. If something happened then you would have to make sure it was perceived in the way you wanted it to be perceived.

ALAN EDWARDS I sometimes think, God, I'd probably have done better and made money if I'd been more like the public perception of PR. But you're not going to go anywhere if you're telling a

pack of lies all the time. A good PR is someone who can influence perception and attitudes towards a person or product or whatever. I've often felt an awful lot of people who called themselves publicists or PRs were really people who were turning up at the things or arranging celebrity parties or doing film premieres. That was a misuse of the word. But Alastair Campbell as a PR was one of the greatest there's ever been. He was an inspiration because he did it on the most amazing scale. There was a plan. There was an idea. There was a strategy. There was a science.

ALASTAIR CAMPBELL I once persuaded the *Guardian* to change a headline, following a *Big Issue* interview with Tony, from 'Blair lurches to the right on crime' to 'Blair backs zero tolerance'. That's not that powerful. You're just having an argument about a headline. People do that all the time. Certainly if there was a headline produced and you had the capacity to change it by saying, 'Listen, that does not reflect what he said,' what's wrong with that? I bet Joe Haines used to do that for Wilson and I'm sure Bernard Ingram did it for Thatcher. I get written about as though this whole spin-doctor thing started with me. What was Machiavelli? Leaders have always had people alongside them who are shaping the environment around them; whether it's making sure you know who is in the room or it's making sure you know what elephant traps are being laid for you. The idea that you could be the Prime Minister and not have a team of people around you to help you lift that load is madness.

GEOFF MULGAN There was a lot of spin and a lot of attempts to get Murdoch and the *Mail* on board. There was a view that it would be quite hard to win a majority with them viscerally hostile as they had been in the past. If you could get a news editor, you could control public opinion. Spin was very much a notion of a centralised top-down media structure.

PETER HYMAN There is a lot of garbage said about spin. Journalists who say they were spun, basically it just means they were crap journalists. If Alastair tells you something, if you're a half-decent

journalist, you think, Is that his gloss on it? The basic point about spin is no different from any organisation. If M&S put out a press release on their annual figures you would expect them to put the best gloss on it: 'We have made a loss but it's for this reason. Don't worry, it's going to get better.' That's all governments did

ALASTAIR CAMPBELL What is spin? It's bollocks, honestly. It really is. I like to think that what we did was strategic communication. We were operating in a period when the media was changing beyond all recognition, really fast. I think what our critics came to define as 'spin' was frankly anything that we did. If you're a Prime Minister, or anybody with a high profile, communication is part of what you do.

TONY BLAIR 'Spin' is just a jealous person's way of describing good presentation. You've got to have a high-quality media operation or you're just an idiot. Alastair was a genius at it. It's important to realise he was a very trusted advisor and in areas of presentation the first port of call for advice.

STRYKER McGUIRE Campbell was brilliant at strategy. He was very tough with the media but was also respected because he knew what he was talking about. He would berate people when he felt they said the wrong things about Blair. He was very defensive, generally, partly because the newspapers for the most part were Conservative and against them. Labour always feel like the underdog and the media is out to get them.

JOHN NEWBIGIN I remember being absolutely shocked when we got into government that they didn't seem to have any plan for presentation or management of presentation. One department would put out a major press notice and another department would do one at the same time. That was crazy. You've got to have a central matrix so you're not all competing with each other to get a top news story. That was Alastair Campbell. 'He's a bloody manipulating Stalinist.' It was just good news management. To say it was all about spin is bullshit.

ALASTAIR CAMPBELL What our critics liked to say was that it was all confection and about just getting good headlines. Now, did we rather have good headlines than bad? Yes. Why? Because that would assume that then you're able to get your message through on your terms. I'll tell you my favourite sound bite: *Veni, vidi, vici* – I came, I saw, I conquered. Caesar. It's genius. Was that spin? The Bible: Ten Commandments. Was that spin? We had five pledges. People operate in threes, fives and tens; that's what we did. If you're doing a list, it's always five or ten. Is that spin? It's just a way of communicating.

CHRIS SMITH Clare Short wrote in *An Honourable Deception?*: 'From the start [New Labour] was obsessed with presentation rather than content [. . .] it became clear that neither Blair nor New Labour had any significant guiding principles, philosophy or values . . . it [was] focused on winning media approval.' That's a reasonably fair assessment. When he stood for leadership, I remember saying, 'I'm going to support Tony because he has the best chance of winning us an election, but my problem is I don't think he believes in anything.'

ALASTAIR CAMPBELL That's bullshit. Honestly. Clare was a loyal Labour minister who absolutely despised us. Tony did have values and he did have principles, but they weren't hard left. Look. Were we focused on presentation? Yes. But the reason for it was about the values we hold. It was about the stuff that we wanted to do to change the world for the better. I wouldn't and couldn't have done the job I did, for as long as I did, working as hard as I did, if I didn't believe that what we were doing was what I believed in my heart.

TONY BLAIR I had a very funny conversation with Alex Ferguson once about leadership, where he was saying, 'If there's a cabinet member that's difficult you've just got to throw them out. You should do the same.' I said, 'Yeah, but what would happen if you threw them out but they were in the dressing room the next day?' He said, 'Well, that might be difficult!' I wasn't able to

transfer cabinet members or sell them on to the French National Assembly.

STRYKER McGUIRE I do think that Tony Blair had an amazing antenna to politics. That was a great strength of his. He wasn't a puppet operated behind the scenes by Alastair Campbell. When you talk about the four key power centres – Blair, Campbell, Mandelson and Philip Gould – that was a real collaboration.

TONY BLAIR The team I had around me – Alastair, Jonathan, Anji [Hunter], Sally Morgan, David Miliband, Andrew Adonis – was a team of real quality and cohesion. In my memoir, I wrote, 'As a machine it was close to unbeatable, like Manchester United at their best: exciting to watch, unnerving for opposition and pretty much unstoppable.' Obviously cabinet was different: you had people you disagreed with; there were problems. One of the things that the time represented, and in a way Man United players represented it, was an understanding that although we lived in more individualistic times, there was still a unique capacity to be greater together than alone. That was really important. In football you get a team who gel in a way that gives them a greater strength than the individual talents. It can be the same in politics. You can have a team of extremely gifted people, but if they're pulling in different directions then they're not as effective. It's kind of an obvious point: whatever arena you're in, in leadership if your top team is not cohesive then it's a problem.

PETER HYMAN The accusation was that this was too superficial, that you needed to get on with the business, the real job of government, which is making the trains run on time and the health service efficient and doing education and running the economy – it became too easily branded as 'too metropolitan'. If you were living in a rundown part of the country did you feel part of Cool Britannia? Not really. You wanted something more bread and butter. That then got bound up with the accusations that Tony was surrounding himself with spin doctors. Our opponents cleverly morphed that into, 'Cool Britannia is just another bit of spin.'

ALASTAIR CAMPBELL You've got to remember where we were coming from. If you saw the way that Michael Foot or Neil Kinnock used to get treated, I was absolutely determined that wasn't going to happen to us. That meant being robust. It meant being aggressive. I didn't care what the press thought of me, as long as I felt, and Tony and the core team felt, I was being effective in what I did. And whatever the noise, the public knew what we were on about. They like to say all of that was spin. Often on TV programmes, people say, 'Oh, yeah, but you lied.' You say, 'Go on, then, give me a lie. Just give me one lie.' They say, 'Over Iraq.' 'Well, it wasn't a lie. We got things wrong.'

PETER HYMAN The basic point is, unless you're in power you do nothing. Blair said this for years and years: 'If you're a political party the aim is to be in power. If you can't win power you never put anything into practice. It simply doesn't matter what your ideas are. They're never going to see the light of day.' After eighteen years in opposition was New Labour obsessed about getting a fair hearing in the press in order to neutralise the people who had destroyed Neil Kinnock? Did we woo Murdoch? Did we do ridiculous things in order to not get destroyed? Yes. Did we then get too close? Possibly. On the other hand, you can say we won a landslide that gave us the space to then do things like the minimum wage or bring peace to Northern Ireland or open thousands of Sure Start centres. People can still say, 'Well, that agenda could have been more left wing,' but let's face it, that agenda was still preferable to another five years of the Tories.

VIRGINIA BOTTOMLEY It took a long time for the Labour Party to realise that Blair wasn't all he professed to be. Politics is like being in a funfair: they put up a card of ducks, they shoot at you, and in the end they've all gone so you have to put up another card of ducks and in comes another party. It's a simple metaphor but I think it's true.

CAROLYN PAYNE Anyone loses their veneer after a while. It's extraordinary Blair stayed so popular for so long.

ALASTAIR CAMPBELL Tony said, on day one, 'You can't govern on euphoria but you can get a lot of energy from goodwill.' If he had decided to go for the Good Friday Agreement six years in, it would have been harder because we would have had a lot of baggage, but the fact was that Tony was 'man of moment'; he was a new force trying something different. How many people had said, 'Northern Ireland: absolutely insoluble.' John Major had done all sorts of things to lay the foundations, but it needed that change and that sense of new and energy to come together; that feeling that anything was possible.

GEOFF MULGAN Blair gets more credit because he did more of the heavy lifting, but that wouldn't have been possible without the significant ground laid by John Major.

VIRGINIA BOTTOMLEY The nature of politics is you reap what someone else sowed; what you sowed someone else will reap.

JOHN MAJOR When I became Prime Minister, Albert Reynolds became Taoiseach, and soon afterwards we met in the White Room at Downing Street and had a conversation that was absolutely pivotal. I remember saying, 'If the problems of Northern Ireland had been in Surrey and Sussex they would never have been tolerated. We need to do something about it.' Albert agreed wholeheartedly and, at that moment, the concept of what became the Downing Street Declaration was born. Most of my cabinet were opposed to going down the route we had chosen, and preferred to stick with the position that Margaret Thatcher had, which was, 'We don't negotiate with terrorists.' But if you don't negotiate with terrorists, the terror simply goes on. We were a long way towards a peace agreement, but we couldn't finish it – for a rather curious reason. The Conservatives were so far behind in the opinion polls that Sinn Féin and the IRA thought we would probably lose the election, and they would get a better deal from an incoming Labour government. Tony Blair made a very good deal. I would have been very happy to have signed off on it, and I admire the way he completed it.

IRVINE WELSH Blair swans around taking credit for the Good Friday Agreement, but it was about Ecstasy. I've spoken to

nationalist and loyalist politicians who say a whole generation of kids were taken out of the IRA and the UDF because they were dancing in fields. They couldn't recruit – although at raves they would still go to their respective community leader's dealer in each corner – because they'd all be dancing together. They were forced to a solution because nobody wanted to get involved in terrorism.

CHRIS SMITH Labour's first term in office achieved a huge amount and did lots of really good things for the country: the institution of the Human Rights Act, the start of progress on lesbian and gay equality, free museums, the banning of hand guns. There was a whole range of things, which were determinedly pushed through by all of us who were in government.

TONY BLAIR We made progress in our first term, but it was only in our second term that we made more progress; for example, we started to make deep-seated education reform, which is the best response to lack of opportunity.

STRYKER McGUIRE There's a Gordon Brown party-conference speech where he says, 'If anyone says that to fight doesn't get you anywhere, that politics can't make a difference, that all the parties are the same, then look at what we have achieved together since 1997 . . .' and then he enumerates all the changes. It's a powerful and handy list: 'The winter fuel allowance, the shortest [NHS] waiting times in history, crime down by a third, the creation of Sure Start, the cancer guarantee, record results in schools, more students than ever, the disability discrimination act, devolution, civil partnerships, peace in Northern Ireland, the Social Chapter, half a million people out of poverty, maternity pay, paternity leave, child benefit at record levels, the minimum wage, the ban on cluster bombs, the cancelling of debt, the trebling of aid, the first ever climate-change act.'

DARREN KALYNUK The extraordinary several years of optimism and forward-looking had had its moment. The brief intersection between politics and the cultural world was over.

WHAT THE FUCK IS GOING ON?

Millennium Dome. Tate Modern

ALASTAIR CAMPBELL Governments shouldn't run tourist attractions: discuss.

CHRIS SMITH When Tony Blair called me into the cabinet room on the Saturday after the '97 election and said, 'I want you to do the Heritage job,' I had the presence of mind to ask, 'Can we change the name of the department?' and 'Do we have to go ahead with the Dome?'

ALASTAIR CAMPBELL We could have killed the Dome at birth. I think majority opinion was in favour of killing it.

TONY BLAIR Cancelling it was going to be expensive. Obviously we got criticised by the Tories, which was a bit much because they'd actually got our agreement to do it. It was just like, here's several-hundred-million pounds going into this white elephant.

ALASTAIR CAMPBELL Michael Heseltine had to come to us in January '97 to persuade us that if the Tories were out and we were in, we had to carry on because it required it to go across government.

VIRGINIA BOTTOMLEY As former chair of the Millennium Commission, I was thinking, What is the Millennium? Is it a royal event? No. Is it a military event? No. Is it a political event? No. It is two-thousand years since the birth of Christ; there's no way of saying it differently. So I went to see all the church leaders and

different heads of all the faiths, to say, 'Look, there is a spiritual impoverishment in our lives and I think we should recognise the faith component. It needs a key-values message. But I don't want it to be disruptive or end up as a crusade.'

CHRIS SMITH Tony felt that the Dome was potentially a good symbol of ambition and modernity, and agreed to a review. We concluded that it was a fantastic building and it could be built on time and within budget. At this point they'd just started digging the site, but there was a serious problem in that no one had any idea what to put in it, which remained the principle problem throughout: it was a building in search of content. I made the case for turning it into an educational resource for the nation, but Tony made it very clear that he wanted an all-singing, all-dancing millennium experience. Peter Mandelson was put in charge of content.

JOHN NEWBIGIN People asked, what is our country like at the beginning of the twenty-first century? What are we proud of? What are we good at? How does the world see us? But where John Piper and Graham Sutherland and a whole bunch of twenty-year-olds basically put the Festival of Britain together in 1951 to reflect the resurgence of optimism and confidence after the Second World War, committees bogged down the millennium event.

STRYKER McGUIRE There was all this talk about what the Dome would be that never really came to pass. And there were huge problems with the construction.

JOHN NEWBIGIN By the time you get to the end of 1997 you'd got two years left. It was like, 'If we're going to build a fucking great building we better get going.' Nobody could make up their minds. The architect, Richard Rogers came up with the idea of the world's biggest tent; 'We can work out what's going inside later.' In hindsight you can say that's crazy – it's like building the stable before you've bought the horse – but if it was going to be ready on 31 December 1999 that's what you had to do. We were saying, 'We have to do this NOW!'

STRYKER McGUIRE On one memorable occasion Mandelson said, 'If the Dome is a success it will not be forgotten. If it's a failure we will never be forgiven.' 'Wrong!' I said, 'Britons will forgive the government for the Dome, but they won't let it off the hook if it gets schools and hospitals wrong [. . .] the biggest potential Cool Britannia albatross of them all sits along the Thames in Greenwich.' The Dome became a symbol of disillusion and how Labour could never live up to expectations.

ALASTAIR CAMPBELL The launch night on New Year's Eve was a disaster. We heard this story about all these senior media people stuck at Stratford waiting hours for their tickets because there was only one scanner.

TONY BLAIR Oh my God! That was a night I'd happily forget. We made the terrible mistake of getting the journalists on the Tube that then promptly broke down, so the journalists turned up late, as did other people, so the thing was not as packed as it needed to be. I'm not sure what the Queen made of the whole thing.

ALASTAIR CAMPBELL You had the Queen and Tony and Cherie there, and I completely lost it on the phone to Charlie Falconer, who was in charge: 'WHAT THE FUCK IS GOING ON?' Tony said to me, 'Can you calm down. Your rage is too obvious and your ears have gone bright red.' William Hague turned round and goes, in a plumb voice, 'It's all going very well, then?'

MATTHEW WRIGHT It was just chaos. I thought, I'm fucking not spending my night like this. So I went off and visited my mum instead.

CAROLYN PAYNE It was a fiasco. All the senior VIPs and reporters and newspaper owners were kept waiting in the cold for hours – so everyone gave it a really bad write-up.

ALASTAIR CAMPBELL The show itself was pretty average. It wasn't Danny Boyle.

TONY BLAIR I remember being absolutely terrified because part of the show included these acrobats, and Prince Philip said to me,

'They're not using any safety harnesses, you know.' I became absolutely transfixed by the fact that one of these acrobats was going to fall from a great height and squash Her Majesty, which obviously would put a certain downer on our millennium celebrations. And I would go down in history as the person responsible for the accident that felled the Queen. I couldn't wait for it to end.

VIRGINIA BOTTOMLEY The show, and the whole attraction, was disappointing and bland. The imagery and message that New Labour put in became a reprise of the '97 election campaign – 'the many not the few, the future not the past' – when it should have been the history of Britain – Florence Nightingale, Nelson. You could have done the diversity and creativity by making a huge thing about the Commonwealth. It should have been much more unifying; every cab driver should have said, 'God! Have you been to the Dome?'

JOHN MAJOR It was pretty much a disaster. I wouldn't want to dwell on Labour's miseries.

JOHN NEWBIGIN Inside, there were all these different zones, but there was no coherence or theme or clarity about what its core purpose was. Was it a celebration of your core identity? Was it a celebration of our ambitions for the future? What is a celebration of the community of the UK? It ran off in different directions. One big success was the Our Town Story, when every day of the year a different town from the UK was given the centre stage to do something. I still meet people today who say, 'It was the best day of my life.'

JEREMY DELLER I went twice: once as a member of the public and then when they auctioned all the contents in March 2001. The Dome didn't show a country I recognised. It was a corporate view of Britain and too reliant on tech and sponsorship. There wasn't much humour or art. A coracle was the one thing that you could say was handmade; everything else was manufactured or projected. It was all glass and steel and serious. So I thought, Why don't we do an exhibition of things that are made by people? The result was

the Folk Archive, which was a collection of art and creativity from around Britain. It was everything that had not been in the Dome.[1]

PETER HYMAN The Dome was the nail in the coffin of Cool Britannia. It was seen as a waste of time and money, and a symbol of all that was supercritical and spiny and not sustentative about New Labour.

TONY BLAIR I lost confidence in it, myself, after a time, but if I look back now the Dome was a brilliant design, an iconic landmark, and brought in many, many more hundreds of millions of pounds than investment. Today, you wouldn't want to be without it.

MICHAEL CRAIG-MARTIN You can't convince people that because Tony Blair invites a gaggle of celebrities to Downing Street that suddenly government is interested in the arts. It's bullshit. The Dome was a politician's fantasy of culture. It doesn't work like that. Art is a world. There are values in that world. There's history in that world. There's a way in which things happen in that world. Tate Modern was 'art'. Once it's real people, not politicians doing it, they know what to do, and how to spend and get proper value for money.

NORMAN ROSENTHAL The big breakthrough in the sense of the public was *Sensation* in 1997 and then Tate Modern in 2000. To that extent, Nick Serota and I did do something for so-called Cool Britannia.

MICHAEL CRAIG-MARTIN Tate Modern developed what had happened during the nineties and turned it into an institution. It completed the cycle of change of contemporary art as a phenomenon of contemporary life. It was the answer to what Charles was doing at the Saatchi Gallery. That would never have happened without the courage of Nick Serota. When all of us are forgotten Tate Modern will be there. It's a phenomenal achievement.

1 Folk Archive: Contemporary Popular Art from the UK was curated by Jeremy Deller and Alan Kane in 2007.

SARAH LUCAS Years before, when we were doing the shows in the East End, Nick Serota came down, and I remember standing on a rooftop of a building with him and he was looking then for somewhere to make Tate Modern. He had a chat with us all about it, so it was amazing to see that actually happen and develop, and how enormous it turned out to be, possibly even for him.

VIRGINIA BOTTOMLEY I went to the opening of Tate Modern, and Sir Nicholas Serota, in generous-spirited style, gave John Major credit. It's something about politics where people are reluctant to pay tribute to those who really plant the seeds that you subsequently reap. I know it's the nature of all governments, but I found it maddening the way that New Labour hadn't the generosity of spirit to recognise where this great resource came from.

MICHAEL CRAIG-MARTIN Tate Modern successfully applied for £15 million from the Millennium Lottery Fund. The Dome got £600 million. Tate Modern did not directly receive a single penny of taxation money. There was no government support from either party. It was considered a vote-loser. Tate Modern was everything successful that they wanted from the phenomenally expensive disaster of the Dome. Tony Blair was invited to open Tate Modern a year earlier and had refused. He only came at the last minute when it became clear it was going to be a success. The Queen opened it. I've never seen her do anything more coldly.

TONY BLAIR Maybe people thought I shouldn't or couldn't accept the offer, but I definitely wanted to do it. There had been such a great explosion of British art. I was aware of its importance.

NORMAN ROSENTHAL It was quite right Tony Blair should be there, but the Queen didn't quite know what she was doing. She didn't know where she was.

JEREMY DELLER Someone said to me, 'You've got a minute with the Prime Minister if you want to meet him.' I thought, Oh, fuck! I'd made these bags that said 'Capitalism Isn't Working', so I thought I could present him with one and it would be like when

Katharine Hamnett met Margaret Thatcher in 1984 at Downing Street and wore a '58% DON'T WANT PERSHING' T-Shirt. I ran to the shop and said, 'I'm about to meet Tony Blair, could you give me a bag, a couple of my books and a CD of Acid Brass.' I was then taken up to a designated area. Blair was walking towards me and these security guys, who were like huge rugby players, were manhandling people out of the way of this very crowded, uncontrolled environment. And then just as he got close I got pushed aside and he walked past.

GREGOR MUIR Why the YBAs aren't recognised at the opening of Tate Modern is a big question.

TRACEY EMIN Tate Modern was for international artists. We were the Young *British* Artists. We didn't qualify. And we were too young to be considered part of the establishment.

JEREMY DELLER The YBAs had been invited to the party, but the Tate hadn't bought their work because Charles Saatchi owned it all. The politics behind that is quite interesting. Saatchi was buying art in a way that the Tate wouldn't have been able to compete with.

NORMAN ROSENTHAL The Tate didn't own any of the YBAs' work. It was as simple as that. That's another whole long story. There was jealousy between Nick Serota and Charles Saatchi. Nick made a speech and said, 'The YBAs will be regarded as a phenomenon of the 1990s, not something to continue into the twenty-first century.' But you mustn't take these statements too seriously. Either artists survive or they don't. Is Damien Hirst still alive? Yes. Is Sarah Lucas still alive? Yes. Is Tracey Emin still alive? Yes, she is. Tate Modern was a reflection of the broadening interest in art.

JEREMY DELLER It was a major moment when art found its home in the national conscience, and such a moment of pride.

MAT COLLISHAW Tate Modern was the embodiment of art going mainstream. It was this welcoming cathedral that took people of all backgrounds, of all classes and demographics, and proposed

that they could spend a few hours of their leisure time looking at and thinking about paintings and sculptures and photographs and video. It was an incredible monument to the achievement of the twenty years that we had spanned.

GREGOR MUIR Tate Modern was the point at which the baton was truly handed on. It couldn't have opened any sooner or any later. It opened in a city built by artists, in a city where contemporary art has truly been acknowledged and made itself known.

WHEN I WAS BORN FOR THE 7TH TIME

Asian culture. Muslim riots

CARLA POWER Asking why Cool Britannia was white-faced is a really good question. It harkened back to the very white Swinging London of the Julie Christie, Mick Jagger, Kings Road days and it ignored people like Hanif Kureishi and Meera Syal, who were all doing their own thing creatively. When I think of all those lily-white faces on magazine covers it was a very white and privileged movement. They can't help being white, but in hindsight it was a weakness on the part of *Newsweek* and *GQ* and *Vanity Fair*. It was seeing London as the centre of global capital, but it wasn't seeing it as the centre of a multicultural universe.

DAVID BADDIEL Cool Britannia was white and quite male. Although there are some very significant females, the big bands, the big comedians, the big politicians were all white and male.

WAHEED ALLI Cool Britannia was definitely white-led, but it created a ripple effect in other communities. It took the ceiling off where your ambition could be. People like me, a gay, Asian guy, how do you get into the House of Lords at thirty-three?

KEITH ALLEN Of historic importance was the realisation in the Asian community that there was an opportunity to be a part of British culture, especially with young Asians who had been so incredibly oppressed. There was a shift.

TJINDER SINGH At the start of the nineties the flag was inflammatory, and by the end of the decade the politicisation had gone because of what was changing in society. Things were looking good and there was a real sense of something happening, certainly in London. Asians had become more acceptable: through time; through perseverance; by being seen in different areas of music and literature, people like Hanif Kureishi, Salman Rushdie, although he was still in exile because of the fatwa, Meera Syal, and Gurinder Chadha.

MEERA SYAL There was a sense that Britishness was only one thing. It was cricket. It was cucumber sandwiches. It was *Midsomer Murders*. That was Britain. If you didn't erase yourself from whatever made you different, to be that version of British, then you didn't belong. What we were saying was, 'We can love our culture, it can be part of who we are, and we can be British too. This is a new kind of Britain. You've got to change the way you think of what British is.'

GURINDER CHADHA Cool Britannia was all about identity and us taking our place as part of a hybrid identity, where we could be British but we could also be something else. Cool Britannia allowed you to have multiple identities.

MEERA SYAL We were still only little babies in that world. Every awards ceremony we went to was like a huge, big party for us: 'We've been let in. Here we are. The brown people are here.' It did feel like we were the lucky visitors.

GURINDER CHADHA Any time you had an Indian on *Top of the Pops* it was amazing. When 'Brimful of Asha' came out and went to number one it was fantastic because he sings it in Punjabi. That was a big deal.

MEERA SYAL It was a more sophisticated version of the game we used to play when I was a little kid: 'Quick! There's a brown person on the television.' Everybody would rush, 'Where, where?' Sometimes, unfortunately, it was a white person with boot polish on their face, but occasionally it was a real brown person.

DAVID BADDIEL 'Brimful of Asha' was a big song. The sensibility of that song was very nineties. The fact that they're called Cornershop is very British. But I still don't know what the title means.

MEERA SYAL 'Brimful of Asha' was joyous. It was that thrill of, 'It's an Asian guy! It's a song about Asha Bhosle![1] The video's about a little Asian girl playing vinyl records!'

TJINDER SINGH Norman Cook wanted to do a remix of 'Brimful of Asha' and we agreed. Our album *When I Was Born for the 7th Time* was doing well and had been album of the year until his version came along. The remix killed it.

GURINDER CHADHA Cornershop sang 'Norwegian Wood' in Punjabi on that album, which was amazing. In 1992 we did an Indian version of Cliff Richard's 'Summer Holiday' for *Bhaji on the Beach*. It was the first time Punjabi lyrics had been used on a white pop song. It was very funny and people loved it.

TJINDER SINGH People say, 'They reclaimed that song.' We didn't need to do that. We did 'Norwegian Wood' in Punjabi in praise of what the Beatles had done. The spirit of the time was upbeat and positive, but we were dragged down with people putting labels on it like the 'Rebirth of Asian Cool'. What the fuck does that mean? We were not part of an Asian underground scene. To call it underground when it was overground was ridiculous.

MEERA SYAL All of a sudden British Asian music became very popular in the mainstream. It had been going on for years and years.

TJINDER SINGH When we started Cornershop, Asians did not like us at all. We were not Asian enough for them. It works both ways. You've got to convince the honky side and the Asian side. Neither culture took too kindly to a wog on stage with a guitar. Asians with a guitar were anathema. That was fighting talk, in itself. Five years into that everything was great and there was buoyancy in the culture. Five years after that everyone was back to their earlier places.

1 Indian playback singer whose career has spanned over six decades.

MEERA SYAL Suddenly, Indians were cool, but we'd always been here, for centuries actually, if people knew their history. Growing up as a kid in the seventies, and certainly the eighties, we were this invisible community: the people who served you in restaurants; who mended your broken bones; or handed you your fags and your paper. We didn't really have any coolness about us. We didn't have a sense of humour. We were seen as passive, law-abiding, insular people. There was a population of people like me, children of immigrants, born in this country who had nothing out there that reflected their experiences. We didn't have our own authentic, very unique experience of growing up bi-culturally. That's why *Goodness Gracious Me* was so loved. It was that feeling, That's who we are. We have never seen ourselves reflected.

DAVID BADDIEL There was an Asian angle on comedy. *Goodness Gracious Me*, which was Meera Syal, Sanjeev Bhaskar and Anil Gupta.

MEERA SYAL There was something very specific about that period that made people open and willing to experiment, to open the doors and let the establishment take a step back. There was a flowering of consciousness of the first generation that carried the legacy of the motherland with them and was burning to speak and hadn't been heard. That gave us a particular edge and anger and bullishness; this need to fight to be heard.

SHERYL GARRATT I was always really keen to find Asian people to put in *The Face* but it wasn't easy. Then all those Asian writers came up.

MEERA SYAL I can't think of anything that crossed over the way that *Goodness Gracious Me* did. I guess *Desmond's*; the Norman Beaton barbershop comedy on Channel 4 was groundbreaking. We still had that slight 'are Asians funny?' question subtlety asked by the BBC. It was like, 'If people get it, great. If they don't, we've lost nothing.' So we went out to white Middle England and they loved it. Radio 4 was inundated with, 'This is the freshest thing we've heard in years.' Then we got a pilot. Very low budget, in which

we premiered 'Going for an English'. And off the back of that we got given six half-hours on TV. It was a long trek.

GURINDER CHADHA To have a comedy show that was entirely ethnic felt very groundbreaking. 'Going for an English' was definitely positive.

MEERA SYAL 'Going for an English' was a classic reversal sketch: a bunch of Asian louts in a white restaurant in Bombay. Richard Pinto and Sharat Sardana wrote it. They'd obviously been talking about how white people behave in Indian restaurants. Our reaction was, 'Oh yeah, we get that.' It was a real coming of age for us because instead of being the butt of the jokes, we were making the jokes, and that was very different from my childhood. The only time *Goodness Gracious Me* got an adverse reaction was when we did a sketch set in a church with the Coopers – they were actually called the Kupars, but they pretended they were English. They go to take communion and they put pickle on the Holy Communion. Ann Widdecombe was deeply offended.

GEOFF MULGAN This is a much more complicated story about the class make-up of different Asian communities in Britain. Some were effortlessly part of it, but some of the more Pakistani, Bangladeshi backgrounds in the northern cities, where their elders were plugged into the Labour Party, the young people weren't at all. One of the things which obsessed me in that period was that there was not a root into leadership and a connection to power for people in the poorer communities of places like Bradford and Oldham. The ruling cast, as it were, in those cities didn't represent them, didn't look like them. I focused on leadership: how do we have a root for those communities into power structures. That was one of the things missing. In retrospect, it was very similar to the diagnosis ten years before about failure of the power structures to reflect society as it was then.

MEERA SYAL That whole legacy of the destruction of communities that all those years of Thatcherism had done had an effect. Maybe

it made it starker. People were going, 'Britain's great again,' and at least half the population were going, 'Has anything changed. Really? Up here?'

GURINDER CHADHA Cool Britannia was very much London-based. It was southern. It was played out in magazines and the media. It was about quite privileged people and branding. That's not to denigrate the power of it and a lot of good things that came out of it. But we still had poverty on a grand scale. We still had people worried about their future and their kids' future. You still had mass unemployment and large parts of the country where there was no manufacturing and no prospect of being developed and jobs. You had whole communities, sacrificed under the Tories, where the effects were still being felt, even after Blair came in.

CARLA POWER That exploded in the riots: in Oldham over three successive nights in May 2001; in Burnley in June, where there were clashes between hundreds of white and Asian youths and widespread damage to property; and the worst of it in Bradford in July, where thousands of youths rioted.

GURINDER CHADHA The riots were between Asian Pakistanis and white people because there weren't enough jobs and opportunities. We'd seen it before in the eighties. It was people saying to the government, 'Don't just leave us on the scrap heap.' Change wasn't happening fast enough. Things weren't getting better fast enough. If people have got jobs and are doing well, they're not going to riot. If people haven't got enough money and food on the table then they're going to look to blame other people. It's that simple.

TJINDER SINGH Those tensions were similar to what was happening at the start of the nineties. In between there had been positivity, which manifested itself in a lot of integration and people getting on a hell of a lot more. It took the sting out of what the flag used to represent. But unfortunately things went back. One can never

move away from the time of Powell.[2] It's always going to be bad if you are a person of colour.

GURINDER CHADHA I had the first screening of *Bend It Like Beckham* with a live audience soon after the riots. I went up on the train to Manchester and they said, 'There's such a demand for your film that we've had to put it in two cinemas.' I was like, 'Wow! The Asian community has obviously come out in big numbers.' I got to the theatre and it was all white, and a lot of people who were quite poor. I saw this woman who had brought packets of cheap crisps to hand out to the kids because they couldn't afford to buy popcorn in the cinema. It was things like that. At the end of the film a blonde woman around thirty, wearing a white shirt, white trousers and white stilettos, was crying. She said, 'You think you've made a comedy, don't you? It's not. What you've showed us is that everyone will do the best for their kids. It doesn't matter who you are.' That was a seminal moment for me. I had humanised a community to her that had been the enemy. Suddenly she saw 'them' as people who were worried about their kids just like her. I didn't have that in mind when I made the film, but it was amazing. I think that's one of the reasons why it became a big thing.

MEERA SYAL When I wrote *Anita and Me*, which turned the lens on the white working-class community, I got many letters from white people saying, 'I grew up in a village like that. I remember how it used to be.' I hope that they understood that those 'other people' in their funny clothes with funny accents actually bled and loved and hurt as much as they did. When the book went on the national curriculum it was one of the proudest moments of my career. The study guides had whole sections about the Empire and what it did to India and why immigrants, like my parents, had come over to England in the sixties. That was the main reason why I wrote *Anita and Me*. It felt like my parents' journey mattered and that they weren't going to be forgotten.

2 In April 1968, Conservative MP Enoch Powell made the infamous 'Rivers of Blood' speech, 'in this country in fifteen or twenty years' time the black man will have the whip hand over the white man'.

A TURNING POINT IN HISTORY
9/11

TONY BLAIR I opened my speech at conference in 2001 by saying, 'In retrospect, the Millennium marked only a moment in history. It was the events of September 11 that marked a turning point in history.' Talk about government being a sobering experience, this was certainly a shock, the reverberations of which you still feel today. You suddenly realise, 'No, life's not like that. There's plenty of bad things out there that could happen, and one of them has.'

NOEL GALLAGHER I believed in Tony Blair. I still do. But people loathe him. Do you know what's sad about that? They really don't know why. There's this thing that developed, 'I fucking hate Tony Blair.' 'Really. Why?' 'He's got too many teeth.' 'Well, that's not enough, I'm afraid.' 'I don't like his smile.' 'That's not enough either.' 'He's a war criminal.' 'That's nonsense.' I feel bad for him because had it not been for 9/11 who knows what the world could have become.

TONY BLAIR Part of the spirit of optimism of the nineties was that the Berlin Wall had fallen. It looked like liberal democracy had triumphed and the world was on an arc of unstoppable progress and development. And then suddenly you've got this shocking terrorist event in which three-thousand people died on the streets of New York.

ALASTAIR CAMPBELL People had been talking about this new form of global terrorism that made the IRA look like choir boys:

the whole thing about Abdul Qadeer Khan, the Pakistani scientist with the nuclear stuff; Al-Qaeda and what they could and couldn't do; and Bin Laden. I don't think anybody predicted that level of spectacular, but there was definitely a lot of chatter that something as bad as 9/11 might happen.

DAVID KAMP We lived in Greenwich Village, about a mile south from where it happened. We were getting our child off to nursery and we heard the sound of a plane. I thought, Wow! That plane is flying low. Then someone told us that an aircraft had hit the World Trade Center. We thought it was an accident, some errant pilot. We certainly didn't have terrorism in mind. Then the second plane hit. My first instinct was to get groceries and provisions. I ran across Seventh Avenue South and already traffic had stopped; police were mobilising and cars were off the road. I stood in the middle of the road and directly saw both towers aflame, with big gashes in them.

SIMON FOWLER I was driving and listening to the Steve Wright show in the afternoon on Radio 2, and he said, 'We've had reports that a plane has crashed into one of the Twin Towers.' I hate to say this, but I thought, The Twin Towers – what are they? In my mind's eye a light aircraft had lost control. I got home and put the TV on and then the second plane went in. That was the beginning of the change.

ALASTAIR CAMPBELL That morning the news was leading with, 'Tony Blair going to the lion's den . . . Trade unions angry about reform programme.' We were working on his speech on the top floor of the hotel in Brighton. It was my number two, Goodrich Smith, who knocked on the door and said, 'You'd better turn the telly on, something's happened in New York.' Turned the TV on, made a couple of phone calls, and then we actually went back to the speech. Then, half-an-hour later, Goodrich comes back in: 'You'd better turn the telly back on, the other tower's been hit.' 'Fucking hell!' What is the size that says: one Twin Tower you carry on with the speech; two Twin Towers you decide not to do

the speech? But that's what we did. We went over to the TUC [Trades Union Congress] and Tony announced that he was going back to London.

PETER HYMAN I was in Number 10 watching it on TV. We were gobsmacked. We talked with Jonathan Powell, who was the Chief of Staff, and also to Alastair about whether the speech could go ahead and what they should do and how they should come back. Don't forget the fear. There was obviously shock but it was an unknown territory – Number 10 might be under threat. You thought this might be an act of war against many countries, and obviously Britain was allied to America.

GEOFF MULGAN Number 10 didn't really have a plan of what to do in those circumstances, which was a bit of a surprise, so quite a few of us went to work from home because we thought there might be some kind of an attack.

ALASTAIR CAMPBELL We got on a train and there was a guy from *Time* magazine who had been at conference. Every time I've seen him since, he says, 'I can never get over the fact that you guys came back by train!' The police had worked out that was the quickest way: driven to the station; wait for the train; got on among the other passengers – I don't even think it was first class – sit in this carriage. Robert Hill was with us, one of the speech advisors, and he was listening to BBC 5 Live on his earpiece, telling us what they were saying while we were making phone calls. Tony asked for a pad and was writing out a list of things we had to address and think about. One of them was, 'Link to rogue states /WMD.' Another was, 'Intelligence re perpetrators – almost certainly Al-Qaeda.'

TONY BLAIR My response was: one, that I'd seen this potential problem growing for some time because there'd been various terrorist incidents round the world, but not on the scale to get this level of awareness. Two, I thought, This changes the whole security picture. We're now in a fight with these radical Islamist extremists. Three, that the Americans must not feel isolated and

that we should be shoulder to shoulder and stand in alliance with them. And four, that this was going to be a long struggle. Of course I was surprised and shocked by it, but I was quite focused on what had happened.

GEOFF MULGAN Blair immediately grasped its significance. He definitely worked out a lot of what would happen over the next few years much quicker than others.

SIMON FOWLER Then a plane went into the Pentagon. It was like Martians were attacking us.

ALASTAIR CAMPBELL It was definitely a moment when I had a sense of what sort of pressure falls on leaders. At that point, I hadn't seen the recording with Bush at the elementary school in Florida when a security advisor whispered the news in his ear, but I remember thinking, I wonder how they tell Bush?[1] Then there was that thing about how he vanished because their security is tighter than ours, and they were more paranoid. Your world changes: that morning we were talking about the TUC, public service reform, and by the end of the day planning visits to Pakistan and India.

DAVID KAMP We had a friend whose wife called us and said, 'He's at Windows on the World,' which was the restaurant at the top of the tower. He had called her to say, 'A bomb has hit the building. I'm safe. We're all being directed to the roof.' Later, I walked past St Vincent's hospital in the Village, and everybody was on standby with ambulances and every doctor and nurse waiting for the waves of the patients to come in. I spoke to a doctor and said, 'What's the news?' He said, 'The news is we're not going to get any patients.' Meaning there weren't going to be any living people to save.

1 President Bush had been briefed on route to the school in Sarasota after the first plane hit the World Trade Center. He asked to be kept informed. Then, during the lesson Bush was observing, White House Chief of Staff Andrew Card whispered in his ear, 'A second plane has hit the second tower. America is under attack.'

MAT COLLISHAW I was in Geneva with Tracey Emin. I'd gone to a supermarket and I was looking at about forty screens showing the plane flying into the tower. I was texting Tracey, 'Oh my God! It's totally gone.' She replied, 'Yeah, yeah, yeah. It's awful, isn't it?' 'Now the other one's gone. It's absolutely terrible.'

TRACEY EMIN I texted back saying, 'I'm just really upset. I just can't stop crying.' Mat replied, 'It'll be all right.' I said, 'It won't be all right. It's terrible. It's both of them.'

MAT COLLISHAW We arranged to meet in a bar and Tracey arrived making cute little chirping noises, but she'd obviously been crying.

TRACEY EMIN Mat gave me a hug. He looked at me, and said, 'You don't *know*, do you?' I said, 'What?'

MAT COLLISHAW I said, 'The Twin Towers have gone down.' She lifted up her hat and showed me her very thin plucked eyebrows.

TRACEY EMIN I'd had a facial because I had a huge monobrow. I looked like Julia Roberts so I was wearing really big sunglasses to cover up my face. The whole time I was talking about my eyebrows and Mat was talking about the Twin Towers.

MEERA SYAL 9/11 happened on the last day of filming of *Anita and Me*. I specifically remember because that was the day my parents came to the set in Nottingham. I thought, Thank God we're all together. Then, like everybody else, we got back home, put the news on and didn't move from the television for twelve hours. I thought, The world has changed. That's it now. Something has shifted for all of us.

GEOFF MULGAN If it hadn't been George W. Bush in the White House the meaning of 9/11 would have been very different. Bush was going to spark off an era of aggressive US intervention in various places. Blair thought he had to ally closely with the Americans to try to mitigate some of what they would do, which I think was a huge historical error, and certainly made it hard to keep a lot of positive elements alive. Good Friday had all been

about 'embrace your enemy' and take the courage to try to at least understand how the world looks to them; 9/11 precipitated almost an opposite stance, which we're still dealing with today.

STRYKER McGUIRE I don't think 9/11, global terrorism, was a big factor in Labour's decline. British people grew up with the IRA. When I first arrived in the UK I was in the City going to do some interviews. I'd picked up a cup of coffee and, when I got to the station, I was thinking, Where do you throw things away in this country? Where are all the bins? Terrorism was already on people's mind. I don't think 9/11 burst the bubble of hope.

VIRGINIA BOTTOMLEY Through all of that time the Americans supported the IRA while we were under threat. My husband and I were on the IRA hit list, but the Americans were saying, 'Be forgiving to the other side.' Our children were brought up with constant threats; car bombs. All our windows were reinforced and we had to have bomb curtains. When our daughter went to school she had to be sent round the corner, and then whoever was driving would have to check in case there was a bomb underneath the car before picking her up. The IRA blew up some of our friends. We had already tightened up our airport security and so on and so forth. So I thought 9/11 was a horrific event, but the American reaction was in total contrast to how they had responded to the IRA over the years.

TOBY YOUNG It plunged us into a perilous era in which security couldn't be taken for granted. In retrospect, Cool Britannia had bathed in an age of innocence.

MEERA SYAL There was a shift in attitude very much for my Muslim friends. To the average low-IQ racist, a brown person's a brown person. They're not going to ask if you're Muslim or Hindu before they smash you in the face. In a way, it did feel that all of the good stuff that had happened in the years before was wiped out. I knew how people would think: Muslim equals terrorist; brown person equals danger. That's the way it was going to be.

CARLA POWER I talked to British Muslims because I wanted to see how they were reacting to the post-9/11 environment. It was tense. I had Muslim guys leaning against the car in Birmingham saying, 'Well, I can sort of see why Bin Laden did what he did.'

ALASTAIR CAMPBELL It was definitely a moment when you felt a chapter was ending and a new one was beginning. Interestingly enough, we'd just had the 2001 election and the slogan was 'schools first', because we'd been too focused on foreign policy. It was basically saying, 'We're going to focus much more now on the domestic.' 9/11 changed all of that. It defined the rest of the time. As a result, you had Afghanistan, and then Iraq.

PETER HYMAN 9/11 ultimately led to Iraq, which obviously led to the skewing of everything to do with New Labour and the lens through which people see Blair. History changes on these things. Without 9/11 it would have been a very different Blair premiership.

STRYKER McGUIRE Money, prosperity, optimism were important facets of what happened, but at the same time they were part of the undoing. Everything has a cycle. The sort of Britain Blair wanted to make was ultimately destroyed by what he thought would be Britain's saviour, which was its close relationship with the United States. If you see the nineties as a period when this country was looking outward, it subsequently becomes more inward-looking.

OLIVER PEYTON The Iraq War was the death knell for New Labour. A million people marched. What the fuck was Blair doing with George Bush? It was a betrayal. 2001 is the right time to stop the Cool Britannia story. After that it turns into something else.

NOEL GALLAGHER When people get into political discussions about Tony Blair, you have to stop and say, 'I get out of my mind quite a lot, but remind me, was he flying one of the planes? Was George Bush flying the other one? Is that right, because that's how you lot are fucking going on about it.' Whoever's in charge of Britain at the point America goes to war, you're going with them, and that's the end of it. That's just the way it fucking is.

CHRIS SMITH Blair led us into the biggest foreign policy mistake that the country has made since Suez, and that will characterise history's assessment of him.

ALAN McGEE It was a major fuck-up bombing Iraq. You cannot get past that one. If he hadn't gone to war I think he would have been the great Labour Prime Minister.

TONY BLAIR Well, first of all 9/11 did happen. You're put in the position of Prime Minister to take these decisions, and you've got to do what you think is right, at the time. The problem we got into with Iraq was that the depths of this extremism were very deep, and what people never do is put the counterfactual. Supposing you'd left Saddam there until the Arab Spring broke out in 2011. How do we know we would be in a better position today? If you look at the Middle East: we had intervention in Iraq, we had non-intervention in Syria, we had partial-intervention in Libya and we had someone else's intervention in Yemen. Of those four countries there's only one country whose prime minister and president are turning up in Downing Street and the White House and who are accepted globally and recognised as the legitimate government – that's Iraq. So when people talk about Iraq, over a time they're going to have come to a point where they say, 'Okay, intervention is very difficult, but non-intervention is also difficult.' That argument will carry on, and I'm perfectly happy to have it with whoever wants it. When people write the history of this government properly, it will see that it changed the country radically. Maybe the country became divided over Iraq, but ultimately it was a country with a successful economy, improving public services, falling crime, the introduction of a whole series of changes in our society: minimum wage, civil partnerships, different attitudes to a whole range of social issues. We stood tall in the world. And, in 2005, at the height of Iraq, we won the 2012 Olympic bid. We were big players. In the end people are going to make their judgements about that. Harold Macmillan was once asked, 'What's the most difficult thing about being Prime Minister?' He said, 'Events.' He's right, and 9/11 was a big, big, big event.

WHILE ROME BURNED
Cool Britannia legacy

TONY BLAIR Cool Britannia represented fresh, more equal, getting rid of old attitudes and traditions that had no place in the modern world; a Britain that was young, vibrant and forward-looking and exciting. And what's really interesting, which is why this book is interesting, is that I had a strong feeling that that mood of forward-looking optimism was victorious and increasingly uncontested. But you have to say today that judgement looks wrong and it wasn't as uncontested as I thought. It didn't sweep all before it, for ever. It was still actually resented in many quarters. If you look at the country today you would not describe it as a Cool Britannia type of spirit at all.

KEITH ALLEN The nineties was one step forward, twenty steps back from the political and social gains of the eighties. The idea of freedom and freedom of expression was sold very short. You could argue the nineties was the same as Nero fiddling while Rome burned and *Cabaret* in Berlin pre-Second World War: that while we were engaged in this hedonistic life, building blocks were being put in place that would lead to the situation we are in now, which is that our freedoms have undoubtedly been challenged and curtailed. We allowed it to happen. We didn't do enough, politically.

DAVID KAMP There had been this authentic sense of hope, of a page turning; this renaissance in British culture. I think it went wrong for two reasons: people took too many drugs, which inhibited and retarded artistic development; and secondly disillusionment

with Tony Blair. There was genuine belief that New Labour, and Blair specifically, were going to represent a sea change politically, where the cynicism of old politics and the snobbishness and lack of egalitarianism in the British political system would change. Blair turned out to be just another political centrist who was selling something with a shiny label. There was a sense that we'd been sold a bill of goods.

MATTHEW WRIGHT The iconic image of Noel Gallagher at the Downing Street reception with Tony Blair was the zenith of Cool Britannia. You had a cool leader and a cool artist together at an address that isn't known for coolness. We haven't seen anything like it since, possibly because inherent in Cool Britannia was the seed of its own destruction – that being, as soon as you become knowingly cool you're desperately unhip. Within weeks of that reception Oasis's cool and mass credibility waned. I don't know if you can have 'mass' and 'cool' at the same time. When something becomes mass market it becomes product, and that's not cool; that's just commercial. Thereafter, Cool Britannia was on the way out.

PETER HYMAN People can critique Cool Britannia as 'a few parties at Number 10' and dismiss it all as part of the narrative against New Labour. Through that light then Cool Britannia becomes a piece of superficial nonsense, another piece of spin, something that doesn't amount to anything. But if you give it the benefit of the doubt, you'd say, 'There was actually a serious point about how Britain was portraying itself in the world and what the country's future was.' There were mistakes that we made, but the idea that Britain should be presenting itself not just based on its past, but on its future, is still right. If we'd done it properly it would have given people an optimistic narrative about Britain. I would go as far as to say that its relative failure has shaped what became the cataclysmic Brexit decision.

JOHNNY HOPKINS What came out of it that had any value? I don't see it in the UK film industry. I don't see it in the art world. It was all about marketing in the crassest kind of way. It doesn't matter if it was *Sensation*, Cool Britannia or New Labour.

GREGOR MUIR There was an ephemeral nature about the whole phenomenon. It existed in a very fragile sense through the coming together of certain people, certain exhibitions, certain artworks and certain places at a specific point in time. By 2000 the scene had atomised. The artists who were once very used to being in a cluster or close together were moving away. It had been over a decade. It was understandable that people wanted to persue their own path. Some resented, quite rightly, the now perceived excesses, and that certain key players reduced it to a question of money while others entered into a new celebrity world. It's the idea that punk lasted a hundred days. If you had experienced punk within those hundred days it would have meant something different to you than outside of those hundred days.

OLIVER PEYTON Things change. Things became flash. It felt like it was all about the money and celebrity. There was a migration of richer people into the country. Bling restaurants started. Things became too brash. Art became a status symbol and a commodity for hedge-fund people. What was accessible before became inaccessible. Suddenly an artwork that was £20,000 was now £3 to 4 million.

TRACEY EMIN There was a spasm and people went off on a different trajectory. I moved into a different circle and became friends with people like Stella McCartney and Vivienne Westwood. In a weird way, I was un-needed from the art world. When you're young you're tainted by the fun and glamour of everything. It became not what my peer group was doing, but this bigger group of people, what they were doing. That was the beginning of the end. The big world came in and took over. Before, we were creating, we were inventing; we were making everything happen; we were pushing it; we were our own engine. The mainstream world could see the financial value of what we were doing, and everybody wanted a piece – chiselling into me, wanted to make money from me – everybody was looking for what they could get out of a situation.

STEVE COOGAN There's a danger with anything where you open the floodgates and you're like, 'No, that's not what I meant at all. Close the gates.'

SUZI APLIN When you're in an era you don't realise it. I'm sure people during punk didn't say, 'We're changing the world with all this music and graphic design.'

WILL MACDONALD We were in the middle of the bubble. We were just getting on and doing what we were doing. When you wore flares in the seventies you didn't think, This is a bit weird. But afterwards you go, 'Those trousers were a bit wide.' It was only as the end of the decade was in sight that you started to look back: 'Oh, that was an interesting time . . . we were at the centre of Cool Britannia.'

ALAN McGEE It was an incredible, amazing decade. I don't think we'll see another one like that in my lifetime. But we lacked information; the Internet was only just coming up. You were living in a zone where music defined you. Now Instagram defines you.

MELANIE CHISHOLM If you think of Instagram, the culture of young people is all about looking at themselves and documenting. They're not present. We were in it. We were present. We were living it. There was more freedom; less narcissism.

BRETT ANDERSON A really good thing about Cool Britannia was that it shifted where the mainstream was. Previously, alternative bands had been marginal, and it put them right into the centre of the mainstream. It was a brilliant thing. Regardless of what I personally think of those bands, at least there was an intelligent voice, in lots of cases, and people were listening to interesting music.

ALAN McGEE Ultimately, I define myself by music, not the politics, not the five minutes of celebrity fame, not the money even. I define myself by the records that I put out and the concerts I went to. There were probably ten amazing bands came out of the

nineties – Happy Mondays, Massive Attack, Primal Scream, Oasis, Blur, My Bloody Valentine, Portishead, Cast, the Verve, Super Furry Animals – if that's all that came out of it, fuck me, that's something to believe in.

DAVID BADDIEL It was last time there was a vibrant subculture – before the Internet – a coming together of young people creating something that was a proper artistic moment, owned by the people involved. It felt like, 'This is our punk. This is our Summer of Love.' There was an enormous amount of talent knocking about, brilliant music and art and fashion. There was a crosscurrent between comedy and TV, and even something like *Viz* felt like part of it, a British comic. Suddenly it all burst in to the mainstream and became a massive deal. And then, like all of those things, faded away very quickly.

IRVINE WELSH I saw it as a requiem mass for British culture. We've had a good run now we're selling it off to the global market. It was the end of culture in that form. To paraphrase the sixties, 'If you can remember the nineties you weren't there.' It was a little bit like that. With the massive growth of the Internet, culture was taken online and it dissipated.

TOBY YOUNG Generally, cultural phenomena have a short shelf life. It's quite difficult to sustain that level of energy and excitement and media interest for more than a year or so. In so far as people come to believe that the zeitgeist has taken up residence in a particular city, they also believe that the zeitgeist is going to move on.

VIRGINIA BOTTOMLEY Could you not argue Cool Britannia fed into a lot of the work that led towards the 2012 Olympics? So instead of Cool Britannia and the arts it became Cool Britannia and sport. That's how I envisaged it.

GEOFF MULGAN The premise of a 'rise and fall', where these things come and go, is a newspaper version of the Cool Britannia story. It's very much like the dot.com bubble that came two or

three years later. The truth is they have a hype cycle, but the underlying realities are a much deeper process of change. Today, London is dramatically more dynamic as a creative centre and a digital capital, far more magnetic to the rest of the world than it was in '96, '97. So, weirdly, although the phrase 'Cool Britannia' came and went, the reality has been extraordinarily resilient. This is why London has continued to pull in young people and talent energy from all over the world and comes top in the rankings of world cities.

WAHEED ALLI We should look back with real pride. If you're black, if you're gay, if you're a woman, if you're disabled, there's no better time to have been alive than the last twenty years. You look back with pride because you helped enable that change. But whether Cool Britannia is pivotal or not, history decides.

TONY BLAIR What is true is that social attitudes change. The Britain of today is definitely much more open-minded on all of these socially liberal questions. You can get caught up in the Cool Britannia thing, but in the end it was a very simple idea, and that was to say that the country should live and breathe freely. It was about saying, 'We've had a great past, we have done wonderful things and we're proud of our history, but we're not going to live in it. We're a modern world now. We're going to have a great future.' That was the spirit of the times. And it's a spirit we've lost, tragically.

JARVIS COCKER I was aware of the contradictions and troubled by some of the things at the time, but as I've got older I've become more tolerant of things changing by increments rather than having a revolution. It was an exciting and positive time to be part of it, even if it was just the idea that it was possible for things to come from grassroots and be put in a spotlight. That said, if the title of this book had just been 'Cool Britannia' I wouldn't have been interested. I don't look back in anger . . . and it's a better title!

DAMON ALBARN Everything that's written is irrelevant. It's those moments performing and writing music which remain

extraordinary experiences. I always feel that everyone, whether it's consciously or subconsciously, self-mythologises. Fuck, for a lot of people in this country that week with Oasis is the only thing I've ever done. Is that what I want to be remembered by? Not particularly. I just wanted to breathe and see more of the world and not be so isolated on this little island celebrating, or maybe self-harming itself.

NOEL GALLAGHER We didn't look as good as people in the sixties or during Glam in the seventies, but the characters have stood the test of time. I'm still around. Damon is still around. Jarvis is still around. The main protagonists are still doing it. Everything I do is an extension of that time. That says quite a lot; that nobody came along to take our place. We were all young, opinionated, talented and cool. We were it or it was us, whatever that thing was. The music stood the test of time, which is why people endlessly go on about Blur and Oasis and Pulp. Fucking hell! They'd love us to get on a cruise ship and do a Britpop tour.

Acknowledgements

Don't Look Back in Anger is presented as an oral narrative, bringing together sixty-eight contributing voices of the period. I am indebted to each and every one of you for giving the gift of time and thought, without which this book would not exist. I am equally grateful to all the many individuals who introduced or enabled those conversations to happen.

I am hugely thankful to Noel Gallagher for generously granting permission to use lyrics from 'Don't Look Back in Anger' and for also giving his approval for its use as the title of this book.

In the publishing world, I am indebted to Anna Valentine for having the vision, commitment and excitement, from my initial pitch through all the stages of its development, to putting *Don't Look Back in Anger* on book shelves, and as an editor offering challenging and incisive advice. To Steve Burdett for a thorough and razor-sharp copy edit. To Kishan Rajani for the design of the front cover. And to all the team at Trapeze Anna Bowen, Shyam Kumar, and Leanne Oliver.

Carrie Kania was the first person to read a draft of this book, and as a reader, literary agent and friend has supported and encouraged its growth from early conversations over coffee in Soho to what I hope will be the popping of corks in Mayfair.

Thank you to Martin Betts, whose knowledge and insights, stretched over many, many hours of conversation have never failed to lift my spirit.

To Susie: your support, faith and critical input has been amazing. We are the shadows dancing through this story. xx

And finally, thank you to Lily, Eleanor and Lottie: you are a constant source of joy and pride. xxx

Timeline

(Records listed by first week charted)

1986

27 October: Big Bang, deregulation of financial markets

1987

December: Shoom opens, UK's first acid-house club

1988

6 August–29 September: *Freeze* exhibition

1989

9 November: Fall of Berlin Wall

1990

11 February: Nelson Mandela released

31 March: Poll tax demonstration, London

27 May: The Stone Roses at Spike Island

2 June: England New Order 'World in Motion'

8 June–8 July: FIFA World Cup in Italy

10 August: *The Word* launched on Channel 4

22 November: Margaret Thatcher resigns as Leader of the Conservative Party

27 November: John Major elected Leader of the Conservative Party

1991

30 November: Nirvana 'Smells Like Teen Spirit'

1992

9 April: General Election – Conservative Party returned to office

25 April: *Melody Maker* front cover – Suede: Best New Band in Britain

8–9 August: Madstock, Finsbury Park. Madness with special guest support Morrissey

15 August: Inaugural season of the Premier League

September: Nick Hornby *Fever Pitch* (film April 1997)

16 September: Black Wednesday, pound withdrawn from European Exchange Rate Mechanism

28 September: *The Big Breakfast* launched on Channel 4

1993

January: Tracey Emin and Sarah Lucas open *The Shop*

April: *Select* magazine front cover 'Yanks Go Home'

10 April: Suede *Suede*

22 April: John Major speaking at the Conservative Group for Europe: 'Fifty years from now Britain will still be the country of long shadows . . .'

1994

14 January: *Fantasy Football League* launched on BBC2

19 March: Blur 'Girls and Boys'

8 April: Suicide of Kurt Cobain discovered

14 April: Atlantic Bar & Grill opens

23 April: Oasis 'Supersonic'

May: *Loaded* magazine launched, 'For men who should know better'

12 May: Death of John Smith, Leader of the Labour Party

17 May: Blur *Parklife*

21 July: Tony Blair elected Leader of the Labour Party

31 August: IRA declare 'complete ceasefire'

10 September: Oasis *Definitely Maybe*

3 November: The Criminal Justice and Public Order Act 1994 allows the police to shut down events 'characterised by the emission of a succession of repetitive beats'

9 November: First UK National Lottery

14 November: Eurostar opens

1995

25 March: Elastica *Elastica*

April: Chris Evans *Breakfast Show* on BBC Radio 1

16 May: Oasis 'Some Might Say'

17 June: Blur at Mile End Stadium

26 August: Blur 'Country House', Oasis 'Roll with It'

9 September: War Child *The Help Album*

23 September: Blur *The Great Escape*

11 November: Pulp *Different Class*

20 November: Princess Diana speaking on *Panorama*: 'There were three of us in this marriage [. . .] I would like to be the queen of people's hearts.'

1996

26 January: *The Girlie Show* launched on Channel 4

9 February: *TFI Friday* launched on Channel 4

19 February: BRIT Awards, Noel Gallagher: 'Blair's the man! Power to the people!'

23 February: *Trainspotting* film released (book 1993; soundtrack 7/96)

20 April: Ocean Colour Scene *Moseley Shoals*

27–28 April: Oasis at Maine Road

June: Sex Pistols reform

1 June: Baddiel & Skinner & Lightning Seeds 'Three Lions'

8–30 June: Euro 96

20 July: The Spice Girls 'Wannabe'

10–11 August: Oasis at Knebworth Park

October: Alexander McQueen appointed chief designer at Givenchy

1 October: Labour Party Conference, Blackpool. Tony Blair: 'Labour's coming home!'

November: *GQ* magazine 'Great British Issue'

4 November: *Newsweek* magazine 'London Rules'

11 November: John Major speech at the Lord Mayor's Banquet: 'Our theatres give the lead to Broadway, our pop culture rules the airwaves, our country has taken over the fashion catwalks of Paris.'

1997

24 February: BRIT Awards, Geri Halliwell wears Union Jack dress

March: *Vanity Fair* magazine 'London Swings Again!'

1 May: General Election, Labour Party landslide

June: Creative Industries Task Force established

30 July: Downing Street reception party

30 August: Oasis *Be Here Now*

31 August: Princess Diana dies

18 September: *Sensation* exhibition opens

October: Zoe Ball *Breakfast Show* on BBC Radio 1

13 December: Robbie Williams 'Angels'

2 December: Turner Prize. 'Is Painting Dead?' broadcast on Channel 4

1998

January: *Goodness Gracious Me* launched on BBC2

14 March: *NME* front cover 'EVER HAD THE FEELING YOU'VE BEEN CHEATED?'

April: Formation of Panel 2000 to help give Britain a 'cool' image abroad

11 April: Pulp *This Is Hardcore*

22 May: Good Friday Agreement

10 June–12 July: FIFA World Cup in France

13 June: England United '(How Does it Feel to Be) On Top of the World?'

20 June: Fat Les 'Vindaloo'

28 August: *Lock, Stock and Two Smoking Barrels*

2000

11 May: Tate Modern opens

2001

May–July: riots in Oldham (26–28 May), Leeds (5 June), Burnley

(23–24 June), Bradford (7 July), Stoke-on-Trent (14 July)
11 September: Attack on Twin Towers, New York

2002

11 April: *Bend It Like Beckham*

List of Illustrations

First Plate Section

Gallery, London (Jeremy Deller / The Artist and The Modern Institute / Toby Webster Ltd, Glasgow Photo: Mark Blower)

14. Tony Blair and Alastair Campbell, London, April Fool's Day, 1997 (Tom Stoddart Archive / Getty)

15. Mat Collishaw and Tracey Emin at the opening of *Sensation* at the Royal Academy, 18 September 1997 (Daffyd Jones)

16. *Myra* by Marcus Harvey displayed at *Sensation*, Royal Academy, 1997 (Daffyd Jones)

17. Poem written by Jeremy Deller, 'The Mall', London, 3 September 1997 (Jeremy Deller / The Artist and The Modern Institute / Toby Webster Ltd, / Glasgow Image)

18. Jeremy Deller's poem covered over by flowers. The Mall, London, 3 September 1997 (Jeremy Deller / The Artist and The Modern Institute / Toby Webster Ltd, / Glasgow Image)

19. David Beckham is sent off for England in the World Cup second round match against Argentina, June 30 1998 (Ross Kinnaird / Getty)

20. Gurinder Chadha at the Sundance Film Festival, 2003 (Sundance / Wire Image / Getty)

21. The Queen with Tony Blair at the opening of the Millennium Dome, 31 December 1999 (Press Association)

Index